AERIAL
GEOLOGY

AERIAL

GEOLOGY

A HIGH-ALTITUDE TOUR OF NORTH AMERICA'S SPECTACULAR VOLCANOES, CANYONS, GLACIERS, LAKES, CRATERS, AND PEAKS

MARY CAPERTON MORTON

TIMBER PRESS · PORTLAND, OREGON

Frontispiece: A small seasonal creek cuts a canyon through layered sandstone in southern Utah.

Published in 2017 by Timber Press, Inc.
The Haseltine Building
133 S.W. Second Avenue, Suite 450
Portland, Oregon 97204-3527
timberpress.com

Printed in China
Book design by Anna Eshelman
Cover design by Kimberly Glyder and Anna Eshelman

Library of Congress Cataloging-in-Publication Data

Names: Morton, Mary Caperton.
Title: Aerial geology: a high-altitude tour of North America's spectacular
 volcanoes, canyons, glaciers, lakes, craters, and peaks / Mary Caperton
 Morton.
Description: Portland, Oregon: Timber Press, [2017] | Includes bibliographical
 references and index.
Identifiers: LCCN 2016057866 | ISBN 9781604697629 (hardcover)
Subjects: LCSH: Geology—North America. | Landforms—North America. |
 Landforms—North America—Pictorial works.
Classification: LCC QE71 .M67 2017 | DDC 557—dc23 LC record available at
 https://lccn.loc.gov/2016057866ISBN: 978-1-60469-762-9

A catalog record for this book is also available from the British Library.

to
my Big Sky family
and
my favorite Christmas tree laccolith

More than 4 billion years of geologic history have shaped the North American continent.

The results can be seen etched across the landscape: from a string of volcanic islands in the North Pacific Ocean, to an earthquake-sculpted Mexican peninsula, to a perfectly round impact crater in northern Quebec. This aerial journey will introduce you to one hundred places that offer glimpses into the greatest geologic tale ever told: the story of Earth.

CONTENTS

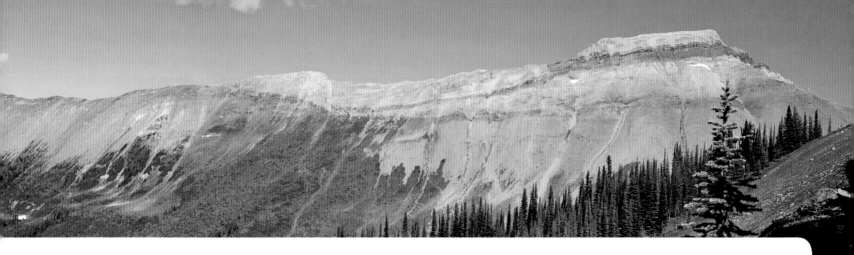

CONTENTS (continued)

PREFACE

As a young girl, I overturned a rock in a stream high in the mountains of West Virginia and found it covered with seashells. I knew something about fossils then and had a vague understanding about Earth's age, but finding a slice of an ancient ocean floor on a mountaintop forever changed the way I saw the world. My fascination was not fleeting and I am now a geology writer, an avid traveler, and a mountaineer.

In many ways, geology is best understood from the air. Altitude grants a greater perspective of the land and helps us begin to visualize the extraordinary forces that have shaped our planet over the last 4.5 billion years. Mountaineering is one way to gain that perspective—the higher you go, the more you see and the more you see, the more you learn. If mountaintops are fantastic classrooms, airplane window seats are even better.

This book highlights one hundred of North America's most distinctive geologic features and describes how they came to look the way they do from a bird's-eye view—or an astronaut's, or a satellite's. On the ground, deserts appear devoid of moisture but from the air, large-scale features of the landscape reveal that even the most arid places are often shaped by water. Southwest expanses of sandstone—often relics of ancient inland seas—have been sculpted into magnificent canyons by rare rainwater over many millennia.

Follow me from the shores of Alaska, down the West Coast, through the desert Southwest, over the high Rockies, across the patchwork Great Plains, and up the ancient, fossil-rich mountains of my childhood, to the edge of the East. This book is for everyone who ever wondered how seashells end up on mountaintops, and for the high flyers who are transfixed by the view 30,000 feet above the planet. I hope this book changes the way you see the world and inspires you to get out and explore more of it.

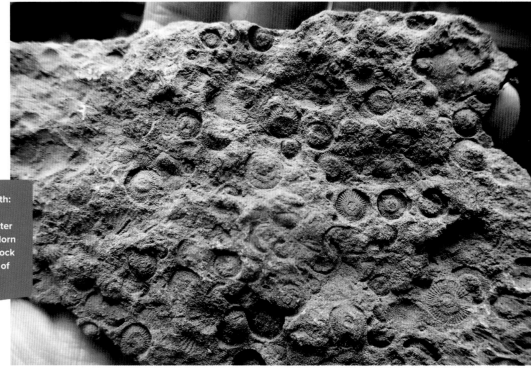

A treasure from my youth: fossilized segments of stems from an underwater plant called a crinoid adorn a 350-million-year-old rock found in the mountains of southern West Virginia.

GEOLOGY 101

The geologic story of North America is a fascinating one. It's also more than 4 billion years long—much more than we could ever hope to cover here. However, if you're curious about the world around you, enjoy the big-picture perspective, and are interested in some of the processes that are constantly reshaping our planet, here's a crash course on the basics. It's a good place to start on your aerial tour of the continent's most breathtaking landforms.

Supercontinents and Plate Tectonics

The most powerful geologic force on Earth is plate tectonics, which governs the formation and breakup of continents (such as North America) and supercontinents (such as ancient Pangaea). The planet's outer shell, called the lithosphere, is broken into eight major tectonic plates and many smaller ones, which slide around the planet, driven by the convective forces (motion created by heat) produced by the planet's hot inner mantle and core. Plate tectonics move continents, build mountains, fuel volcanoes, and set off earthquakes.

North America as we know it was formed around 200 million years ago, after numerous journeys to the equator and back to its more mid-latitude location. Prior to that, it was a fragment of the supercontinent Pangaea, known as Laurentia. Pangaea amassed around 300 million years ago and began to break up around 200 million years ago, when the Mid-Atlantic Ridge (a spreading ridge that runs under Iceland) began opening, forcing apart the conjoined landmasses that would become North and South America, Eurasia, and Africa—and creating the Atlantic Ocean.

The majority of North America is situated on the North American Plate: a massive tectonic puzzle piece that runs from Mexico and the Caribbean to the Arctic, and from the edge of the Pacific

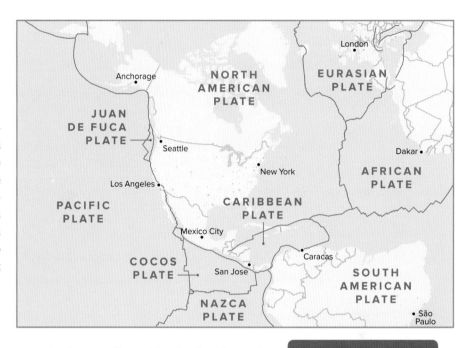

Ocean to the spreading Mid-Atlantic Ridge under the Atlantic Ocean. As the Atlantic Ocean continues to widen at a rate of about an inch per year, the North American Plate is pushed toward the southwest, where it collides with the Pacific Plate—the major plate underlying the Pacific Ocean—and several smaller oceanic plates.

Continental crust is less dense than waterlogged oceanic crust, so the more buoyant North American Plate rides over the top of the Pacific Plate, forcing the oceanic plate downward, forming a subduction zone. The tremendous forces generated at these plate boundaries, or subduction zones, fuel earthquakes and volcanism along the active western margin of the continent, such as the magnitude 9 megaquake unleashed by the Cascadia Subduction Zone on January 26, 1700, and the eruption of Mount Saint Helens on May 18, 1980.

Tectonic plates are bounded and fractured by faults, where two adjacent masses of rock meet and move relative to each other. Major types of faults include transform faults, thrust faults, and normal faults. Transform faults, also known as strike-slip faults, occur when bordering volumes of rock slide past one another in a lateral motion, with little or no vertical movement. The San Andreas Fault on the coast of California is an example of this kind of fault, where the North

> Earth's rigid outer shell is broken into dozens of major and minor tectonic plates. Most of North America sits atop the North American Plate.

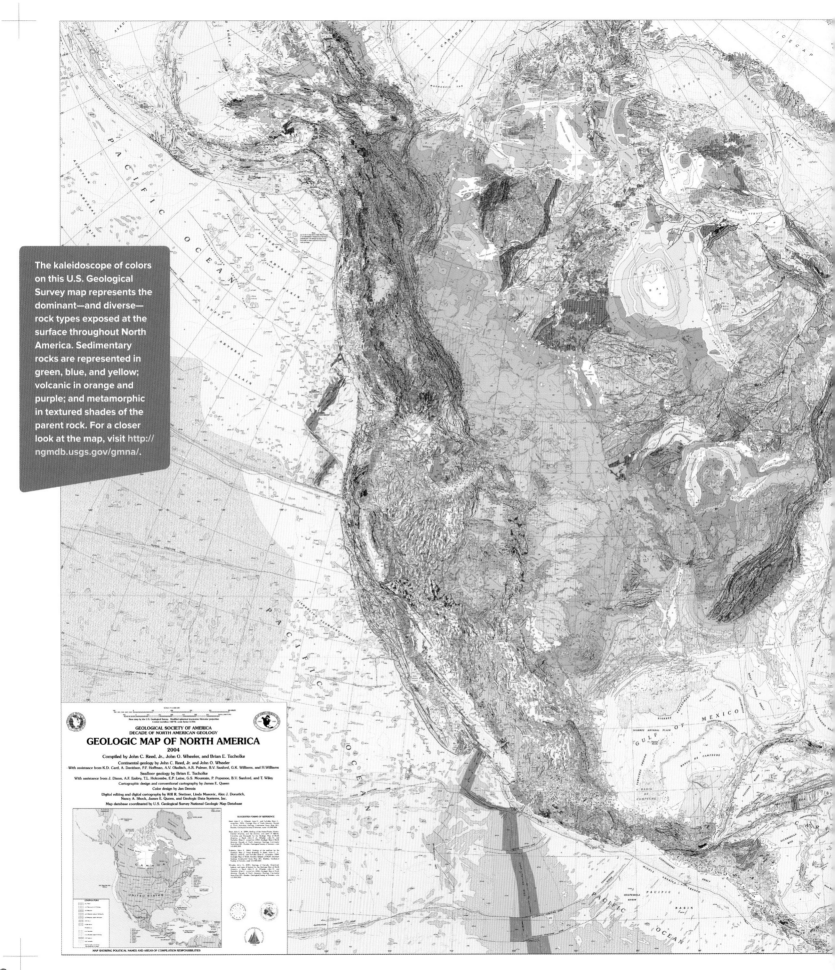

The kaleidoscope of colors on this U.S. Geological Survey map represents the dominant—and diverse—rock types exposed at the surface throughout North America. Sedimentary rocks are represented in green, blue, and yellow; volcanic in orange and purple; and metamorphic in textured shades of the parent rock. For a closer look at the map, visit http://ngmdb.usgs.gov/gmna/.

GEOLOGICAL SOCIETY OF AMERICA
DECADE OF NORTH AMERICAN GEOLOGY
GEOLOGIC MAP OF NORTH AMERICA
2004
Compiled by John C. Reed, Jr., John O. Wheeler, and Brian E. Tucholke

American Plate is moving laterally to the Pacific Plate, at a rate of one to two inches per year. This movement sometimes occurs smoothly—aseismically—and other times makes violent jumps that unleash earthquakes.

Earthquakes can also be generated in the interiors of tectonic plates, where tectonic forces are squeezing the lithosphere together or pulling it apart in compressional and extensional landscapes. Thrust faults occur when compressive forces move blocks of rock over adjacent blocks, often creating mountains, sometimes with older layers of rock forced on top of younger layers. This reverses the usual order of geology, in which younger rocks sit on older rocks. Thrust faults can be found in the Rocky Mountains of Glacier National Park, where rocks more than a billion years old have been forced on top of rocks that are merely 100 million years old.

Normal faults occur in extensional environments, where Earth's lithosphere is being stretched across a wide region. As the crust thins and weakens, blocks of rock drop downward, forming valleys and basins. The most famous example of this kind of tectonic setting is the basin and range area that stretches for hundreds of miles across Nevada into eastern California. Here, extensional stresses in the interior of the continent have created a rippled pattern of elongated mountain chains separated by broad valleys and basins.

A Rocky History

The oldest rocks on the planet are more than 4 billion years old and some are found in North America. They exist as part of the Canadian Shield—a region of pre-Cambrian volcanic and metamorphic rock that forms the geologic core of the continent. The Canadian Shield stretches from the Great Lakes region north to the Arctic, underlying more than half of Canada. In turn, this shield is part of the North American Craton, a much larger, somewhat younger, mass of bedrock that also underlies the continent. These ancient forms are the foundation of North America. Over the past 4 billion years, the continent has taken many shapes, but these basement rocks

have always made up the root of North America.

If you look at a geologic map of the continent, the swirling maze of colors representing the different kinds of exposed rock is downright psychedelic. North America's eons-long habit of wandering down to the equator and up toward the poles has left behind a trail of myriad rock types that were deposited in wildly varied environments, ranging from hot, steamy tropics to arctic, ice age conditions.

Rocks are made up of minerals. Some rocks, like quartz, are composed of just one kind of mineral. Other rocks, such as gneiss, consist of several types of minerals—for example, quartz, feldspar, and mica. Rocks can generally be classified in one of three categories: igneous, sedimentary, and metamorphic. Igneous rocks can be erupted above ground at volcanoes, either in the form of oozing lava or explosive ash. Sometimes, volcanic eruptions take place underwater, through vents or fissures on the seafloor. When lava hits air or water, it cools quickly, forming dark, monochromatic rocks, often with lots of escaped air bubbles. Igneous rocks that form underground, such as granite, tend to cool slowly, allowing for large crystals to form. This makes these intrusive rocks especially crystalline, colorful, and hard.

Sedimentary rocks are formed when sediments accumulate in thick layers and are cemented into rock through a process called lithification. Sedimentary rocks often form with distinctive layers, representing varying conditions at the time the sediment was deposited. The most common sedimentary rocks in North America are sandstone (formed from many layers of sand and other fine-grained sediments) and limestone (made up of the calcium carbonate–rich skeletons of marine organisms such as corals, mollusks, and shelled protozoa).

Metamorphic rocks are transformed when existing rocks—igneous, sedimentary, or previously metamorphosed—are cooked by extreme heat and pressure, often deep within the planet or during episodes of mountain building. Metamorphism often significantly alters the chemical composition of the parent rock and changes its physical form into a completely different type of

rock with a new set of properties. For instance, relatively soft sandstone can be metamorphosed into quartzite, one of the planet's hardest rocks. Rocks that are already metamorphic may be cooked again and again, changing their properties each time.

Eons of uplift and erosion, mountain building and glacial carving, volcanic outbursts and super rifts have shaped the North American continent into one of the most geologically diverse landmasses on Earth. A wide variety of rocks have been laid down over many periods, with some stretches of time famous for producing types of rock that are many feet—even miles—thick. For example, during the Mesozoic Era, at a time when dinosaurs ruled the planet (roughly 250 to 65 million years ago), an immense inland sea covered much of what is now the desert Southwest. Sedimentary layers accumulated at the bottom of this sea would later be lithified into sandstone and sculpted by wind, rain, and freeze-thaw cycles into the sinuous canyons, soaring arches, and spooky towers that make southern Utah's Red Rock Country world famous—there's no other place quite like North America's southwestern desert anywhere on the planet.

The rocks and landforms we see on the surface today are the result of differential erosion; various kinds of rock erode in different ways at different rates. Softer rocks weather readily, sometimes disappearing altogether from the topographic record, while harder rocks may resist erosion for billions of years.

Perhaps the most important thing to remember about North America's—and every continent's—geology is that all these processes are ongoing. As anybody who has witnessed a rockfall or felt an earthquake knows: geologic time includes now. And one of the best ways to wrap your mind around the incomprehensibly grand concept of geologic time is to see the landscape on a grand scale—from high above.

Eon	Era	Period	Epoch		Millions of years ago
PHANEROZOIC	CENOZOIC	Quarternary	Holocene		0.01
			Pleistocene	Late	0.8
				Early	1.8
		Tertiary (Neogene)	Pliocene	Late	3.6
				Early	5.3
			Miocene	Late	11.2
				Middle	16.4
				Early	23.7
		Tertiary (Paleogene)	Oligocene	Late	28.5
				Early	33.7
			Eocene	Late	41.3
				Middle	49.0
				Early	54.8
			Paleocene	Late	61.0
				Early	65.0
	MESOZOIC	Cretaceous	Late		99.0
			Early		144
		Jurassic	Late		159
			Middle		180
			Early		206
		Triassic	Late		227
			Middle		242
			Early		248
	PALEOZOIC	Permian	Late		256
			Early		290
		Pennsylvanian			323
		Mississippian			354
		Devonian	Late		370
			Middle		391
			Early		417
		Silurian	Late		423
			Early		443
		Ordovician	Late		458
			Middle		470
			Early		490
		Cambrian	D		500
			C		512
			B		520
			A		543
PRECAMBRIAN	PROTEROZOIC	Late			900
		Middle			1600
		Early			2500
	ARCHEAN	Late			3000
		Middle			3400
		Early			3800
HADEAN					4200
					4600

Earth's 4.6 billion years of history are organized into various geologic eons, eras, periods, and epochs. The earliest rocks began forming during the Hadean Eon, around 4.4 billion years ago. We currently live in the Holocene Epoch.

A note on NASA imagery

This book was made possible in part by NASA's Visible Earth project, based at the Goddard Space Flight Center in Greenbelt, Maryland. The intrepid explorers at NASA's Earth Observation System always have eyes on our planet, studying and imaging our blue marble in all its glory.

Some of the photographs in this book were taken by orbiting astronauts, but the majority are not really photographs. They're images, created by layering different digital processes to highlight the most compelling features of the land below, whether it be aspects of the topography, hydrology, or ecology. A few of the images in this book are false color or otherwise enhanced to better show the landscape; these are identified in captions.

All NASA photographs featured here, and thousands more, are freely shared with the public at visibleearth.nasa.gov.

100
GEOLOGICAL
WONDERS

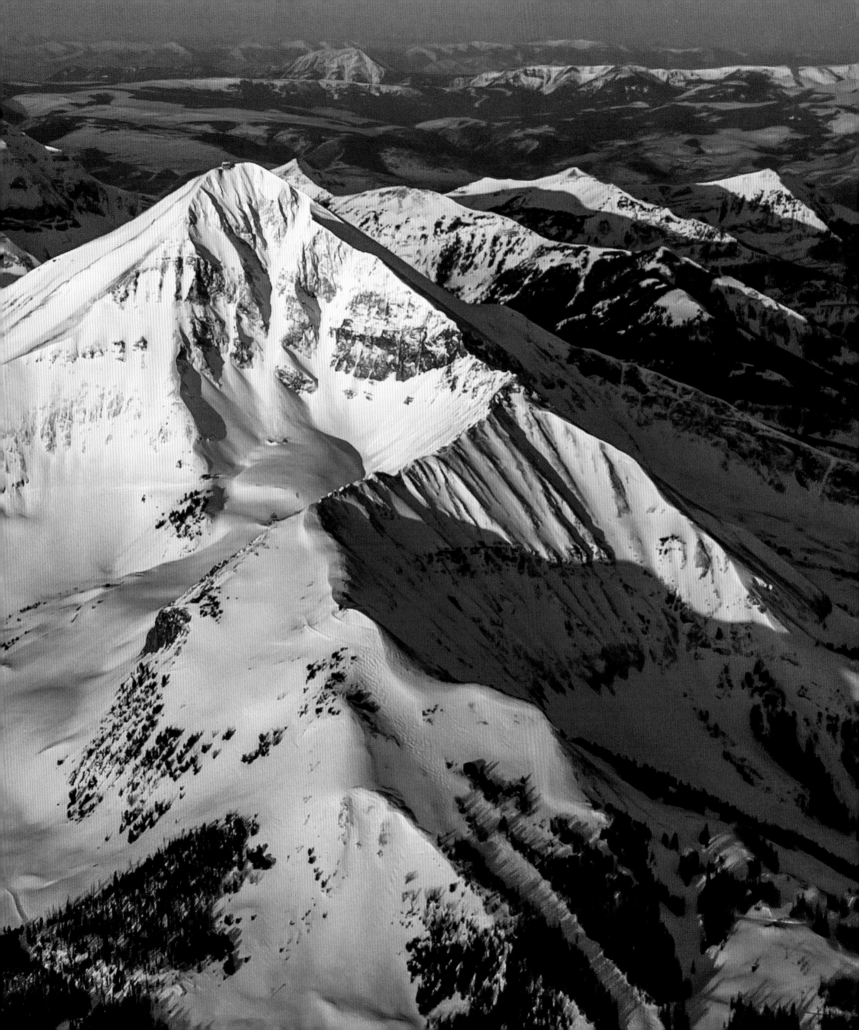

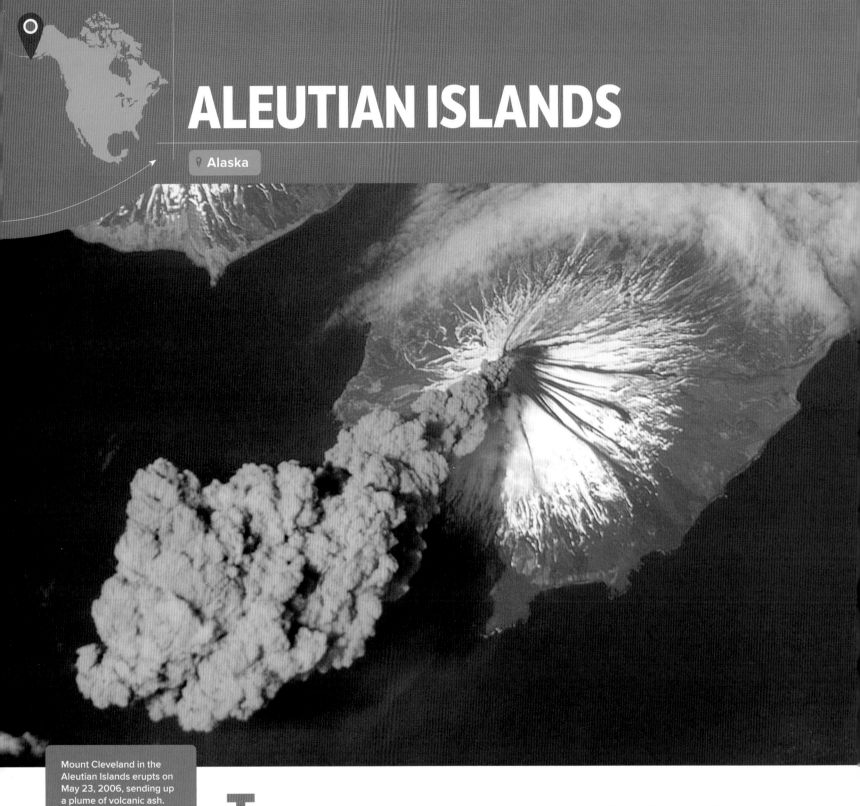

ALEUTIAN ISLANDS

Alaska

Mount Cleveland in the Aleutian Islands erupts on May 23, 2006, sending up a plume of volcanic ash.

The Aleutian Islands stretch in a 1200-mile-long arc from Russia's Kamchatka Peninsula eastward to the Alaska Peninsula, marking the division between the Bering Sea to the north and the North Pacific Ocean to the south. The island arc is made up of fourteen large volcanic islands and fifty-five smaller ones, the product of ongoing plate tectonic collisions along the Pacific Ring of Fire (a string of volcanic and seismic activity around the Pacific Ocean rim). From the air, the easternmost islands, near the Alaska Peninsula, are clearly the largest, with the tallest volcanoes.

These islands were formed by the same geologic processes (along the interface between two

Ring of Fire volcano chain that regularly erupts as tectonic plates collide

major tectonic plates) that created the Aleutian Mountains on the Alaska Peninsula. The landscape here continues to be active, as the Pacific Plate dives under the North American Plate, forming a convergent plate boundary. The Aleutian Trench, which runs along this convergence, has been measured to depths over 25,000 feet. As the heavy, waterlogged Pacific Plate is subducted, increasing heat and pressure release the stored water in the downward-heading plate, partially melting the descending and overriding plates. This low-density melt rises to the surface and erupts along a chain of volcanoes on the North American side of the plate boundary. Earthquakes along this trench generate shaking up to magnitude 8.7 and tsunamis that travel as far as Hawaii and South America.

As a reminder that geology isn't just ancient history, the Aleutian volcanoes continue to erupt and present significant threats, including ash clouds that can damage aircraft and cause jet engine failure. In 1988, the Alaska Volcano Observatory was formed in Anchorage to monitor the Aleutian Islands as well as the state's other active volcanoes. In recent years, Mount Cleveland and Mount Pavlof have been the most active in the Aleutians, erupting every five to ten years.

What is now the eastern end of the Aleutian Islands also helped set the scene for the first migration of humans to North America. During the last ice age—which reached its peak about 20,000 years ago and ended approximately 11,500 years ago—the Bering Land Bridge connected Russia and Alaska. Back then, huge quantities of the planet's water were frozen in mammoth continental ice sheets, lowering sea levels and exposing the land bridge for a period of a few thousand years. Sometime between 20,000 and 15,000 years ago, the first people made their way into North America via this bridge, migrating from Asia into the New World. At that time, the modern-day Alaska Peninsula and eastern Aleutian Islands were part of the southern edge of this exposed passageway. ∎

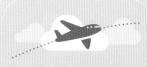

FLIGHT PATTERN

Look for a chain of mountainous volcanic islands curving to the southwest from the Alaska Peninsula on flights between the United States and Asia.

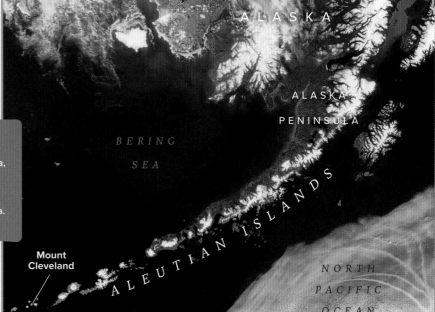

The Aleutian Islands separate the North Pacific Ocean from the Bering Sea, following a convergent plate boundary. Shown here is the eastern portion of the island arc, off Alaska.

Denali's two high points, the north and south summits, are visible in the upper center of this NASA image. The south summit is the higher of the two, at 20,310 feet.

Highest mountain in North America, still rising half an inch each year

After being called Mount McKinley for nearly a century, the original Athabaskan name of Denali, meaning "great one," was officially restored in 2015. And a great one it is. Not only is Denali the highest mountain on the North American continent at 20,310 feet, it's still growing taller by nearly half an inch a year. From the air, however, Denali can be hard to pick out from surrounding peaks in the Alaska Range. Its double summit is sandwiched between the white expanse of the Kahiltna Glacier to the west and the elongated Tokositna Glacier to the south.

The Denali Fault (a tectonic fault named for the mountain) is part of the greater continental-wide strike-slip fault system that runs along the west coast of North America and includes the notorious San Andreas Fault in California. Strike-slip faults, also called transform faults, occur when two adjacent plates slide past each other, sometimes moving smoothly and other times becoming stuck, eventually releasing their stored energy all at once in the form of earthquakes. This intracontinental fault system is in turn connected to—and driven by—the offshore subduction zone where the Pacific Plate is diving under the North American Plate at a rate of about an inch per year.

Over time, movement along the Denali Fault has given rise to the Alaska Range and Denali. Continued movement along the Denali Fault, which runs under the Alaska Range, accounts

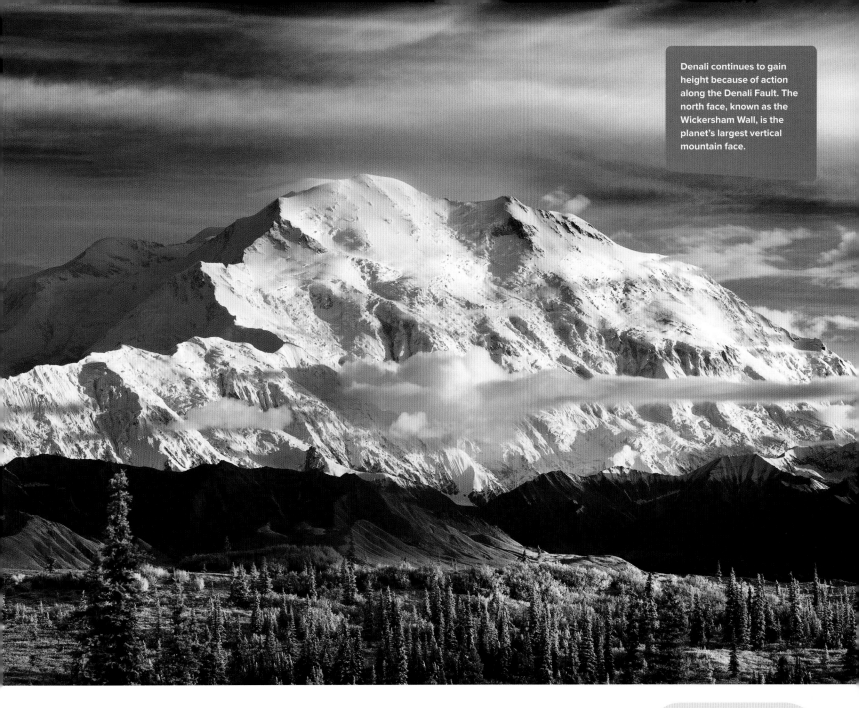

Denali continues to gain height because of action along the Denali Fault. The north face, known as the Wickersham Wall, is the planet's largest vertical mountain face.

for Denali's ongoing ascension. The north face of Denali, known as the Wickersham Wall, is the largest vertical mountain face on Earth—higher than any face on Mount Everest. From the base of the Wickersham Wall, at 5350 feet of elevation on the Peters Glacier, to the north summit, the face soars upward for nearly 14,000 steep, vertical feet. The avalanche-swept direct route up the face is so dangerous it has only been climbed once, in 1963, by a team of alpinists from the Harvard Mountaineering Club.

The distinction between the highest mountain and the tallest mountain is an important one in geology, and in mountaineering. The highest point on Earth is the summit of Mount Everest, at 29,029 feet, as measured from sea level. But the tallest mountain is measured from base to summit. By this metric, Denali is taller than Mount Everest, as it rises more than 18,000 feet from its base, while Everest stands only 12,000 feet above its base, which sits on the already high-altitude Himalayan Plateau. Both Everest and Denali are dwarfed by the Mauna Kea volcano on the Big Island of Hawaii, which, measured from its base on the ocean floor to the summit, is 33,476 feet tall. However, its elevation above sea level is a mere 13,808 feet. ▣

FLIGHT PATTERN

Denali may be visible en route to Fairbanks, Alaska, which lies a hundred miles to the north of Anchorage.

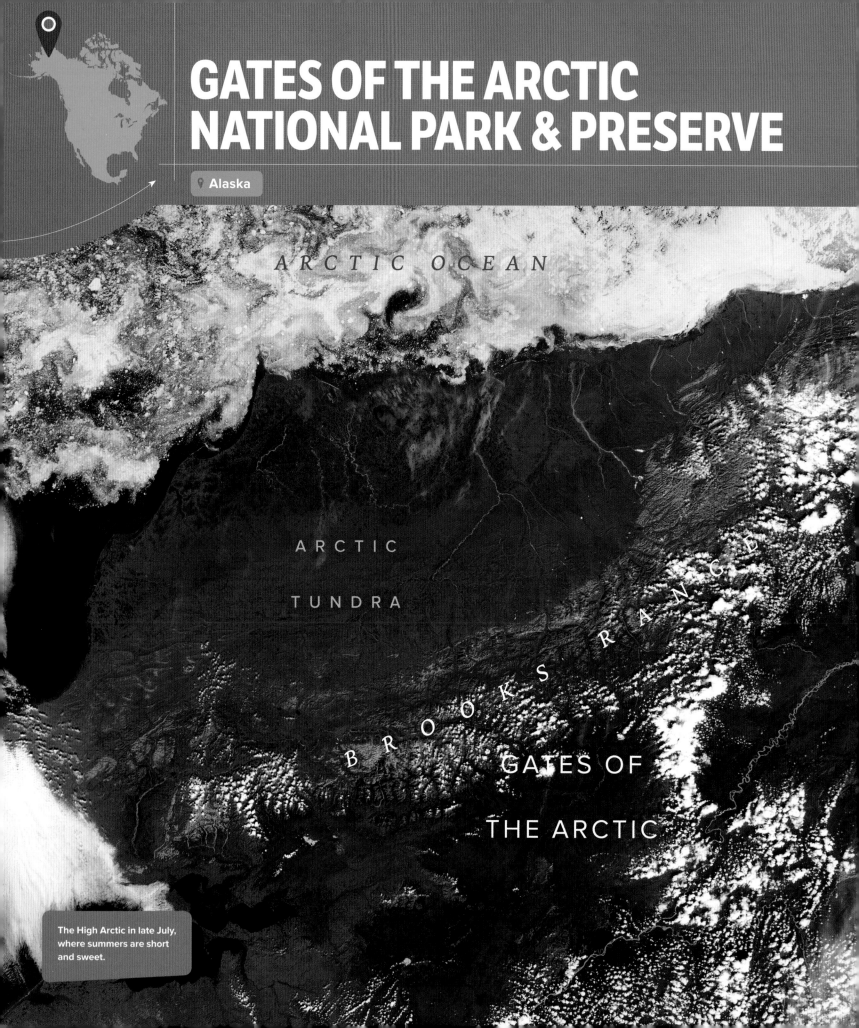

GATES OF THE ARCTIC NATIONAL PARK & PRESERVE

📍 **Alaska**

ARCTIC OCEAN

ARCTIC

TUNDRA

BROOKS RANGE

GATES OF
THE ARCTIC

The High Arctic in late July, where summers are short and sweet.

Brooks Range meets Alaskan tundra in a national park with no roads, no trails

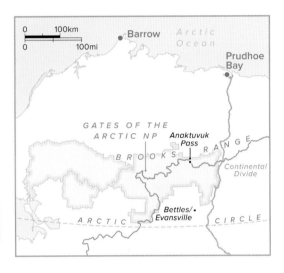

Gates of the Arctic National Park and Preserve is the northernmost national park in North America and it's not a place for a casual visit. With no roads and no trails, this landscape is one of the most remote and untamed places in North America.

The name Gates of the Arctic is apt when the region is viewed from above: the Brooks Range, a major component of the park, presents an impressive wall separating the mountainous country of central Alaska from the rolling hills of the High Arctic tundra. The east-west-running Brooks Range straddles the continental divide for 600 miles. Water from the range's north slopes flows into the Arctic Ocean and runoff from the south slopes finds its way to the Pacific Ocean. On the north side of the range is the Arctic foothills tundra, a hilly, deeply permafrosted region that is home to some of the largest migrating herds of caribou in the world.

The view of this landscape depends on the time of year: snowy, icy winters are long and formidable, with temperatures plunging well below zero for nine months of the year. Summers are brief and busy, as an entire ecosystem of life-forms hurries to breed and raise their young in a few short months. These annual freeze-thaw cycles, along with glacial erosion, have sculpted the Brooks Range into one of Earth's most dramatic landscapes.

A village may seem out of place in this wilderness, but the community of Anaktuvuk Pass, in the northeast area of the park, is home to around 350 people of Nunamiut descent. In fact, people have lived in the region for more than 13,000 years, following the herds of caribou on their annual migrations. This ecozone may have hosted the first humans in North America after their journey from Asia across the Bering Land Bridge.

Just south of the Brooks Range is the Batza Tena obsidian source, an outcrop of volcanic glass that ancient people used to make tools such as knives, arrowheads, and spear points. Each obsidian source has its own unique geochemical signature, enabling geoarchaeologists to trace far-flung individual tools back to their original source. Tools made from Batza Tena obsidian have been found throughout Alaska, transported on foot for hundreds of miles by the seasonally nomadic hunter-gatherers who scraped a harsh existence from this severe environment.

Today, the only ground access into Gates of the Arctic is by way of the Dalton Highway, a primitive unpaved road that runs from Fairbanks, Alaska, up to Prudhoe Bay on the Arctic Ocean and is frequented by large trucks from the oil industry. The highway defines the eastern boundary of Gates of the Arctic National Park and Preserve as it snakes through a pass in the otherwise impenetrable

Brooks Range. From the road, entry into the park is tricky, as there is no bridge over the deep, cold waters of the Middle Fork Koyukuk River, which parallels the highway. This natural barrier means that flying is the most practical way to reach Gates of the Arctic. Hardy visitors who make it to the tiny town of Bettles, just south of the park, can arrange to be dropped off by a small float plane equipped to land on one of the many lakes in the area. ▮

FLIGHT PATTERN

To fly over the Gates of the Arctic National Park and the Brooks Range, you'll need to charter a plane out of Fairbanks or Bettles, Alaska. Look for the impressive mountain range stretching for 600 miles east and west, as well as the expanse of Arctic tundra rolling north toward the Arctic Ocean.

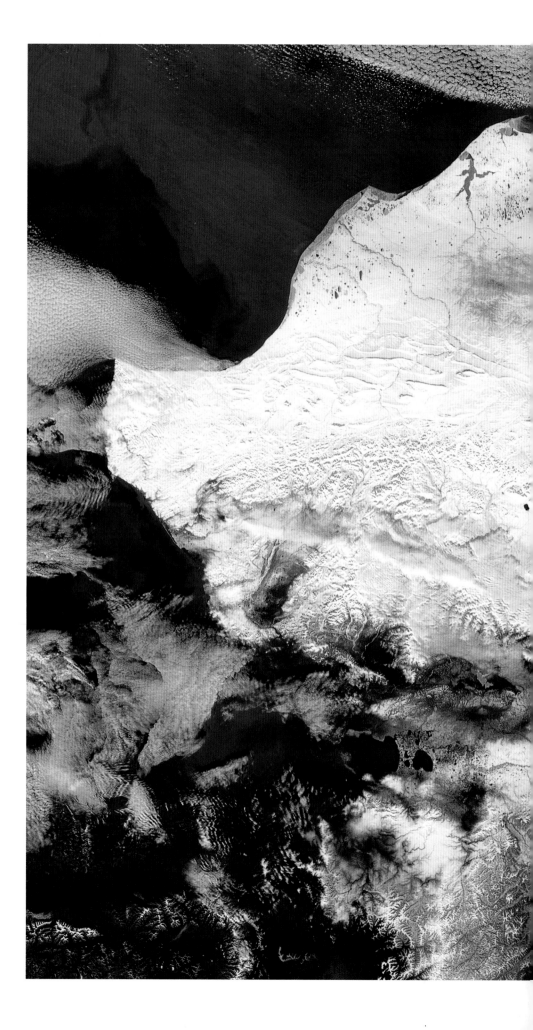

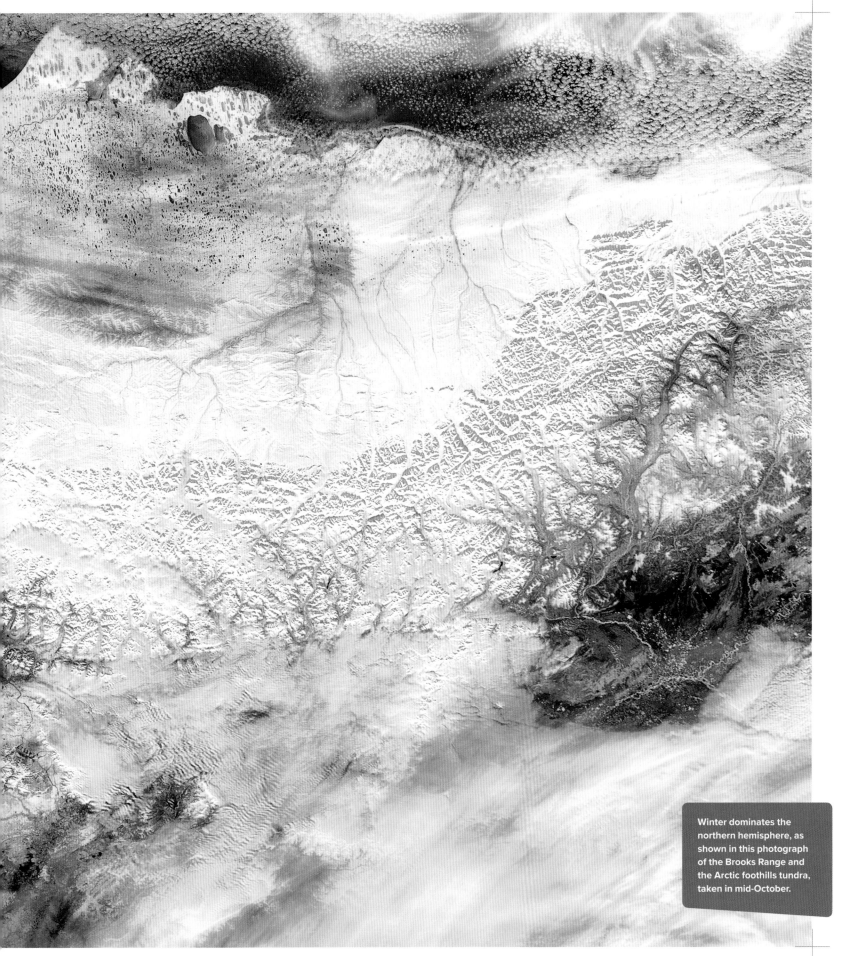

Winter dominates the northern hemisphere, as shown in this photograph of the Brooks Range and the Arctic foothills tundra, taken in mid-October.

BEAR GLACIER

Alaska

An impressive sight from any angle but especially from high overhead, Bear Glacier is the eastern gateway to Kenai Fjords National Park in southern Alaska. From the perspective seen here, the river of ice has flowed downhill for thirteen miles to its terminus in the Bear Glacier Lagoon, a bright blue lake of glacial meltwater separated from the open water of Resurrection Bay in the Gulf of Alaska by a terminal moraine, or ridge of rock deposited by the glacier. A dozen miles upslope to the west lies Bear Glacier's parent, the Harding Icefield, a 300-square-mile mountainous expanse of ice that's one of the largest ice fields in North America.

Glaciers form when snow accumulates at high elevations year after year, compressing into a thick sheet of ice. As this ice gets thicker and heavier, it begins moving downslope under its own weight, grinding and carving the rock at its base on its journey to the ocean. These slow-moving rivers of ice are powerful erosive agents, capable of chiseling entire mountain ranges into broad U-shaped valleys and grinding even the hardest rocks into fine powder.

Moraines are accumulations of debris formed by this glacial movement. From above, it's easy to see that Bear Glacier is adorned with a number of moraines. Lateral moraines are stripes across the glacier's surface, formed from eroded dirt and rocks that gather at the edge. When tributary glaciers join the main flow, as they do upstream in the Harding Icefield, these stripes merge together into medial moraines toward the middle of the merged ice flows. A terminal moraine is a mass of rocks carried to the end of the glacier and left as the toe of the glacier melts and retreats upslope. Terminal moraines mark the historic end of a glacier, before it began melting back to its current location. Bear Glacier's terminal moraine dates back several hundred years, when the

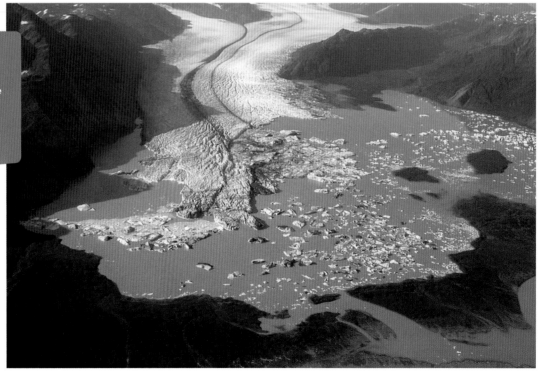

Like many glaciers in Alaska, Bear Glacier is retreating rapidly as a consequence of climate change. Here the glacier and the lagoon are pictured in 2002 (left) and 2007 (right).

Thirteen-mile-long river of ice noted for prominent moraines and accelerated melting

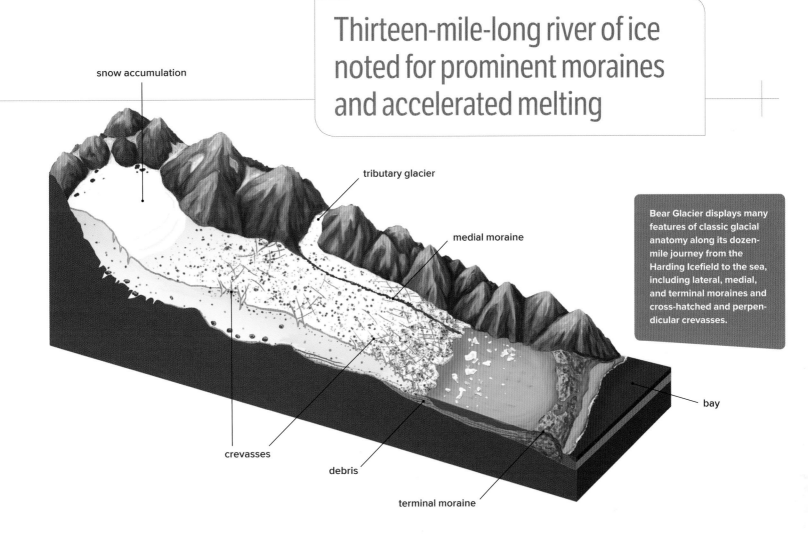

snow accumulation

tributary glacier

medial moraine

crevasses

debris

terminal moraine

bay

Bear Glacier displays many features of classic glacial anatomy along its dozen-mile journey from the Harding Icefield to the sea, including lateral, medial, and terminal moraines and cross-hatched and perpendicular crevasses.

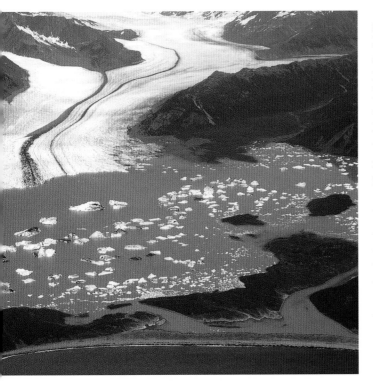

glacier made its way down to Resurrection Bay. During times of increased melting, the waters of the lagoon spill over into the bay, in a glacial lake outburst flood. As overflow sloshes out, the lagoon's water level drops and chunks of ice break off from the toe of the glacier, forming car- and house-sized icebergs that can be seen floating in the lagoon. The lagoon's bright green-blue color results from light bouncing off glacial flour—very finely ground sediments in the water.

Just upstream from the lagoon, the body of Bear Glacier is broken into deep crevasses that crack open as the glacier moves. Crevasses typically open in lines parallel to the downhill direction of glacial movement, but sometimes cracks will also appear running perpendicular to the direction of travel, making a cross-hatch pattern. These deeply crevassed areas most often occur atop rocky outcrops buried deep under the ice. ■

FLIGHT PATTERN

Keep an eye out for a long tongue of a glacier that starts in a massive white ice field and ends just short of the open bay in a bright blue lagoon. You might fly over Bear Glacier en route to Anchorage or Homer, Alaska.

MALASPINA GLACIER

📍 Alaska

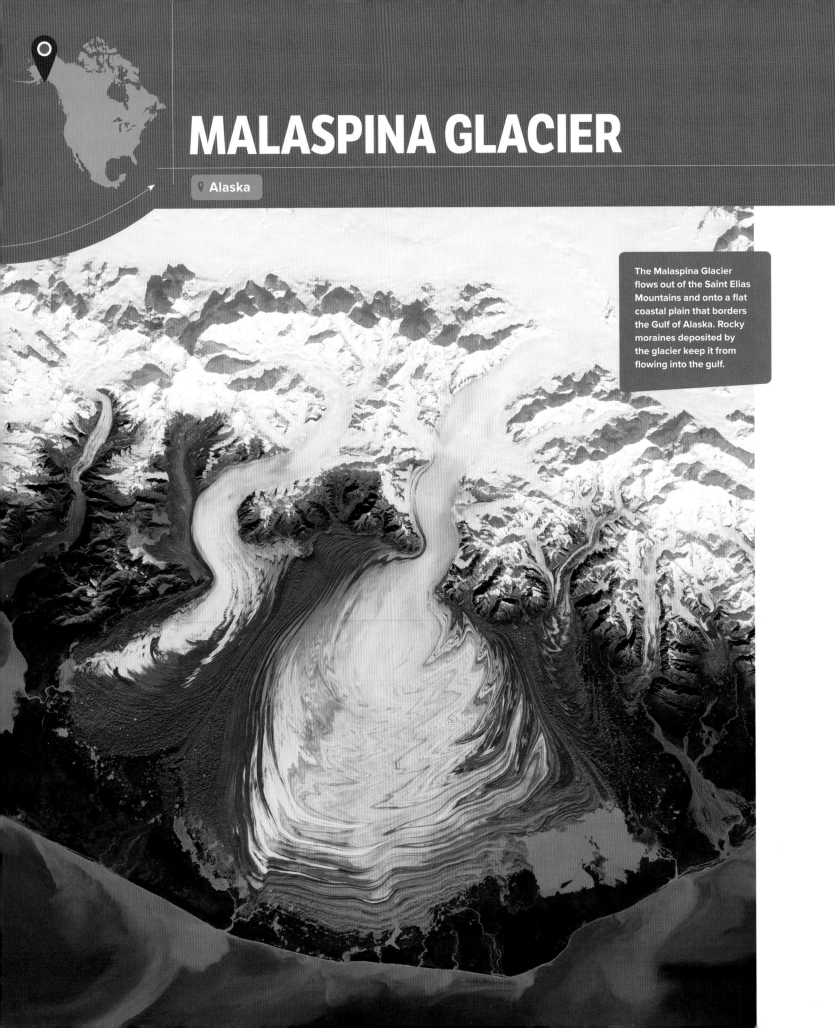

The Malaspina Glacier flows out of the Saint Elias Mountains and onto a flat coastal plain that borders the Gulf of Alaska. Rocky moraines deposited by the glacier keep it from flowing into the gulf.

World's largest piedmont glacier, more than 2000 feet thick

Glaciers may be rivers of ice, but they can take many shapes based on the underlying topography. The Malaspina Glacier in southern Alaska, for example, looks almost perfectly round from above. It is a piedmont glacier, which forms when one or more glaciers spill out onto a relatively flat plain, where they spread laterally, like pancake batter on a grill. The Malaspina is the largest piedmont glacier in the world—bigger than the state of Rhode Island.

This mass of ice covers more than 1500 square miles and is fed by several other glaciers that descend from the Saint Elias Mountains onto the coastal plain between Icy Bay and Yakutat Bay. The edge of the Malaspina comes within a few miles of the Gulf of Alaska, but its terminal moraine of piled-up rocks keeps it from reaching the water.

From the air, you can see wavy, circular, and zigzag patterns across the top of the glacier. The brown lines against the white ice are moraines—rocks, soil, and dust that get scraped up by the glacier as it moves, then are left on top of the ice, usually along the sides of the glacier. When two glaciers come together, these lines of debris merge to form a medial moraine close to the center of the ice.

Glaciers that flow at steady rates tend to have relatively straight moraines, while those that periodically surge because of increased melt or steep changes in topography develop wavy moraines.

These are caused by the folding, shearing, and compression of the ice. The patterns of curves, zigzags, and loops on the Malaspina Glacier are the result of such surges as well as many individual rivers of ice combining into one ice mass on the flat plain.

Measuring the thickness of a glacier isn't a perfect science, but a useful technique involves using seismic waves to create a three-dimensional picture of the interior of the ice. Such studies have shown the Malaspina to be over 2000 feet thick. The ice is so heavy that the bottom of the glacier has sunk nearly 1000 feet below sea level. Long-term studies of the health of the glacier have revealed that the Malaspina lost more than sixty feet of thickness between 1980 and 2000. The meltwater produced from this shrinkage was sufficient to raise global sea levels by half of one percent during that time period. ▪

FLIGHT PATTERN

Look for a large disc-shaped mass of ice on the gulf side of the Saint Elias Mountains, the range across southeastern Alaska and southwestern Canada. You might fly over the Malaspina Glacier en route to Juneau or Anchorage, Alaska, which lie to the southeast and northwest of the glacier, respectively.

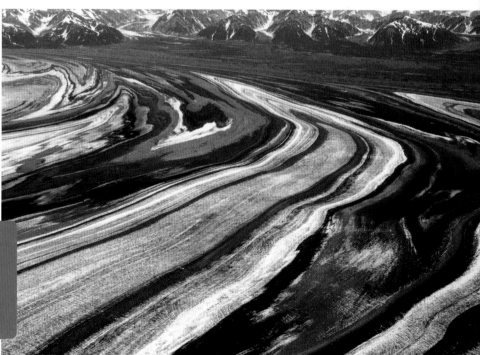

The sinuous patterns in the surface of the Malaspina Glacier are especially complex because of the large number of glaciers that meet to form this huge expanse of ice.

GLACIER BAY

Alaska

The landscape of Glacier Bay, shown here with false-color enhancement, has changed dramatically over the past few hundred years, as a result of climate change. This whole region was once covered in ice.

Glacier Bay's collection of more than 1400 glaciers looks impressive from a satellite view, but 250 years ago, this inlet in the Gulf of Alaska was home to just one gigantic glacier called the Grand Pacific Glacier—a chunk of ice more than 4000 feet thick. An aerial perspective helps highlight the powerful erosive forces produced by millions of years of advancing and retreating glaciers. From the air, the main channel of the bay traces where the imposing body of the Grand Pacific Glacier used to reside. Along the shoreline, dozens of branches, inlets, and lagoons have been carved out by rivers of ice as they've made their way from the mountains down to the sea.

When these sluggish ice flows reach the rela-

Once home to a single monolithic glacier, now a labyrinth of active ice flows

tively warm waters of Glacier Bay, huge chunks of ice calve—break off—from the leading edge of the glacier. These chunks then become icebergs, which can float for years, sometimes presenting a hazard to boats in Glacier Bay. After a magnitude 8.4 earthquake struck the region in 1899, Glacier Bay was closed to ships for nearly a decade in response to the hazards posed by icebergs that were calved during the shaking.

The effects of climate change on ice are undeniable, looking at Glacier Bay. The Grand Pacific Glacier that once covered the entire bay has retreated by more than sixty-five miles in the last few hundred years, to the head of the bay at Tarr Inlet, leaving dozens of separate glaciers in its wake. This retreat is driven by melting ice, as well as increased calving at the leading edge of the glacier, where it meets the open water of the bay. It's interesting to note that despite an overall trend of retreat, many glaciers around Glacier Bay have been advancing in recent years—a result of offshore weather patterns bringing increased snowfall to the Fairweather Range, where many of the glaciers originate.

Accessible only by boat, Glacier Bay National Park is located in the southern Gulf of Alaska, near Juneau. No roads run to the park and only a few trails lead to the interior. On the water, cruise ships and kayaks are met by soaring walls of ice that spill down into the bay. ■

FLIGHT PATTERN

Keep an eye peeled for expansive ice sheets in the inland mountains that flow down toward the Gulf of Alaska. You might fly over Glacier Bay en route to Juneau, Alaska.

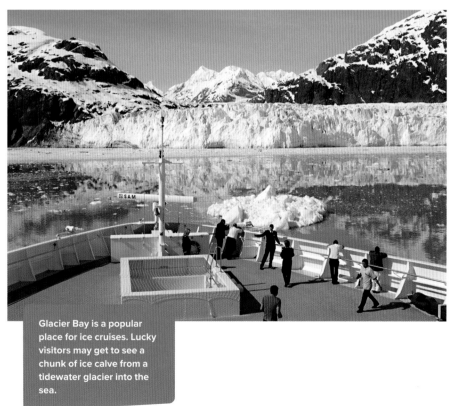

Glacier Bay is a popular place for ice cruises. Lucky visitors may get to see a chunk of ice calve from a tidewater glacier into the sea.

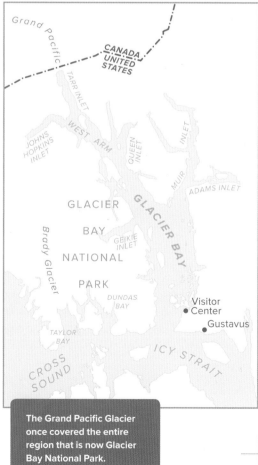

The Grand Pacific Glacier once covered the entire region that is now Glacier Bay National Park.

ALEXANDER ARCHIPELAGO

Alaska

The coastline of British Columbia and southeast Alaska is a maze of more than 1000 islands, inlets, and peninsulas sprinkled throughout the Gulf of Alaska, forming what is called an archipelago. In a satellite image, the deep channels you see dividing the islands from each other and from the mainland hint at a long history of separation. Many of the landmasses here were actually formed near the equator several hundred million years ago, then pushed to their current positions along the coast of North America by plate tectonics during the Jurassic Period, around 200 million years ago. Geologists refer to these as exotic terranes, because they formed elsewhere—in this case, in tropical equatorial seas—and were then transported, eventually becoming part of an existing landmass. During the last ice age, the archipelago's submerged coastal mountains were scoured by glaciers and carved into the puzzle of heavily eroded islands we see today.

The meandering route taken by cruise ships, ferries, and fishing boats through this morass of islands is the Inside Passage, which avoids the hazards of the open ocean and links many otherwise isolated coastal and island villages. The dry land of the islands is literally just the tip of these "icebergs"; when viewed from the seafloor, the islands are actually huge mountains, with only their tops peeking above the waves.

The Inside Passage through the Alexander Archipelago affords ships some protection from storms and big waves, but navigating the confusing and narrow waterways between the islands is not for novices. The closely spaced geometry

Maze of islands, inlets, and peninsulas, with life forms not found elsewhere

of the islands generates strong tides, with up to thirty-foot differences between low and high tides. Many ships have run aground in these waters under the helm of inexperienced pilots who become disoriented by the ever-changing landmarks between tide levels.

Numerous islands in the Alexander Archipelago are accessible only by boat or plane, and the group is so cut off from the mainland that a significant number of the plant and animal species here aren't found anywhere else. This includes the Alexander Archipelago wolf, a smaller subspecies of the gray wolf that thrives on the islands' healthy population of Sitka black-tailed deer. Molecular DNA studies of the Alexander Archipelago wolf indicate that the subspecies has been separated from the mainland gray wolf population for about 8000 years. The first of the island wolves likely migrated on glaciers, which used to link the mainland to the islands before they melted and retreated inland as much as fifty miles. ■

FLIGHT PATTERN

The Alexander Archipelago looks like a web of islands and deep waterways along the southeast coast of the Gulf of Alaska. Look for it on your way to Juneau, Alaska.

ALASKA

BRITISH
COLUMBIA

ALEXANDER

ARCHIPELAGO

GULF

OF

ALASKA

*Inside
Passage*

Until as recently as a few hundred years ago, ice sheets covered much of the Alexander Archipelago. Now the islands and peninsulas are separated by deep water channels.

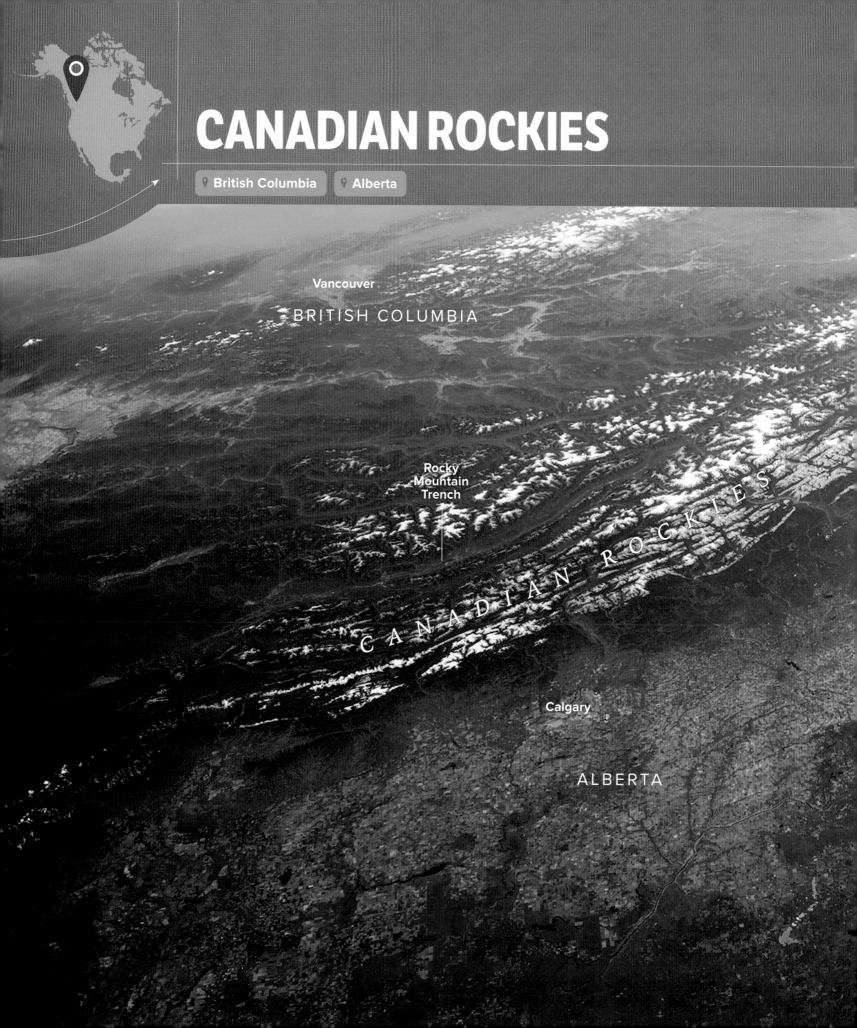

CANADIAN ROCKIES

British Columbia Alberta

Vancouver

BRITISH COLUMBIA

Rocky
Mountain
Trench

CANADIAN ROCKIES

Calgary

ALBERTA

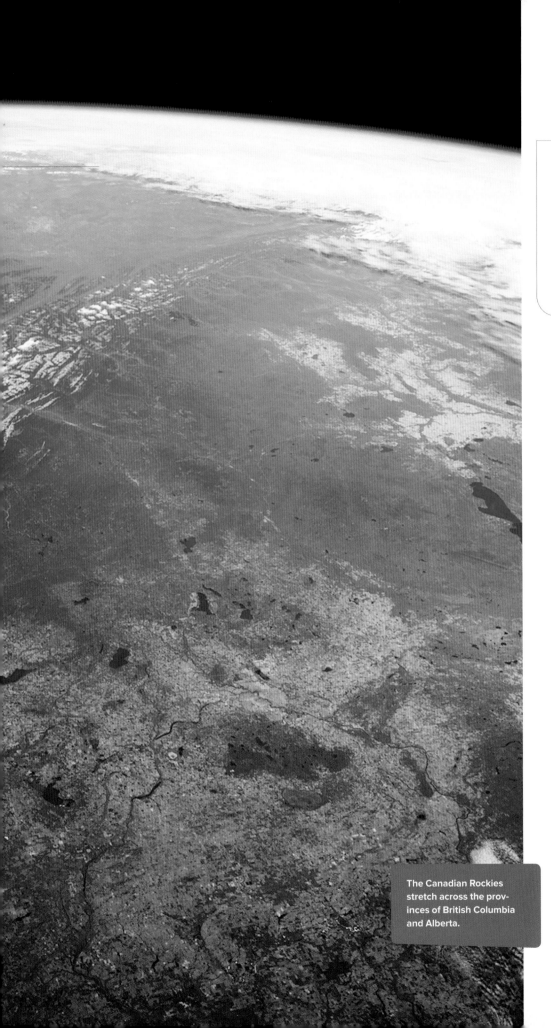

The Canadian Rockies stretch across the provinces of British Columbia and Alberta.

Sheer walls and inaccessible peaks at the north end of famed mountain range

Looking down on western North America, it's easy to locate the Rocky Mountains: the dominant north-south-running mountain range that rises between the Midwestern prairies to the east and the Pacific Ocean to the west. The Canadian Rockies and U.S. Rockies aren't delineated merely by the international border between Canada and the United States. The northern part of the Rocky Mountains has its own unique geology that gives these sheer-walled peaks their distinct character.

The full range of the Rocky Mountains, which stretches from northern British Columbia south into New Mexico, is actually made up of a series of individual mountain ranges, each with different geologic origins. These divisions can get incredibly complicated, but overall, the Rockies can be split into two halves: the Canadian Rockies and the U.S. Rockies, with the dividing line in Glacier National Park in northern Montana. The Canadian range is defined by prairies to the east, the fault-produced valley known as the Rocky Mountain Trench to the west, and the Liard River to the north. North of the Liard River, the range gives way to the Mackenzie Mountains, a range that runs along the border between the Yukon and the Northwest Territories.

The Canadian and U.S. Rockies were uplifted around the same time, but are made up of very different types of rock that erode in distinctive ways. Whereas the U.S. mountains are composed

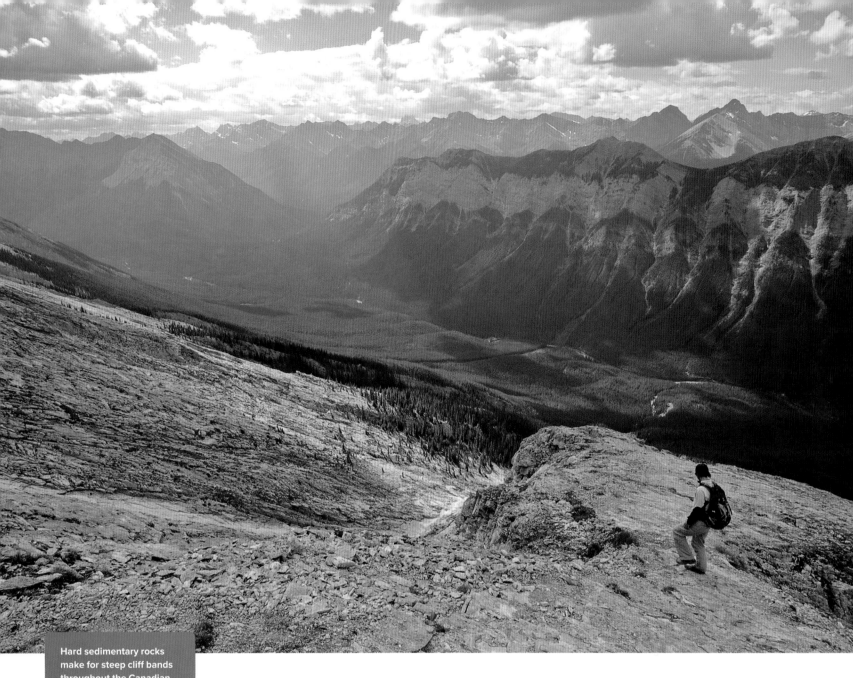

Hard sedimentary rocks make for steep cliff bands throughout the Canadian Rockies, including in the mountains around Banff, Alberta.

of ancient metamorphic and volcanic rocks such as gneiss and rhyolite, the Canadian mountains are made up of mostly sedimentary rock (such as limestone and shale) and metamorphic rock produced during mountain building. Hard sedimentary rocks, deposited in layers millions of years ago (long before they were uplifted into mountains), tend to erode into steep cliffs that make many of the summits in Canada inaccessible to even the most sure-footed mountain goats. Such impressive cliffs stand in contrast to the Colorado Rockies, where trails lead to the tops of the highest fourteeners (mountains with summits over 14,000 feet), all of which are surmountable by any reasonably fit hiker in a good pair of boots.

Because they are farther north, the Canadian Rockies have also been more heavily glaciated than their U.S. counterparts. Broad flows of ice tend to carve U-shaped valleys, with wide, flat floors and steep walls. The U.S. Rockies, however, have been more strongly influenced by the erosive power of running water in the form of rivers, which carve more V-shaped valleys with narrow floors and sloping or terraced walls. ◾

A manmade reservoir called Lake Minnewanka sits in a valley in the Canadian Rockies, northwest of Banff, Alberta.

Lake Minnewanka

Banff
(ALBERTA)

FLIGHT PATTERN

While you can't see the United States–Canadian border from the air, it's hard to miss the Rocky Mountains. You might also be able to spot the Rocky Mountain Trench, a large valley on the range's western front. You could fly over the Canadian Rockies en route to Calgary, Alberta, or Vancouver, British Columbia.

The Canadian and U.S. Rockies were both uplifted during the same mountain-building event, but they are made up of different types of rock: volcanic and metamorphic on the U.S. end and sedimentary and metamorphic in Canada. These varied rock types erode at different rates and in distinctive patterns.

American Rocky Mountains
Rocky Mountain National Park

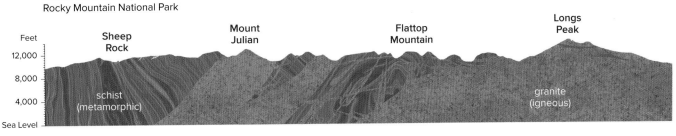

Longs Peak

Flattop Mountain

Mount Julian

Sheep Rock

Feet
12,000
8,000
4,000
Sea Level

schist (metamorphic)

granite (igneous)

0 1 2 3 4 5
Miles

Canadian Rocky Mountains
Banff National Park

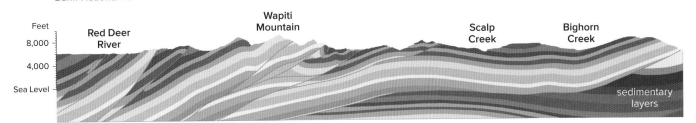

Wapiti Mountain

Scalp Creek

Bighorn Creek

Red Deer River

Feet
8,000
4,000
Sea Level

sedimentary layers

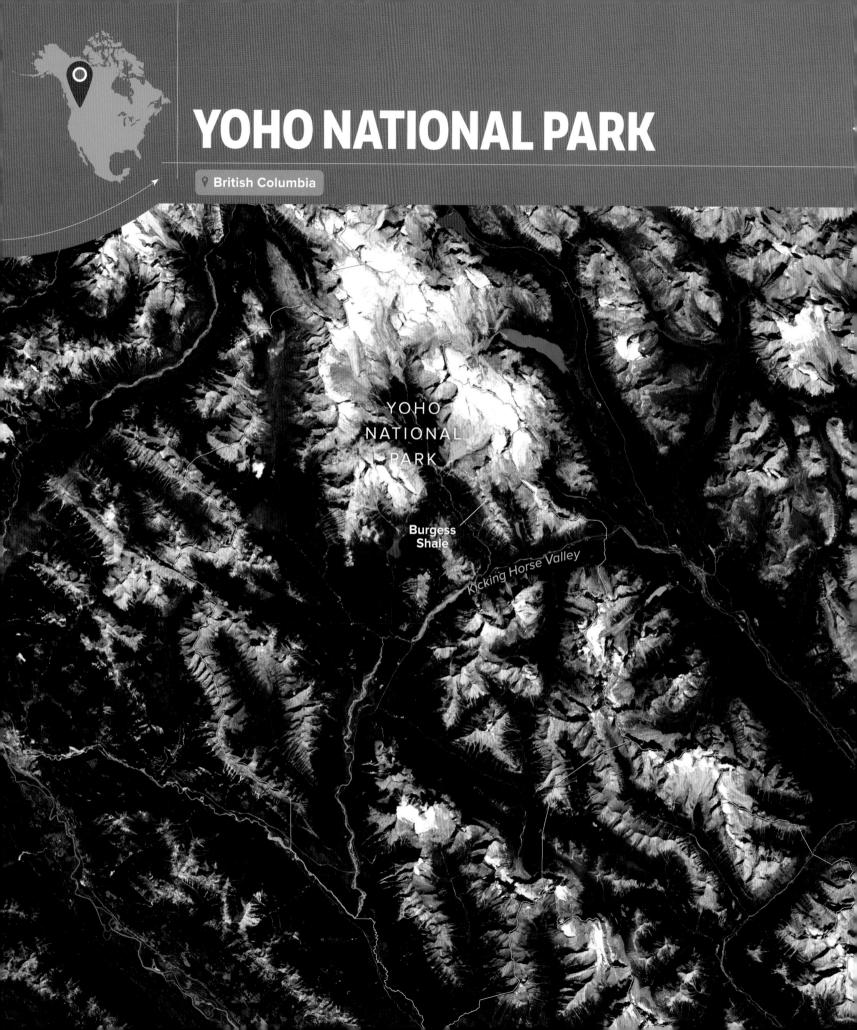

YOHO NATIONAL PARK

📍 British Columbia

YOHO
NATIONAL
PARK

**Burgess
Shale**

Kicking Horse Valley

Celebrated lode of rare fossils, preserved in a perfect geologic cache

Not all geologic treasures can be easily seen from the air. Canada's Yoho National Park, west of Banff on the west side of the Canadian Rockies, doesn't really stand out in the midst of surrounding mountains. You'll have to get much closer to see Yoho's most famous features: rare fossils representing some of the earliest complex life-forms on Earth.

Most fossils are formed from mineralized shells, bones, teeth, and other hard parts of long-dead organisms. But in a few uncommon cases, fossils are found that preserve everything, including seldom-seen soft body parts such as eyes, gills, and even stomachs containing last meals. One of the most famous localities for these extraordinary fossils is the Burgess Shale, on a ridge in Yoho National Park. The fossils found here date back 505 million years, only 65 million years after the planet's first complex life-forms evolved.

Around 570 million years ago, the first multi-cellular life developed in shallow seas. This momentous event was soon followed by the Cambrian Explosion—the rapid evolution of many types of life-forms. Within a few million years, virtually all major phyla (a taxonomical classification of organisms) appeared on the scene, including the early ancestors of vertebrates. The fossils found in the Burgess Shale provide an exquisitely detailed snapshot of this pivotal time in evolution.

Fossilization requires something of a perfect storm. To become a fossil, an organism must avoid predation, scavengers, and decomposition and come to rest in an ideal environment for preservation, most often through rapid burial of the carcass. This layer must then undergo lithification into rock in a way that preserves the delicate structure of the fossil. The rock layer must avoid metamorphosis, compression, and distortion for millions of years. In a lucky happenstance of nature, the Burgess Shale fossils cleared all those hurdles to become some of the most celebrated fossils in all of paleontology.

Cambrian-era soft-bodied fossils are found at a few sites around the world, but the most famous quarries are located in Yoho. When the Canadian Pacific Railway was being built through Kicking

The Walcott Quarry—a fossil-rich, 505-million-year-old slice of ocean floor—is located about midway across this ridgeline in Yoho National Park.

FLIGHT PATTERN

You might fly over Yoho National Park en route to Calgary, Alberta. People are allowed to visit the site on foot, but you must go with a certified guide through Parks Canada or the Burgess Shale Geoscience Foundation.

Horse Valley, workers would occasionally find "stone bugs," which were actually fossilized trilobites, a type of marine arthropod, now extinct. In 1886, one of these fossils made its way to a scientist with the Geological Survey of Canada, who combed the ridges above the valley until he found the source: a trove of trilobite fossils on the side of Mount Stephen, near the town of Field, British Columbia.

Across the river, the Walcott Quarry, discovered in 1909, would become the most famous source for Burgess Shale fossils—over 100,000 specimens have been removed from the site and placed in the Smithsonian Institution in Washington, DC, and the Royal Ontario Museum in Toronto. This famous fossil quarry is only about ten feet high and less than a city block long, capped on either end by metamorphosed rocks that contain no fossils. But despite the quarry's small size and over a century of rigorous excavation, many fossils still remain, waiting to be discovered. ■

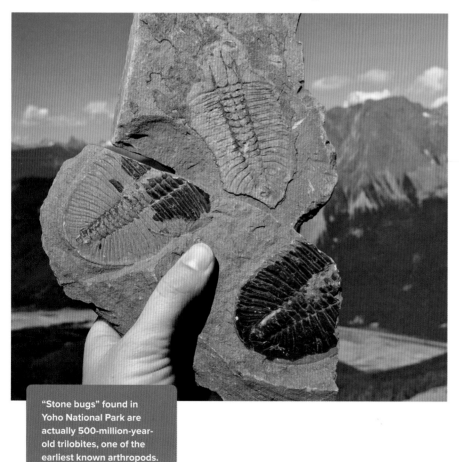

"Stone bugs" found in Yoho National Park are actually 500-million-year-old trilobites, one of the earliest known arthropods.

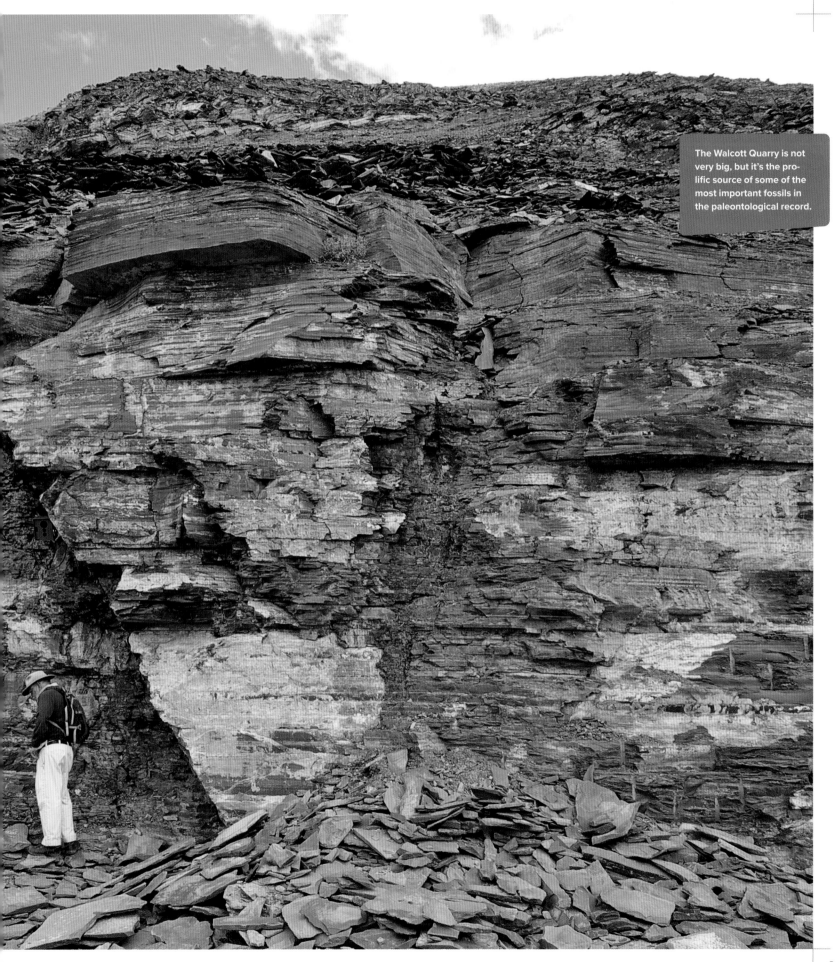

The Walcott Quarry is not very big, but it's the prolific source of some of the most important fossils in the paleontological record.

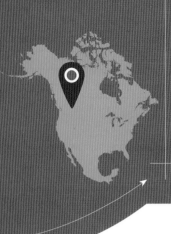

THE BUGABOOS

FLIGHT PATTERN

The Bugaboos' spires are visible in the northwestern extreme of the Purcell Mountains, in southeast British Columbia, perhaps en route to Calgary, Alberta. Calgary is about 150 miles due east of the Provincial Park. Heli-skiing is also popular in the park.

See those gray spires of rock jutting straight up from a snowy expanse southwest of Banff, in the Purcell Mountains of British Columbia? You've just caught sight of the Bugaboos: a strange name for a majestic range of spiky granite peaks.

Dozens of monolithic towers rise thousands of feet above the surrounding glaciated terrain here, the highest of which top out at greater than 11,000 feet of elevation. The rock that makes up these spires is a type of very hard granite called granodiorite that dates to around 135 million years ago. The rock at the base of the spires is much older, up to a billion years old. The spires were born when a granite intrusion called a batholith forced its way up through the older, softer rock, slowly cooling underground and forming the large crystals that make this granite much harder than the surrounding rock. Millions of years of heavy glaciation and erosion then removed the surrounding weaker rock, exposing the spires.

The range is located in the heart of an interior wet belt, a mountainous zone of temperate rainforests and extensive ice fields in British Columbia, where moisture from the Pacific Ocean is released in the form of rain and snow. As much as thirty feet of snow falls here each winter, much of it accumulating year after year as ice that feeds the still-active and growing glaciers of the region.

The Bugaboos may seem an odd name, but it was inspired by back-breaking frustration. The first prospectors to explore this region in the late 1800s found rocks gleaming with gold. But after a minor gold rush to this isolated and rugged region, the gold turned out to be pyrite: fool's gold. In their vexation, the miners christened this place the Bugaboos, a name they used for goldless dead-ends.

A few years later, the Bugaboos would become a mecca for another kind of gold rush. Mountaineers caught wind of the unusual collection of spires, and soon high-alpine experts from all over the world were traveling to the granite wonderland to put up first ascents of the seemingly insurmountable rocks. After hair-raising routes pioneered by famous mountaineers such as Yvon Chouinard (founder of the Patagonia clothing company) started attracting more climbers, the Canadian government established the Bugaboo Glacier Provincial Park and the Bugaboo Alpine Recreational Area to protect the fragile region. ▪

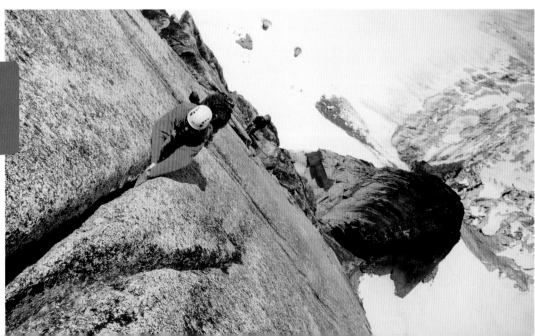

Climbers ascend Snowpatch Spire in the Bugaboos, on Surf's Up, a route requiring nine pitches (nine rope lengths).

Granite towers of billion-year-old rock and thirty feet of annual snowfall

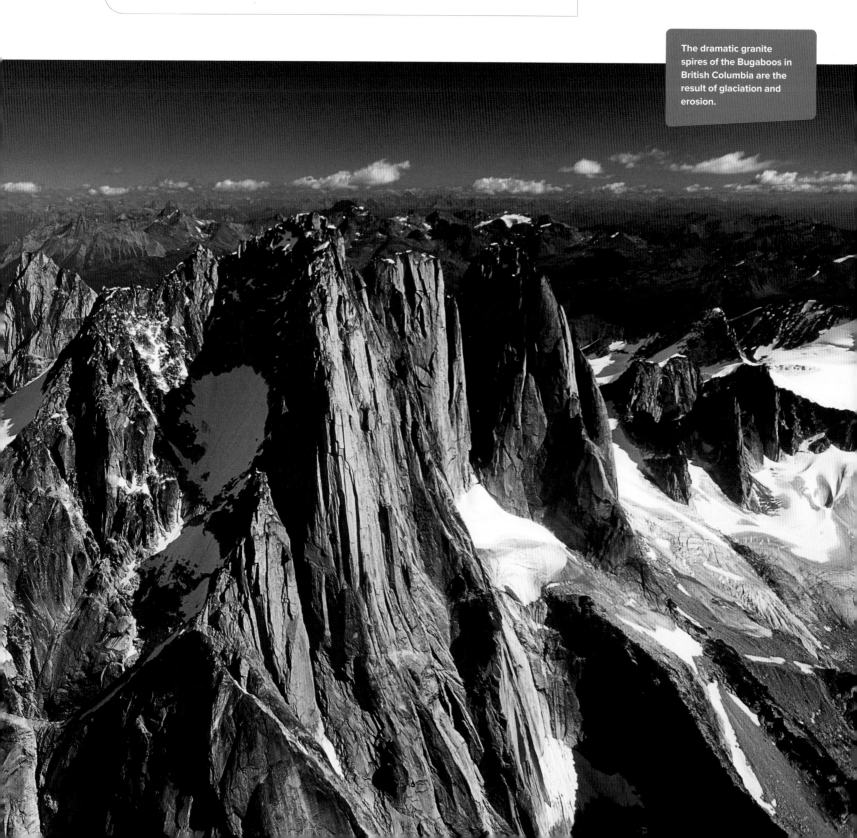

The dramatic granite spires of the Bugaboos in British Columbia are the result of glaciation and erosion.

VANCOUVER ISLAND

📍 British Columbia

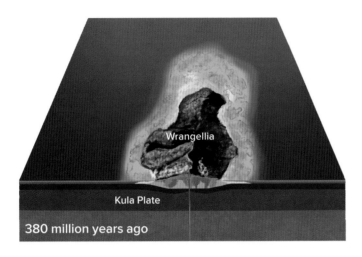

Wrangellia

Kula Plate

380 million years ago

Wrangellia

Kula Plate

North American Plate

100 million years ago

The Pacific Northwest coast of North America has been accreted over millions of years by the addition of exotic terranes formed elsewhere and tacked onto the continent by plate tectonic movements.

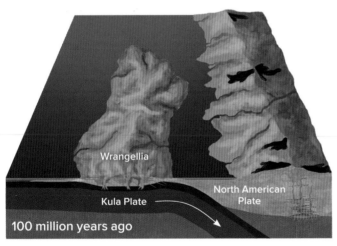

Vancouver Island

Juan de Fuca Plate

exotic terranes

Today

Looking down, just off British Columbia's southwest coast and north of Washington's Olympic Peninsula, you can see a large, elongated, mountainous island: Canada's breathtaking Vancouver Island. While it is one of the largest islands in the Pacific Ocean, the term "Pacific island" tends to conjure up images of remote, tropical paradises—a description that does not match today's Vancouver Island. However, once upon a time, this landmass was indeed situated in the tropics, near the equator.

Around 380 million years ago, the oldest rocks on Vancouver Island were formed by underwater volcanic eruptions that produced piles of basalt near the equator, in what is now the middle of the Pacific Ocean. Later, shells of marine organisms piled up on the basalt layers, forming a thick shelf of limestone, which was then raised above the waves by more volcanism. This landmass, known as Wrangellia, then began drifting slowly northeast on the back of the Kula oceanic plate.

Driven by tectonic forces, Wrangellia and the Kula Plate drifted north and east until around 100 million years ago, when they collided with the west coast of North America. The Kula Plate began subducting under the North American Plate. As the raised topography of Wrangellia butted up against the edge of the North American continent, the landmasses began warping and uplifting un-

Mountainous island's foundation formed near equator then migrated north

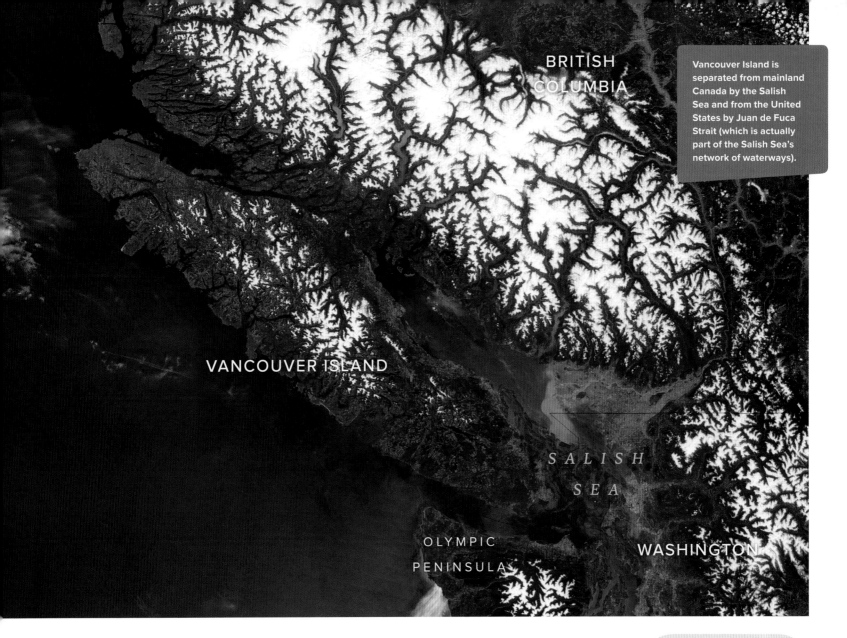

BRITISH
COLUMBIA

VANCOUVER ISLAND

SALISH
SEA

OLYMPIC
PENINSULA

WASHINGTON

Vancouver Island is separated from mainland Canada by the Salish Sea and from the United States by Juan de Fuca Strait (which is actually part of the Salish Sea's network of waterways).

der the tremendous strain, forming the Insular Mountains on Vancouver Island.

Over the next 50 million years, several smaller landmasses collided with Wrangellia and joined the landmass that is now Vancouver Island. More marine basalts, granite, and gneiss were added to the mix of rocks found on the island.

Today, the Kula Plate has completely subducted under the North American Plate, but the strain generated by its descent, plus the ongoing subduction of the Farallon and Juan de Fuca Plates, still occasionally rock the island. On January 26, 1700, the Cascadia megathrust earthquake, with an estimated magnitude of 9.0, struck off the coast of Vancouver Island. In 1946, a magnitude 7.3 quake shook the Forbidden Plateau on the east side of Vancouver Island, the largest on-land quake to strike Canada in recorded history. Such quakes have left a record

of landslides and collapsed mountain summits across Vancouver Island, adding more complexity to the island's mishmash of geologic layers.

Not all plate movement under Vancouver Island is violent, however. Sometimes creep along plate boundaries occurs imperceptibly, in the form of episodic tremors and aseismic slip events. This "quiet quake" phenomenon was discovered in the early 2000s on Vancouver Island, after geoscientists at the Geological Survey of Canada noticed GPS signals were shifting on the island without accompanying earthquake activity. They found a two-week-long episode of tremors too small to be detected by most instruments. The tremors produced smooth movement along the plate boundary that in a not-so-smooth scenario would have been equivalent to a magnitude 7 earthquake. But there was no shaking or damage. ◼

FLIGHT PATTERN

The large, heavily forested island, with snow in winter atop its interior mountains, is nestled close to British Columbia's southwest shoreline and Washington's northwest corner. Flights to Vancouver, British Columbia, or Seattle, Washington, may offer aerial views.

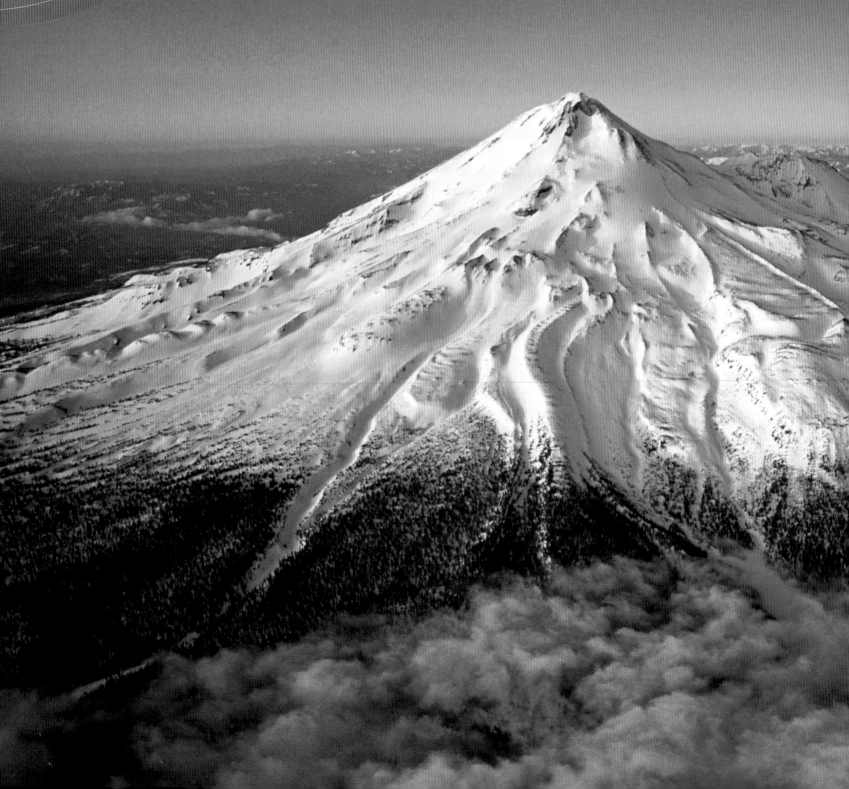

CASCADE VOLCANOES

📍 British Columbia | 📍 Washington | 📍 Oregon | 📍 California

Inland arc of volcanoes traces offshore subduction zone

At 14,179 feet, Mount Shasta is the second-tallest peak in the Cascades, after Mount Rainier.

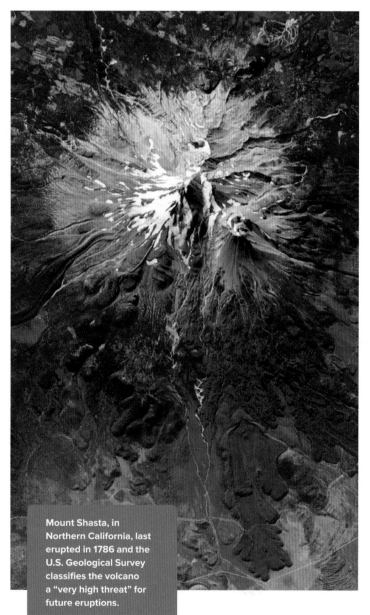

Mount Shasta, in Northern California, last erupted in 1786 and the U.S. Geological Survey classifies the volcano a "very high threat" for future eruptions.

Standing alone and snow-crowned, towering thousands of feet above the surrounding landscape, the volcanoes of the Cascade Range are among the most imposing singular mountains on Earth. This line of eighteen volcanoes—including Mount Baker, Mount Rainier, Mount Saint Helens, Mount Hood, and Mount Shasta—forms an arc over 700 miles long, running from the Silverthrone Caldera in southwestern British Columbia to Lassen Peak in Northern California. Seen from the air, the linear relationship of the peaks marching down the landscape hints at their geological connection to each other.

The volcanic arc parallels the 700-mile-long Cascadia Subduction Zone, fifty miles off the Pacific coast, where the Juan de Fuca, Explorer, and Gorda Plates are diving under the North American Plate at a rate of just under half an inch per year. These forces generate tremendous earthquakes as well as the stratovolcanoes of the Cascade Range—conical formations built up by many layers of hardened lava, pumice, and volcanic ash. In addition to more than 4000 stratovolcanoes, the Cascadia forces have also spawned shield volcanoes, volcanic vents, cinder cones, and lava domes several hundred miles inland from the subduction zone.

Subduction zones such as Cascadia produce volcanoes as a result of water releasing and partial melting of the down-going and overlying plates. As the Juan de Fuca, Explorer, and Gorda Plates are driven down into the asthenosphere—the upper layer of the planet's mantle—increasing heat and pressure melts some of the rock and releases the water trapped in the down-going plate. As this water rises, it triggers partial melting of the rocks making up the overriding plate. This hot, buoyant melt rises to the surface, and collects in magma chambers underlying the volcanoes. When these

magma chambers reach a crucial tipping point, the volcanoes may erupt, such as during the 1914–21 eruption of Mount Lassen and the 1980 eruption of Mount Saint Helens.

Volcanism along this arc started around 37 million years ago, but the mountains we know today began developing around 7 million years ago, with the highest peaks growing to their present-day statures over the last 100,000 years. In the last 2,000 years, the Cascade Volcanoes have erupted over a hundred times, with seven of the peaks erupting in the past two centuries. Magma, erupted as viscous lava, is only one of the potential hazards. Hot, searing ash in the form of pyroclastic flows can also spread rapidly, devastating forests and killing any living thing in the way. Lahars—highly mobile mudflows of volcanic ash and debris—can flow downhill for miles, blocking rivers and causing downstream flooding.

From the air, the aftereffects of these repeated eruptions can be seen surrounding the main vent of each volcano, with a wide swath of devastation extending outward from the volcano in a circular pattern, forming the characteristic stratovolcano cone. Pyroclastic flows and lahars tend to follow natural drainage systems down the flanks of the volcano, creating rocky tongues of debris. ∎

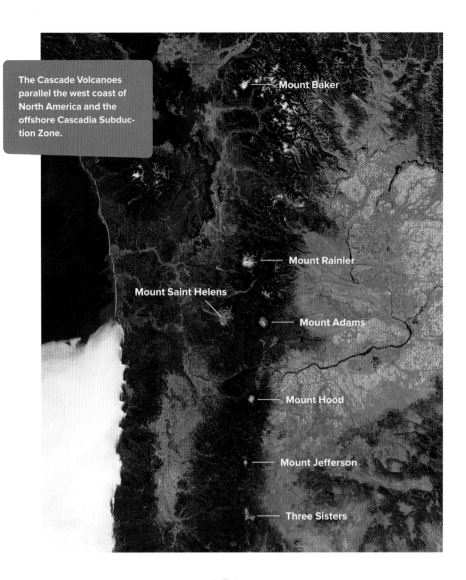

The Cascade Volcanoes parallel the west coast of North America and the offshore Cascadia Subduction Zone.

Mount Baker
Mount Rainier
Mount Saint Helens
Mount Adams
Mount Hood
Mount Jefferson
Three Sisters

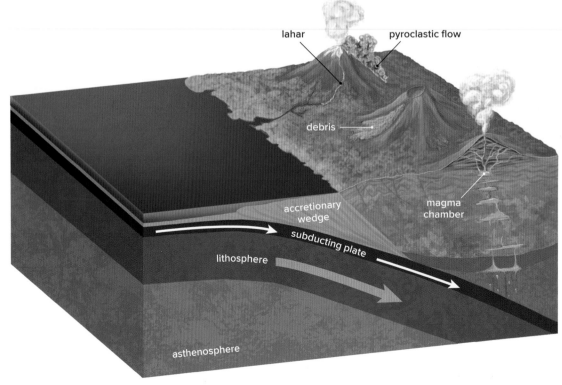

Stratovolcano chains form parallel to subduction zones when water released from the down-going plate triggers melting of the overlying plate and the molten material rises to the surface, fueling volcanic activity, such as seen in the Cascade Volcanoes.

lahar pyroclastic flow

debris

accretionary wedge

magma chamber

subducting plate

lithosphere

asthenosphere

The crater of Mount Hood is still active, with ongoing gas seeps and hot rocks that jut above the snow. To summit the volcano, climbers must scale the often unstable and dangerous crater wall.

FLIGHT PATTERN

Several of the Cascade Volcanoes sit near major population centers, including Mount Rainier near Seattle, Washington, and Mount Adams, Mount Saint Helens, and Mount Hood near Portland, Oregon. Look for the large, conical snowcapped mountains in a rough north-south line that parallels the Pacific Northwest coast.

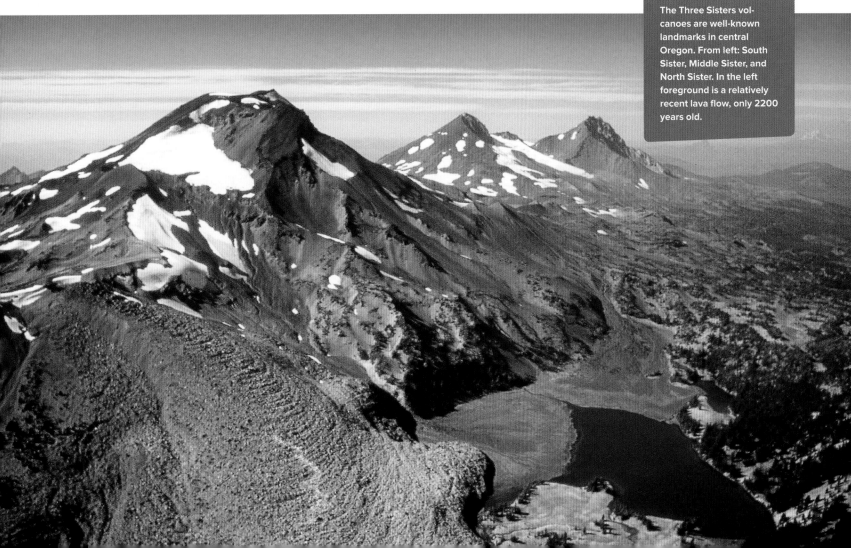

The Three Sisters volcanoes are well-known landmarks in central Oregon. From left: South Sister, Middle Sister, and North Sister. In the left foreground is a relatively recent lava flow, only 2200 years old.

OLYMPIC PENINSULA

📍 Washington

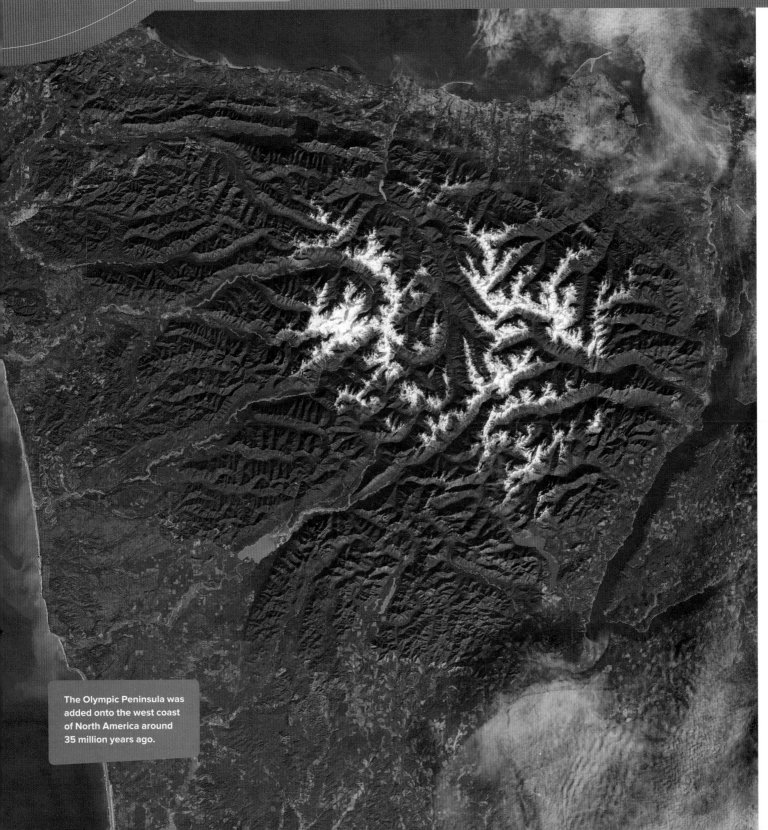

The Olympic Peninsula was added onto the west coast of North America around 35 million years ago.

If the box-shaped peninsula you see from high over northwest Washington State looks tacked on to the edge of the continent, it's because it was. Plate tectonics created the western edge of North America over millions of years, periodically adding chunks of land that were once separate from the main landmass. One of the best examples of this accretionary process is the Olympic Peninsula, which was connected to the Pacific Northwest coast around 35 million years ago.

The creation of the peninsula started with the eastward movement of the oceanic Farallon Plate, which was eventually subducted under the continental North American Plate. As the Farallon Plate was shoved underneath the overriding plate, some of the Farallon Plate was scraped off by the edge of the North American Plate, where it piled up and jammed against the edge of the continent. This created a dome of seafloor material that would later be uplifted and carved by glaciers into the snowcapped Olympic Mountains you can see from the air, in the middle of the peninsula.

Thus, these mountains—the highest is Mount Olympus, at 7962 feet—are actually composed of rocks that once sat on the floor of the Pacific Ocean. The material is volcanic basalt that weathers into crumbly, dark rock. And it weathers a lot: the western slopes of the peninsula are the wettest place in the United States, receiving in excess of seventy feet of snow and twelve feet of rain each year.

All that moisture feeds more than 180 existing glaciers within the boundaries of Olympic National Park, which covers a majority of the peninsula's interior. The largest ice mass is Blue Glacier on Mount Olympus, which covers just under two square miles of rough alpine terrain, over 900 feet thick. The Olympics receive a lot of moisture, but the Olympic glaciers are still shrinking at an alarming rate, because of higher year-round temperatures. The Blue Glacier has shrunk nearly a mile in length since the 1800s and the ice is 200 feet thinner. In 2009, an updated glacier inventory found that Olympic National Park had 184 glaciers, down from 266 in 1982. If you had flown over the peninsula in the late 1970s and again in 2009, you would have seen a 34 percent loss of ice in just thirty years.

At lower elevations, wet conditions have also spawned a moss-covered temperate rainforest—one of the rarest biomes on Earth. Temperate rainforests once thrived from southern Oregon to southeast Alaska, but they now exist in North America only in a few protected pockets like this one. A unique adventure in the Olympics involves hiking from the Pacific Ocean through a rainforest to a glacier: The Hoh River Trail runs for eighteen miles along the glacier-fed Hoh River up to its headwaters at the Blue Glacier, in the shadow of Mount Olympus. ▪

Glacier-rich outlier that attached to continent 35 million years ago

FLIGHT PATTERN

Look for the snowcapped Olympic Mountains flanked by lush green rainforest, on a boxy piece of land surrounded by ocean and inner waterways, in the northwest corner of Washington. You may fly over the Olympic Peninsula en route to Seattle, Washington; Portland, Oregon; or Vancouver, BC.

Clear-cuts mar the view across Olympic National Park, toward Mount Olympus, the highest summit in the background.

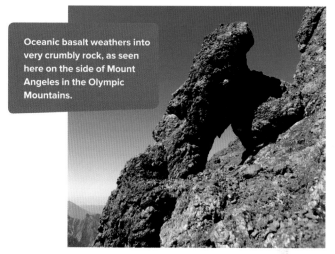

Oceanic basalt weathers into very crumbly rock, as seen here on the side of Mount Angeles in the Olympic Mountains.

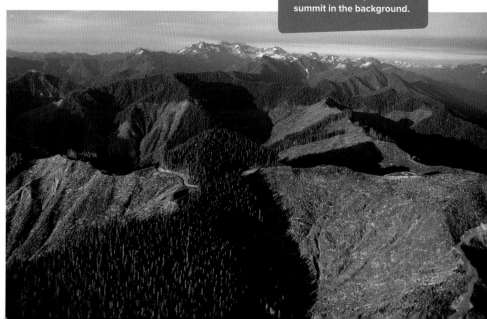

MOUNT SAINT HELENS

On May 18, 1980, Mount Saint Helens in Washington State blew its top in the largest volcanic eruption to strike the lower forty-eight states since the 1915 eruption of Mount Lassen in California. The eruption was categorized a 5 on the Volcanic Explosivity Index—on par with infamously destructive eruptions such as Mount Vesuvius in Rome in AD 79 and Mount Fuji in Japan in 1707.

Decades after cataclysmic eruption, still North America's most restless stratovolcano

To those who flew over the mountain before its eruption, and have seen it from the air since, the sight is a sobering lesson that not all geologic activity occurs over millennia. Geologic time truly includes right now.

In the months leading up to the blast, Mount Saint Helens showed signs of reawakening from a 123-year nap, including a series of escalating small earthquakes and episodes of steam venting from a newly formed summit crater. On the morning of the eruption, at 8:32:17 a.m., a magnitude 4.2 earthquake set off a rock slide that snowballed into a catastrophic, world-record-setting landslide down the north face of the volcano. When the weight of the rock lifted off the underlying magma chamber, the change in internal pressure triggered an eruption. The resulting blast was so powerful that older rock ejected from the depths of the

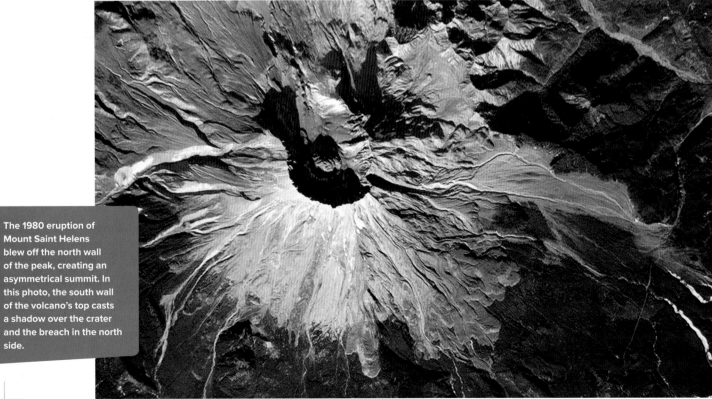

The 1980 eruption of Mount Saint Helens blew off the north wall of the peak, creating an asymmetrical summit. In this photo, the south wall of the volcano's top casts a shadow over the crater and the breach in the north side.

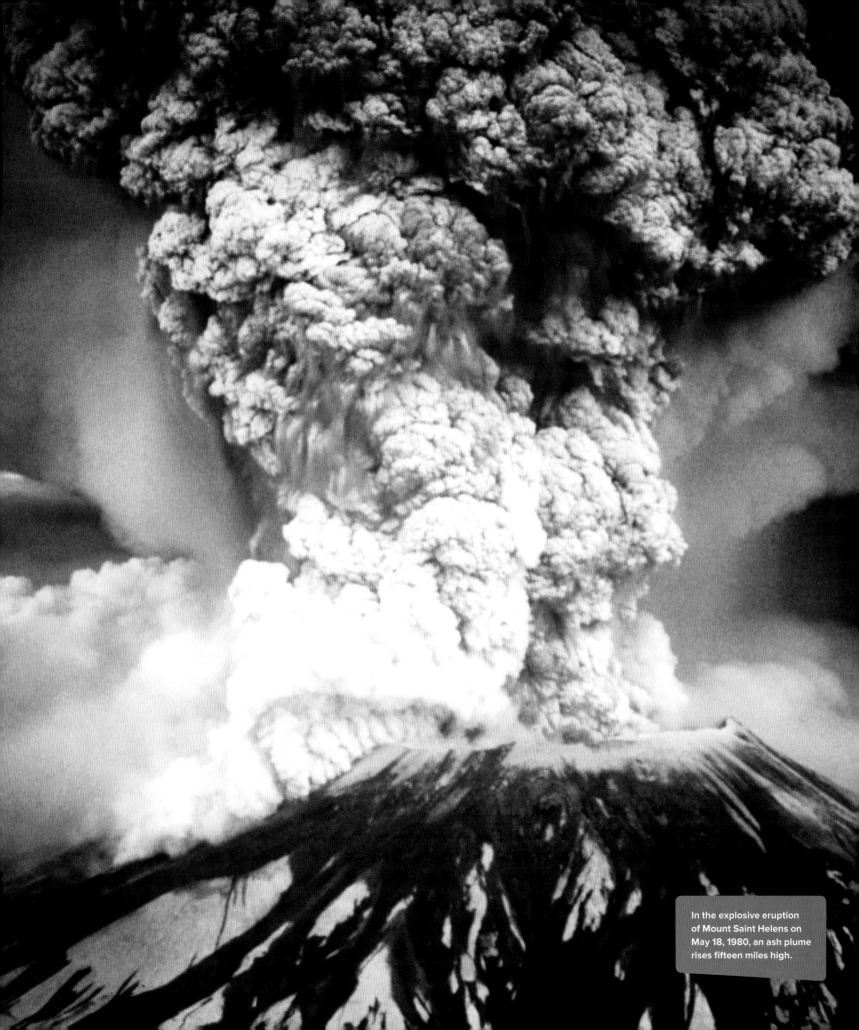

In the explosive eruption of Mount Saint Helens on May 18, 1980, an ash plume rises fifteen miles high.

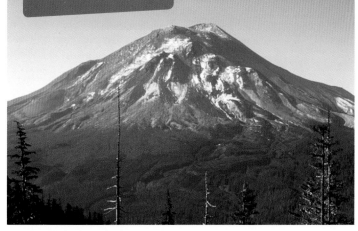

Mount Saint Helens, one day before its eruption May 18, 1980 (left), and from the same vantage point two years later (right). In the later image, steam and gases escape from a post-eruption lava dome that has formed inside the crater.

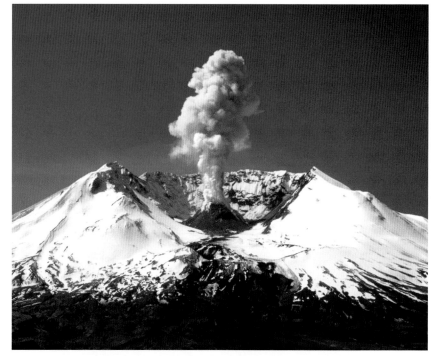

1972

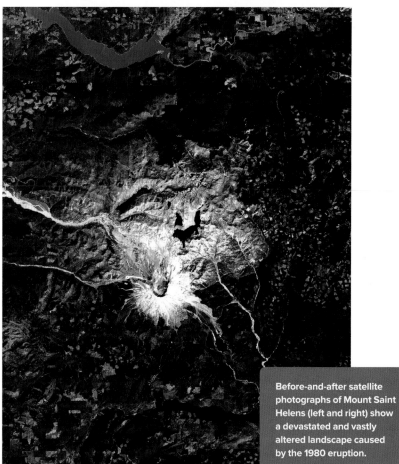

1999

Before-and-after satellite photographs of Mount Saint Helens (left and right) show a devastated and vastly altered landscape caused by the 1980 eruption.

volcano overtook younger rocks still avalanching off the flanks, depositing a huge amount of mixed material from the north face of Mount Saint Helens into Spirit Lake, a large lake north of the mountain.

Once started, the event quickly evolved into a Plinian eruption, one similar to the eruption that devastated Mount Vesuvius. This type of event is characterized by explosive, powerful plumes of ash and volcanic material. In under ten minutes, the column of ash and super-heated gas from Mount Saint Helens rose to a height of more than fifteen miles above the volcano's summit. The column eventually transported ash across eleven states, as far away as Oklahoma. Heat generated by the eruption melted snow, ice, and glaciers on the summit and flanks of the volcano, and the resulting meltwater mixed with ash and debris to form multiple, highly mobile mudflows or lahars. These lahars moved at speeds up to ninety miles per hour and one traveled as far as the Columbia River, fifty miles to the southwest. Searing hot gases spewed out laterally from the blast zone, incinerating everything in a nineteen-mile radius from the volcano and leaving a ring of devastation that is still recovering.

The volcano continued to erupt over the next few days, followed by smaller blasts over the next year, before going quiet again. The disaster left fifty-seven people dead and millions of acres of forests reduced to scorched wasteland. In the years following the eruption, Mount Saint Helens National Volcanic Monument was created for scientists to study the process of ecological recovery and for the public to visit the site of the historic eruption.

Today, nearly four decades later, intermittent swarms of earthquakes and a dynamic landscape inside the crater serve as constant reminders that this is still very much an active volcano. Lava domes have formed and settled over the years, and recently two giant magma chambers were discovered below the surface, one three to seven miles down and the other seven to twenty-four miles deep. Geologists around the world keep a close and wary eye on the not-so-saintly behavior of North America's most restless stratovolcano. ▣

FLIGHT PATTERN

You might catch a glimpse of Mount Saint Helens en route to Portland, Oregon, or Seattle, Washington. From the air, the pattern of the eruption on the north side of the volcano is striking, with the entire north wall of the summit blown out, creating a mammoth crater where the side of the mountain used to be.

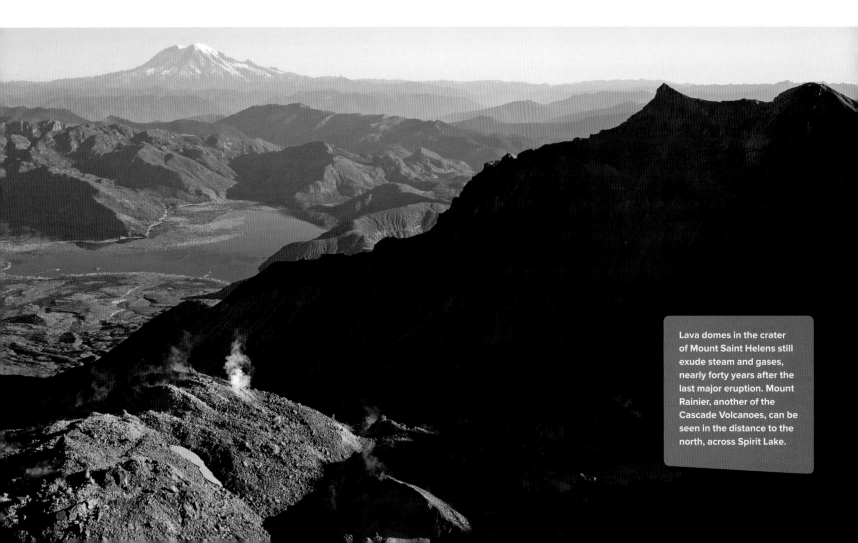

Lava domes in the crater of Mount Saint Helens still exude steam and gases, nearly forty years after the last major eruption. Mount Rainier, another of the Cascade Volcanoes, can be seen in the distance to the north, across Spirit Lake.

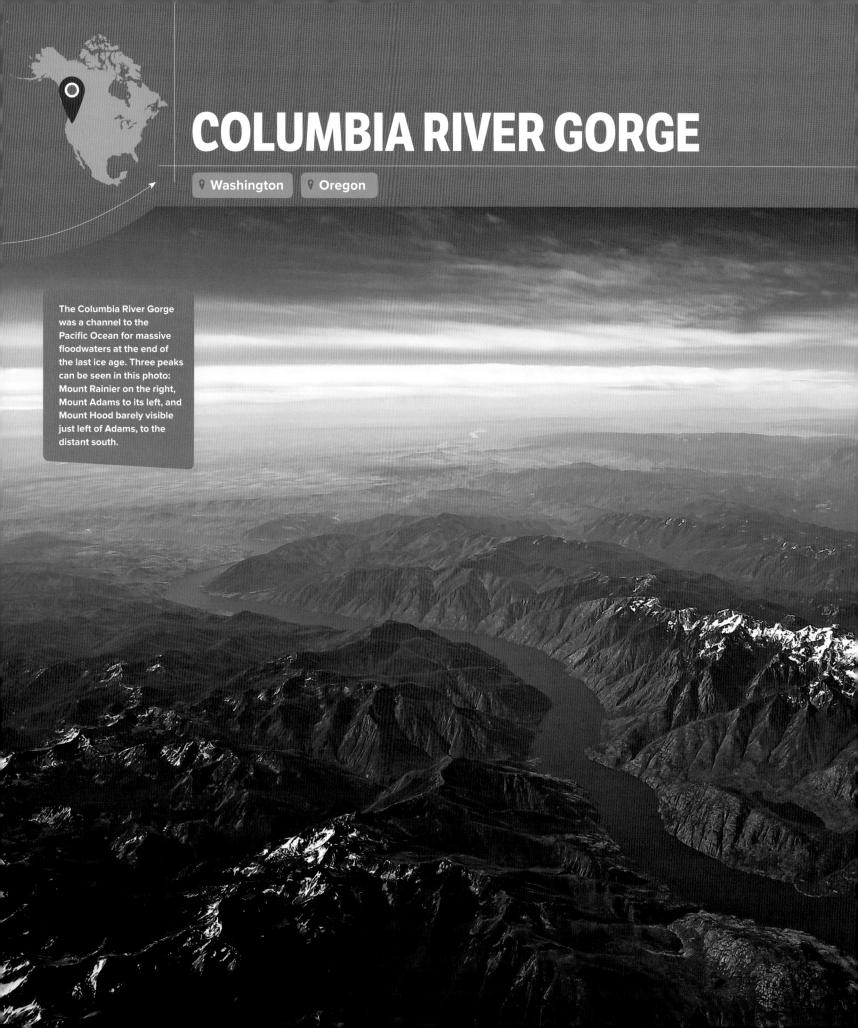

COLUMBIA RIVER GORGE

📍 Washington 📍 Oregon

The Columbia River Gorge was a channel to the Pacific Ocean for massive floodwaters at the end of the last ice age. Three peaks can be seen in this photo: Mount Rainier on the right, Mount Adams to its left, and Mount Hood barely visible just left of Adams, to the distant south.

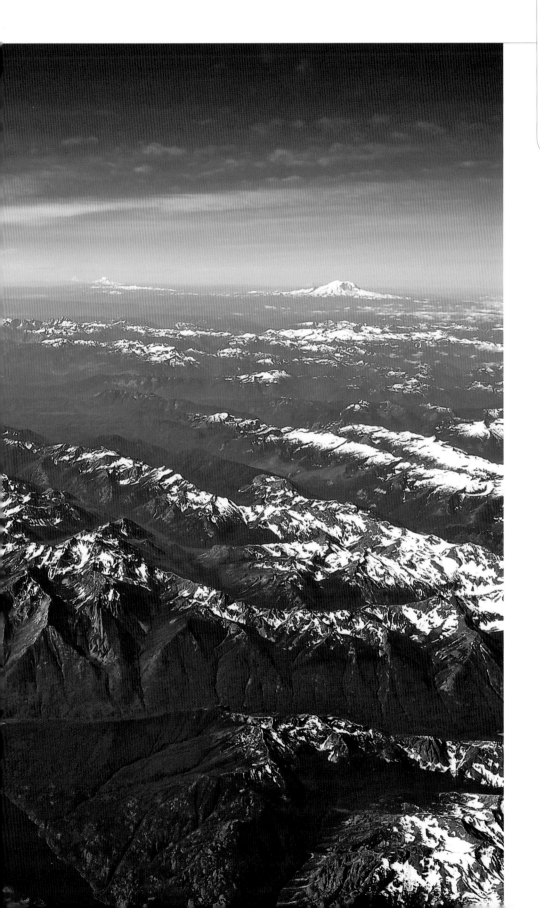

Formed by repeated superfloods carrying up to twenty times the water of the Amazon

For centuries, travelers via land and river have followed this eighty-mile-long canyon that makes up much of the border between Oregon and Washington. Today, air passengers flying into Portland, Oregon, or Seattle, Washington, get an especially telling view of the enormous conduit that is the Columbia River Gorge. But while the gorge has transported people and goods for centuries and is today home to a major interstate, thousands of years ago this canyon was an expressway for superfloods.

The gorge began forming during the Miocene Epoch, between 17 and 12 million years ago, not long after widespread volcanic eruptions covered this part of North America with thick layers of basalt. Around 7 million years ago, the formation of the Cascade Range volcanoes in Oregon and Washington increased rainfall in the region, further chiseling the canyon system into the underlying volcanic rock.

But the most significant carving of the Columbia River Gorge came later, toward the end of the last ice age, when a series of catastrophic floods released near what is now Missoula, Montana, swept across eastern Washington, through the Columbia River Gorge, to the Pacific Ocean. These flooding events, the Glacial Lake Missoula floods, were triggered by periodic ruptures of an ice dam on the Clark Fork River in Montana. When intact, the ice dam held back the waters of Glacial Lake Missoula. Melting at the end of the last ice age led to cataclysmic ruptures at least several times between 15,000 and 13,000 years ago.

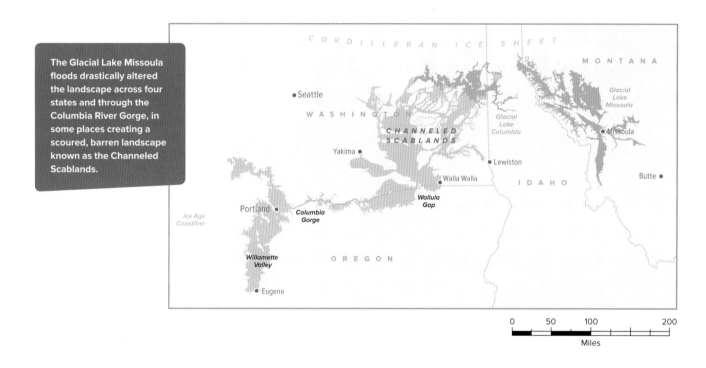

The Glacial Lake Missoula floods drastically altered the landscape across four states and through the Columbia River Gorge, in some places creating a scoured, barren landscape known as the Channeled Scablands.

FLIGHT PATTERN

Look for a deep gorge and a wide river running east and west before it turns sharply north near Portland, Oregon, and west again near Longview, Washington, on flights to and from Portland, Oregon.

The largest of these floods discharged more than twenty times the amount of water that flows in the Amazon River—all at once. At times, flow rates were as high as a hundred miles per hour, with enough force to carry house-sized boulders for many miles downstream. Geologists are unsure how many of these floods occurred, but evidence for as many as sixty separate flooding events has been uncovered in eastern Washington.

The impact of these floods on the Columbia River Gorge is hard to fathom. Before the floods, the now 4000-foot-deep canyon would have been less of a gorge and more of a river valley. By some estimates, more than fifty cubic miles of rock was carried downriver. Piles of loose rock topping 400 feet, carried by the floods, still sit on the banks of the river. Submerged debris fields from the floods can be seen on the seafloor of the Pacific Ocean, extending hundreds of miles offshore from the mouth of the Columbia.

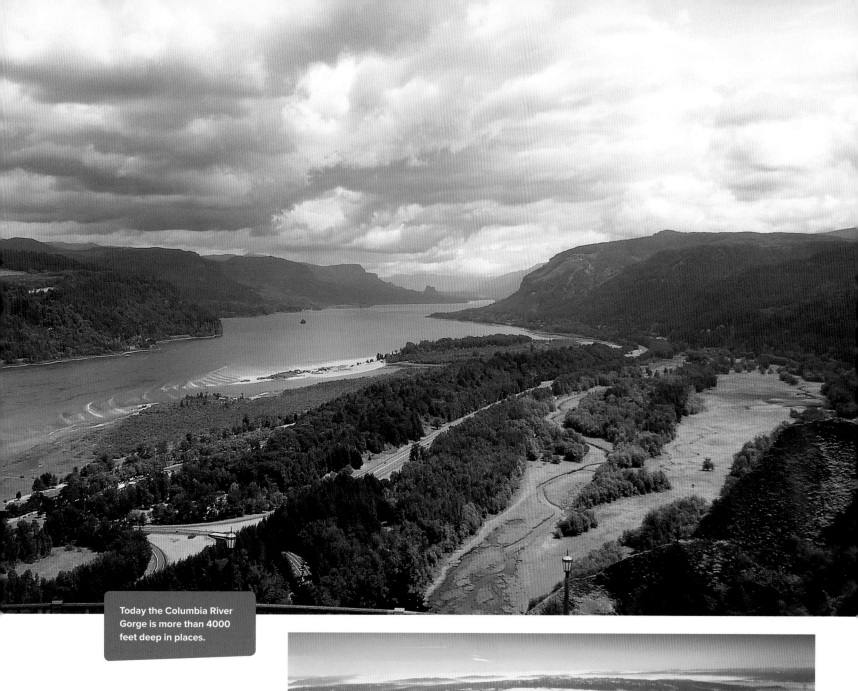

Today the Columbia River Gorge is more than 4000 feet deep in places.

As evidenced by numerous feeder canyons, a huge network of rivers and streams drains into the Columbia River.

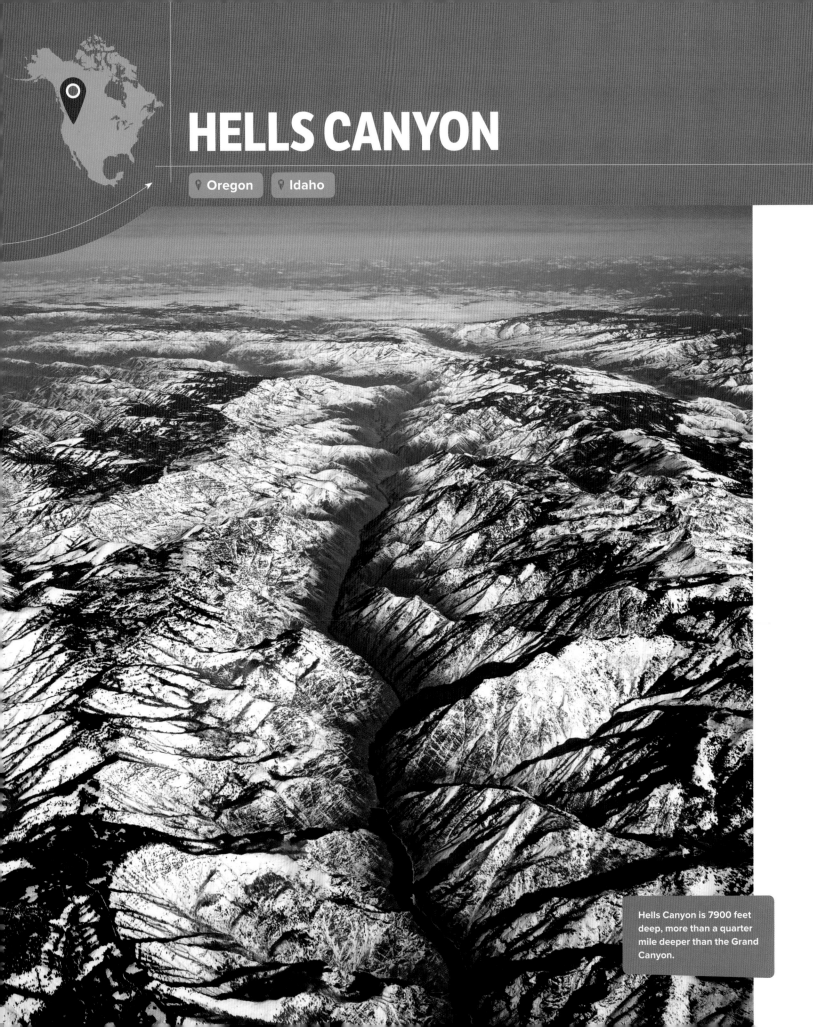

HELLS CANYON

Oregon Idaho

Hells Canyon is 7900 feet deep, more than a quarter mile deeper than the Grand Canyon.

North America's deepest canyon, site of the second-largest flood in history

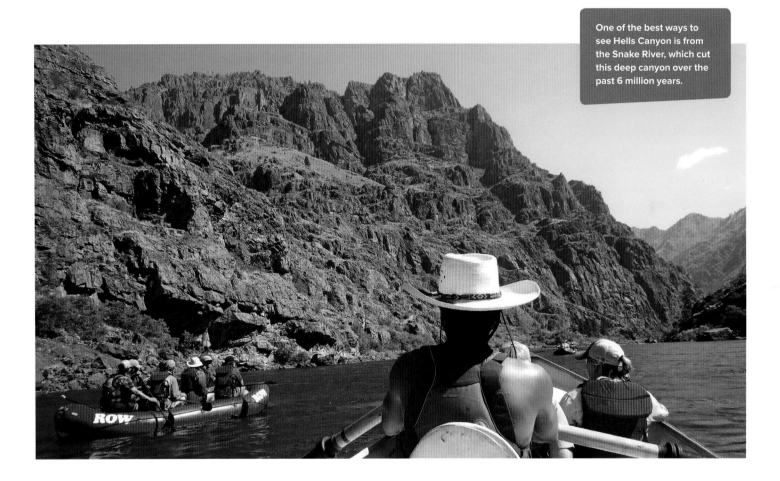

One of the best ways to see Hells Canyon is from the Snake River, which cut this deep canyon over the past 6 million years.

The Grand Canyon is the most famous canyon in North America, but it's not the deepest. That distinction goes to Hells Canyon, a 7900-foot-deep chasm on the border between Oregon and Idaho. From high above, it looks like a narrow rip through layers of jagged, dark rock. The rocks that make up the walls of Hells Canyon have a diverse geologic history that includes tectonic crashes, large-scale volcanism, and catastrophic floods.

Between 130 million and 17 million years ago, a series of tectonically driven collisions with offshore landmasses and islands helped build the west coast of North America. This time period was also punctuated by vigorous volcanic activity in what is now the Pacific Northwest, including Oregon, Idaho, and Montana. The tremendous flood basalts produced by these widespread eruptions resulted in volcanic flows so thick, they formed a high plateau called the Columbia River Basalt Group. Around 6 million years ago, the Snake River changed course and began cutting down into this plateau, forming Hells Canyon. Originally, the river ran south, but at some point, uplifting tectonic forces tipped the flow of the river toward the north. Most of the canyon carving took place

FLIGHT PATTERN

The narrow gouge in the terrain that is Hells Canyon can be seen on flights to Lewiston or Boise, Idaho. The canyon creates a portion of the border between Idaho and Oregon.

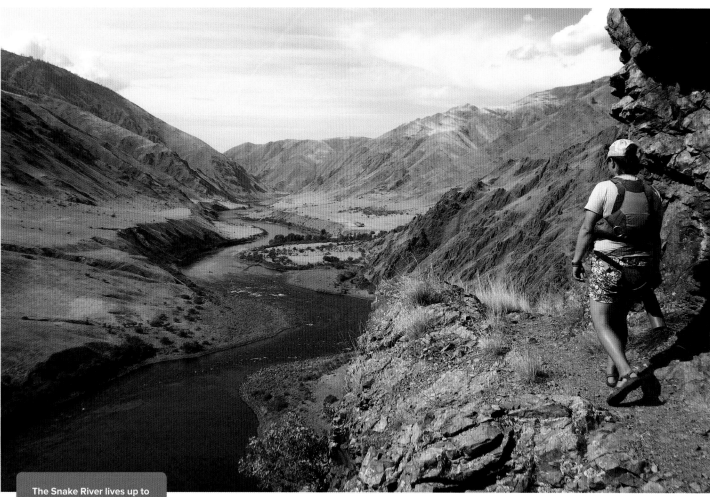

The Snake River lives up to its sinuous name through the deep gorge of Hells Canyon. The benches above the river were carved out all at once by the Lake Bonneville flood, around 14,500 years ago.

over the last 2 million years, a result of melting glaciers and most recently because of a single catastrophic event, the Lake Bonneville flood.

Some 30,000 years ago, Lake Bonneville covered a huge region in the vicinity of Utah's Great Salt Lake. Around 14,500 years ago, geological activity caused the lake to take on waters from a redirected river, raising Lake Bonneville's water level to the point that it topped a natural dam at Red Rock Pass in what is now eastern Idaho. The resulting megaflood is the second-largest flood in the geologic record; more than 15 million cubic feet per second of water poured over the Snake River Plain at speeds up to seventy miles per hour. When this wall of water reached the already deep and narrow Hells Canyon, the erosive hydrologic power significantly increased the size of the canyon, creating the impressive passage we see today.

The canyon's oldest rocks are exposed in the northern stretches of the canyon, where the Snake River has cut deeper into the geologic layers, revealing 300-million-year-old volcanic rocks that originally erupted at the bottom of the Pacific Ocean. Younger coral reefs built on top of these volcanic layers are seen in the middle stretches of the canyon, where steep gray limestone walls line the river. Also exposed are remnants of the islands that had earlier collided with and helped build the west coast of North America. ◾

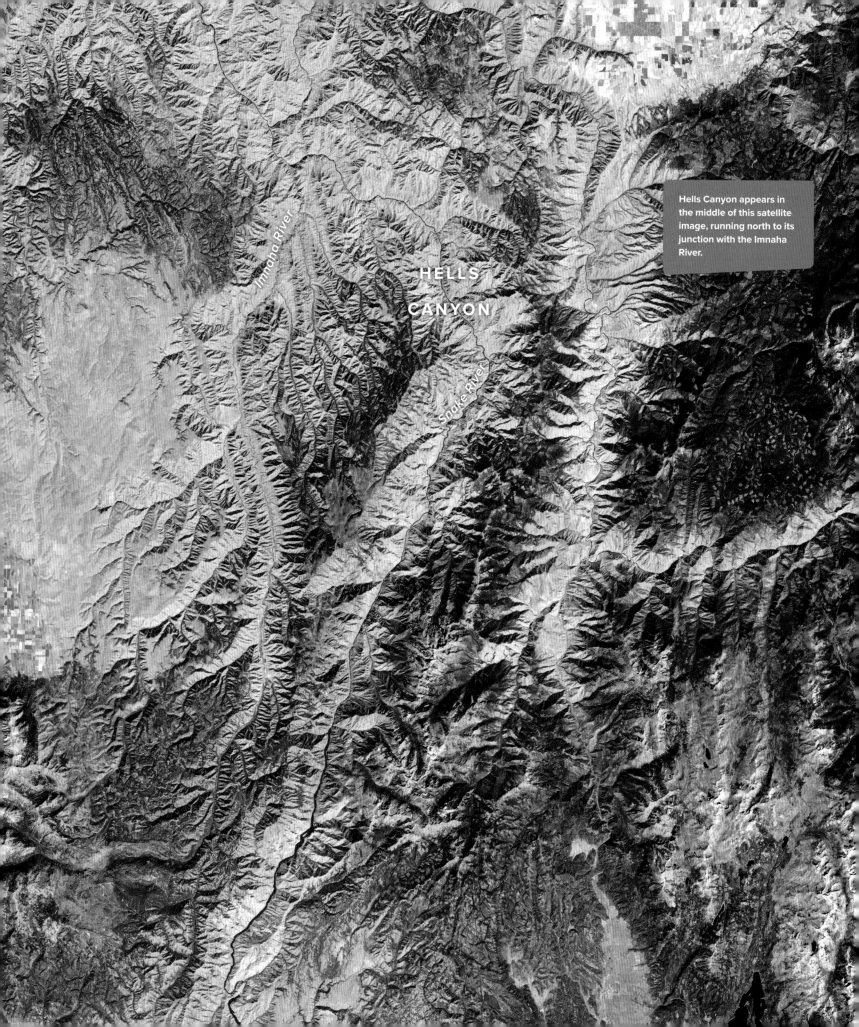

Imnaha River

HELLS

CANYON

Snake River

Hells Canyon appears in the middle of this satellite image, running north to its junction with the Imnaha River.

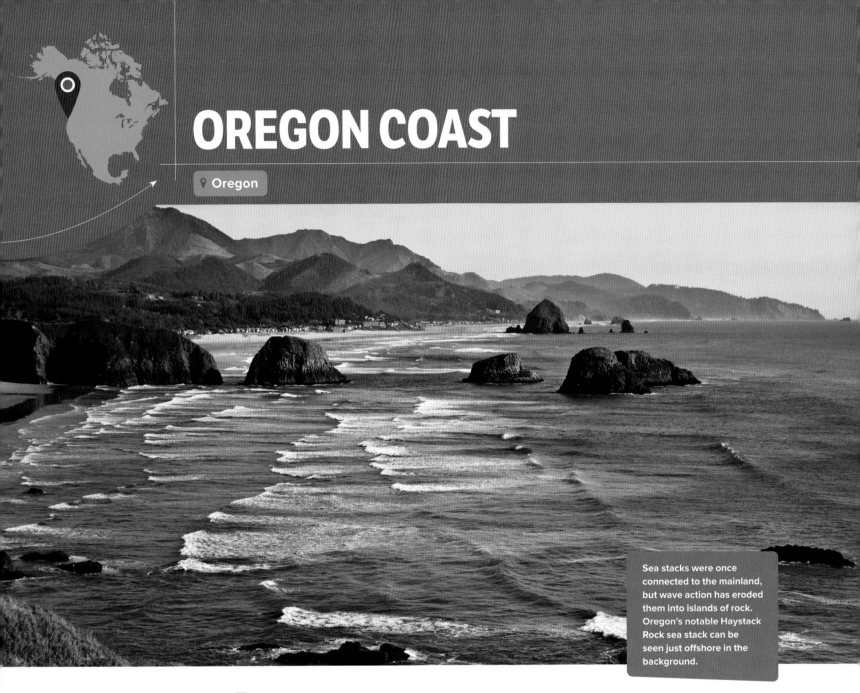

OREGON COAST

Oregon

Sea stacks were once connected to the mainland, but wave action has eroded them into islands of rock. Oregon's notable Haystack Rock sea stack can be seen just offshore in the background.

FLIGHT PATTERN

It's not hard to know when you're flying over the Oregon coast, perhaps on flights from or to Portland, Oregon. From the air, the steep cliffs and dark basalt formations are apparent along the beaches and underwater, just offshore.

As anyone who has followed the Oregon coast in an airplane knows, this isn't an extended shoreline of sun-drenched sand and tropical waters. Unlike the East Coast, where the edge of the continent drops off gradually, making for flat beaches and shallow waters, the continental shelf on the West Coast falls precipitously just offshore, creating cold seas and rough surf. Oregon's coast in particular is defined by sheer dropoffs, soaring bluffs, and stone-strewn beaches—a fascinating 363 miles of continental fringe between California and Washington.

Starting around 66 million years ago, Oregon's coast got very rugged when copious undersea volcanic activity began creating offshore islands. Over millions of years, many of these islands collided with and were connected to the coastline by plate tectonic movements, in an accretionary process that has added to landmasses throughout geologic time. This series of collisions created the Coast Range that runs for 200 miles from the Columbia River in the north to the Coquille River in southern Oregon. Some of the mountains rise to heights exceeding 3500 feet—an abrupt change in elevation from the summits down to the Pacific Ocean.

Later, basalt flows from volcanic eruptions in northern and eastern Oregon would find their

The abrupt edge of a continent, defined by volcanism and far-traveling lava flows

Low tide exposes wave-carved basalt rocks near Cape Perpetua on the Oregon coast.

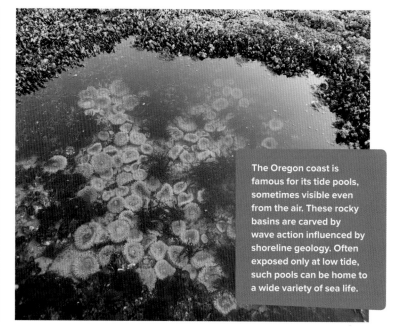

The Oregon coast is famous for its tide pools, sometimes visible even from the air. These rocky basins are carved by wave action influenced by shoreline geology. Often exposed only at low tide, such pools can be home to a wide variety of sea life.

way to the coast, adding to the jagged topography of the coastline. By 10 million years ago, this volcanism had waned and since then, wind and waves have been carving the coast into the cliffs and beaches we see today. The entire coastline of Oregon is designated as public land and is open to anybody, at any time, as long as the tides are favorable.

From the air, some of the most unique features of the Oregon coast are sea stacks: rocky outcrops that were once onshore formations but have been eroded and are now freestanding pinnacles of rock near the shoreline. The most famous of these is Haystack Rock, near Cannon Beach, a 325-foot high basalt monolith formed from lava flows that erupted in eastern Oregon's Blue Mountains around 15 million years ago. ▪

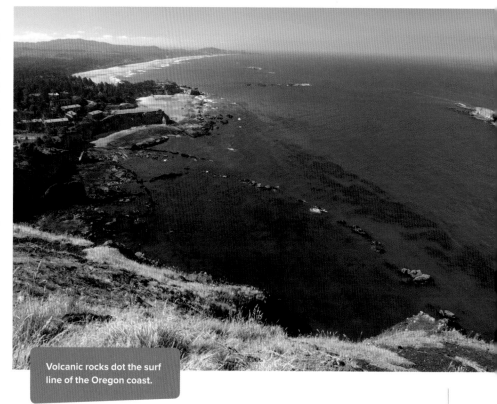

Volcanic rocks dot the surf line of the Oregon coast.

CRATER LAKE

Ash from the long-ago eruption of Mount Mazama blanketed the Pacific Northwest, dwarfing the fall zone from the 1980 eruption of Mount Saint Helens. A layer of ash that dates to around 7700 years ago can still be found throughout the Crater Lake region.

FLIGHT PATTERN

Look for the round, brilliant blue lake in southern Oregon, in line with the rest of the Cascade Volcanoes. You might fly over Crater Lake on West Coast routes heading north or south.

Seen from high in the sky, Crater Lake in southern Oregon is a bright blue circle surrounded by steep crater walls; it is famous for being one of the world's deepest, clearest lakes. Ten thousand years ago, however, the scenery was very different. Mount Mazama, a majestic, 12,000-foot volcano similar in stature to Mount Hood, graced the spot. Around 7700 years ago, the volcano erupted, collapsing in on itself in one of the world's greatest geologic catastrophes.

The eruption of Mount Mazama was cataclysmic: in a matter of days, the volcano ejected more than twelve cubic miles of pyroclastic ash and pumice, over fifty times the amount of debris ejected by Mount Saint Helens during its 1980 eruption. The debris field was immense. Layers of ash and pumice blanketed the land to the northeast, far into central Canada. The volume of erupted magma left an unstable void in the magma chamber under the mountain and soon after the eruption, the volcano collapsed, creating a crater 4000 feet deep and six miles across.

Over the next 250 years, rain and snowmelt filled the crater, establishing Crater Lake. To this day, no rivers run into the crater and the lake is filled entirely by rain and snow. The lake is nearly 2000 feet deep—the deepest in the United States and the tenth deepest in the world. Because of the lack of sediments and pollution in the lake, water clarity is exceptional, with clear views down well over a hundred feet. Crater Lake National Park is the only national park in Oregon—testimony to the site's beauty and geological significance.

If you're not flying too high, two islands can be seen in the lake: Wizard Island, a cinder cone that formed from a smaller eruption at the west end of the lake sometime after it filled with water, and Phantom Ship, a small jagged feature on the lake's south side that is made up of spires of andesite. The rocks that make up Phantom Ship are some of the oldest rocks in the crater, suggesting they may be part of one of the fissures where lava escaped during the catastrophic eruption of Mount Mazama.

In legends told by the Klamath Tribe, Mount Mazama's destruction was the culmination of an epic battle between Llao, god of the Underworld, and Skell, god of the World Above. Artifacts such as obsidian spear points and moccasins found beneath the eruption's ash layers confirm that the ancestors of the Klamath, the Makalak, lived in the area and likely witnessed the eruption. The Klamath name for Crater Lake means "the high mountain that used to be." The Klamath Tribe believes that Skell still lives in the lake and may rise again someday. They just might be right—ongoing hydrothermal activity (areas of heated water) in the depths of the lake hint that the volcano is still active. ▣

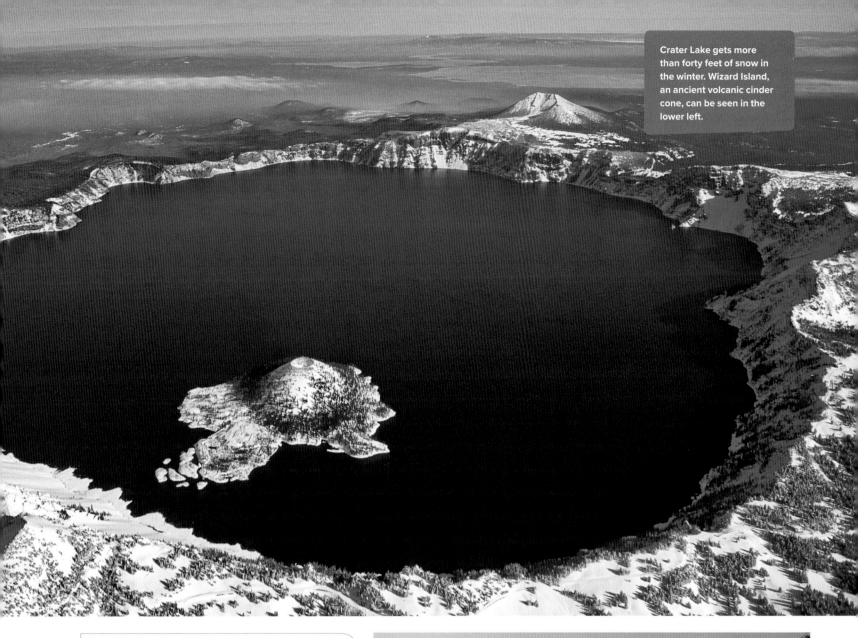

Crater Lake gets more than forty feet of snow in the winter. Wizard Island, an ancient volcanic cinder cone, can be seen in the lower left.

Once 12,000-foot Mount Mazama, now a collapsed volcano

Crater Lake's walls are steep and impassable, except for one maintained trail at Cleetwood Cove that takes hikers down to the water.

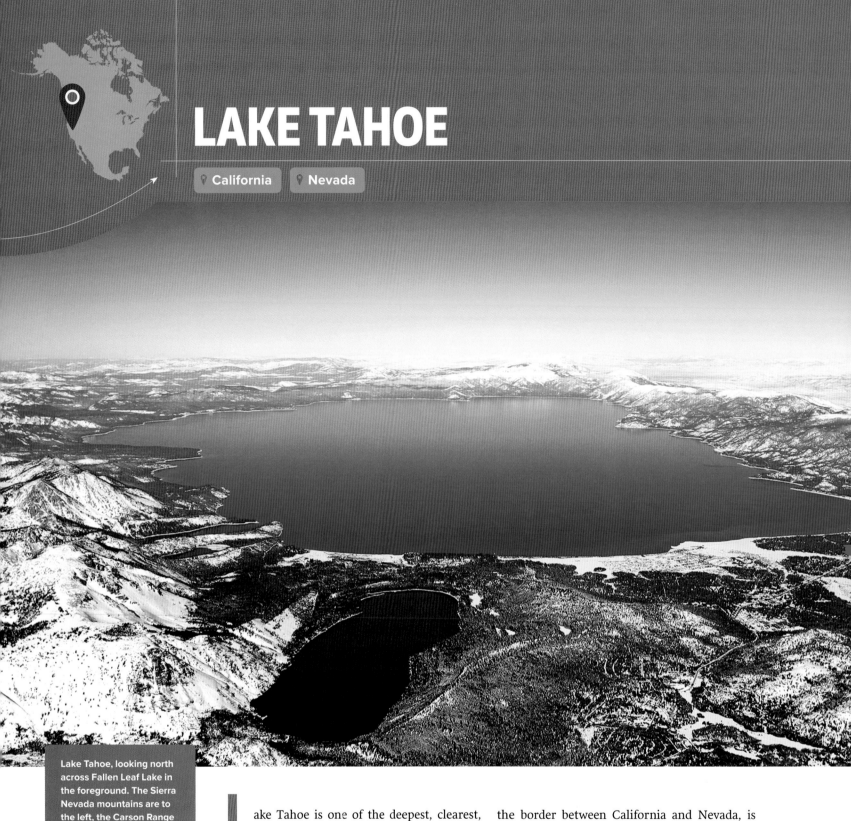

LAKE TAHOE

📍 California 📍 Nevada

Lake Tahoe, looking north across Fallen Leaf Lake in the foreground. The Sierra Nevada mountains are to the left, the Carson Range to the right.

Lake Tahoe is one of the deepest, clearest, bluest lakes in the world—though not quite as deep (1600 feet) as Oregon's Crater Lake (2000 feet), or as clear. The oval shape of Lake Tahoe (and the fact that it sits in a bowl surrounded by mountains) helps perpetuate the myth that this famed lake was formed inside a collapsed volcanic crater, like Crater Lake. But Lake Tahoe, on the border between California and Nevada, is actually the result of long-term vertical faulting throughout the Great Basin region.

The Great Basin, which stretches across Nevada and into eastern California, was created by extensional forces that are pulling apart Earth's crust. These forces create a pattern of uplifted blocks of mountains alternating with down-dropped blocks

Clear, deep, and possibly deadly body of water sitting atop three known faults

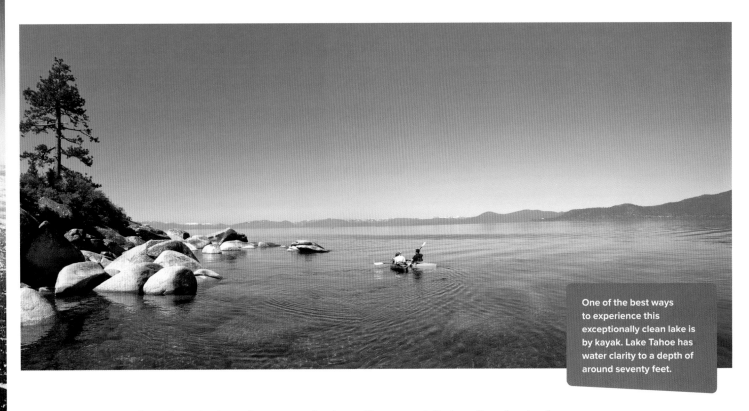

One of the best ways to experience this exceptionally clean lake is by kayak. Lake Tahoe has water clarity to a depth of around seventy feet.

that form valleys. Lake Tahoe sits in a down-dropped valley between the uplifted blocks of the Carson Range to the east and the Sierra Nevada mountains to the west. These extensional forces are ongoing; the Sierra Nevada block continues to move at a rate of about a half-inch per year—relatively speedy in geologic terms.

At least three faults lurk under Lake Tahoe, all of which are capable of producing large earthquakes. The West Tahoe Fault lines up along the west side of the lake between Emerald Bay and Tahoe City. The East Tahoe Fault follows the eastern shoreline and the North Tahoe Fault connects the two in the northern part of the lake. Of the three, the West Tahoe Fault is considered to be the most dangerous. Detailed mapping of the lake bottom and adjacent Fallen Leaf Lake has revealed that the last major quake to strike Lake Tahoe occurred between 4100 and 4500 years ago. Paleoseismic studies suggest that earthquakes tend to recur at time intervals of 3000 to 4000 years, meaning the area may be overdue for a shaking.

Because Lake Tahoe is so deep—it's the second-deepest lake in North America and the seventeenth deepest in the world—earthquakes along the faults under the water may trigger significant tsunamis: walls of water displaced by rapid fault movement. Waves could reach heights over thirty feet, tall enough to destroy most of the marinas and homes along the shores of the lake. Shoreline residents wouldn't have much warning to get to high ground; a tsunami could travel all the way across the lake in a matter of seconds. Evidence for past tsunamis has been found in McKinney Bay, on the west side of the lake, where an extensive collapse of a land shelf around 50,000 years ago helped shape the bay, possibly triggered by an earthquake-generated tsunami. ◼

FLIGHT PATTERN

Look for a bright blue oval on the border of Nevada and California. Ski resorts on the north and west sides of the lake are visible from the air in winter; they capitalize on the 300 inches of snow that falls annually on the east side of the Sierras. You might see Lake Tahoe flying into Carson City or Reno, Nevada.

SAN FRANCISCO BAY

California

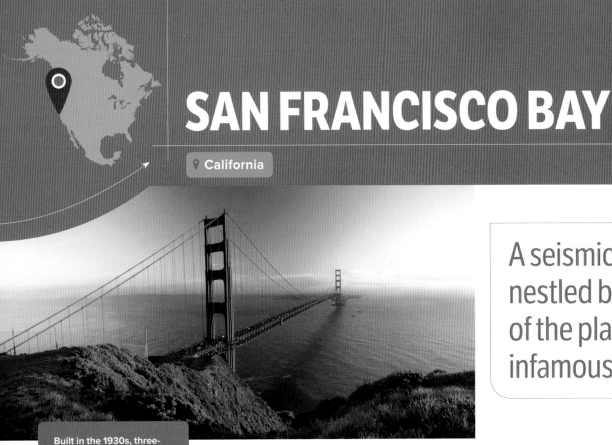

A seismic nexus nestled between two of the planet's most infamous faults

Built in the 1930s, three-mile-long Golden Gate Bridge has been retrofitted to withstand an earthquake up to magnitude 8.3.

FLIGHT PATTERN

Keep an eye peeled for the three-lobed inlet. You will fly over the San Francisco Bay en route to San Francisco International Airport or Oakland International Airport.

San Francisco Bay is perhaps the most seismically intriguing hot spot in North America. It parallels and crosses two of the world's most notorious faults: the San Andreas Fault to the west and the Hayward Fault to the east. As a result of Earth's crust downwarping (broad, downward folding) between the two faults, San Francisco Bay has an odd semicircle shape, visible in satellite images. The downwarping forms a bowl-shaped depression that holds the curving bay.

Viewed from the air, the San Andreas Fault runs along the Pacific coast, marked by a series of long, narrow lakes north and south of the entrance to San Francisco Bay. The bright orange Golden Gate Bridge spans this entrance. The Hayward Fault runs roughly along the interface of the gray urbanized zone and the green mountains to the east of the bay. Brown and tan colors in the bay's waters are caused by salt marshes and artificial ponds for harvesting salt.

San Francisco Bay's earthquake history goes back at least 28 million years, when the San Andreas Fault was born out of forces generated by the Pacific Plate moving relative to the North American Plate. The San Andreas is a transform fault, one that occurs when two tectonic plates scrape past each other. In some places, the plates in this type of fault move smoothly, lubricated by fluids and ductile rocks; in other spots the two sides of the fault get stuck and then move violently all at once, in an earthquake. Here, the offshore Pacific Plate is moving northwest and the North American Plate is moving southeast at a rate of about an inch and a half per year. Around 650,000 years ago, movement between the San Andreas Fault and the Hayward Fault opened a depression between the two faults. This area remained a valley until the last ice age, when increased runoff from the Sierra Nevada mountains filled the valley with water, creating the three-lobed bay we see today.

In 1906, a magnitude 7.8 quake struck along the San Andreas Fault just offshore San Francisco, setting off widespread fires in the mostly wood-built city. Fire would go on to destroy over 80 percent of the city's buildings and more than 3000 people died. On October 17, 1989, a magnitude 6.9 earthquake struck approximately sixty miles south of San Francisco, killing sixty-seven people and causing more than $5 billion in damage.

The prospect of a quake striking this region again is not a matter of if, but when. The thirty-year forecast for the area estimates a 72 percent probability that at least one earthquake with a magnitude of 6.7 or greater will strike before 2043. ■

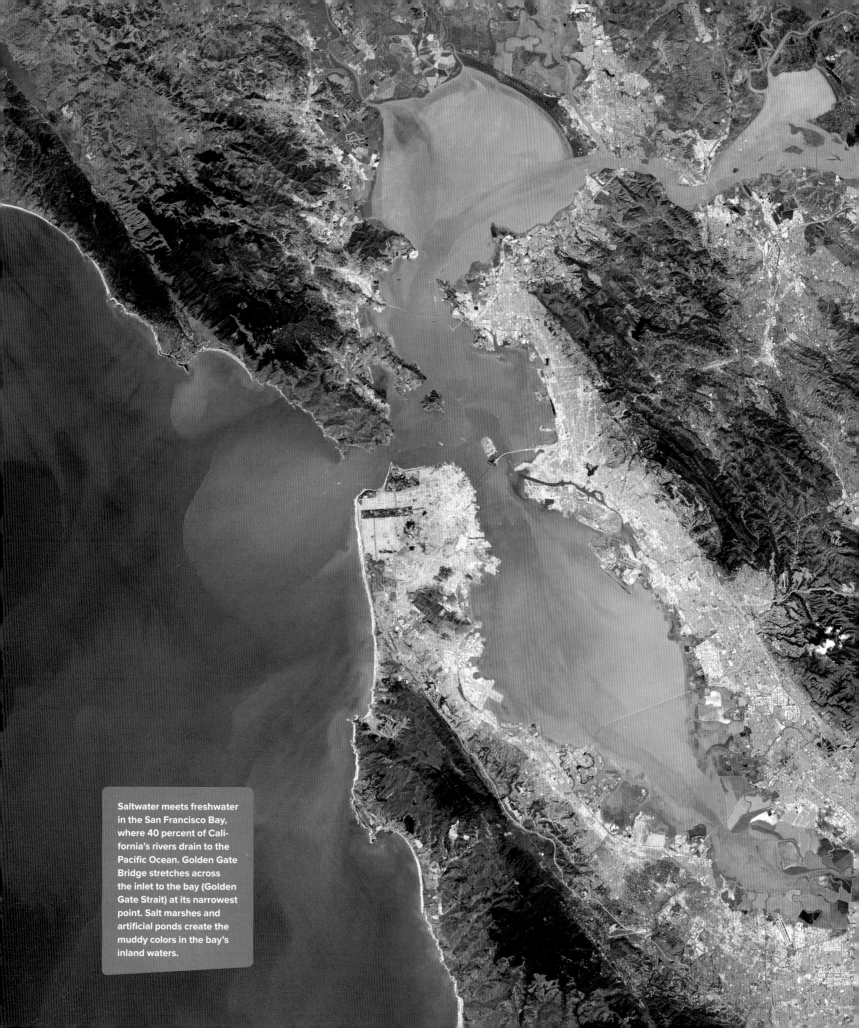

Saltwater meets freshwater in the San Francisco Bay, where 40 percent of California's rivers drain to the Pacific Ocean. Golden Gate Bridge stretches across the inlet to the bay (Golden Gate Strait) at its narrowest point. Salt marshes and artificial ponds create the muddy colors in the bay's inland waters.

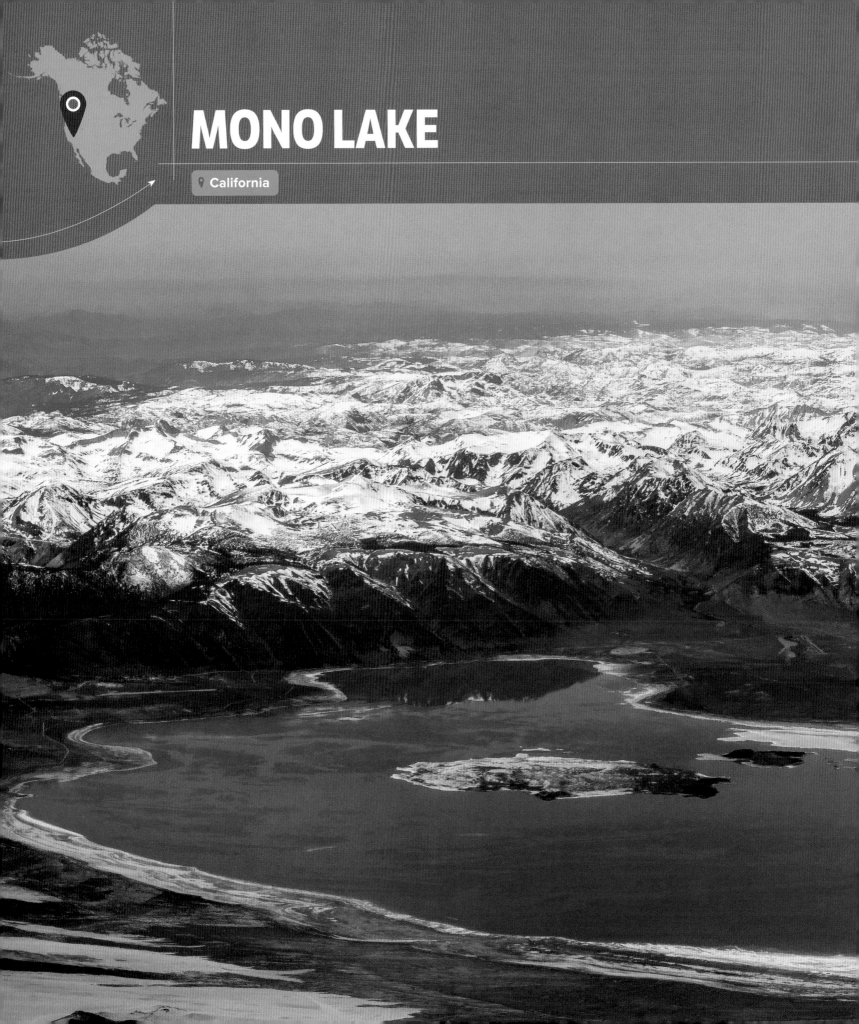

MONO LAKE

📍 California

760,000-year-old lake with no outlet, where accumulated salts sculpt bizarre towers

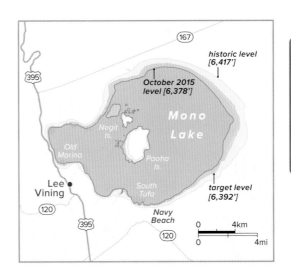

Mono Lake sits in a dead-end basin created by extensional stretching of Earth's crust. Before humans began piping water out of the lake, the only way out was through evaporation.

Mono Lake has been a dead-end for water draining off the Sierra Nevada mountains for the past 760,000 years. Paoha Island, in the center, and Negit Island, just to its right in this photo, have been nesting grounds for birds for many thousands of years.

Mono Lake is located just east of Yosemite National Park, on the eastern flank of the Sierra Nevada mountain range. From an airplane, the lake often appears as a greenish blue dot against a backdrop of the snowcapped Sierra Nevadas. Despite its proximity to Yosemite's towering granite walls and lush alpine meadows, Mono Lake is another world, described by Mark Twain in the 1860s as a "lifeless, treeless, hideous desert . . . the loneliest place on Earth." While the lake may not have suited Twain's tastes, it has long been a salty desert oasis for many living things, especially birds.

Geologically, Mono Lake was a dead-end basin (known as a pluvial lake) for millennia: streams flowed in, but there was no way out, except by evaporation. Over the past 760,000 years, and perhaps much longer, salts accumulated in the lake with no outlet, and today the basin contains more than 280 million tons of dissolved salts.

All that salt forms tufa towers along the shoreline of the lake. These bizarre spires are created when underwater springs rich in calcium mix

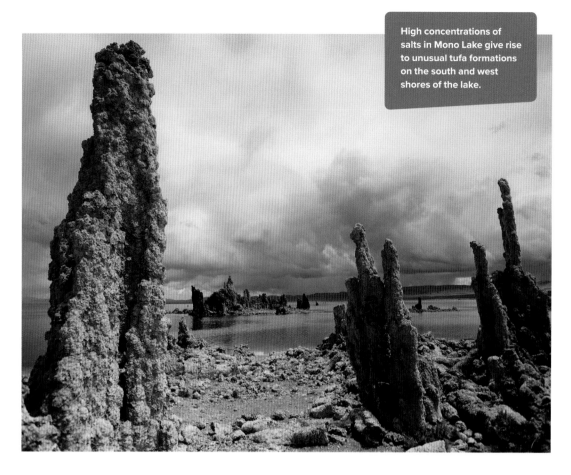

High concentrations of salts in Mono Lake give rise to unusual tufa formations on the south and west shores of the lake.

FLIGHT PATTERN

You could fly over Mono Lake en route to Sacramento or San Francisco, California, or Reno, Nevada. Look for the greenish blue lake backed up against the Sierra Nevada mountains. The main tufa areas are along the south and west shores of the lake.

with the carbonate-rich lake water, precipitating limestone. Over time, this reaction forms towers up to thirty feet tall, along with other shapes that have been exposed along the shoreline as the lake level has dropped.

What happened to lower the lake's water level? In 1941, the city of Los Angeles began tapping water from the Mono Basin, nearly destroying the lake in a matter of decades. Between 1941 and 1982, the unique saline lake shrank to 70 percent of its pre-tapped surface area, dropping forty-five vertical feet and losing half its volume. Average salinity, which was around fifty grams per liter prior to water diversion, nearly doubled by 1982, when the lake reached its lowest levels. The low water made access to Negit Island in Mono Lake easy for predators such as coyotes, and the California gulls that had raised their young on the island for thousands of years abandoned their nests.

In 1983, the Audubon Society took its case to the Supreme Court of California in defense of Mono Lake and the next year, the court ordered that the lake be restored to a minimum height of 6392 feet above sea level. Since the ruling, Mono Lake has risen steadily—as has its resident bird population. In 1941, the surface level was 6417 feet above sea level. As of October 2015, it stood at 6378 feet, its rise hampered in part by California's long-term drought. ▥

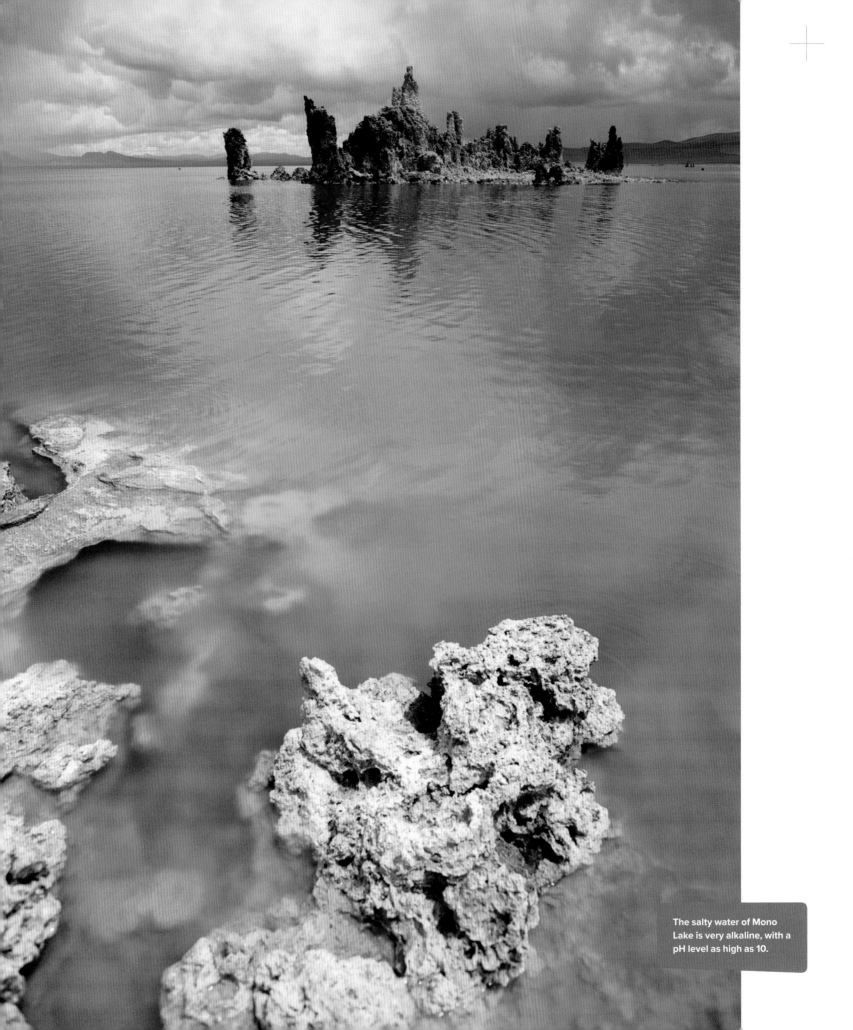

The salty water of Mono Lake is very alkaline, with a pH level as high as 10.

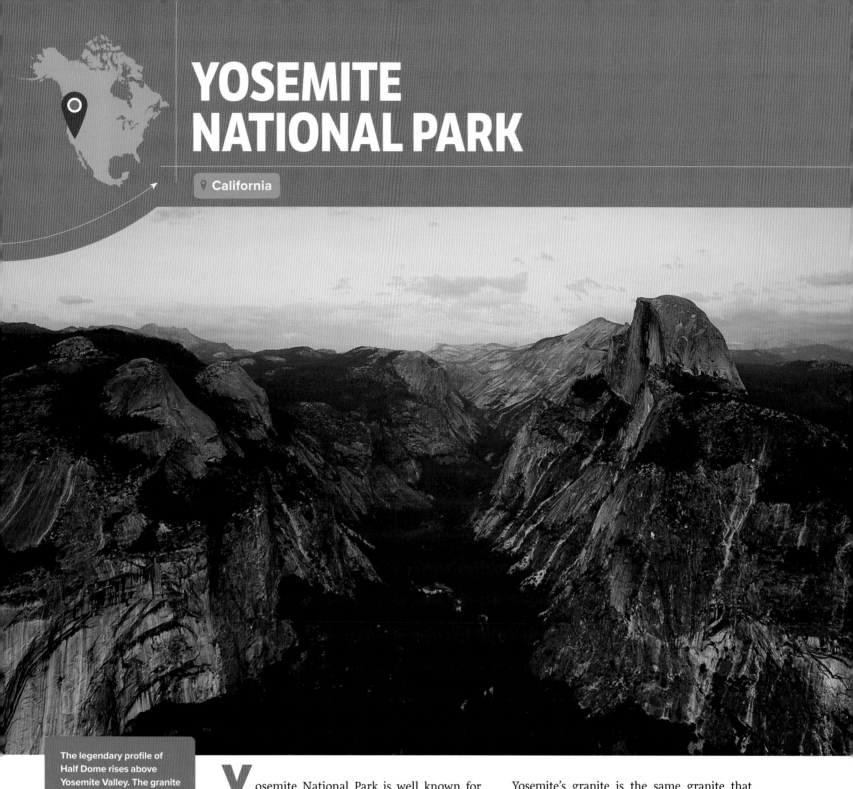

YOSEMITE NATIONAL PARK



California

The legendary profile of Half Dome rises above Yosemite Valley. The granite formation was sculpted by glaciers, not split in half.

Yosemite National Park is well known for many natural wonders, but the star of the show is granite. Sheer walls of the silvery gray rock rise 3000 feet above the valley floor, beckoning climbers from all over the world to scale the stone faces—once thought impossible to conquer. From altitude, formations such as Half Dome, with its mound-sliced-in-half shape, can be seen towering above surrounding cliffs and deep green forests.

Yosemite's granite is the same granite that makes up the Sierra Nevada range. This rock was born about six miles underground between 120 and 80 million years ago, when a series of deep underground eruptions formed a buried mass of granite called the Sierra Nevada Batholith. This granite was eventually uplifted to the surface by tectonic forces and carved by glaciers into the high peaks of the Sierra Nevada mountain range, as well as the iconic walls and rock formations of Yosemite.

Iconic granite walls born six miles underground, then uplifted and exposed

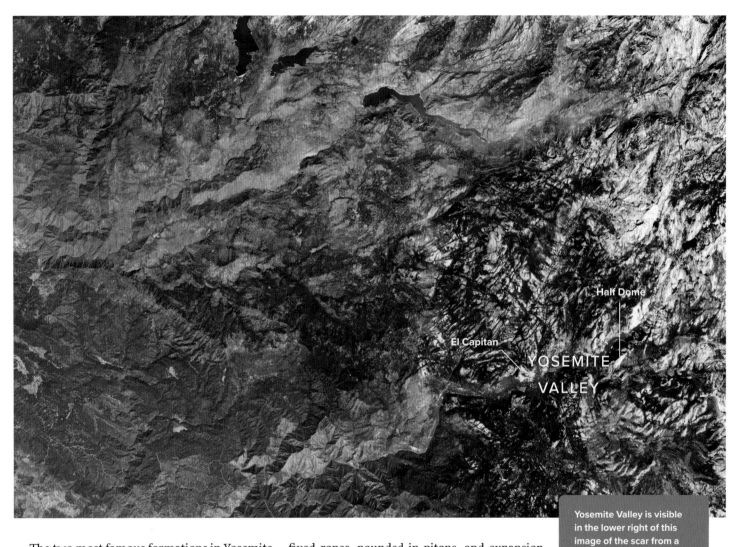

Half Dome

El Capitan

YOSEMITE
VALLEY

Yosemite Valley is visible in the lower right of this image of the scar from a 2013 fire, which burned 255,000 acres of California forests.

The two most famous formations in Yosemite are El Capitan and Half Dome. El Cap, as it is commonly known, is a 3000-foot-high block of granite that towers over the west end of Yosemite Valley. El Capitan's granite does not have many joints, so glacial ice did not erode the formation's façade as much as other Yosemite walls. El Cap was conquered in 1958, when a team led by Warren Harding (the climber, not the president) surmounted the wall in forty-seven days using fixed ropes, pounded-in pitons, and expansion bolts to link a route to the summit. The next year, a team led by Royal Robbins repeated the feat in just seven days, sparking one of the most heated rivalries in Yosemite's often contentious climbing history. This not-always-friendly competition pioneered new routes on many of Yosemite's soaring granite surfaces and put Yosemite on the map as an elite global climbing destination. Today, seasoned teams typically take four to five days to

scale El Capitan, with the current speed-climbing record at just under two and a half hours (remember, that's 3000 feet, straight up). In 2015, climbers Kevin Jorgensen and Tommy Caldwell made headlines by free climbing one of the hardest routes up El Cap. In free climbing, upward progress is made using only natural features of the rock, with ropes employed solely to catch climbers in the event of a fall.

Half Dome is the other famous granite feature in Yosemite. Contrary to common belief, Half Dome is not missing its other half. The distinctive formation, with its one sheer face and three rounded sides, was sculpted by glaciers into a shape that the California Geological Survey declared "perfectly inaccessible" in 1870. It took only five years for them to be proved wrong, when, in 1875, George Anderson pioneered a route to the top by drilling eyebolts into the sloping east side of the dome. These days, any fit hiker can follow in Anderson's footsteps, thanks to a series of cables bolted up the granite along the same route. Permits for the cable route up Half Dome are highly coveted and the route is limited to 300 hikers per day. ▪

FLIGHT PATTERN

Commercial airline pilots on flights en route to Sacramento, California, or the Bay Area will often point out the renowned valley of granite below. Half Dome is especially identifiable.

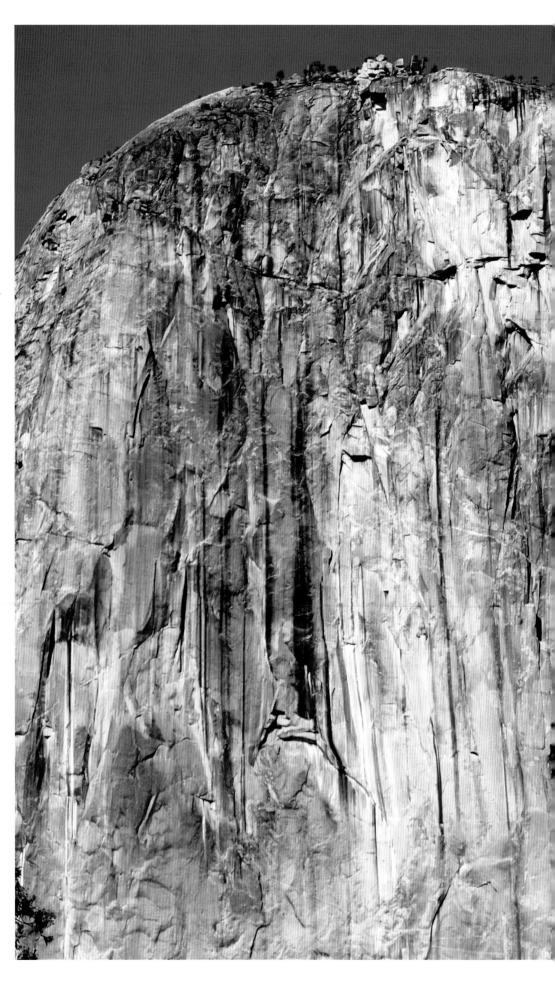

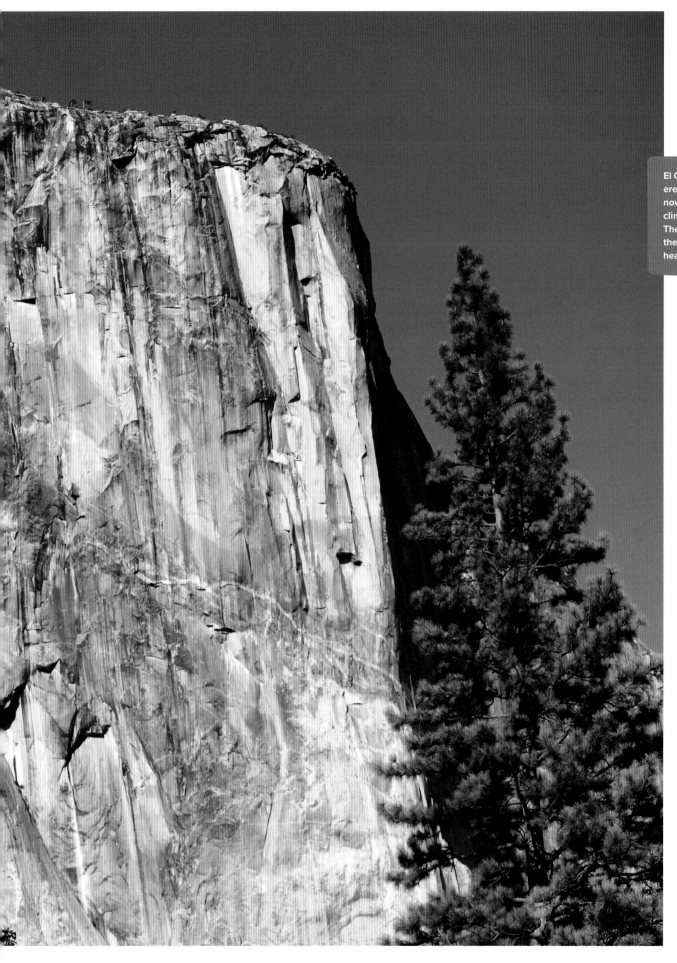

El Capitan, once considered insurmountable, is now a mecca for big-wall climbers in Yosemite Valley. The relatively few joints in the wall preserved it from heavy glacial erosion.

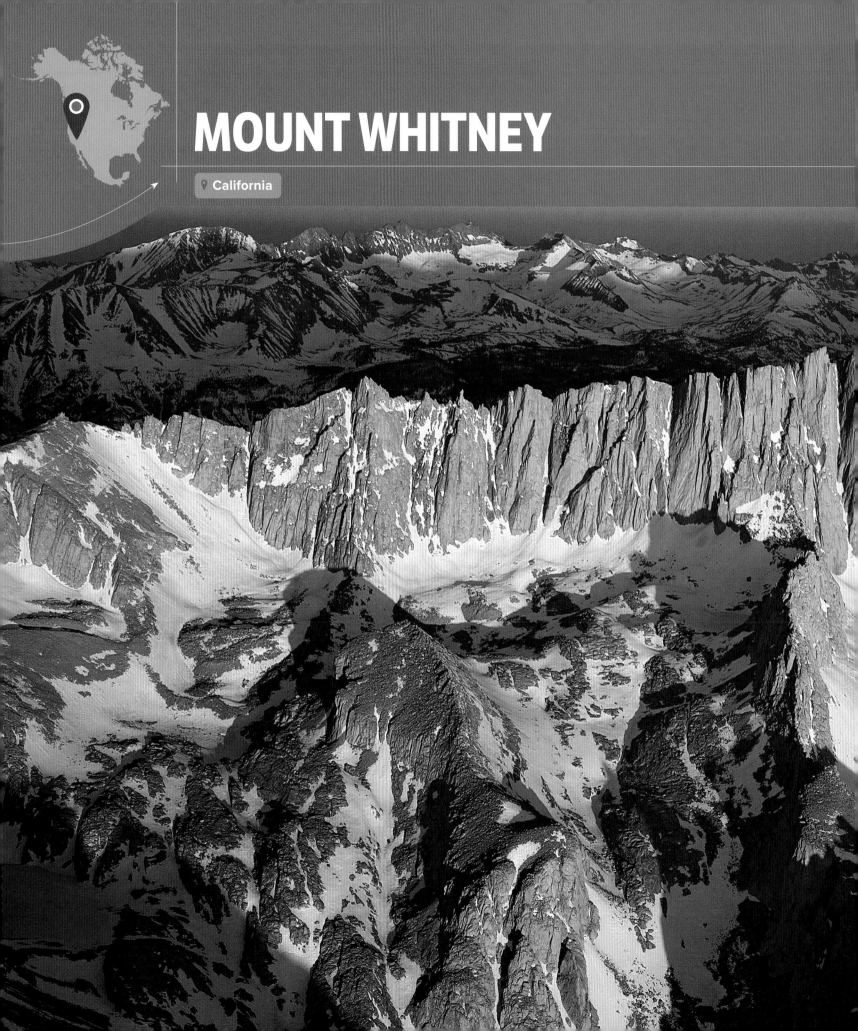

MOUNT WHITNEY

📍 California

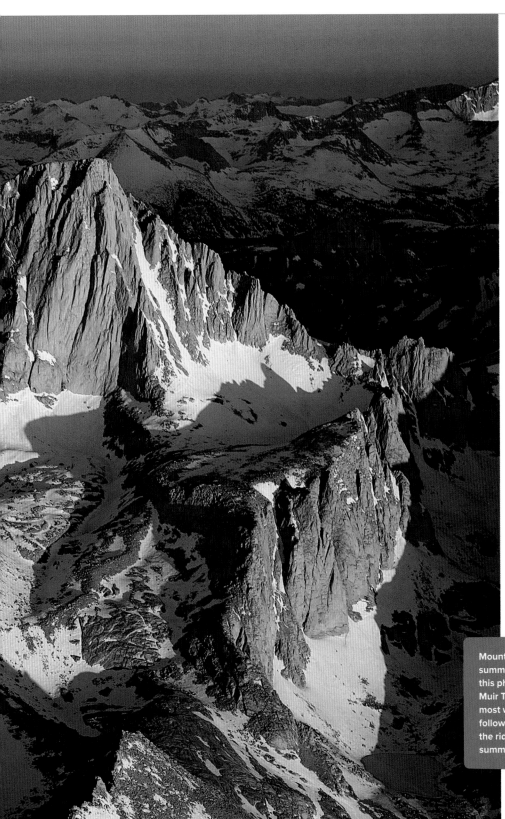

Highest summit in lower forty-eight states, growing a millimeter taller each year

At 14,550 feet, Mount Whitney is the crown jewel of California's Sierra Nevada mountain range and the highest summit in the lower forty-eight states. Right behind it is Mount Elbert in Colorado, at 14,439 feet, but Whitney holds a trump card: it's still growing taller. The entire Sierra Nevada range is being uplifted at a geologically brisk rate of a millimeter per year, suggesting that the whole mountain range may have been raised in the last 3 million years—a blink of an eye in mountain-building time.

The Sierra Nevada mountains are dominated by granite—the remains of a mass of intruded molten rock, or batholith, that formed underground during the Cretaceous Period, when dinosaurs ruled Earth. Back then, the mountain range existed as a series of gently rolling hills. Over the last 2 to 10 million years, this reservoir of extra-hard granite was uplifted by extensional tectonic forces and carved by glaciers into the impressive mountain range we see today.

Mount Whitney's sunlit summit ridge is stunning in this photograph. The John Muir Trail, one of the peak's most well-known features, follows the backside of the ridge and ends at the summit.

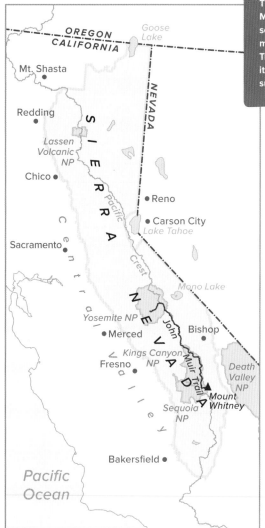

The 210-mile-long John Muir Trail is an especially scenic section of the much-longer Pacific Crest Trail that runs from Yosemite Valley south to the summit of Mount Whitney.

FLIGHT PATTERN

Look for Mount Whitney on flights to Las Vegas, Nevada, or Los Angeles, California.

From the air, the sloping ridgeline to Whitney's summit stands out among the Sierra Nevada's other jagged peaks. The process of extensional uplift, in which an expanding crust thins and surface rocks break apart, has created a lopsided mountain. Whitney's eastern slope falls away at a much steeper angle than its western slope, a pattern that can be seen along most of the 400-mile-long Sierra Nevada range, which has formed along a normal fault, a type of fault that occurs in extensional environments. This means that the granite found at the top of Mount Whitney is the same granite that makes up the Alabama Hills, thousands of feet lower in the Owens Valley, at the base of the range.

As Mount Whitney grows taller, the Alabama Hills and the Owens Valley continue to drop down at a rate of about a millimeter per year. The extensional forces stretching the crust between the two sides of the fault sometimes trigger large earthquakes, such as the 1872 Lone Pine quake, which struck the region at a magnitude 7.9, one of the largest earthquakes to occur in California in recorded history.

Most hikers reach the top of Mount Whitney following the famed John Muir Trail: a 210-mile-long footpath that runs from the granite domes of Yosemite along the jagged crest of the Sierra Nevadas to Mount Whitney's summit, constantly gaining and losing elevation through some of the most breathtaking alpine scenery anywhere. ▪

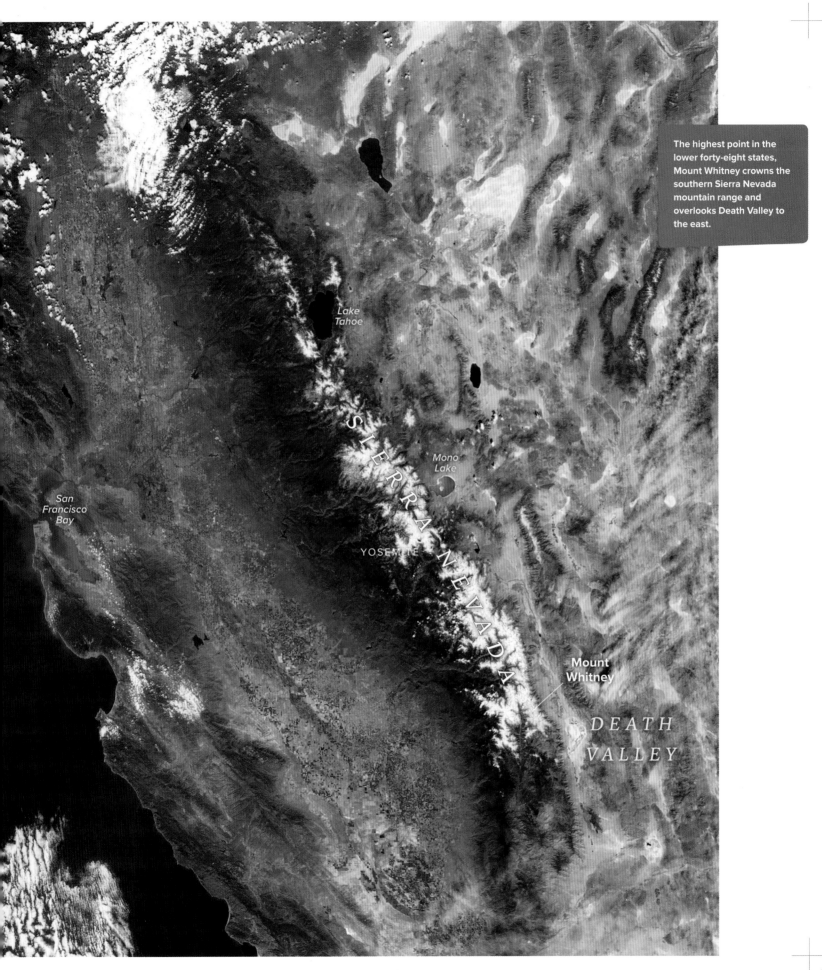

The highest point in the lower forty-eight states, Mount Whitney crowns the southern Sierra Nevada mountain range and overlooks Death Valley to the east.

Lake
Tahoe

Mono
Lake

San
Francisco
Bay

S I E R R A N E V A D A

YOSEMITE

Mount
Whitney

DEATH
VALLEY

DEATH VALLEY

California

A desert called Death Valley sounds like a place to avoid, but despite the ominous name, this valley in southeastern California is stunningly beautiful and surprisingly vibrant. It may appear as you gaze down on it that Death Valley is nothing but shades of brown, but on the ground, the rocks of Death Valley are vividly colorful.

Death Valley is enclosed by mountain ranges on both sides: the Panamint Range to the west and the Amargosa Range to the east. The highest point in the Panamint Range is Telescope Peak, at 11,043 feet. The peak is even more impressive when viewed from Badwater Basin in Death Valley, the lowest point in North America, at 282 feet below sea level. This gives Telescope a remarkable vertical rise above the landscape: a gain of more than 11,325 feet above the valley floor.

Such extreme elevation changes are characteristic of the basin and range topography that dominates this region—topography that was caused by extensional forces pulling apart Earth's crust. As the crust stretched, faults developed, creating alternating blocks of down-dropped and uplifted crust that resulted in valleys separated by parallel mountain ranges. Death Valley is an extreme example of one such down-dropped block. From the air, you'll be able to see this pattern of basins and ranges on a large scale.

Death Valley is a desert because it sits in the rain shadow cast by California's Sierra Nevada range. These mountains block most of the moisture coming from the Pacific Ocean, leaving Death Valley to get by on less than two inches of rainfall per year and making this one of the driest places

Death Valley is one of many valleys created by extensional stretching of Earth's crust in Nevada and eastern California.

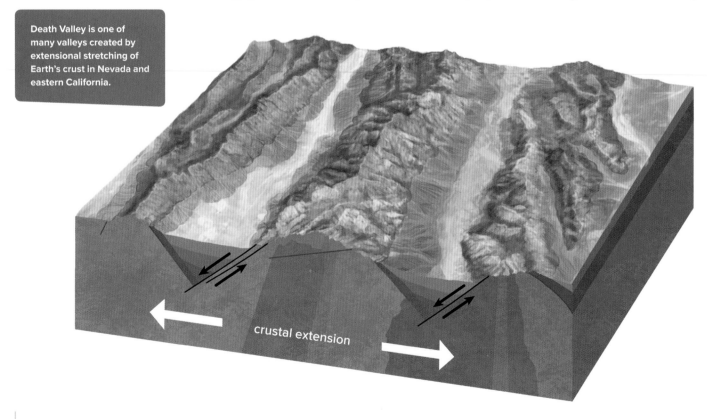

crustal extension

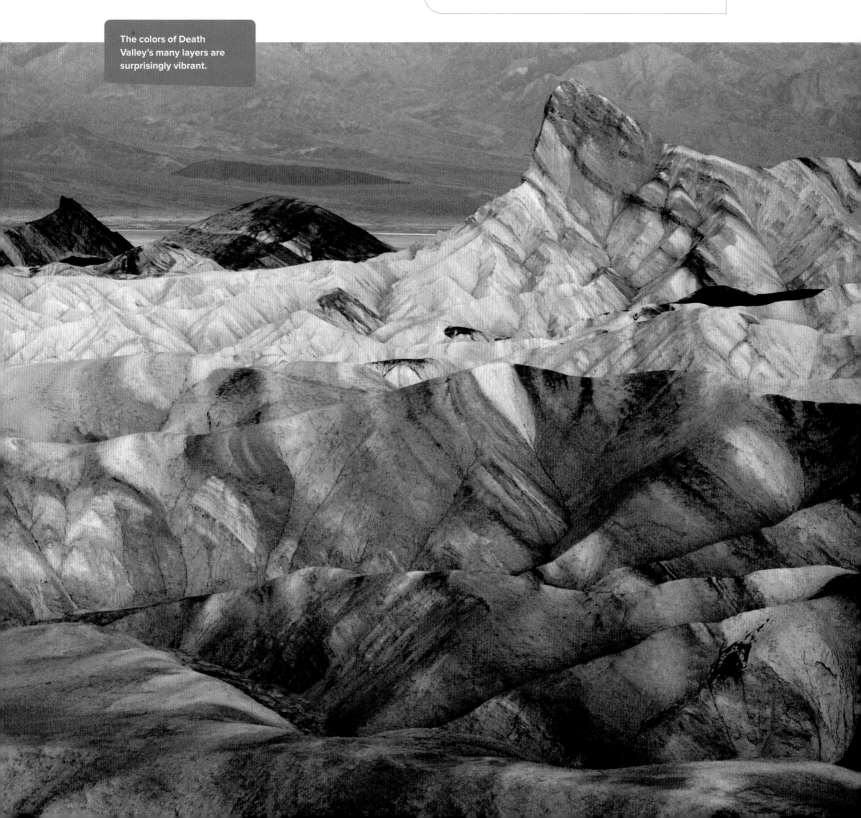

A down-dropped block caused by Earth's crust pulling apart

The colors of Death Valley's many layers are surprisingly vibrant.

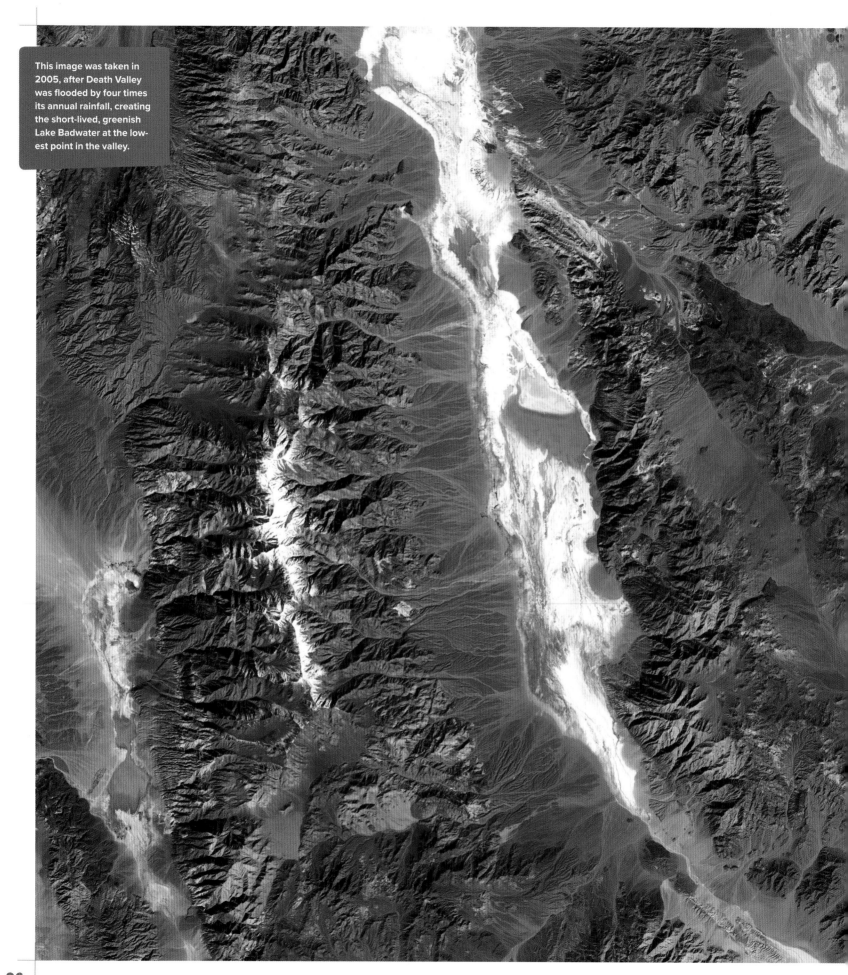

This image was taken in 2005, after Death Valley was flooded by four times its annual rainfall, creating the short-lived, greenish Lake Badwater at the lowest point in the valley.

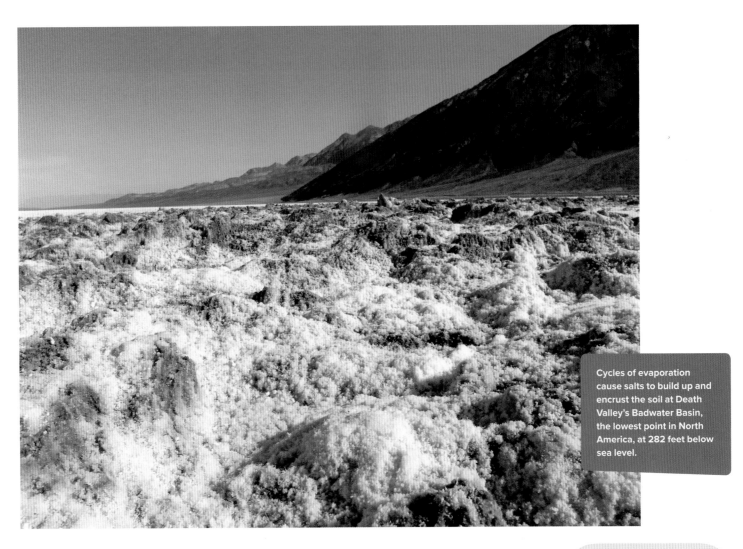

Cycles of evaporation cause salts to build up and encrust the soil at Death Valley's Badwater Basin, the lowest point in North America, at 282 feet below sea level.

on the planet. Dry—but not without striking visual interest. At popular Zabriskie Point, the elongated mudstone formations are colored by layers of red, brown, and yellow. At Artist's Palette, another Death Valley highlight, bright pinks, greens, purples, and blues can be seen in the rocks, colored by chemical weathering of embedded metals and minerals, including iron, hematite, mica, and manganese.

The most colorful seasons in Death Valley occur every ten years or so, when decadal variations in the Pacific Ocean's El Niño climate cycle send more rainfall than usual to Death Valley. The moisture gives rise to a superbloom, when wildflower seeds that have lain dormant for years all bloom at once. The last superbloom took place in the winter and spring of 2016, with yellow desert sunflowers, purple phacelia, pink desert five-spot, and white gravel ghosts bringing new hues to already colorful Death Valley. ■

FLIGHT PATTERN

You might fly over Death Valley en route to Las Vegas, Nevada, which lights up the vast desert 120 miles to the east.

SAND TO SNOW NATIONAL MONUMENT

Underground springs are one of the few reliable sources of water in the Mojave Desert, a section of which is included in the Sand to Snow National Monument. Oases are easy to spot in an otherwise parched landscape.

FLIGHT PATTERN

You might fly over Sand to Snow National Monument en route to Los Angeles or San Diego, California.

ocated less than a two-hour drive from Southern California's most populated hub, the Sand to Snow National Monument is a world apart. Vast stretches of desert are punctuated by scattered oases of palm trees that serve as life-giving way stations for wildlife such as coyotes, mountain lions, and bighorn sheep. From the air, look for an expanse of desert running up into a mountainous region (the San Bernardino Mountains) about seventy-five miles northeast of Los Angeles.

While the Sand to Snow terrain may feel a million miles from civilization, its proximity to urban Southern California makes this ecozone the most visited wilderness region in California—part of the motivation to preserve it as a national monument. The 154,000-acre protected area extends from the lowlands of the Mojave Desert up to the

Radical terrain shift from 11,503-foot summit to Mojave Desert floor

11,503-foot summit of San Gorgonio Mountain in the San Bernardino National Forest.

The San Bernardino Mountains, home to San Gorgonio Mountain, are part of the greater Transverse Ranges of Southern California, a chain of mountains formed by movement of the North American and Pacific Plates and the San Andreas and Garlock Faults. This chain was raised rapidly and recently—within the past 2 million years—and is still growing taller. The high elevation lends erosive power to the many rivers that drain the mountains, carving out dramatic river gorges, especially on the south side of the range. Rocks and sediments washed out of the mountains are deposited on the valley floor in massive alluvial fans (fan-shaped deposits of water-transported material), some over 1000 feet thick. The landscape between the mountains and the valley is home to some of the most rugged topography in Southern California.

The new monument shares its eastern border with Joshua Tree National Park and its northern border with the Bighorn Mountain Wilderness, and connects those biomes to the San Bernardino Mountains. This helps protect a wildlife migration corridor between the desert and the mountains important for several species, including bighorn sheep.

As biologists work toward a more holistic understanding of populations of wild animals, the importance of migration corridors linking large wilderness areas has been trending in recent years. Many species, especially large species of hoofed mammals and the predators who hunt them, migrate seasonally between water and food sources. Maintaining wild, undeveloped corridors through which these animals may travel freely without encountering busy highways or urbanized areas is important for maintaining healthy, genetically diverse populations of sheep, deer, and elk.

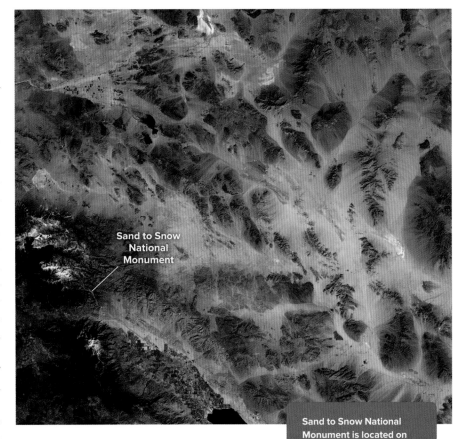

Sand to Snow National Monument

Sand to Snow National Monument is located on the left side of this satellite photograph, against the white peaks. The area includes rapidly uplifted mountains, deeply eroded gorges, and alluvial deposits in the valley. A unique collection of plants and animals are protected here.

Southern California has a robust population of mountain lions, black bears, bobcats, and coyotes, which also benefit from migration corridors. These species are territorial and juveniles must seek out their own hunting grounds after leaving their mothers. Roaming juveniles are the most likely to get into trouble, as they are just learning to seek out reliable food sources and sometimes venture too close to humans and populated areas. ▪

BAJA CALIFORNIA PENINSULA

The Baja California Peninsula hangs off its namesake state like a dog's scruffy tail—a 775-mile-long strip of land once attached to Mexico, before it was sheared off and transported north and west by ongoing tectonic activity.

From the air, brown outcroppings of volcanic rock mark the location of a few of the peninsula's many volcanoes and lava fields, spawned before and after the peninsula began breaking away from mainland Mexico. These volcanoes and the Peninsular Ranges, a southward extension of California's Coast Range, make up the mountainous spine of the peninsula.

Before 15 million years ago, the Baja California Peninsula was part of the North American Plate, stitched along the coast of Mexico. But between 15 and 12 million years ago, a divergent plate boundary, called the East Pacific Rise (which runs from the Salton Sea in California south to Antarctica) began spreading apart, creating new transform faults along the edge of the North American Plate.

In just a few million years, earthquakes and movement along these faults—driven by spreading of the East Pacific Rise—sliced the Baja California Peninsula off the North American Plate and attached it to the Pacific Plate, which is still moving northwest. As the peninsula was shaved off and carried away from the mainland of Mexico, the Sea of Cortez opened between the peninsula and the mainland. Eventually, the Baja California Peninsula will become an island, possibly in the next 10 million years.

In the armpit where the Baja peninsula is attached to Southern California lies the dried-up mouth of the Colorado River. Until a few decades ago, the mighty Colorado ran its course from the

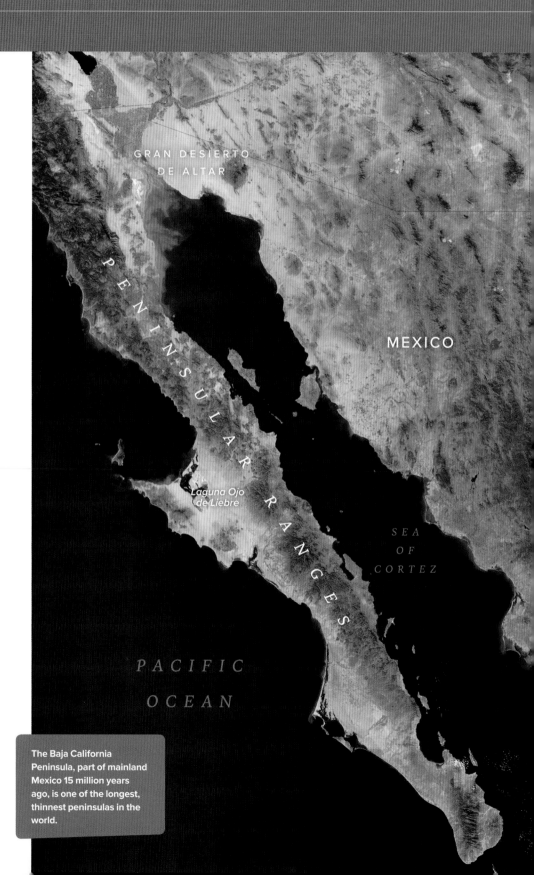

The Baja California Peninsula, part of mainland Mexico 15 million years ago, is one of the longest, thinnest peninsulas in the world.

A slice of Mexico's west coast that was sheared off by earthquake action

FLIGHT PATTERN

En route to San Diego, California, or La Paz, Mexico, look for a long, thin peninsula hanging off the southwest coast of California, separated from mainland Mexico by the Sea of Cortez.

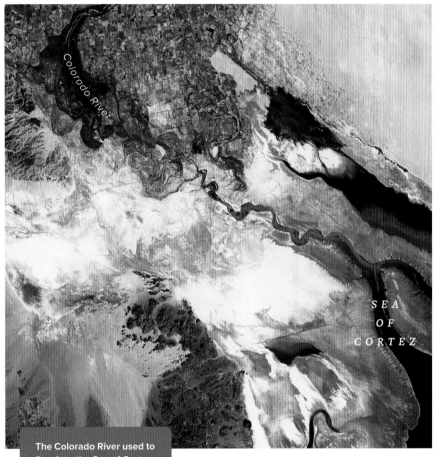

The Colorado River used to flow into the Sea of Cortez in the northeastern part of Baja California, but diversion of the river's water for agriculture and other uses has been unsustainable for decades, and the river (dark blue) now dries up a few miles shy of the coast.

Colorado Rockies through the Grand Canyon before emptying into the Sea of Cortez, creating a vast delta of braided stream channels, estuaries, and marine habitats that supported diverse ecosystems of freshwater, brackish water, and saltwater species. Today, so much water is diverted out of the Colorado (mostly for irrigation), the river doesn't make it to the sea anymore. The once-lush Colorado River Delta has dried up into the Gran Desierto de Altar, or Altar Desert, which can be seen in the juncture between Mexico and the peninsula. Nearby, greenish fields stand in stark contrast.

About halfway down the peninsula, on the Pacific Ocean side, is a semicircular-shaped lagoon known as Laguna Ojo de Liebre, which translates as the Eye of the Jackrabbit Lagoon. This calm, shallow lagoon has served as a nursery for gray whales and their calves for perhaps millions of years. Mother whales come here between December and April to give birth and raise their bus-sized newborns in relative peace and safety before embarking on their 5000-mile journey north to summer feeding grounds in the Arctic Ocean. ◼

RED ROCK CANYON

📍 Nevada

Older limestone sits on top of younger sandstone, a result of violent thrust faults

Next time you find yourself on a plane headed for Las Vegas, take a peek out the window just before landing, and you might catch sight of a premier geologic feature of the desert Southwest: Red Rock Canyon. Here, piles of ancient limestone and not-as-ancient brightly colored sandstone have conspired to create a mecca for rock climbers, adventurers, and anyone who needs a scenic break from the neon nightlife of The Strip.

Around 600 million years ago, what is now Las Vegas was underwater, at the bottom of an inland ocean basin. Over hundreds of millions of years, the calcium carbonate–rich remains of shelled creatures piled up on the seafloor, eventually leaving behind layers of sediments more than 9000 feet thick. With time, these layers compressed and lithified into limestone.

Fast forward to 180 million years ago, when the same ocean was a sea of sand. At that point, a vast desert of giant dunes covered the buried limestone layers. Some of these dunes were thicker than a half-mile and over eons, they compressed and lithified into sandstone. Between 70 and 40 million years ago, when an episode of mountain building called the Laramide orogeny was raising the Rocky Mountains to Himalayan heights, the extreme pressures generated by this large-scale deformation of crust gave rise to a number of thrust faults across the West.

Two of these faults, the Keystone Thrust Fault and the Wilson Cliffs Thrust Fault, run directly through Red Rock Canyon. Here, the thrust faults have displaced the older gray limestone, which now sits atop the younger red sandstone—

Colorful sandstone is exposed along the east side of Red Rock Canyon.

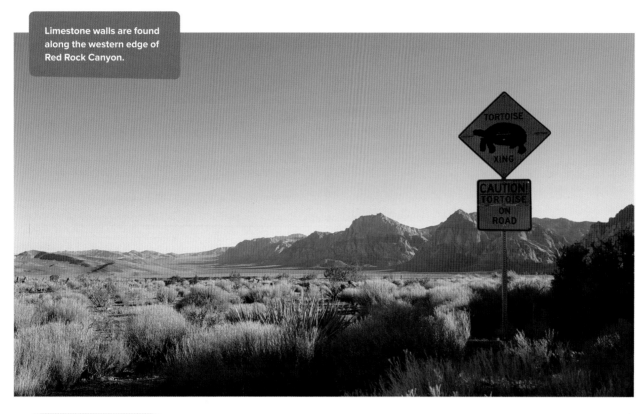

Limestone walls are found along the western edge of Red Rock Canyon.

FLIGHT PATTERN

The canyon lies about fifteen miles west of Las Vegas's McCarron International Airport. Look for the bright red and orange sandstone rocks that line the east side of the canyon. The gray limestone appears on the west side, with a scenic loop road in the middle.

an unusual exception to typical geology, in which older rocks sit beneath younger rocks.

Both limestone and sandstone are attractive to rock climbers, who come from around the globe to tackle the 2000-plus named climbing routes in Red Rock Canyon. The colorful, iron-rich sandstone is usually scaled using sport climbing techniques, in which climbers clip into bolts drilled into the rock. The limestone in the canyon is more often ascended using traditional rock climbing techniques, in which climbers must follow natural features in the rock, placing protective gear in cracks on their way up. ▩

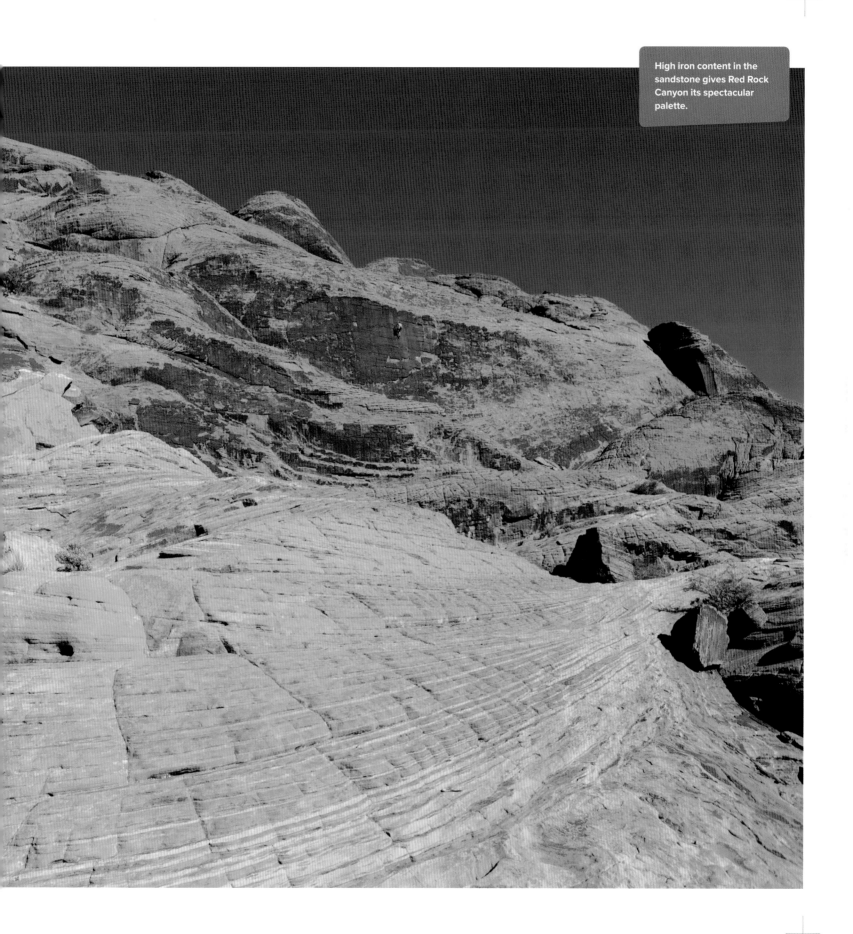

High iron content in the sandstone gives Red Rock Canyon its spectacular palette.

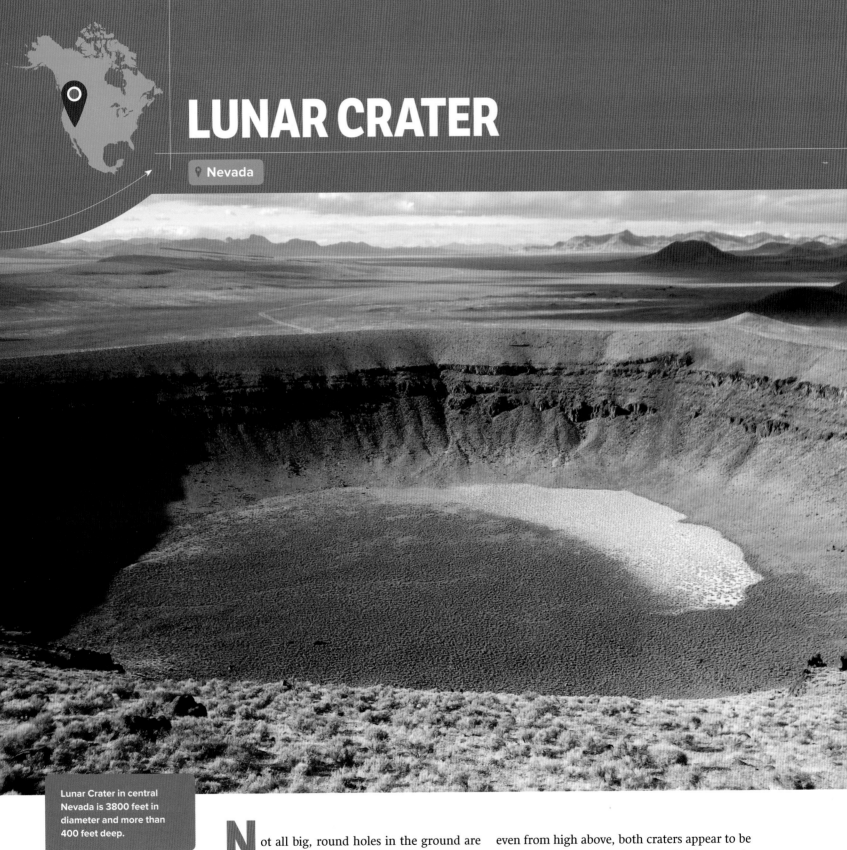

LUNAR CRATER

📍 Nevada

Lunar Crater in central Nevada is 3800 feet in diameter and more than 400 feet deep.

Not all big, round holes in the ground are meteor craters. Some of those big, round holes are volcanic in origin—but telling the difference between the two can be tricky. Lunar Crater, in central Nevada, stands in contrast to Meteor Crater, in Arizona. On the surface and even from high above, both craters appear to be impact features, but a little investigation reveals very different histories.

The Lunar Crater Volcanic Field lies at the southern end of Nevada's Pancake Range. Cinder cones, lava fields, elongated fissures, and piles of

Remains of an explosion caused by groundwater contacting subterranean volcanic heat

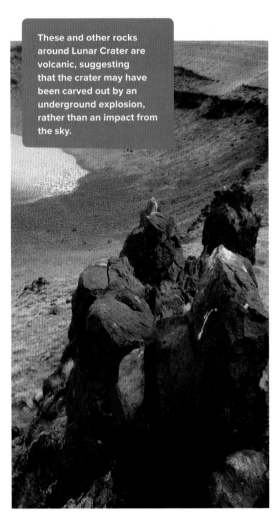

These and other rocks around Lunar Crater are volcanic, suggesting that the crater may have been carved out by an underground explosion, rather than an impact from the sky.

ash are spread over a strip of land twenty miles long and five miles wide, vestiges of a very active volcanic past. At the tail end of all that volcanism yawns Lunar Crater: a 430-foot-deep, 3800-foot-wide hole in the ground. Five miles to the north is another round hole: Easy Chair Crater, 1600 feet in diameter.

Just because a crater neighbors a volcanic field doesn't automatically mean the depression is volcanic, but the rocks and structures of both Lunar Crater and Easy Chair Crater point to explosive origins. In geologic terms, Lunar and Easy Chair are both maars, low-relief craters formed by relatively shallow below-ground explosions. Such explosions are triggered when groundwater comes in contact with an underground volcanic heat source and rapidly expands and explodes, leaving behind a crater at the surface.

As maars go, Lunar Crater is quite large—although the largest maars on Earth, located in Alaska, are more than five miles in diameter. Most maars are a few hundred feet across. Its location in a very arid desert has helped Lunar Crater remain dry; in wetter environments maars often fill with groundwater or precipitation and become maar lakes. Lunar Crater takes its name from its resemblance to maars seen on the moon, some of which were formed by meteor impacts and others by volcanism (telling maar origin stories apart is even harder from a distance of 239,000 miles). ■

FLIGHT PATTERN

Lunar Crater lies in the remote center of Nevada, seventy miles northeast of Tonopah. You might see it on a flight to Las Vegas or Ely, Nevada.

CRATERS OF THE MOON NATIONAL MONUMENT & PRESERVE

Long before aerial imagery was possible, thousands of pioneers made their way west on the Oregon Trail. The journey on foot and by ox-drawn cart was arduous, but few sections were more miserable than a stretch through south central Idaho that is now Craters of the Moon National Monument and Preserve. It is one of the largest basalt lava flows in North America, with jagged black basalt covering nearly 1200 square miles of desolate ground. The barren rock supports little plant life and scarce game—a true no-man's-land.

From the air, Craters of the Moon appears as three black splotches, but the lava field is actually made up of sixty distinct lava flows, between 15,000 and 2100 years old. The more recent volcanic eruptions were likely witnessed by the Shoshone; tribal legends tell of a serpent coiling around a mountain until the black rocks liquefied and the mountain exploded.

More than twenty-four volcanic cones also occupy the landscape, created as lava piled up around a central vent in the planet's crust. The

Lava tubes, cinder cones, and other eruptive marvels in an otherworldly landscape

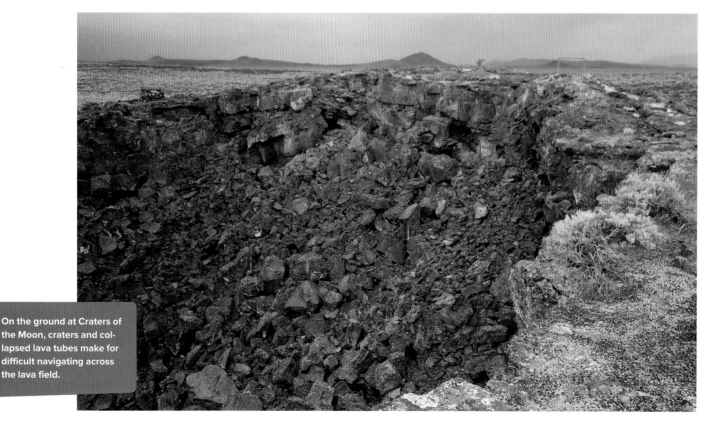

On the ground at Craters of the Moon, craters and collapsed lava tubes make for difficult navigating across the lava field.

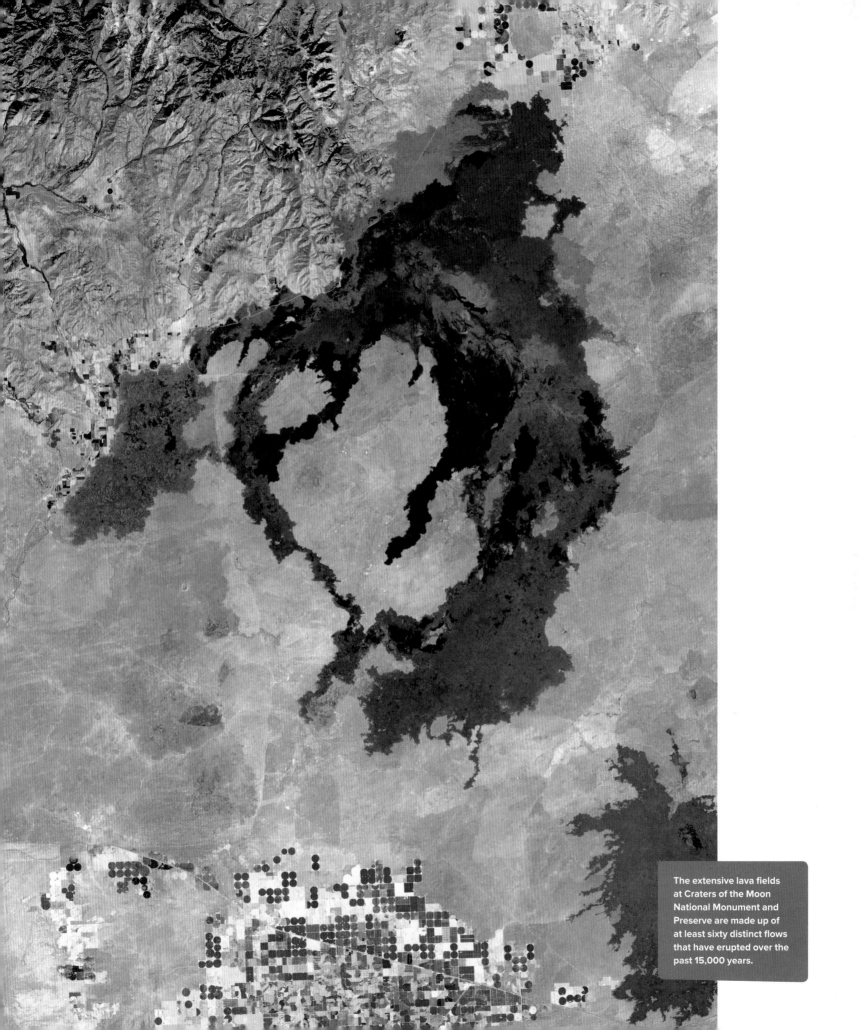

The extensive lava fields at Craters of the Moon National Monument and Preserve are made up of at least sixty distinct flows that have erupted over the past 15,000 years.

source of the lava is Idaho's Great Rift, a crack in the crust that extends fifty-three miles across the Snake River Plain and is thermally connected to the hot spot under Yellowstone National Park in Wyoming. Craters of the Moon is currently dormant, but not extinct. The time between eruptive periods averages 2000 years and some scientists think the area is due for another eruption within the next hundred years.

On the ground, the variety of lavas and volcanic features is apparent. Hot, oozing basalt can take many forms as it cools, including block lava, which often forms in large, angular chunks with smooth sides; aa lava, with a jagged texture; and pahoehoe lava, with a smooth or ropey texture—all of which helped form the Hawaiian Islands as well as occurring at Craters of the Moon. Other volcanic features at the Idaho site include vents, fissures, cinder cones, lava bombs, spatter cones, and lava tubes.

Lava tubes form when the top of low-viscosity lava forms a hard exterior crust as it cools, while the interior is still hot and flowing, creating a roof over the active lava stream. After it cools, a long, tube-like cave is left behind. Native Americans may have used those that were accessible for shelter or ceremonies. One such cavern is the Shoshone Ice Cave, near Craters of the Moon and open to the public. This ancient rock tube was created by fiery hot lava but is now cold enough to maintain a thick, skatable sheet of ice on the floor year-round. ▪

Lava tubes such as those at Craters of the Moon develop when the top of low-viscosity flowing lava forms a hard ceiling crust as it cools, while the interior is still hot and moving, creating a roof over the active lava stream. Once the lava cools, a long cave is left behind. Lava tubes can be fifty feet wide and many miles long, and may show at the surface or be completely hidden underground.

Groundwater forms thick sheets of ice on the floor of the Shoshone Ice Cave.

SAINT ANTHONY SAND DUNES

📍 Idaho

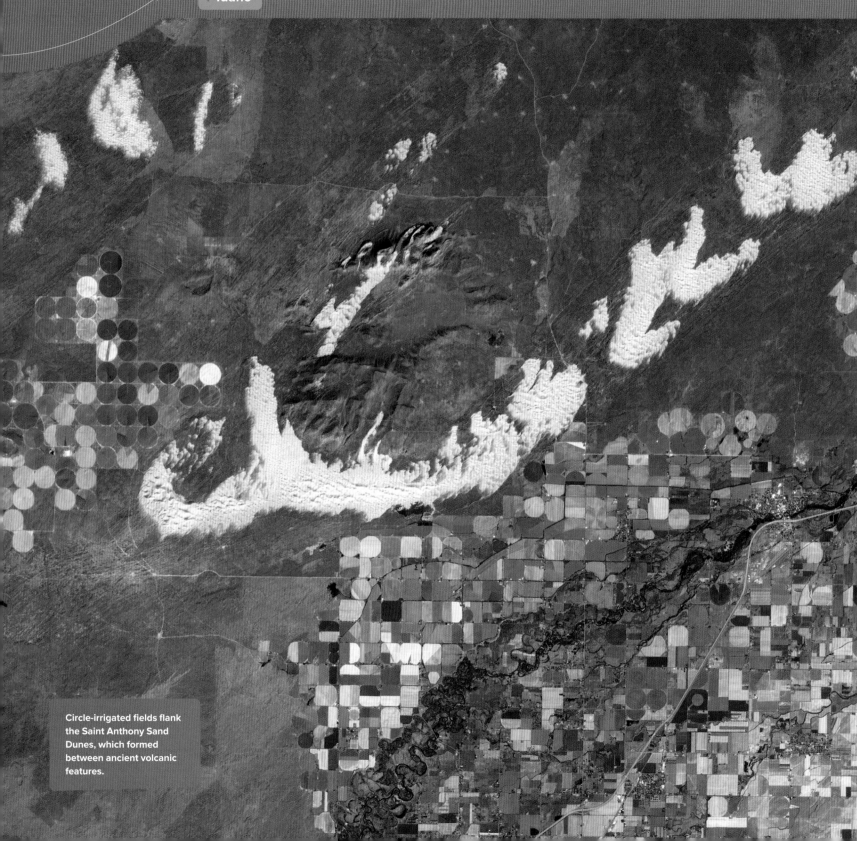

Circle-irrigated fields flank the Saint Anthony Sand Dunes, which formed between ancient volcanic features.

Sand from evaporated lakes blew north and became 400-foot dunes

Flying over southern Idaho, you might spot something below looking very out of place. Between circle-irrigated fields and jagged lava flows lies a surprising landscape for this area: a sea of white, fine-grained sand dunes. The Saint Anthony Sand Dunes date back to about 10,000 years ago, when this part of Idaho was much cooler and wetter than it is today.

Back then, now-extinct creatures such as woolly mammoths grazed on extensive grasslands and drank from several large lakes in the area. Two of these lakes, Mud Lake and Market Lake, still exist about twenty miles southwest of the dunes, but they are dried-up fractions of their former expanses. When the climate began warming at the end of the last ice age, around 11,500 years ago, the shorelines shrank, exposing acres of sandy deposits that had sat at the bottom of the lakes. Sand from the floodplain deposits of the Snake, Teton, and other rivers also added to the bank of sand, which began migrating north.

In order for sand dunes to form, you need a lot of sand, wind, and a place for the sand to collect. Near the present-day town of Saint Anthony, the blowing sand encountered a lava field related to the Craters of the Moon volcanic complex to the southwest. The cracks and crevasses of the cooled lava flow trapped the sand, preventing it from blowing away. On the north side of the dunes are the Juniper Buttes—extinct and highly weathered volcanoes. Trapped by the lava field, the dunes started forming against the southern flanks of the Juniper Buttes.

Today, these dunes cover 175 square miles, in an elongated swath thirty-five miles long and five miles wide, trending to the northeast. The highest dunes, rising more than 400 feet, are still actively moving at a rate of a few feet per year. Many types of sand dunes can be created by wind, but the dunes of Saint Anthony are all barchan dunes—named for the Arabic word for a ram's horns. Barchan dunes are crescent shaped and created by winds that blow from one primary direction, with the horns of the dunes facing downwind.

From the air, the horns of the Saint Anthony Sand Dunes face northeast, primarily blown by winds from the southwest that flow steadily in the winter months. Older dunes, stabilized by plants and no longer moving, appear slightly darker on the north side of the lighter, moving dunes. The hilly formations next to the dunes are the Juniper Buttes. ▯

FLIGHT PATTERN

En route to Idaho Falls or Pocatello, Idaho; Jackson, Wyoming; or Bozeman, Montana, keep an eye out for white, rippling dunes north of Idaho Falls and Rexburg, Idaho.

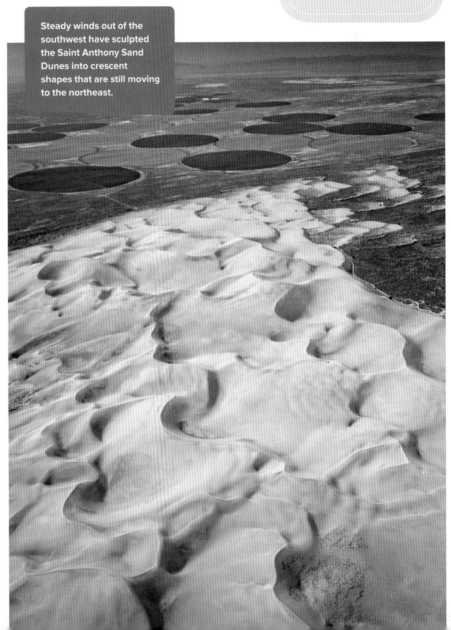

Steady winds out of the southwest have sculpted the Saint Anthony Sand Dunes into crescent shapes that are still moving to the northeast.

BEAR LAKE

📍 Idaho 📍 Utah

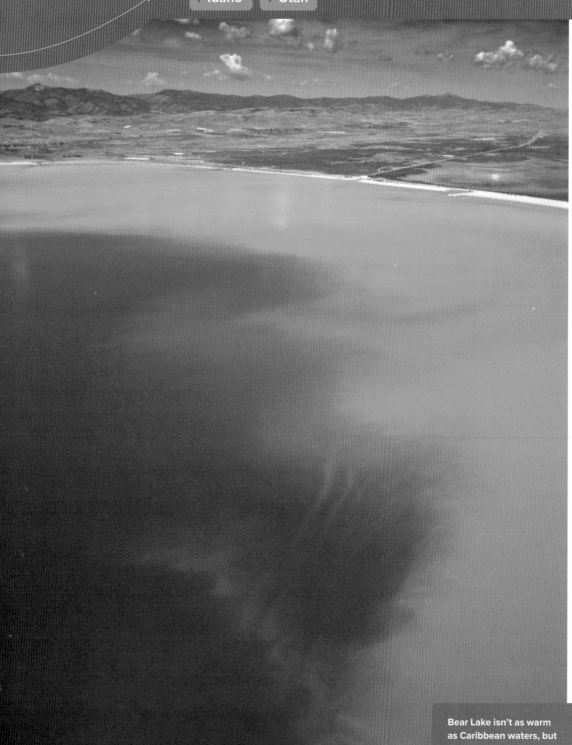

Mud Lake, at the north end of Bear Lake, acts as a sediment trap for the Bear River, helping keep Bear Lake's waters an ethereal blue.

Bear Lake isn't as warm as Caribbean waters, but thanks to all the lime-stone-rich rocks in the area, it's just as blue.

Calcium carbonate from eroded Mesozoic Era limestone creates a turquoise oasis

Peering down into the turquoise water of Bear Lake, on the border between Idaho and Utah, one might suspect a change of flight plan. You don't need a trip to the tropics, however, to swim in a sea of aquamarine. Bear Lake is nicknamed the Caribbean of the Rockies for good reason—light reflecting off minute particles of calcium carbonate suspended in the water give it a beautiful blue-green hue.

Bear Lake lies in a fault-lined valley, through which the Bear River flows out of the Uinta Mountains on its way to its terminus in Utah's Great Salt Lake. This is a half-graben valley, which means it is bounded by a fault along only one side; a full graben is a depressed block of land enclosed on two sides by parallel faults. The valley was not carved by the river—rather, the river was captured by the valley as the fault deepened over time.

The freshwater lake as we know it formed around 150,000 years ago, filling a basin once occupied by a shallow, salty sea. After the sea evaporated, runoff from the Uinta Mountains filled the basin. Around 8000 years ago, a series of movements along the faults on the eastern side of the lake resulted in its present shape and size; Bear Lake covers just over a hundred square miles. This fault system remains active today, slowly dropping the eastern floor of the lake, where depths reach only ninety or so feet.

The region is dominated by limestone deposits, laid down during the Mesozoic Era. Erosion of these layers enriches the water of Bear Lake with calcium carbonate, which reflects blue light, giving the lake its preternatural color. Phosphorus is also abundant, and these unique water conditions have given rise to an unusually high number of endemic species of fish found only in Bear Lake, including the Bear Lake strain of the Bonneville trout, the Bear Lake whitefish, and the Bear Lake sculpin. Several unique species have gone extinct in the last few decades because of manmade changes in the lake's hydrology. ▣

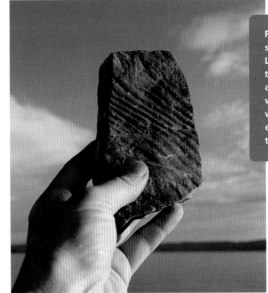

Fossilized ripples preserved in a rock along Bear Lake's shoreline hint at the area's long history as an inland sea. The ripples were sculpted into mud by water. The mud then hardened into rock, preserving the pattern.

FLIGHT PATTERN

It's hard to miss the brilliant turquoise-blue lake between southeast Idaho and northeast Utah. Salt Lake City, Utah, lies a hundred miles to the southwest.

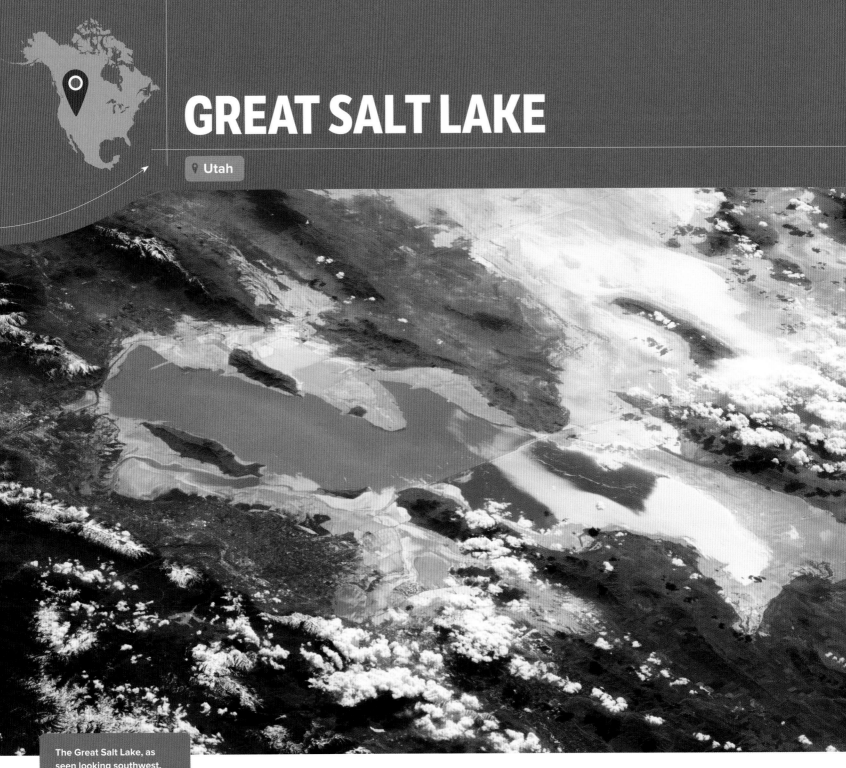

GREAT SALT LAKE

Utah

The Great Salt Lake, as seen looking southwest. The grayish pink and tan zone on the lake's north end results from a railroad trestle blocking the flow of water, creating a hyper-salty habitat where red algae thrive.

Covering 1500 square miles, Utah's Great Salt Lake is a remnant of Pleistocene-era Lake Bonneville, which occupied nearly 20,000 square miles before the last ice age. Seen from above, the Great Salt Lake is a striking mosaic of colors—some natural, some healthy, some neither.

Most of the world's lakes have at least one inlet and outlet, where water flows in, stays for a while—from hours, to months, to years—then flows out, heading downstream until it empties into an ocean. Prehistoric Lake Bonneville was a pluvial lake, a landlocked body of water that was primarily filled by rainwater during the ice age, when regional precipitation was greater. The last vestige of this massive paleolake, the Great Salt Lake, is a terminal lake, with rivers for inlets, but

Vestige of prehistoric Lake Bonneville, which once covered almost 20,000 square miles

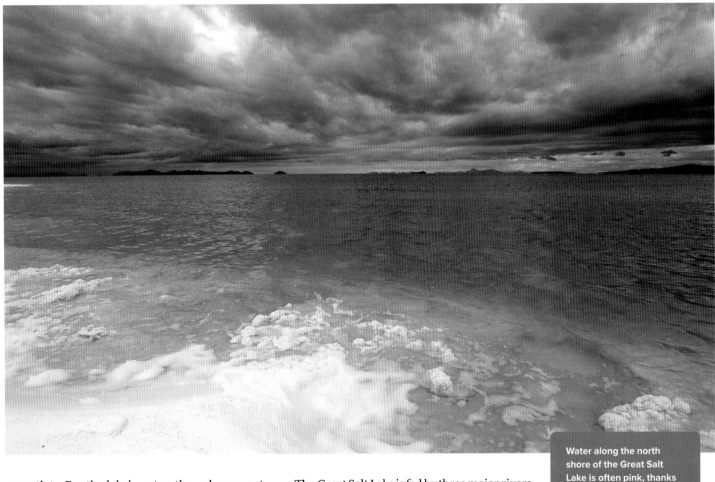

Water along the north shore of the Great Salt Lake is often pink, thanks to salt-loving microbes that thrive in the extra-saline water here.

no outlets. For the lake's water, the only way out is up, through evaporation, which leaves behind a thick-crusted layer of salt ringing a bathtub of brine that's much saltier than seawater. More remains of ancient Lake Bonneville can be seen to the south and west of the Great Salt Lake; they are now called the Bonneville Salt Flats. Here, the hard-packed salt pan left behind when Lake Bonneville dried up has created a perfectly smooth surface, on which some of the fastest land speed records have been set by daredevils driving cars, trucks, and motorcycles screaming along in excess of 600 miles per hour.

The Great Salt Lake is fed by three major rivers, the Jordan, Bear, and Weber, which dump more than a million tons of minerals into the basin each year. In recent years, prolonged drought combined with unsustainable water diversion have shrunk the lake and made it even saltier. Changing lake levels are part of the Great Salt Lake's long geologic history—geologists think some form of terminal lake has formed, evaporated, and re-formed in this region as many as twenty-eight times in the past few million years.

Today, the southern half of the lake appears as varying shades of blue, while the northern arm

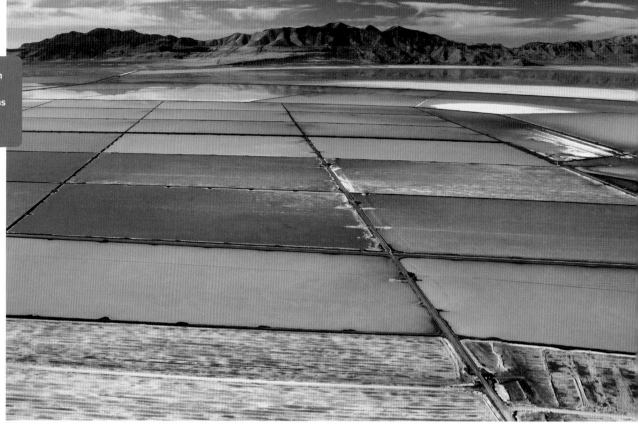

Commercial salt collection ponds create a mosaic of colorful geometric patterns around the shores of the Great Salt Lake.

FLIGHT PATTERN

The best views of the Great Salt Lake are from flights into and out of Salt Lake City, Utah, which sits on the southeastern shore of the lake. The white remnants of Lake Bonneville can be seen to the south and west of the lake.

often looks pink or red. This oddly colored northern branch is cut off from the rest of the lake by a railroad causeway, built in the 1950s, that restricts water flow and leaves the lake there too salty even for brine shrimp. Algae thrive in this stagnant water, contributing to the unearthly hue. Around the edges, manmade evaporation pools form a geometric patchwork, and salt and other minerals are gleaned as part of a billion-dollar industry.

The Great Salt Lake is sometimes called America's Dead Sea, but while it is too salty for fish, the lake is anything but dead. Despite parts of the lake being used for commercial purposes, this is one of the most vibrant bird sanctuaries in the West—an important feeding ground for migrating birds, who feast on the brine shrimp that thrive in the southern end of the lake. ▥

A salty dead-end lake has existed in northern Utah for millions of years, once covering a region two to three times the Great Salt Lake's current size. One remnant of this larger lake, Lake Bonneville, is now known as the Bonneville Salt Flats.

Preston

WYOMING

84

15

Great Salt Lake

L A K E

Odgen

80

80

Bonneville Salt Flats

Wendover

Salt Lake City

Provo

Utah Lake

B O N N E V I L L E

Nephi

Delta

15

70

Sevier Lake

NEVADA UTAH

Lund

Extent of Lake Bonneville

0 100km
0 100mi

50

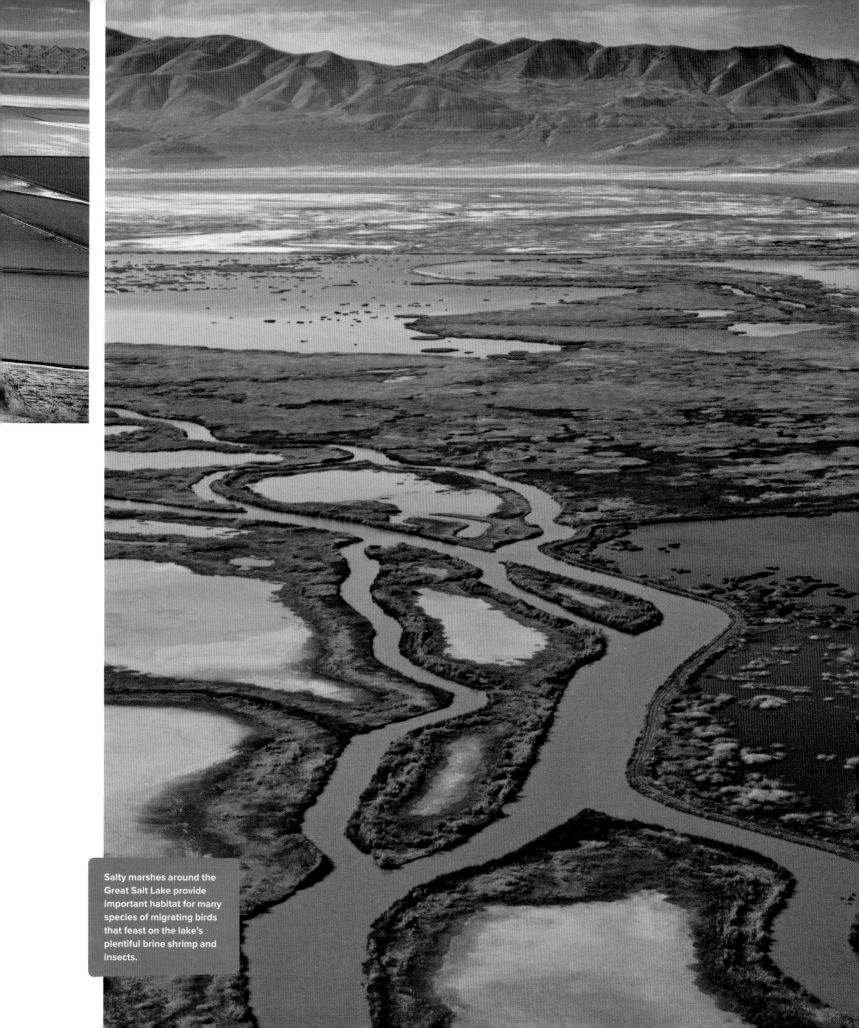

Salty marshes around the Great Salt Lake provide important habitat for many species of migrating birds that feast on the lake's plentiful brine shrimp and insects.

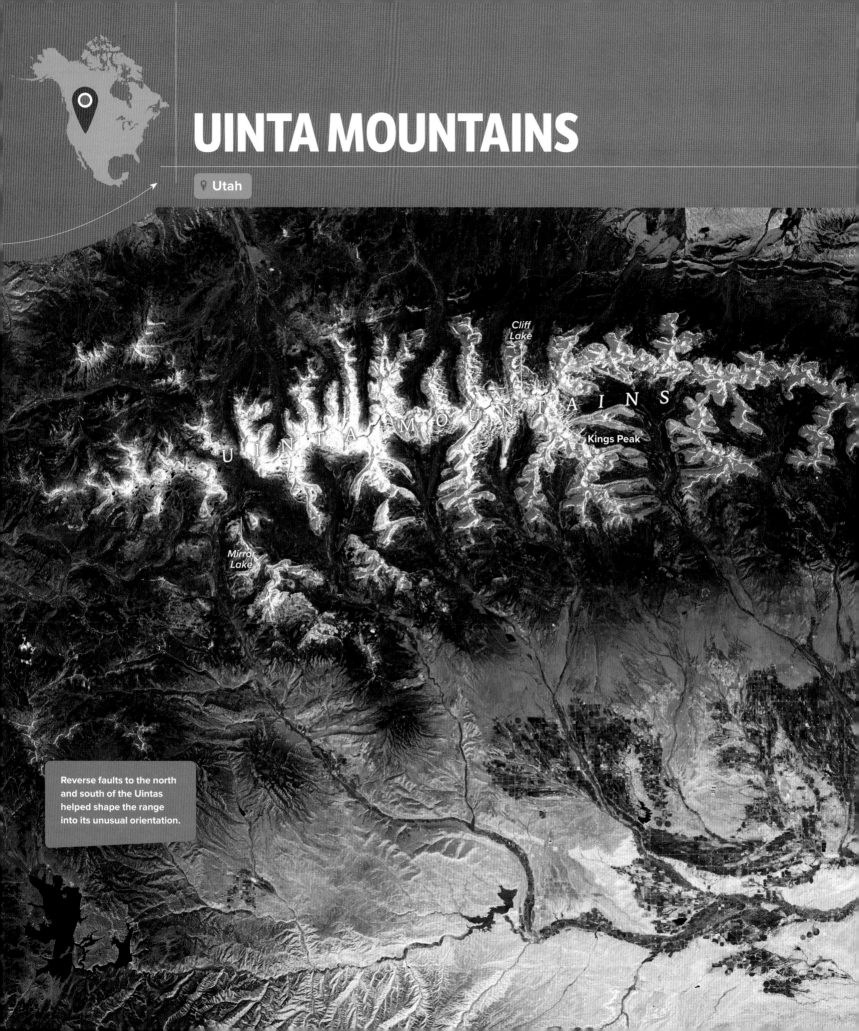

UINTA MOUNTAINS

📍 Utah

Cliff Lake

UINTA MOUNTAINS

Kings Peak

Mirror Lake

Reverse faults to the north and south of the Uintas helped shape the range into its unusual orientation.

One of the only east-west mountain ranges in North America

Most of the major mountain ranges in North America run north and south, formed along tectonic boundaries oriented in those directions. But a handful of ranges run east and west, including the Uinta Mountains in northern Utah.

The sediments that form the High Uintas, as they're sometimes known, were deposited in a basin during the breakup of the supercontinent Rodinia, around 700 million years ago. These layers of shale, slate, and quartzite were piled tens of miles thick; even after millions of years of compression and metamorphosis, the rocks still reach thicknesses of 24,000 feet. Such ancient rocks form the deep roots of the Uintas.

During the Laramide orogeny, the mountain-building episode that uplifted the Rocky Mountains between 70 and 40 million years ago, compressive forces gave rise to steeply angled reverse faults on the north and south sides of the Uinta Mountains. These faults helped direct the uplift of the range into its unusual east-west orientation. Later rotation and uplift of the Colorado Plateau, which runs along the southern boundary of the Uintas, may have also influenced their odd alignment.

The range was heavily glaciated during the last ice age; most of the large, U-shaped stream valleys on the north and south sides of the mountains were originally carved by long valley glaciers. But today, the range is the highest in the lower forty-eight states with no glaciers. Because they are located on the edge of a high desert environment, the Uinta Mountains do not receive enough snow to form permanent ice. Instead, hundreds of small lakes dot the Uintas, including the popular Mirror Lake, easily accessible from Salt Lake City on Utah State Route 150 (the Mirror Lake Highway), and the beautiful Cliff Lake, in the shadow of Notch Mountain.

The highest peaks here are made up of quartz arenite, a very hard type of sandstone that is strongly cemented by silica. Many of the range's peaks exceed 11,000 feet, such as 13,528-foot Kings Peak, the highest point in Utah.

Hikers can explore the range by way of the Uinta Highline Trail, which traverses the mountains for just over a hundred miles east and west. Much of the trail runs above 10,000 feet, well above tree line, and crosses Kings Peak. You don't have to hike the whole trail to tag Kings Peak, but there's no easy route to the top. The shortest hike, from the Henry's Fork Trailhead on the north side of the Uintas, is twenty-nine miles roundtrip—an especially arduous trek to a state high point. ▮

FLIGHT PATTERN

You might fly over the Uinta Mountains en route to Salt Lake City, Utah, which lies a hundred miles to the west of the range. Look for high mountains, usually snow-capped October through July, running east and west.

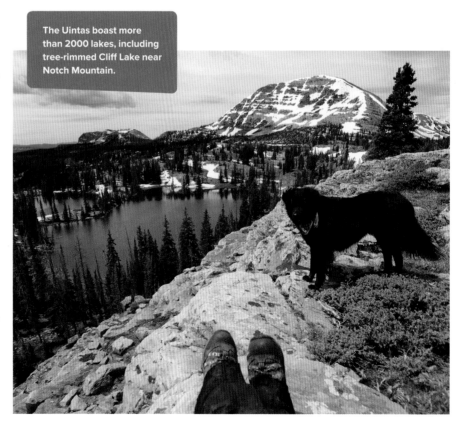

The Uintas boast more than 2000 lakes, including tree-rimmed Cliff Lake near Notch Mountain.

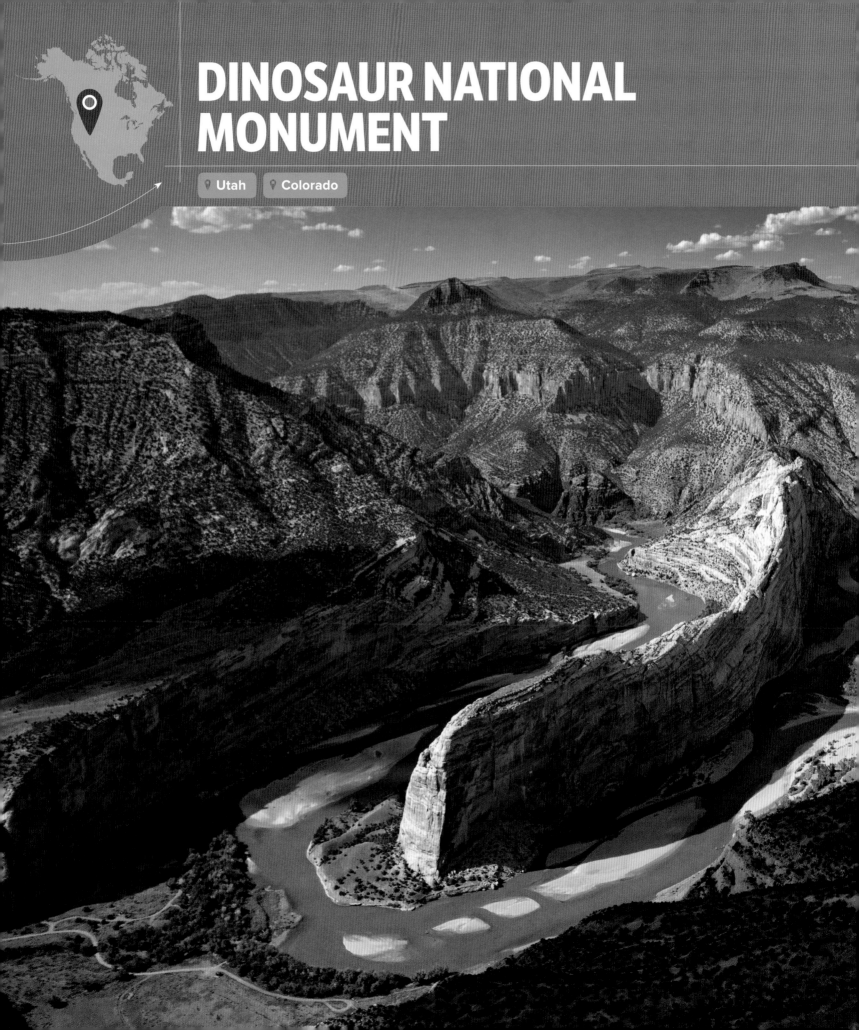

DINOSAUR NATIONAL MONUMENT

Utah Colorado

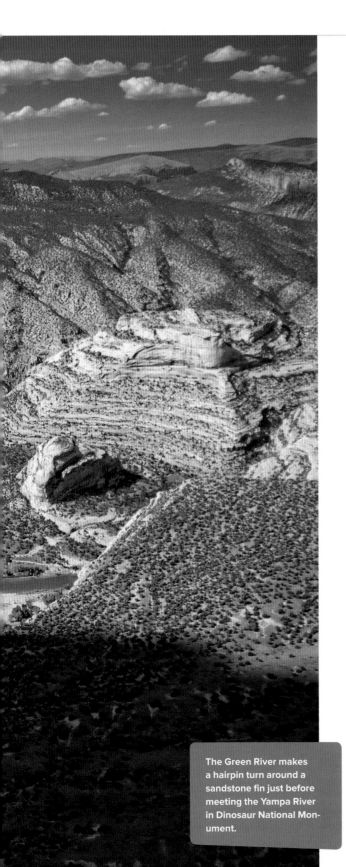

The Green River makes a hairpin turn around a sandstone fin just before meeting the Yampa River in Dinosaur National Monument.

Intact dinosaur fossils and rocks covering 1.2 billion years of Earth's history

Sedimentary layers of rock from the time of the dinosaurs are the most well-known geologic layers in Dinosaur National Monument.

Straddling the border between northeast Utah and northwest Colorado, Dinosaur National Monument is home to more than 200,000 acres of geological and paleontological bounty. Commercial airline flights are unlikely to fly over the park—the deep river canyons and high rocky ridges are located on a remote southeast flank of the Uinta Mountains. After hearing its story, though, you may want to make a point of seeing it from a more down-to-earth perspective.

Thanks to a fortuitous set of circumstances, the rock layers exposed at Dinosaur National Monument cover a remarkable span—over 1.2 billion years, from the Precambrian Era to the Miocene Epoch, the youngest dating to around 10 million years ago. Out of all the official rock layers laid down through geologic history, only three are missing from the exposed rocks at Dinosaur: the Ordovician, Silurian, and Devonian layers, wiped from the record by erosion. The twenty-three layers that are visible make up the most complete exposed stratigraphic column within the

FLIGHT PATTERN

Dinosaur National Monument is located in a secluded area of eastern Utah and northwest Colorado. You could fly over it en route to Salt Lake City, Utah.

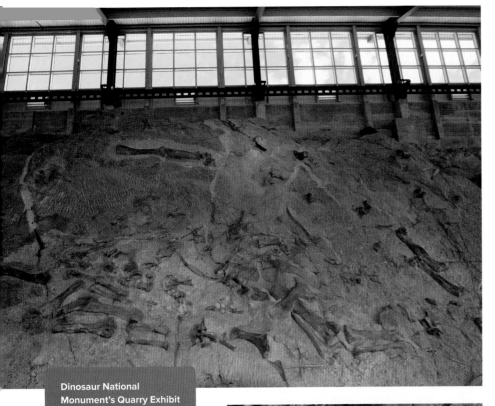

Dinosaur National Monument's Quarry Exhibit Hall allows visitors to see dinosaur fossils preserved in place, likely washed into a jumbled mass by floodwaters.

A petroglyph of a dinosaur-like reptile suggests that Native Americans were aware of the fossils in the area long before they were discovered by modern paleontologists.

U.S. National Park system. As evidenced by the site's name, the most famous layers on display at Dinosaur National Monument are those from the Mesozoic Era—the time of the dinosaurs.

All that exposure is the work of the Green and Yampa Rivers, which meet in the monument. As the land was uplifted during the Laramide orogeny, which built the Rocky Mountains, and during later episodes of regional uplift of the Colorado Plateau, the rivers continued to cut downward through layers, exposing the park's impressive stratigraphy.

Dinosaur bones were first discovered in the area in the late 1800s, but petroglyphs of dinosaur-like reptiles found in the area suggest that ancient people were also curious about the large bones they found weathering out of the Mesozoic layers. In the early years of exploration, more than 350 tons of fossils were removed from the quarries in the area and shipped east, most to the Carnegie Museum of Natural History in Pittsburgh, Pennsylvania, where many are still on display.

The 800-plus quarries in the area, some of which are still actively mined, are famous not just for the quantity of fossils they have produced, but for the diversity of species represented and the quality of preservation. A wide range of dinosaurs have been uncovered here, from giant carnivores such as Allosaurus and massive sauropods with long whip necks and tails, to vegetarians like Stegosaurus and tiny bird-like species.

Most of the fossils appear to have collected in ancient river beds, where dead animals were entombed in sediment that was later deeply buried and lithified into rock, preserving the bones as mineralized fossils. Despite this potentially chaotic method of burial, a few skeletons have been found fully intact and articulated—with all bones in place. Other quarries have uncovered jumbled masses of fossils from many different species, possibly washed together in flash floods. An example of this kind of burial can be seen in the Dinosaur Quarry visitor center on the Utah side of the park. The building was constructed around the Quarry Exhibit Hall, a trove of 1500 dinosaur bones that have been preserved in place, as they were found.

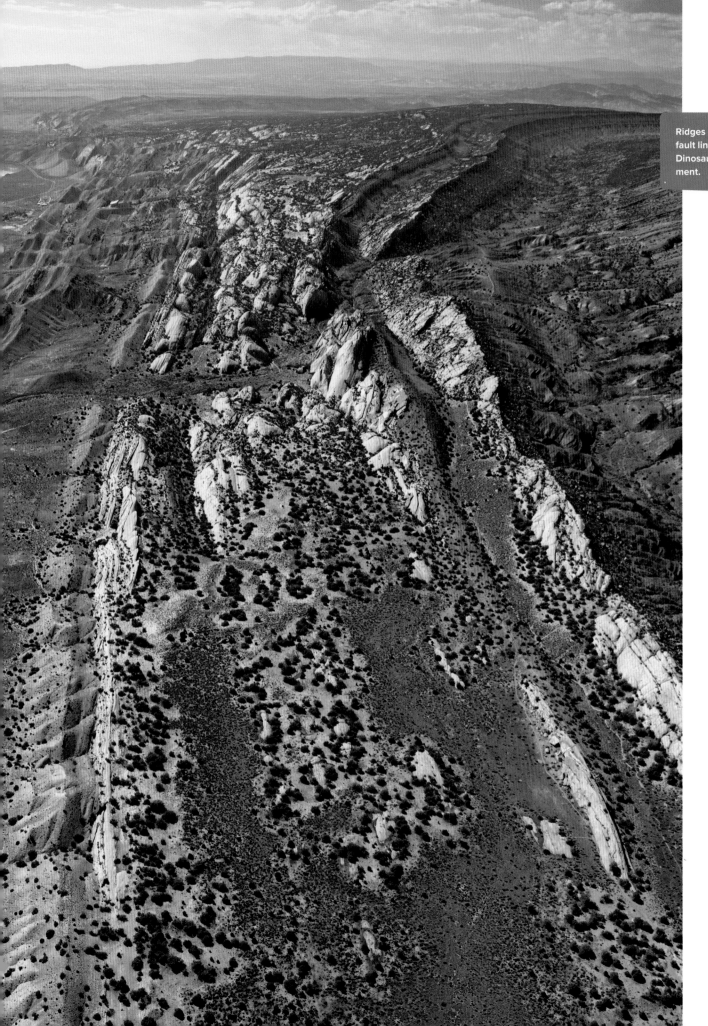

Ridges of rock run along fault lines in the vicinity of Dinosaur National Monument.

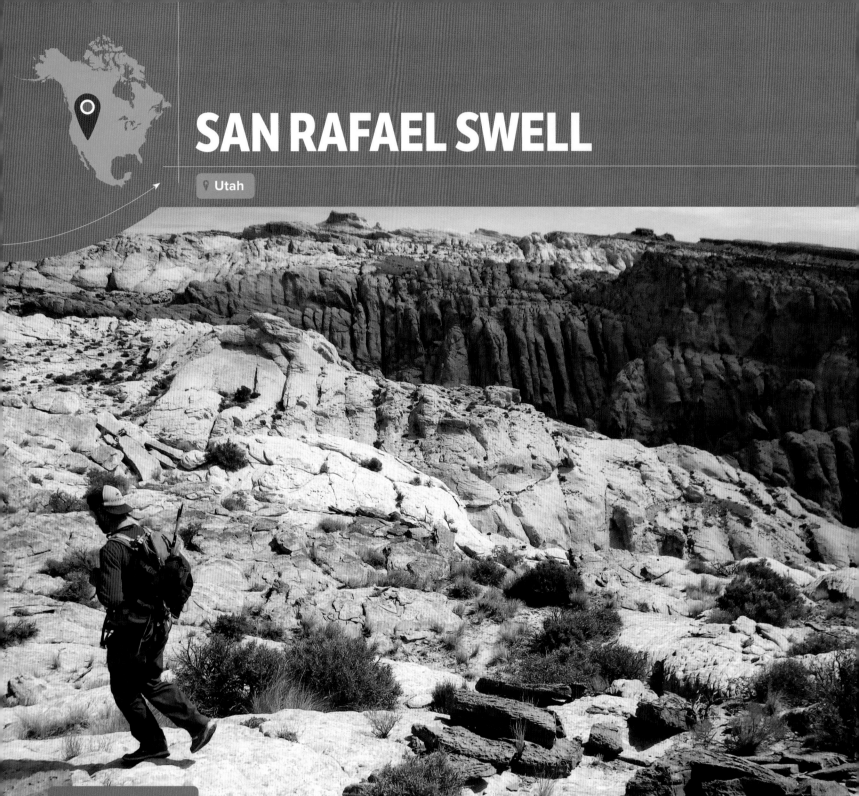

SAN RAFAEL SWELL

Utah

Few established trails lead to the interior of the swell and the confusing landscape is best left to expert navigators.

Utah has its fair share of national parks, but one of the most spectacular landscapes in the state isn't a national park or even a national monument. The San Rafael Swell, located about sixty miles due west of Moab, is an uplifted dome of sandstone, shale, and limestone, seventy miles long and forty miles wide. You can spot the dome from the air—its white, jagged teeth jut out of the desert just south of Interstate 70—in country so intimidating, there's never been a need for federal protection from development.

Fold in planet's crust with cracks forming deep slot canyons

An uplifted dome of many layers of sandstone underlies the San Rafael Swell, which has been deeply dissected by slot canyons carved by flash floods.

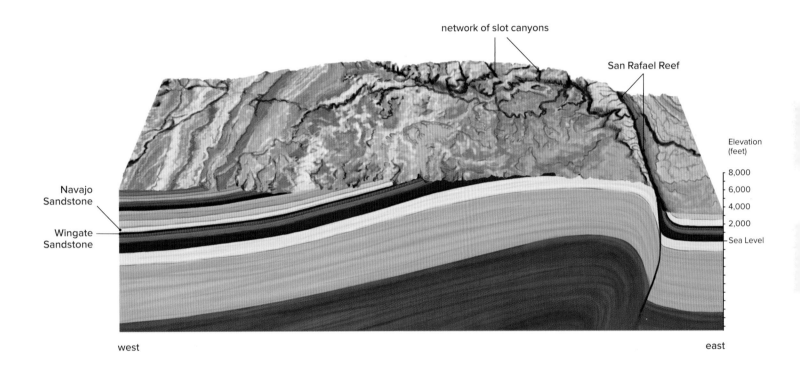

network of slot canyons

San Rafael Reef

Navajo Sandstone

Wingate Sandstone

Elevation (feet)

- 8,000
- 6,000
- 4,000
- 2,000
- Sea Level

west

east

In geologic terms, the San Rafael Swell is an anticline: an upwarped fold in the crust that looks like a dome when viewed in cross section. The rocks of the swell formed around 160 million years ago, after the region's inland sea had evaporated. Between 70 and 40 million years ago, when the Rocky Mountains were rising to the east, the San Rafael Swell was uplifted by the same forces working deep in the planet's mantle. As the top and sides of the dome split and fractured, rainwater found its way into the cracks, eroding them deeper and forming a convoluted network of slot canyons that drain the swell, some only a few feet wide but hundreds of feet deep.

The eastern side of the swell, the San Rafael Reef, is the most dramatically angled and fractured part of the dome. Made up of steeply tilted layers of erosion-resistant white Navajo Sandstone and red Wingate Sandstone, these hard rocks have formed into upright fins, sheer cliffs, and deep canyons.

A few of the reef's slot canyons are passable on foot, but others require technical rappelling gear to navigate their twisting corridors. The best beginner slots are Ding, Dang, Little Wild Horse, and Bell Canyons, with Music and Eardley Canyons requiring ropes, harnesses, rappelling racks, and route-finding experience. The danger of flash

FLIGHT PATTERN

You might fly over the San Rafael Swell en route to Salt Lake City or Moab, Utah.

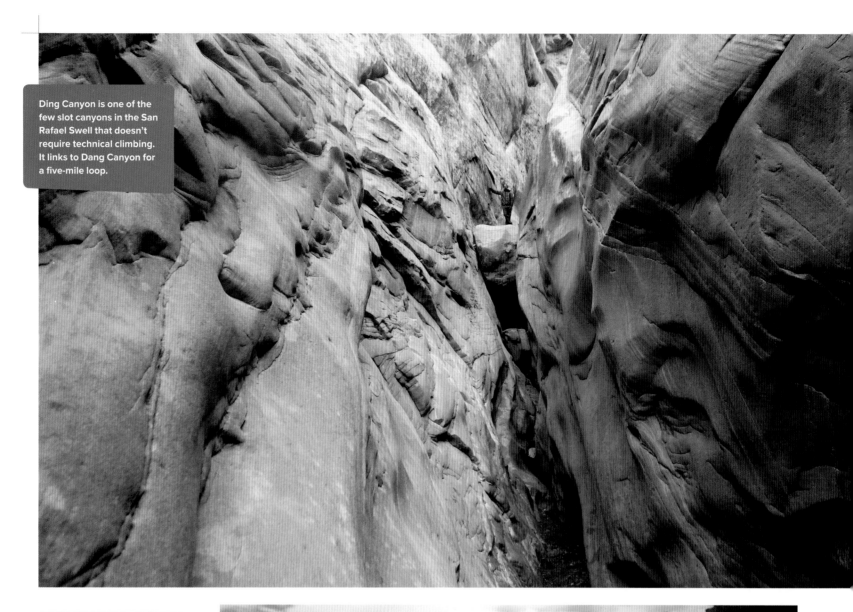

Ding Canyon is one of the few slot canyons in the San Rafael Swell that doesn't require technical climbing. It links to Dang Canyon for a five-mile loop.

Rippled sandstone forms when water creates ripples in mud (suggesting the area was once an inland sea), and the mud hardens into stone.

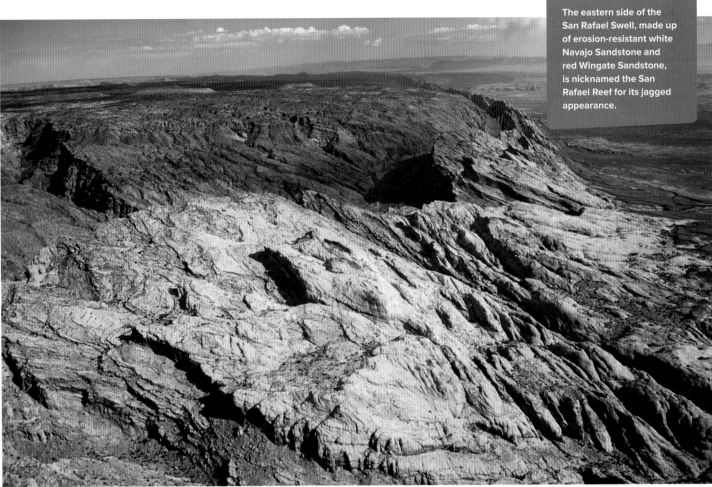

floods in these canyons is high, with no chance of escape from rising waters. Slots can flood even when blue skies are directly overhead. Fast-moving thunderstorms hit miles away, sending water rushing downhill, funneling into the slots.

The rest of the San Rafael Swell can also be explored on foot, and by navigating the maze of tilted layers with all-terrain vehicles on a few roads and trails, including Behind the Reef Road. Parts of the swell have appeared in movies as stand-ins for Mars and other exotic worlds. The Mars Society, dedicated to the exploration and human settlement of the Red Planet, has a Mars Desert Research Station in the San Rafael Swell, where they run survival simulations and conduct research projects. ▮

UPHEAVAL DOME

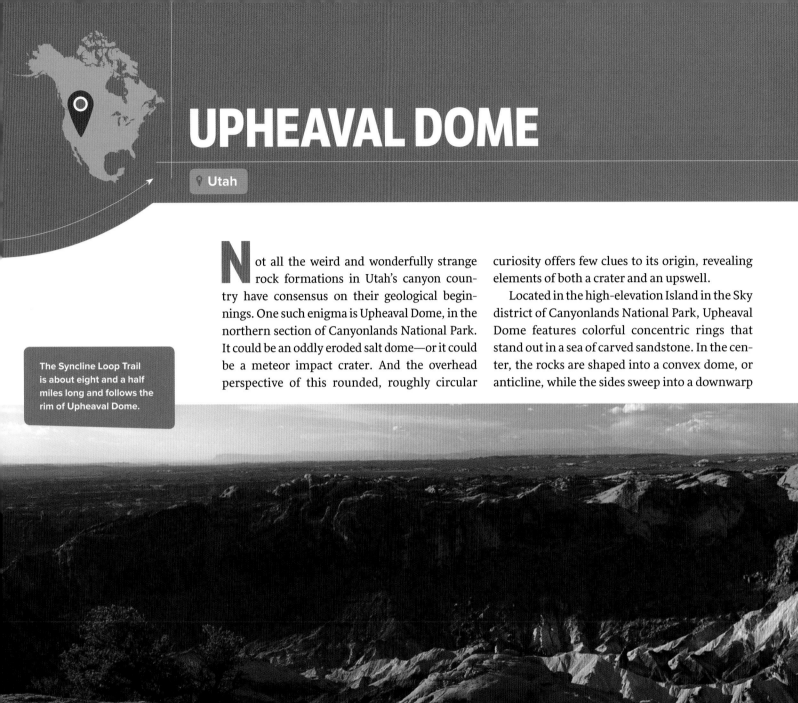

The Syncline Loop Trail is about eight and a half miles long and follows the rim of Upheaval Dome.

Not all the weird and wonderfully strange rock formations in Utah's canyon country have consensus on their geological beginnings. One such enigma is Upheaval Dome, in the northern section of Canyonlands National Park. It could be an oddly eroded salt dome—or it could be a meteor impact crater. And the overhead perspective of this rounded, roughly circular curiosity offers few clues to its origin, revealing elements of both a crater and an upswell.

Located in the high-elevation Island in the Sky district of Canyonlands National Park, Upheaval Dome features colorful concentric rings that stand out in a sea of carved sandstone. In the center, the rocks are shaped into a convex dome, or anticline, while the sides sweep into a downwarp

Meteor impact crater or eroded salt dome? Even geologists aren't sure.

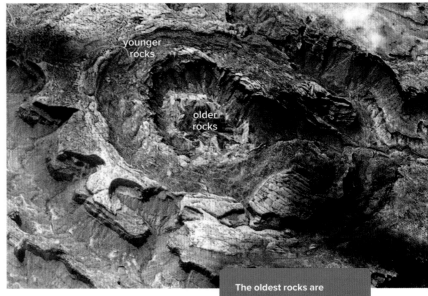

called a syncline, with the whole structure measuring an impressive three miles across. What could have caused these unusual folds in the rock?

There are two competing theories regarding Upheaval Dome's creation. The first is the salt dome theory. Much of Canyonlands National Park and southeastern Utah is underlain by a thick layer of salt, formed during the Cretaceous

The oldest rocks are exposed in the center of Upheaval Dome, with the youngest rocks at the sides, a structure that could support the salt dome theory of formation.

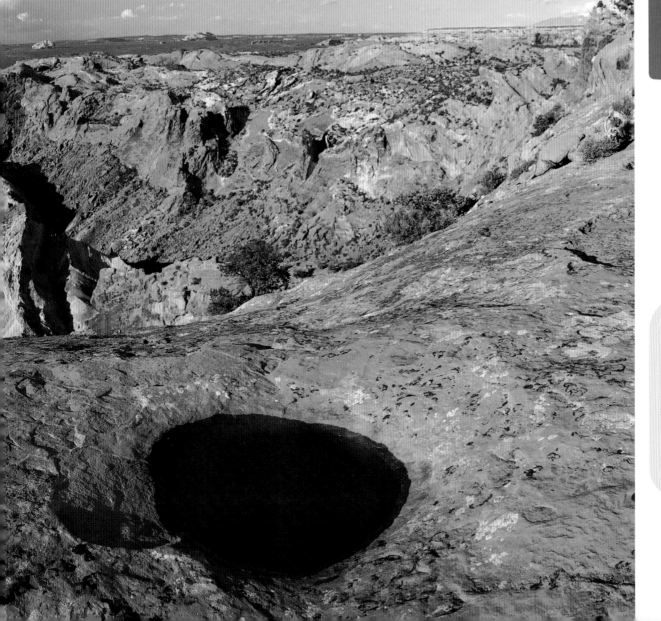

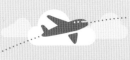

FLIGHT PATTERN

You could view Upheaval Dome on a scenic flight out of Moab, Utah. Look for concentric rings in a sea of canyon-carved sandstone.

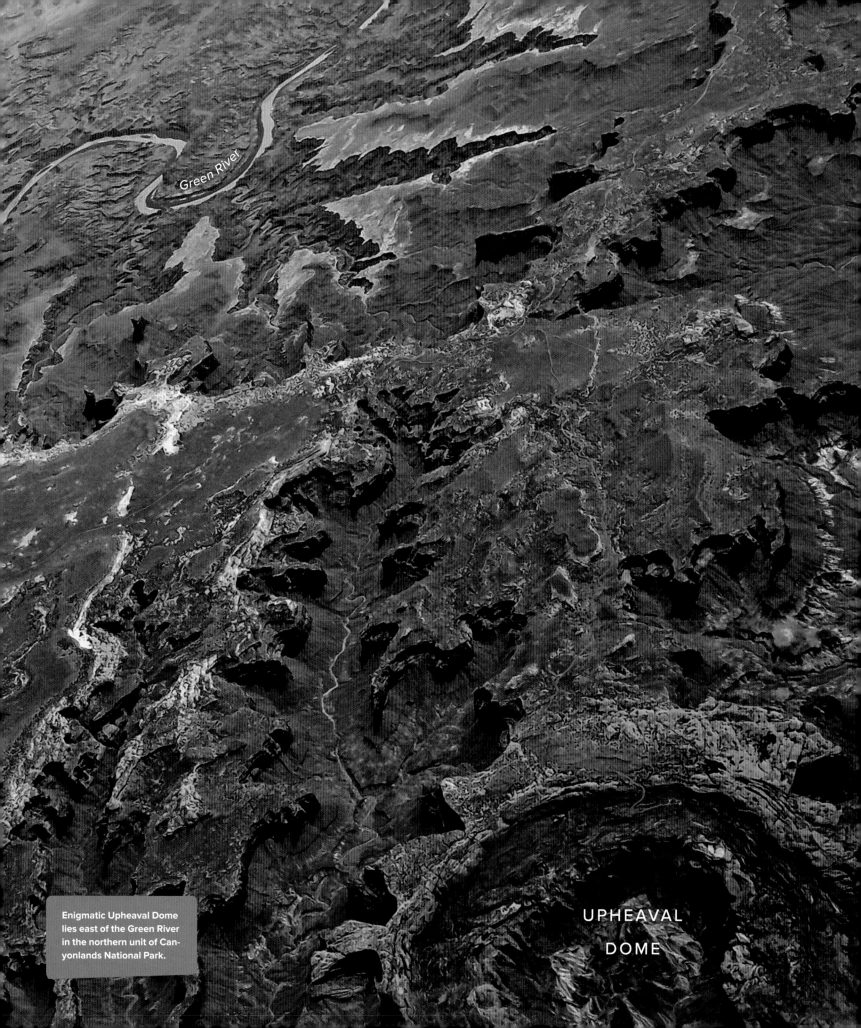

Green River

Enigmatic Upheaval Dome lies east of the Green River in the northern unit of Canyonlands National Park.

UPHEAVAL DOME

Impact Crater

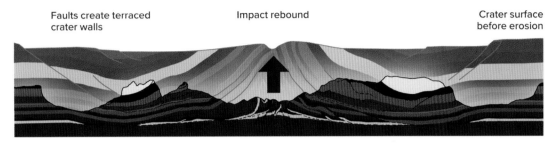

Faults create terraced crater walls

Impact rebound

Crater surface before erosion

Salt Dome

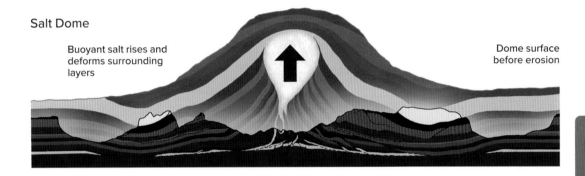

Buoyant salt rises and deforms surrounding layers

Dome surface before erosion

Two competing theories of how Upheaval Dome formed could both produce similar structures on the surface.

Period, when this region was inundated by shallow seas. Under pressure, salt deposits can behave strangely, flowing like slow-moving water or glacial ice. Salt is less dense than sandstone and over time, it can rise through the layers, deforming the overlying rock into a dome at the surface.

But while the salt dome theory is a perfectly reasonable explanation for how such an odd formation could develop here, some geologists think that more exotic forces created the concentric rings—Upheaval Dome could also be the highly eroded crater left by a meteor impact.

Based on the age of the layers in the dome and the pattern of erosion, geologists estimate that a meteorite about 1000 feet in diameter may have hit

the site between 100 million and 60 million years ago. This impact could have created an unstable crater in the relatively soft rock that may have partially collapsed in on itself. When violent impacts occur, the rocks at the center of the impact zone sometimes rebound into a dome shape because of the rapid expansion of superheated rocks.

Most of the scientific studies that have been conducted at the dome in recent years seem to support the meteor impact theory, including seismic refraction and detailed mapping of the rock layers. In 2008, a team found samples of shocked quartz near the dome, suggesting that the rocks had been subjected to the kind of extreme conditions created only by a large impact. ▪

CANYONLANDS NATIONAL PARK

Utah

A thunderstorm sweeps across Canyonlands National Park, possibly setting off flash floods. Most of the annual rainfall here comes during the late-summer monsoon season.

Utah's canyon country is the thickest, richest, most deliciously exposed layer cake in North America. On the ground, the intricate network of canyons, side canyons, box canyons, cliffs, and spires can be all but impassable to even the most sure-footed bighorn sheep. Seen from altitude, Canyonlands National Park reveals its sinuous secrets, carved by millions of years of artful erosion.

The many multicolored layers of rock, sand, and earth that make up this terrain were deposited over a period of 250 million years, between the Pennsylvanian and Cretaceous Periods, during much of which the now-arid Southwest was covered by an inland sea. After the sea retreated, it

A snarl of gorges, spires, and natural bridges carved by erosion

left behind a flat, low-elevation plain of buried sandy sediments that gradually compressed and solidified into sandstone.

Around 25 million years ago, the continuing formation of the Rocky Mountains, a hundred miles to the east, uplifted much of southeastern

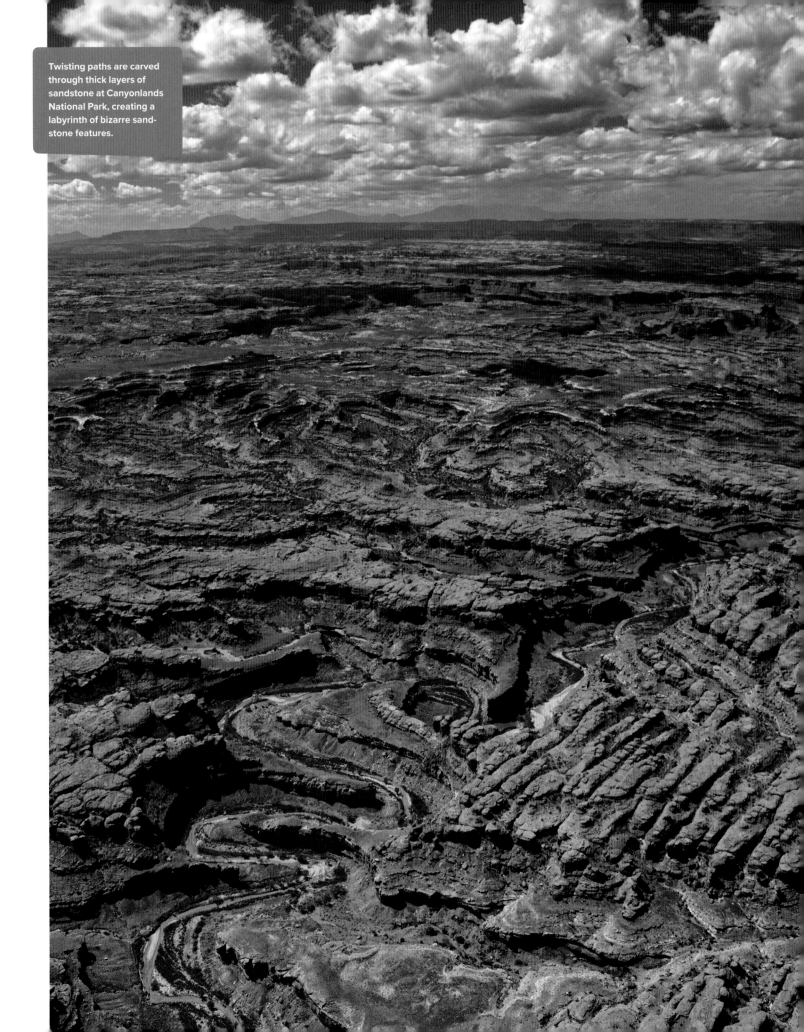

Twisting paths are carved through thick layers of sandstone at Canyonlands National Park, creating a labyrinth of bizarre sandstone features.

Utah as well, boosting it several thousand feet higher in elevation. Volcanic activity triggered by this uplift sprouted three major mountain ranges: the La Sal, Henry, and Abajo Mountains. And then the rains came. As the mountains spawned an increase in precipitation, rainwater began flowing over the layers of buried sediments, carving the soft sandstone into a network of rivers and gorges that would become this true land of canyons.

Today the area is affectionately known as Red Rock Country, but the many layers of sandstone also come in pink, yellow, orange, and white. Different types of sandstone erode at various rates, and this creates strange landforms like arches, spires, balanced rocks, and natural bridges. As softer layers of rock are eroded away, more stubborn layers form cliffs and shelves, giving the whole region a stair-step appearance best appreciated from above.

Two major rivers, the Green and the Colorado, meet in the heart of Canyonlands National Park, with thousands of seasonal tributaries and side canyons creating a bizarre landscape with place names such as Island in the Sky, the Maze, and Cleopatra's Chair. Exploring them all would take a lifetime, a reliable four-wheel-drive vehicle, and several pairs of sturdy boots. ▥

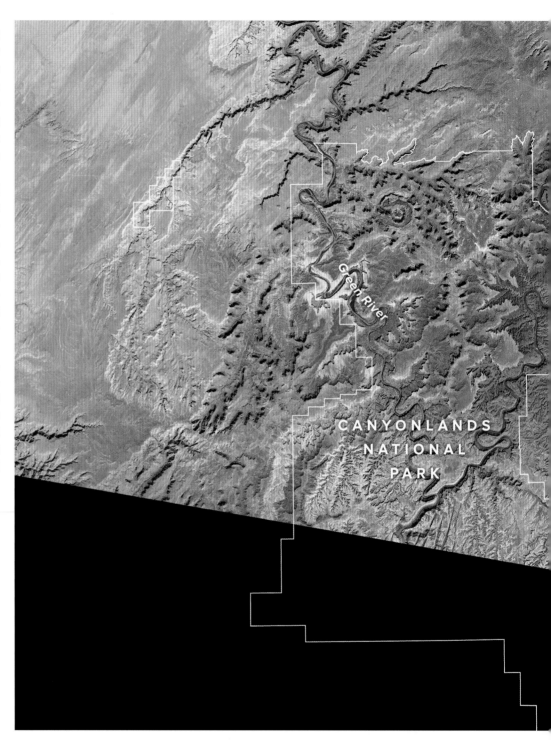

FLIGHT PATTERN

From the air, Red Rock Country does indeed appear red, with a network of canyons snaking across the landscape. You might be able to pick out the Green and Colorado Rivers, and where they meet in the heart of Canyonlands National Park. Look for the Canyonlands en route to Moab or Salt Lake City, Utah; Las Vegas, Nevada; or Grand Junction, Colorado.

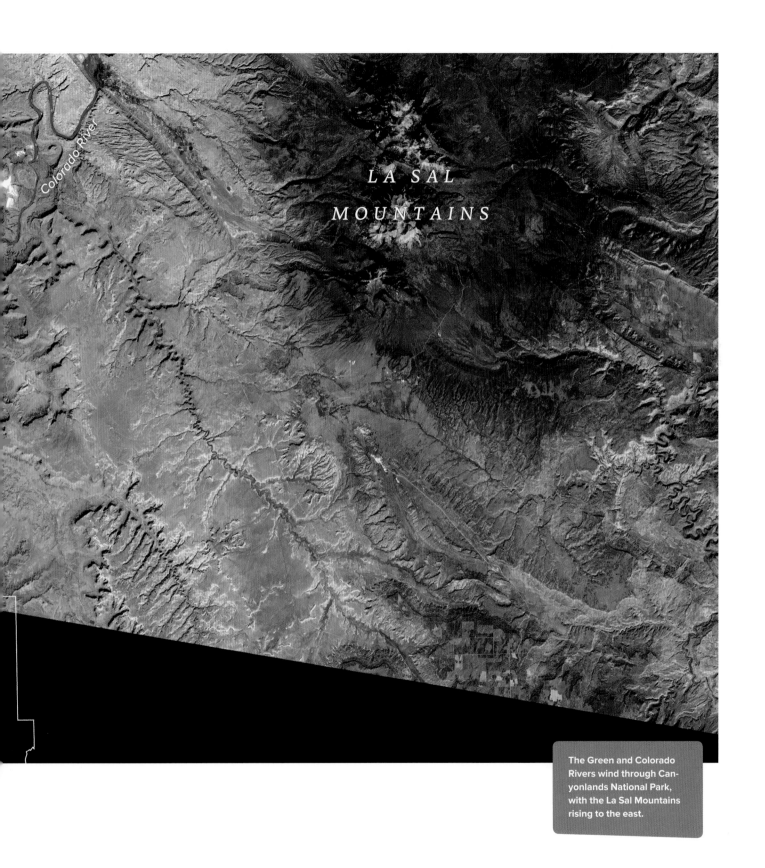

Colorado River

LA SAL
MOUNTAINS

The Green and Colorado Rivers wind through Canyonlands National Park, with the La Sal Mountains rising to the east.

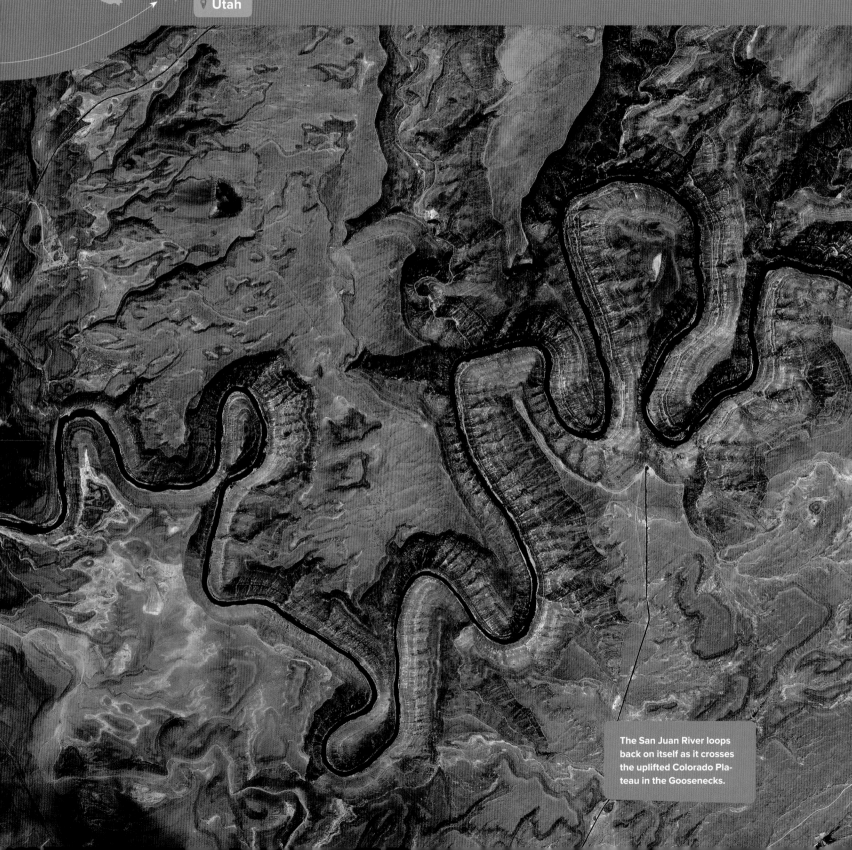

GOOSENECKS

📍 Utah

The San Juan River loops back on itself as it crosses the uplifted Colorado Plateau in the Goosenecks.

Once a flat-bottomed valley, until land rose around a twisting river

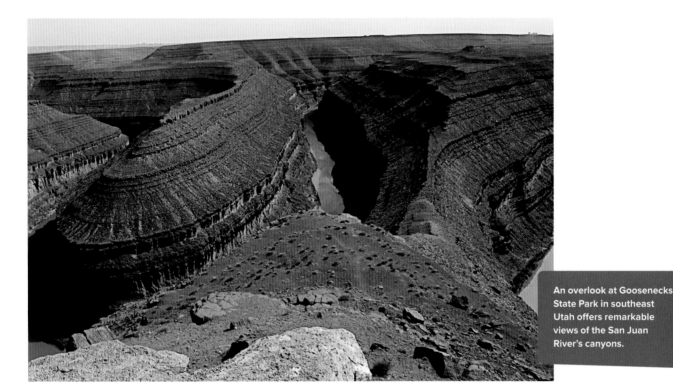

An overlook at Goosenecks State Park in southeast Utah offers remarkable views of the San Juan River's canyons.

Open a geology textbook to the term "entrenched meander" and you'll likely see a picture of Utah's Goosenecks State Park. Here, the San Juan River has carved a series of tightly wound loops through the hard, erosion-resistant sandstone, giving the Goosenecks their name. As the crow flies, the formation is only a mile and a half across, but as the San Juan River flows, doubling back on itself several times, more than six miles are covered before the waterway heads west to meet the Colorado River and Lake Powell, thirty-five miles downstream. In flight, look for hairpin turns in the river to the east of Lake Powell, the long, flooded corridor in south central Utah.

The Goosenecks started out in a very different landscape—a flat-bottomed valley where the ancient river was free to wander back and forth. Starting around 60 million years ago, during the Laramide orogeny, the Colorado Plateau went through a period of regional uplift, and the land rose around the winding river, leaving the flow trapped in its twisting loops. Over time, the plateau has been uplifted even higher and the river has continued to carve its course, now entrenched more than 1000 feet.

The rocks that make up the Goosenecks are 300 million years old and fossils from this region's past life as an inland sea can be found along the Honaker Trail, which runs from the Goosenecks overlook down to the river. This unmarked, hard-to-follow trail began as a supply route for gold miners in the area; now it is most often frequented by bighorn sheep, geologists, and geology students. ■

FLIGHT PATTERN

Look for the trademark twists and turns that identify the Goosenecks of the San Juan River en route to Moab, Utah, or Durango, Colorado.

GRAND STAIRCASE

Utah

Lake Powell

KAIPAROWITS

PLATEAU

GRAND CANYON

CANYONS
OF THE
ESCALANTE

Looking south across the
Kaiparowits Plateau toward
Lake Powell and the Grand
Canyon, in the distance.

Descending terrain shaped by earthquakes, fault drops, crust folds, and erosion

With its labyrinth of canyons, southern Utah's landscape can seem chaotic. One helpful way to visualize the geology of this region, especially from an aerial viewpoint, is to think of it as a staircase of mesas, plateaus, cliffs, and canyons that decreases in elevation from Brian Head Peak, at 11,300 feet, to the floor of the Grand Canyon, at 2200 feet. In between, the landscape drops dramatically from north to south in a series of steps, each with a different underlying geology that has eroded and evolved in its own unique patterns.

Brian Head Peak, a popular Southwest skiing destination, is known as the top step of the Grand Staircase. Between Cedar City, Utah, in the valley to the west, and Brian Head, the landscape swoops steeply upward more than 4000 feet along the Hurricane Fault, the largest earthquake fault in southern Utah. This dramatic fault scarp, known as the Hurricane Cliffs, formed after repeated earthquakes over the last million years. Each major quake dropped the west side of the fault five to ten feet, with more events expected in the future.

Moving down the Grand Staircase from Brian Head Peak, the next section of the staircase can be grouped into three regions: (1) the highlands of Bryce Canyon, Cedar Breaks, and the Paunsaugunt Plateau, (2) the long, ridge-running step of the Kaiparowits Plateau (also known as Fifty Mile Mountain), divided from north to south by the folded-over, 150-mile-long monocline known as the Cockscomb, and (3) the lower canyons of the Escalante, which drain the higher elevations and often take the form of deep, narrow slot canyons. From there, the staircase descends over the

131

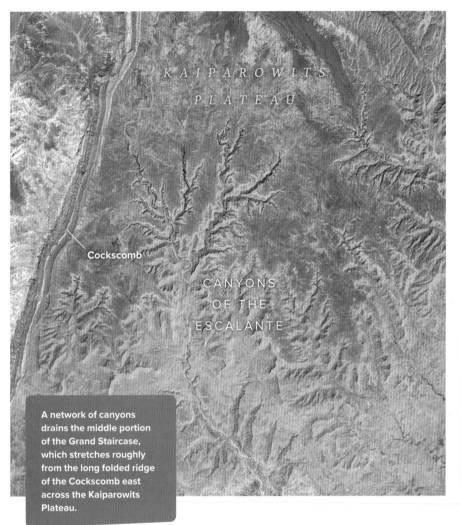

KAIPAROWITS PLATEAU

Cockscomb

CANYONS OF THE ESCALANTE

A network of canyons drains the middle portion of the Grand Staircase, which stretches roughly from the long folded ridge of the Cockscomb east across the Kaiparowits Plateau.

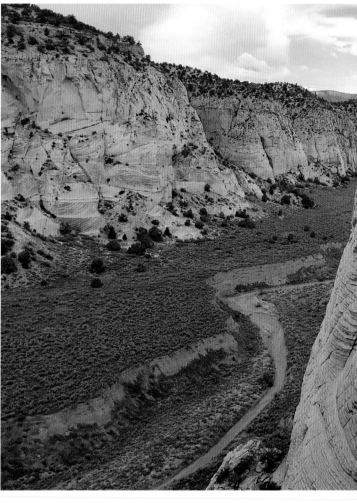

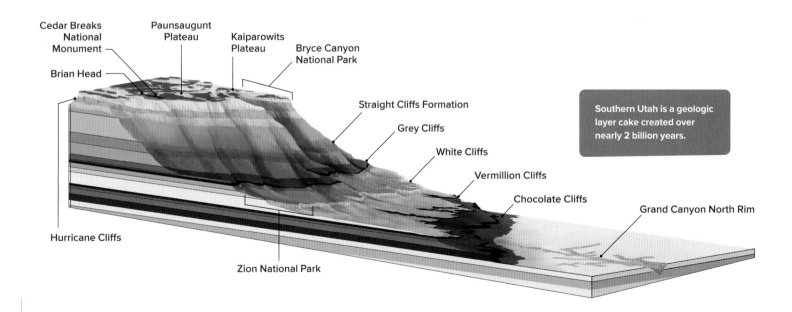

Cedar Breaks National Monument

Paunsaugunt Plateau

Kaiparowits Plateau

Bryce Canyon National Park

Brian Head

Straight Cliffs Formation

Grey Cliffs

White Cliffs

Vermillion Cliffs

Chocolate Cliffs

Grand Canyon North Rim

Hurricane Cliffs

Zion National Park

Southern Utah is a geologic layer cake created over nearly 2 billion years.

The lower canyons of the Escalante drain much of southern Utah toward the Grand Canyon.

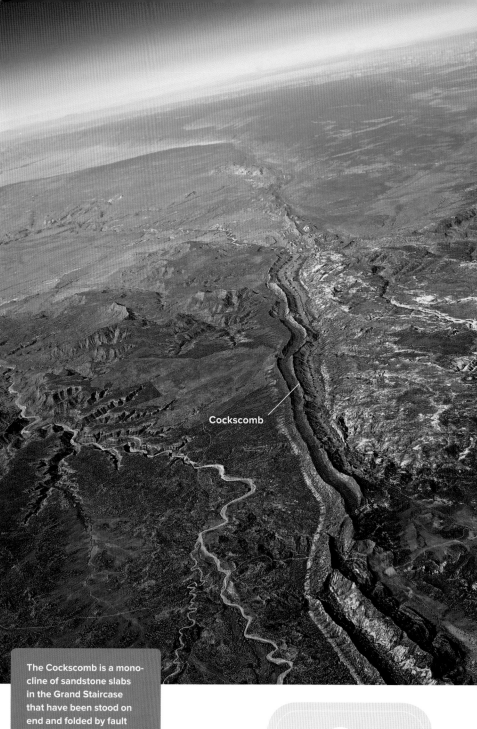

Cockscomb

The Cockscomb is a mono-cline of sandstone slabs in the Grand Staircase that have been stood on end and folded by fault movement, forming a long, colorful hogback.

Vermilion Cliffs, down the Chocolate Cliffs, and on to the North Rim of the Grand Canyon. All told, this super-sequence of sedimentary rock layers spans more than 2 billion years of geologic time.

This region remains some of the most rugged country in the lower forty-eight states, with few highways linking a maze-like network of rough dirt roads and trails that frequently dead-end at impassable cliffs. In 1996, nearly 2 million acres of the Grand Staircase were preserved as Grand Staircase-Escalante National Monument, which encompasses three main regions: the Grand Staircase, the Kaiparowits Plateau, and the Canyons of the Escalante. A number of other national monuments and parks define the area as well, including Bryce Canyon National Park, Cedar Breaks National Monument, and Vermilion Cliffs National Monument. ▪

FLIGHT PATTERN

The Grand Staircase may be visible en route to Saint George, Utah, or on one of the many scenic charter flights offered in this rough-hewn corner of the world, which is often best explored from the air.

133

ZION NATIONAL PARK

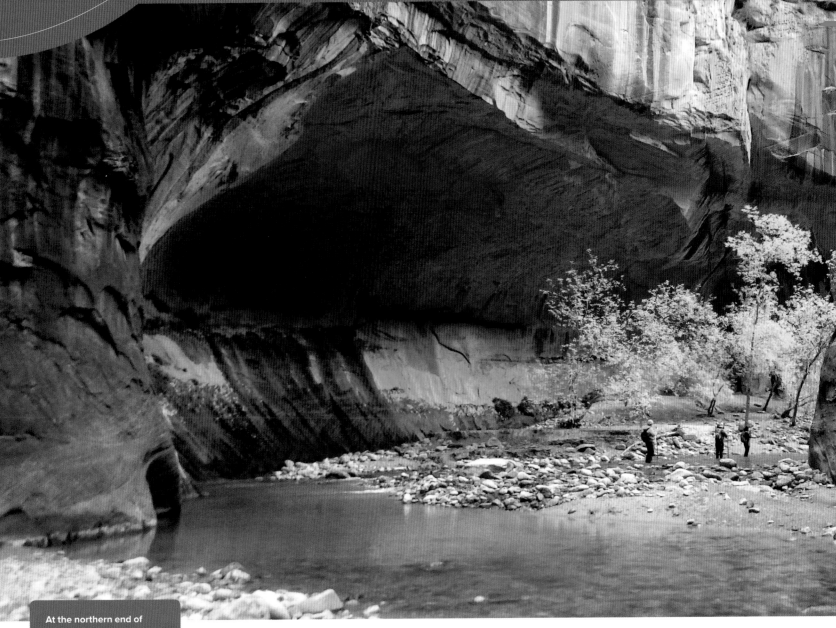

At the northern end of Zion Canyon, the Virgin River has etched a deeply incised route known as the Narrows.

A yawning, magnificent tangle of soaring cliffs and sheer canyons on the edge of the Colorado Plateau, Zion National Park is one of the most renowned steps on the Grand Staircase. Zion sits midway down the staircase, in a canyon carved by the Virgin River. The setting is so picturesque, it was named for the Mormon connotation of heaven on earth.

The Colorado Plateau is a massive region, covering much of the Four Corners sector of Utah,

Canyon cut by river's powerful torrent, deepening 1300 feet every million years

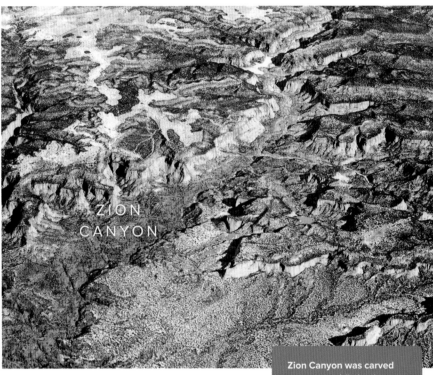

Zion Canyon was carved out very rapidly by the Virgin River, leaving many side canyons hanging high above the main canyon.

Colorado, New Mexico, and Arizona—an area that has been uplifted, tilted, and eroded into a jungle of high desert canyons not found anywhere else on Earth. This region was once an inland sea, where sediments settled over many millions of years, in some places 10,000 feet thick. When the sea dried up, the desert moved in, and an ocean of shifting sand dunes took its place. After being lithified into sandstone by time, heat, and pressure, these layers now represent 150 million years of mostly Mesozoic-aged rock, divided into multiple formations, each with its own distinctive colors, textures, and erosive patterns.

At one time, all these layers were flat and hidden deep in the crust. But starting around 20 million years ago, during one of several episodes of regional uplift, the entire Colorado Plateau raised as high as 10,000 feet. This extreme change in elevation steepened the angle of the streams draining the region, boosting their erosive power as they ran over the landscape. One of the rivers that became exponentially more powerful was the Virgin River, the north fork of which cuts

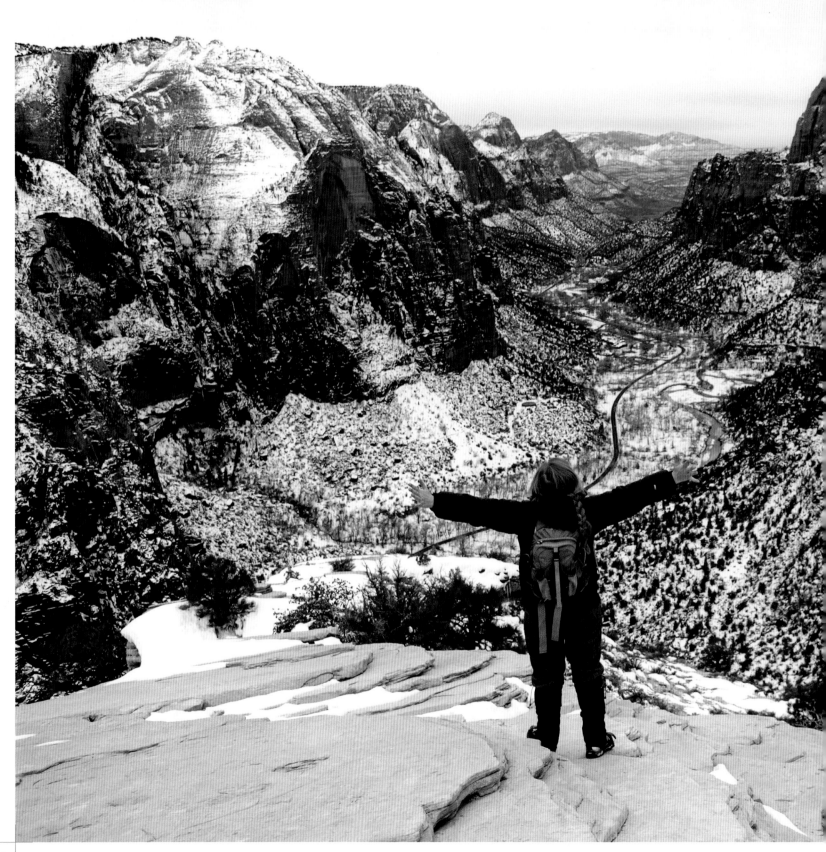

The view from Angel's Landing, one of Zion National Park's most well-known formations, looks right down the gut of Zion Canyon.

through Zion Canyon as it flows off the edge of the Colorado Plateau.

The first pulse of this period of heightened erosion erased all the more recent rock from Zion, scraping away more than 6000 feet of stone and sediment from the last 60 million years of deposition from the Cenozoic Era. Late Cretaceous Dakota Sandstone was left as the youngest exposed layer in Zion. The erosive force of the Virgin River became even more powerful in the last million years, when over half the downcutting of the canyon took place. In that time, the canyon has deepened by more than 1300 feet, creating the upper canyon that is the heart of the national park. This high rate of carving continues today—in excess of 3 million tons of rock and sediment are carried downstream toward the Colorado River each year.

The Virgin River eroded its main channel much faster than the waterways that empty into it eroded their channels, leaving side canyons hanging high above the Virgin River Valley. These tributaries often end in waterfalls plunging from dizzying heights above the main canyon—cascading spectacles such as Emerald Falls and Mystery Falls, which help make Zion one of the world's most scenic places. ▣

FLIGHT PATTERN

You might fly over Zion en route to Saint George, Utah, or Las Vegas, Nevada. Look for a deeply incised canyon on the edge of the raised Colorado Plateau.

RAINBOW BRIDGE

⦿ Utah

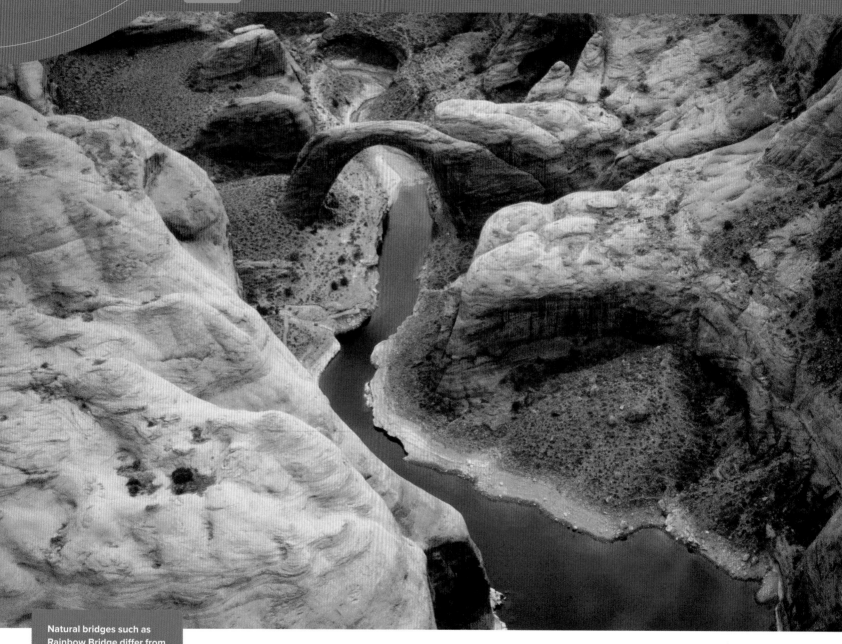

Natural bridges such as Rainbow Bridge differ from arches because they are primarily carved by water, while arches are formed by wind and freeze-thaw cycles.

If wind and water are nature's sculptors, then sandstone is the ultimate medium—more malleable than clay, more graceful than marble. Over millions of years, trickles of water and wisps of wind can have a profound impact on sandstone. One of the most dramatic sandstone sculptures in the Southwest is Rainbow Bridge, an arc that spans 234 feet over a waterway, and one of the largest natural bridges in the world. Natural bridges differ from arches in that they

One of Earth's largest natural bridges

Rainbow Bridge is hidden in a branch of Forbidding Canyon, a meandering gorge off Lake Powell.

Lake Powell

FORBIDDING CANYON

Rainbow Bridge

span a waterway or are primarily water-formed. From the air, Rainbow Bridge can be seen reaching up and over Bridge Creek in the far southern reaches of Utah.

The rocks that make up Rainbow Bridge were deposited during the time of the dinosaurs, when this part of North America was covered by extensive sand dunes, left from an inland sea. These sediments, more than 1000 feet thick, were later reburied under 5000 feet of other sediments. The accumulated weight compressed the sand into Navajo Sandstone, an especially hard type of sandstone that forms sheer cliffs, arches, and bridges all over the Southwest.

Millions of years ago, small Bridge Creek began flowing toward the Colorado River, finding its way through the softer layers of rock and going around the harder layers. When it met the fin of Navajo Sandstone that would become Rainbow Bridge, the creek veered around it, creating a hairpin turn. Turbulence generated in the flowing water by the sharp turns in the creek bed began eroding alcoves in the front and back of the fin. Over time, Bridge Creek wore away a tunnel through the lower part of the fin, leaving the upper bridge spanning the canyon.

Rainbow Bridge has long been held sacred by the Paiute, Navajo, Ute, and Hopi people, who call it Nonnezoshe, "rainbow turned to stone." For centuries, the bridge was protected by its remote and inhospitable location. But in 1963, the flooding of Glen Canyon to create Lake Powell opened access to the bridge to anyone with a motorboat, although low lake levels in recent years have lengthened the hike up the canyon to reach the bridge. ▪

FLIGHT PATTERN

You might fly over Rainbow Bridge on a scenic charter flight of Lake Powell. The bridge is located on the south shore of the lake, down Forbidding Canyon, the lower reaches of which are navigable by boat during high water.

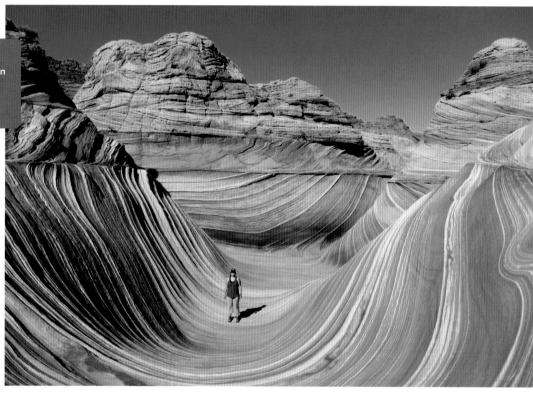

It's best to capture the Wave in midday light, when there are no shadows to obscure the spectacular display.

Bizarre sandstone wonderland, the result of shifting winds on Jurassic-era sand dunes

In a landscape littered with bizarre sandstone formations, the Wave stands out as downright psychedelic. Sitting on the Arizona side of the Arizona–Utah border, these colorful petrified sand dunes have been sculpted into fantastically undulating waves. An aerial perspective reveals bright orange, red, and yellow stone formations, crisscrossed by taffy-like lines.

During the Jurassic Period, this part of Arizona was buried under an immense sand dune field. Periodic changes in the direction of the prevailing winds led to irregularly inclined angles of sand layers (cross-bedding), as the dunes migrated across the landscape. Over time, these layers were lithified into bright orange Navajo Sandstone more than 1200 feet thick.

The thin ridges and ripples preserved at the Wave are evidence of millions of years of shifting wind patterns. Called wind ripple laminae, these lines are part of what make the Wave so photogenic. From the air, the lines highlight the now-frozen movement of the ancient dunes. Nearby checkerboard patterns are created by freeze-thaw weathering of the petrified dunes,

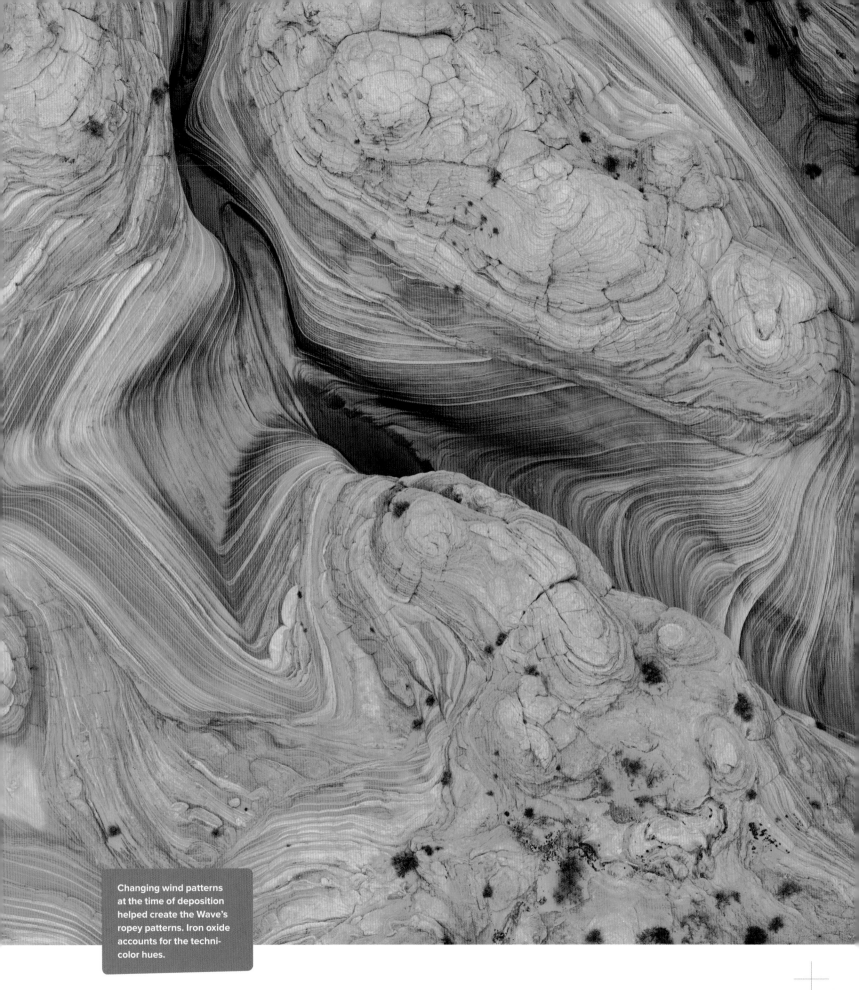

Changing wind patterns at the time of deposition helped create the Wave's ropey patterns. Iron oxide accounts for the technicolor hues.

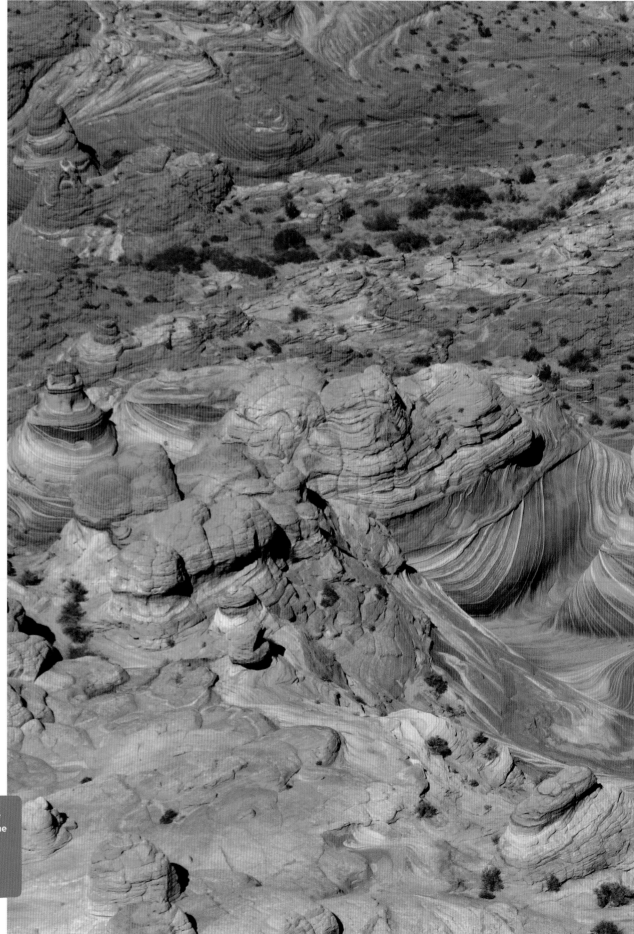

FLIGHT PATTERN

You're only likely to fly over the Wave on a specially chartered scenic flight. The formation is located on the Arizona side of the Arizona–Utah border, about thirty-five miles east of Kanab, Utah.

The Wave is located in the Coyote Buttes region of the Paria Canyon–Vermilion Cliffs Wilderness, on the edge of the Colorado Plateau.

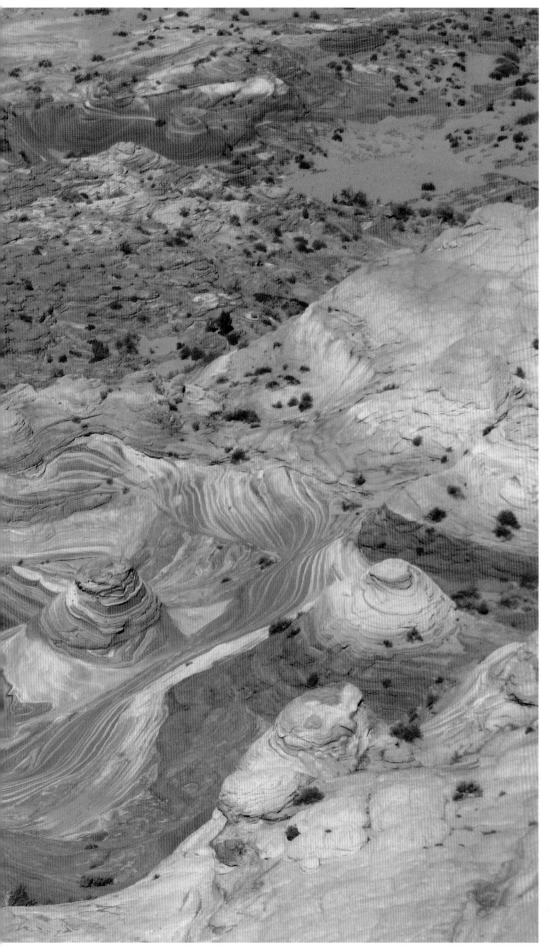

resulting in crosshatching of the sandstone. Dinosaur footprints have also been identified in the rocks near the Wave, relics from ancient travels across the dunes.

The Wave is located within the Coyote Buttes area of the Paria Canyon–Vermilion Cliffs Wilderness, toward the bottom of the Grand Staircase that descends through canyon country. Hidden in the backcountry several miles from the nearest dirt road, the Wave was virtually unknown until the 1990s, when it was featured in German travel brochures of the U.S. Southwest and in the 1996 German nature documentary, *Faszination Natur*. Popularity among Europeans soared and the site soon became one of the most sought-after photography spots for foreign travelers visiting the United States.

Photographs taken here are so coveted that the park service imposed a unique permit lottery system to keep the delicate area from being overrun by snap-happy tourists. Only twenty people a day are allowed to visit. Ten permits are awarded through an online lottery months ahead, and ten permits are given out the day prior at the Grand Staircase-Escalante National Monument visitor center in Kanab, Utah. During the summer, more than a hundred people a day vie for the ten in-person permits. ◾

GRAND CANYON

📍 Arizona

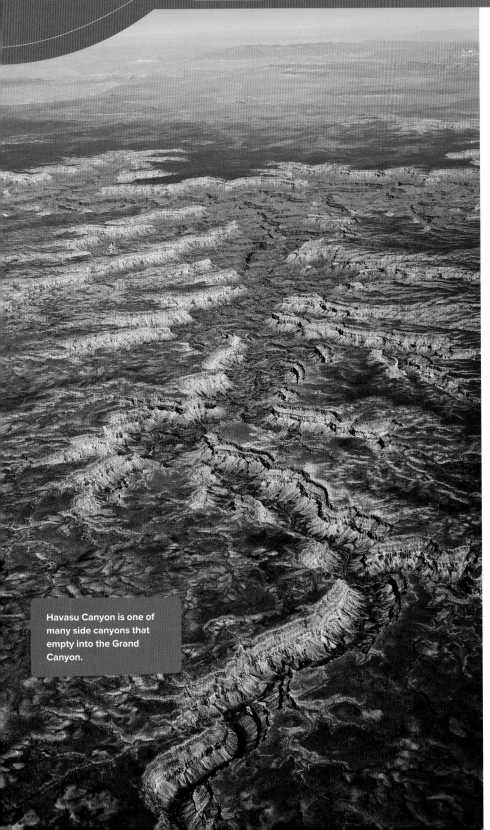

Havasu Canyon is one of many side canyons that empty into the Grand Canyon.

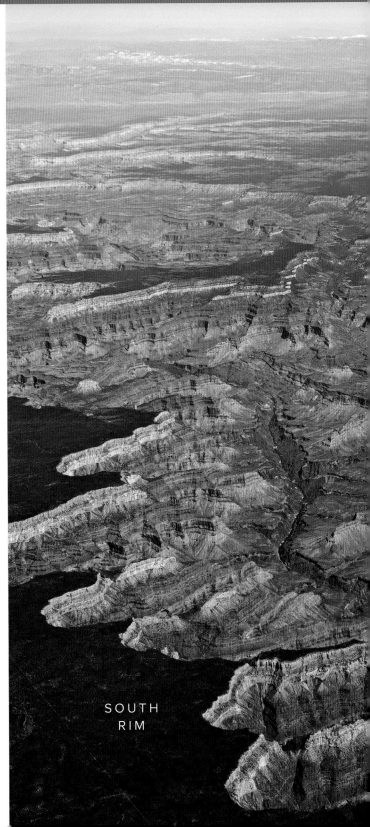

SOUTH RIM

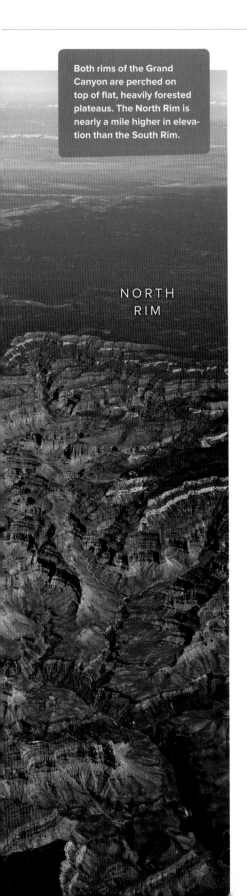

NORTH RIM

The planet's most intricate canyon system, a baby in geologic age

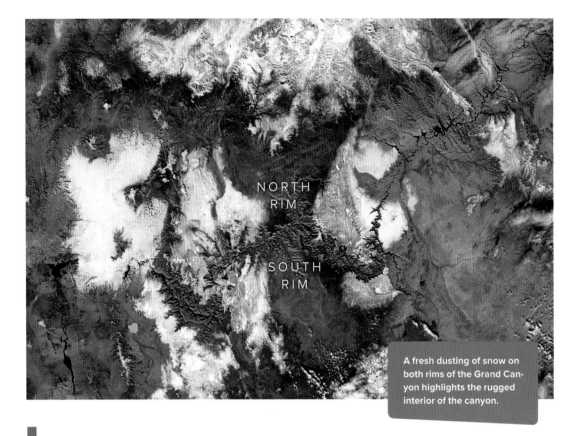

NORTH RIM

SOUTH RIM

A fresh dusting of snow on both rims of the Grand Canyon highlights the rugged interior of the canyon.

It may be surprising to learn that the Grand Canyon is not the deepest, widest, or longest canyon system on Earth—but it is the most intricate, fed by an endless array of watersheds, gorges, seeps, and springs that dump approximately 400 million gallons of water into the mammoth chasm each day. An aerial view provides an outstanding perspective on the hydrologic networks that have carved the labyrinth of ravines and side channels that make the Grand Canyon one of the Seven Natural Wonders of the World.

The Grand Canyon was carved by the Colorado River in a relatively brief span of time—just how brief, geologists aren't sure. Various studies have placed the canyon's age anywhere from 70 to 6 million years old, depending on the mechanisms of formation. Determining an exact age is difficult because all the material that could be used to date the early stages of canyon cutting has been swept out to sea by the Colorado River. But whatever the Grand Canyon's age, it's a baby compared to the oldest rocks exposed by downcutting of the Colorado River, which date back 2 billion years.

As the raven flies, the canyon's North and South Rims are separated by only a few miles, but geologically, ecologically, and hydrologically, they are worlds apart. The North Rim rises nearly a mile higher in elevation than the South. The difference in height is caused by uneven faults on both sides of the Colorado River, as well as the angles of the layers of rock on the North and South Rims.

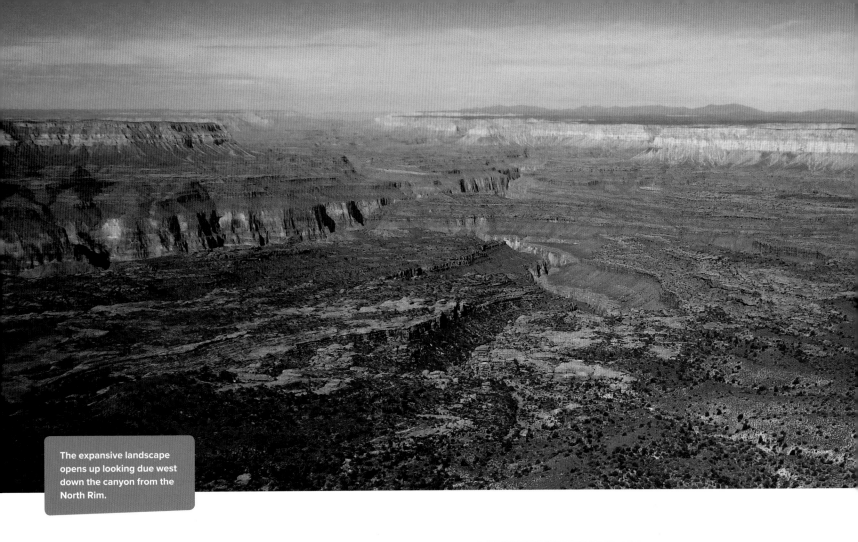

The expansive landscape opens up looking due west down the canyon from the North Rim.

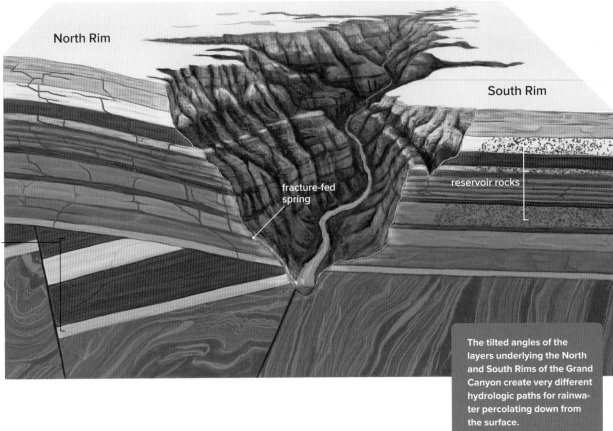

North Rim

South Rim

Sedimentary layers

Kaibab Formation
Toroweap Formation
Coconino Sandstone

Hermit Formation

Supai Formation

Surprise Canyon Formation
Redwall Limestone
Temple Butte Formation
Muav Limestone

Bright Angel Shale

Tapeats Sandstone

Grand Canyon Supergroup

Basement Rock

Vishnu Schist and
Zoroaster Granite

fracture-fed
spring

reservoir rocks

The tilted angles of the layers underlying the North and South Rims of the Grand Canyon create very different hydrologic paths for rainwater percolating down from the surface.

The North Rim lies at the foot of the Grand Staircase, but it's still quite high in elevation—over 8200 feet—making for a much wetter and cooler environment than the South Rim. In the summer, tall ponderosa pines shade the Kaibab Plateau, an elevated expanse that runs to the edge of the North Rim; in the winter, the North Rim of the park is closed from mid-October through mid-May because of heavy snowfall.

All that precipitation makes for a very active watershed on the North Rim. The steep angle of the layers of rock, tilted down toward the canyon, means that water runs quickly from the surface through the ground and out through springs, seeps, cracks, and creeks to the Colorado River. Hydrologists estimate that, on average, it takes around forty years for rainwater to be filtered from the North Rim down to the river—a relatively fast rate of groundwater flow.

The water on the South Rim, however, takes a very different journey. On the south side of the Colorado, the layers are less tilted and more horizontal, creating reservoirs where groundwater pools underground, sitting for long stretches of time. By testing the isotopic ratios of groundwater seeping out of springs along the South Rim, geologists estimate it takes as long as 10,000 years for rainwater that falls on the hotter, drier South Rim to make its way to the Colorado River.

A lot of water runs through the Grand Canyon, but it is definitely a desert environment. The water requirements for the lodges of Grand Canyon National Park are huge—and supplied by a single spring just below the North Rim called Roaring Springs. This plentiful spring runs year-round, fed by rain and snow that falls on the North Rim. As the precipitation seeps into the ground, it makes its way down through 4000 feet of rock, through cracks in the porous limestone and sandstone that underlie the North Rim. When it reaches an impermeable layer where the porous Muav Limestone meets the watertight Bright Angel Shale, the groundwater finds its way through cracks and caves before it pours out of the canyon wall at Roaring Springs. ▪

FLIGHT PATTERN

In addition to the many scenic charter flights that operate over the Grand Canyon, some commercial flights offer views en route to Las Vegas, Nevada, or Flagstaff, Arizona. The area directly between the villages on the North and South Rims is a designated wilderness no-fly zone, but flights are allowed east and west of the park.

SUNSET CRATER VOLCANO

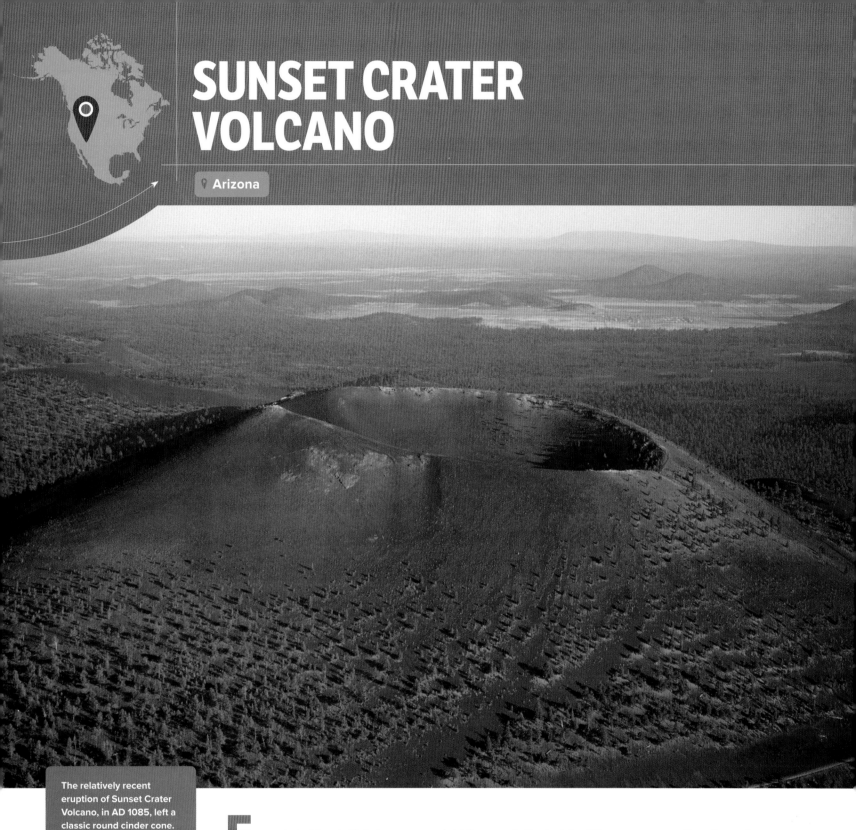

The relatively recent eruption of Sunset Crater Volcano, in AD 1085, left a classic round cinder cone.

En route to Flagstaff, Arizona, you might fly over the San Francisco Volcanic Field and the Sunset Crater Volcano. Look for the white-capped San Francisco Peaks, which host a ski resort you may be able to see in the winter, and the round black cinder cone of Sunset Crater Volcano to the east.

In the last 6 million years, more than 600 volcanoes have sprung up in the San Francisco Volcanic Field, covering 1800 square miles on the southern edge of the Colorado Plateau in northern Arizona. This area includes the San Francisco Peaks—the remains of an eroded stratovolcano similar to the Cascade Volcanoes—and Hum-

Eroded cinder cone marked by lava flows from AD 1085 eruption

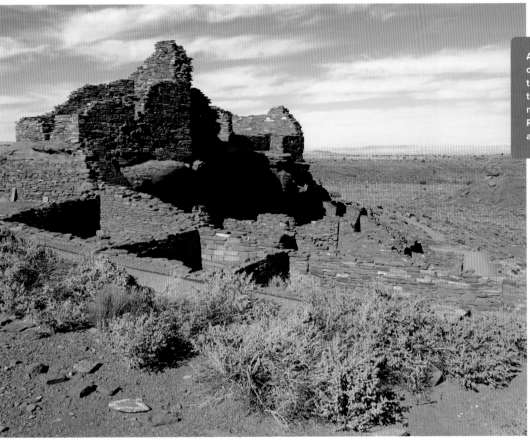

After the AD 1085 eruption of the Sunset Crater Volcano, the Sinagua people moved to the Wupatki Pueblo, fifteen miles northeast of the crater. Ruins of the pueblo remain and can be visited.

phrey's Peak, Arizona's highest point at 12,633 feet. The most recent eruptions occurred around AD 1085 at the Sunset Crater Volcano—the youngest volcano in the complex.

When Sunset Crater Volcano last erupted, the area was inhabited by the Sinagua people, agriculturalists who lived in pit houses and, later, multi-roomed pueblos. The Sinagua people almost certainly witnessed the eruption, as it would have been hard to miss: the main cinder cone of the volcano was created in a matter of days (according to tree ring and paleomagnetic data), rising 1120 feet above the surrounding landscape. The blast may have been accompanied by earthquakes and exploding volcanic fire bombs, as well as ash, cinders, and lava flows a hundred feet thick.

Lava flows emanated from the cinder cones and from several long fissures that opened at the base of the volcano. From the air, these flows stand out black against the landscape, extending for four miles outward from the raised cinder cone, in the direction of the prevailing winds at the time of the eruption.

The San Francisco Volcanic Field has now been dormant for longer than 800 years, but it's not extinct. Another eruption could birth another cinder cone in the next few hundred years. For now, a seismograph installed at the Sunset Crater

National Monument visitor center keeps tabs on earthquake activity that might foretell another eruption. When it happens, we—like the Sinagua people—will have to get out of the way.

Archaeological studies of the region show that in the aftermath of the Sunset Crater eruption, the Sinagua people moved to the Wupatki Pueblo, north and east of the crater. The population of Wupatki and the surrounding area is estimated to have been around a hundred people before the eruption and as many as 2000 after the eruption. The pueblo was supported by cultivated corn and squash, and the Sinagua appear to have collected rainwater for drinking, as few springs are found in the region's loose volcanic soils. By AD 1225 the pueblo was abandoned, likely as a result of prolonged drought. ▦

FLIGHT PATTERN

The black cinder cone of Sunset Crater Volcano can be seen from above, flying over the San Francisco Volcanic Field in northern Arizona. Look for the San Francisco Peaks nearby, which are snowy in winter.

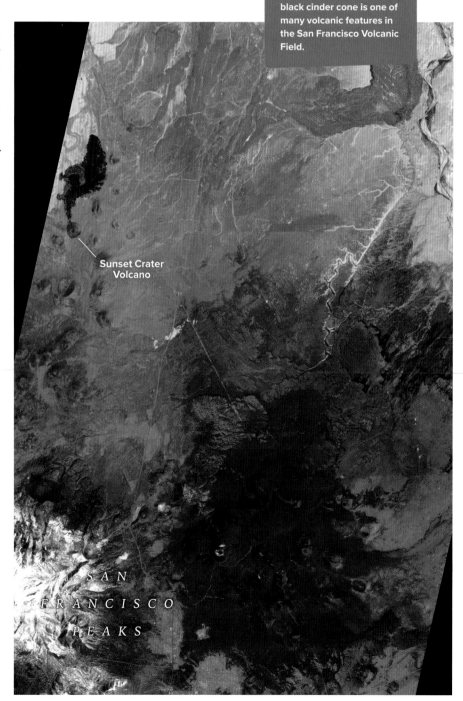

Sunset Crater Volcano's black cinder cone is one of many volcanic features in the San Francisco Volcanic Field.

Sunset Crater Volcano

SAN FRANCISCO PEAKS

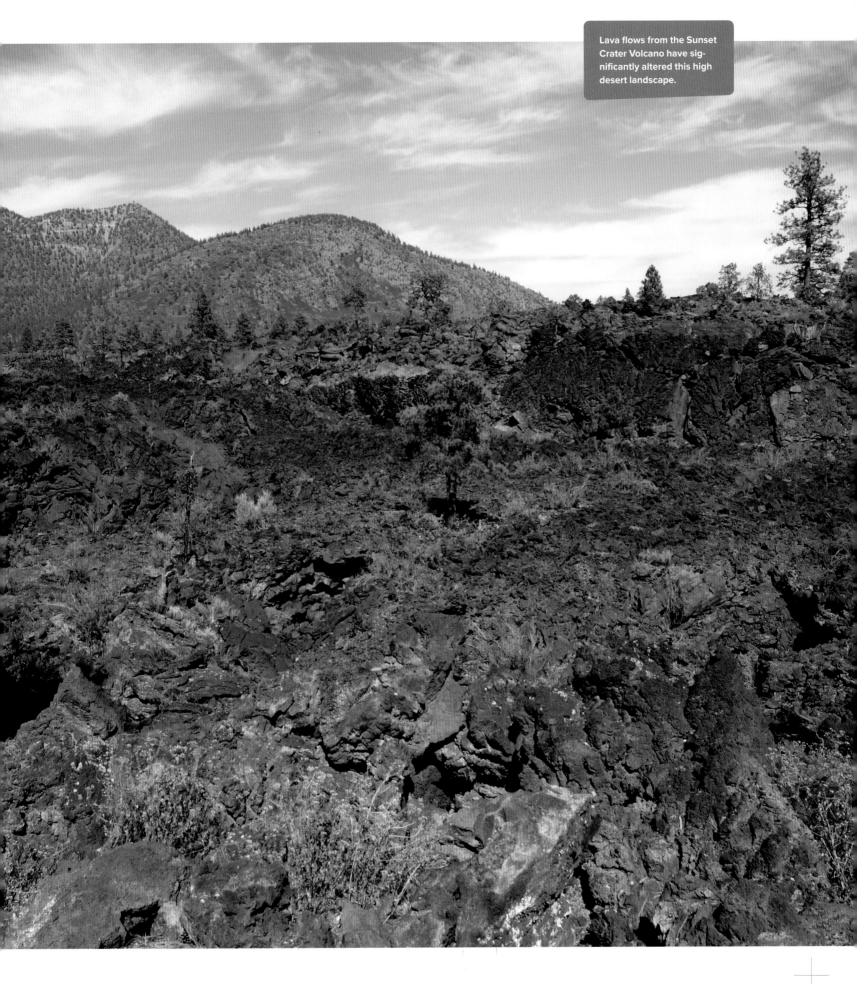

Lava flows from the Sunset Crater Volcano have significantly altered this high desert landscape.

METEOR CRATER

📍 Arizona

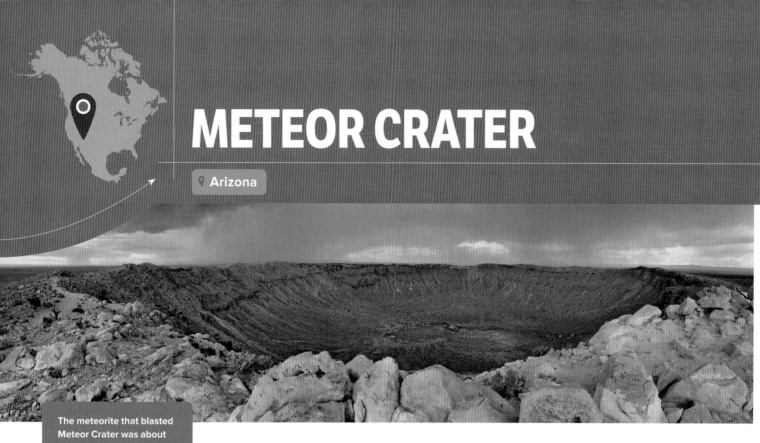

The meteorite that blasted Meteor Crater was about the size of three school buses lined up end to end. However, the hole it created is nearly 4000 feet wide and more than 500 feet deep.

Each year, Earth is struck by an average of five to ten meteorites that make it all the way through our protective atmosphere. Most of these events are small, causing no damage or injuries. But a few times in our planet's 4.5-billion-year history, meteorite impacts have been catastrophic, including the impact that likely played a role in the global extinction of dinosaurs.

Only a small number of meteorite impact craters are visible on Earth's surface today, because of the erasing power of erosional forces over millions of years. Meteor Crater is young enough, however, that it appears almost the same today as it would have looked when it was blasted into the planet 50,000 years ago. From the air, it is easy to spot: a round hole in the ground surrounded by a raised rim of rock, just south of Interstate 40 in east central Arizona.

For a long time, scientists weren't sure whether Meteor Crater was indeed a crater made by a meteorite, or a volcanic crater linked to the San Francisco Volcanic Field just forty miles to the west. It wasn't until the 1960s that the crater was conclusively confirmed as being caused by meteorite impact—the planet's first scientifically recognized meteorite impact crater. The breakthrough came with the discovery at the site of the minerals coesite and stishovite, two rare forms of silica that can be formed only by a large impact or nuclear explosion.

Today Meteor Crater is 3900 feet in diameter, 560 feet deep, and surrounded by a rim of rock that rises 150 feet above the landscape. In the past 50,000 years, the crater rim is thought to have lost about fifty feet from its original height, while the bottom of the crater has been filled in with around a hundred feet of sediments shed from the unstable crater walls. Otherwise, its size and shape are very much the same as just after the dust settled.

One of the longstanding mysteries of Meteor Crater is the seemingly missing meteorite. The object that created the crater was probably an iron-nickel meteorite about 160 feet across that generated more than ten megatons of explosive energy upon impact—over three times the combined energy released by the Hiroshima and Nagasaki atomic bombs in World War II. Most of the meteorite was likely vaporized, leaving little evidence behind in the crater. ▪

Meteorite impact 50,000 years ago unleashed more than ten megatons of energy

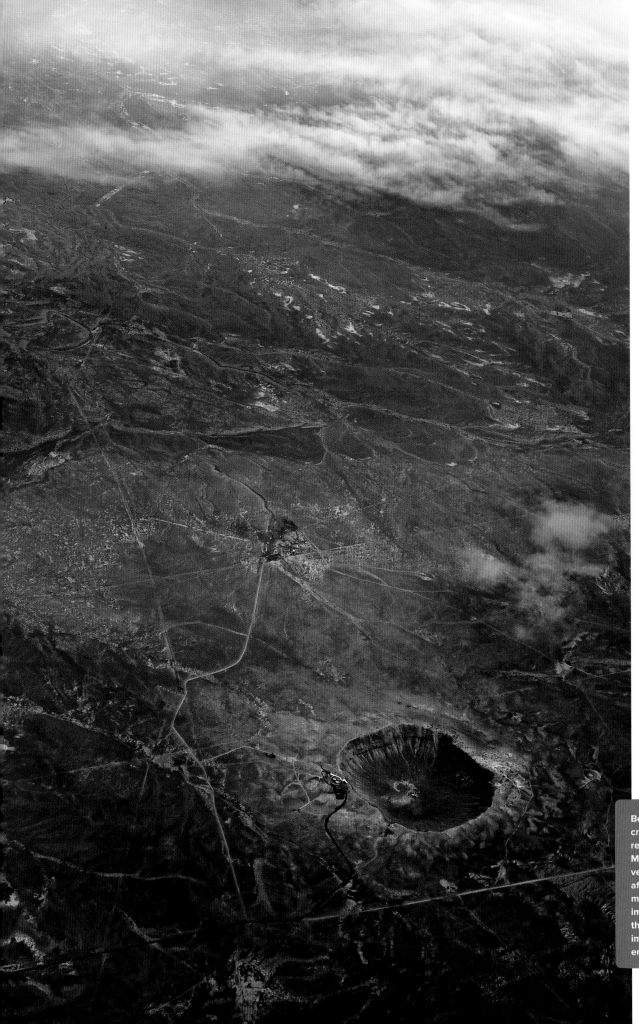

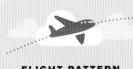

FLIGHT PATTERN

You might fly over Meteor Crater en route to Flagstaff, Arizona, which lies just forty miles to the west.

Because the collision that created it was a relatively recent 50,000 years ago, Meteor Crater still looks very much like it did just after impact. Most of the meteorite was destroyed on impact; only small pieces of the estimated 160-foot-long impactor have been recovered from the crater.

CANYON DE CHELLY

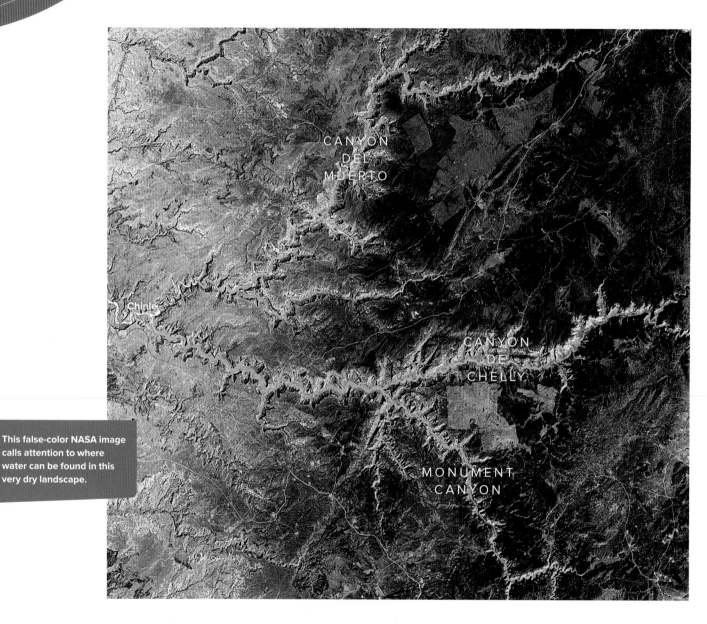

CANYON
DEL
MUERTO

Chinle

CANYON
DE
CHELLY

MONUMENT
CANYON

This false-color NASA image calls attention to where water can be found in this very dry landscape.

Canyon de Chelly, in northeast Arizona, is one of the most sacred Native American locations in the Southwest. Three spectacular canyons—de Chelly, del Muerto, and Monument—lie at the heart of the Navajo and Hopi Nations. In a false-color satellite image, the three canyon systems stand out green against the otherwise arid plateau. Canyon del Muerto enters from the north, with Canyon de Chelly in the middle and Monument Canyon to the south.

200-million-year-old sandstone, 1000-foot walls, and at least 5000 years of human occupation

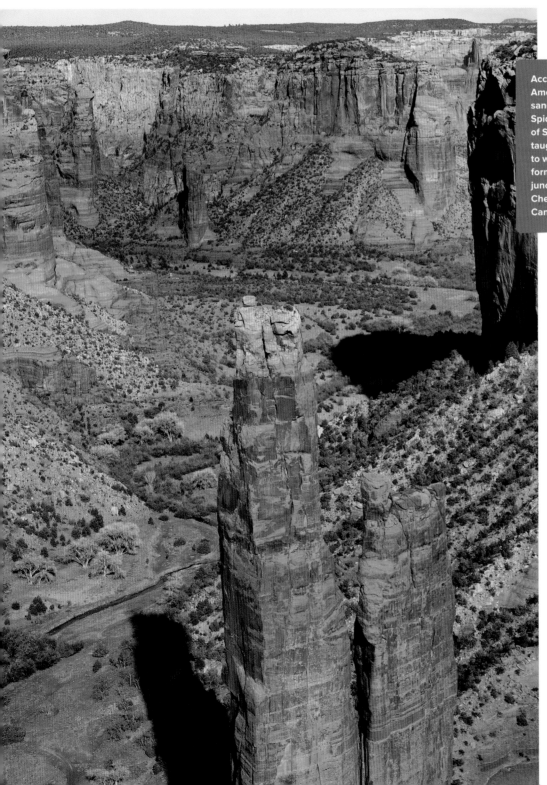

According to Native American legend, the sandstone spire called Spider Rock is the home of Spider Woman, who taught the Navajo people to weave. The towering formation stands at the junction of Canyon de Chelly and Monument Canyon.

These three meet just east of Chinle, one of the largest towns in the Navajo Nation.

From its headwaters in the Chuska Mountains, near the border of Arizona and New Mexico, the Rio de Chelly carves a winding, deeply incised path through thick layers of 200-million-year-old sandstone. The Rio de Chelly and most of its tributaries are enclosed by vertical walls of rock that in some places top 1000 feet. Despite the navigational challenges of traveling in such rugged terrain, humans have inhabited these canyons over millennia for one very important reason: water.

Water can be found year-round in these canyons—a rare occurrence in the desert Southwest. Settlements, cliff dwellings, and ruins are found throughout the canyon systems, wherever people could access plentiful water, grass for grazing livestock, and productive farmland in the shady depths. The Ancestral Puebloans, Anasazi, Hopi, and Navajo people have called Canyon de Chelly home for at least 5000 years, and the agricultural oasis is considered one of the longest continuously occupied sites in North America.

Today Canyon de Chelly is a national monument on Navajo tribal trust land, managed jointly by the National Park Service and the Navajo

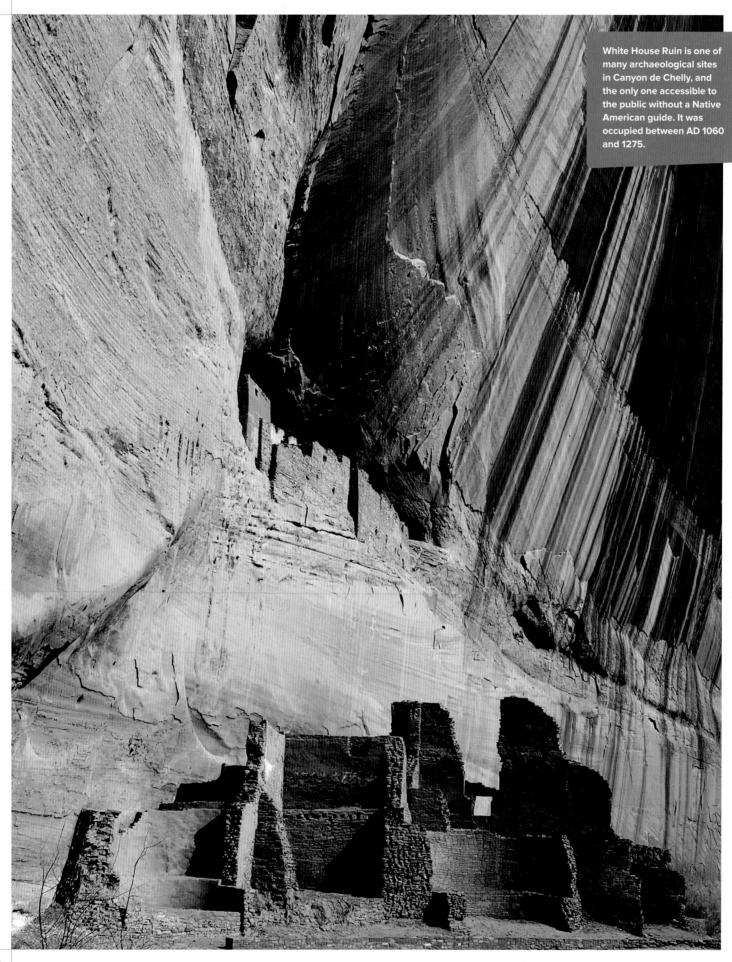

White House Ruin is one of many archaeological sites in Canyon de Chelly, and the only one accessible to the public without a Native American guide. It was occupied between AD 1060 and 1275.

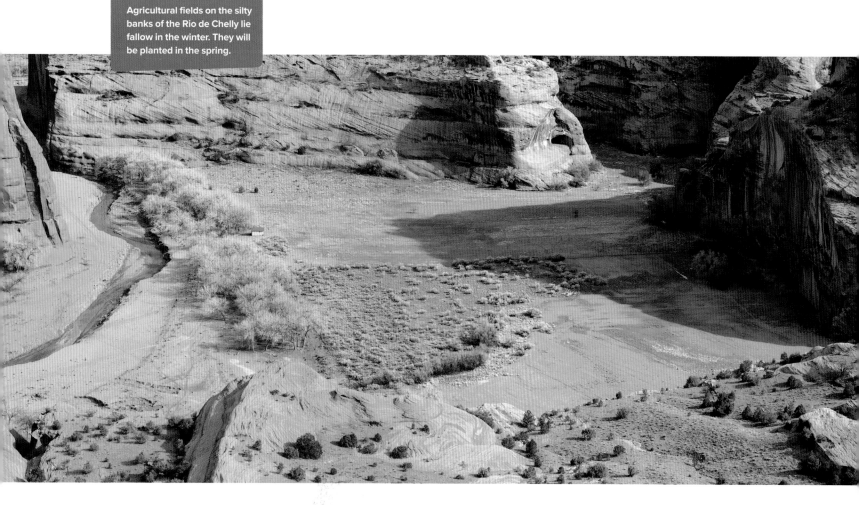

Agricultural fields on the silty banks of the Rio de Chelly lie fallow in the winter. They will be planted in the spring.

Nation. Tragically, the U.S. government has a brutal history in the canyon. In the winter of 1864, Kit Carson led 400 troops into the head and foot of the canyon system, where they destroyed homes, food caches, and croplands as they corralled the people living in the canyon. Around 8000 men, women, and children surrendered and were marched 450 miles to the Bosque Redondo encampment in eastern New Mexico. In 1868, the Treaty of Bosque Redondo allowed the survivors of the disease-ridden camp to return to Canyon de Chelly. When President Hoover declared the canyons a national monument in 1931, the wounds were still fresh and many Navajo people opposed the designation.

Visitors to Canyon de Chelly can only view the canyons from the rim. To descend into the depths, outsiders must go with a native guide on foot, by off-road vehicle, or on horseback. The one exception is the White House Ruin Trail, a steep path cut with tunnels and steps into the sandstone, descending 600 feet down to the canyon floor. This path was likely used by Carson's men to enter the canyon, as there are only a few ways up and down the steep canyon walls. The trail ends at the White House Ruin: two sets of ruins, one built in an alcove in the sandstone wall and the other built from sandstone blocks just in front of the alcove. The structures were once plastered white, but most of the veneer has flaked off over time. ∎

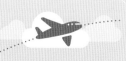

FLIGHT PATTERN

The national monument is located in the remote desert of northeast Arizona. You might fly over Canyon de Chelly en route to Flagstaff, Arizona.

SHIPROCK

FLIGHT PATTERN

You might fly over Shiprock en route to Cortez, Colorado, but you're more likely to see it if you charter a flight. Look for a jagged, dark rock that stands apart from the surrounding landscape, with radiating dikes extending outward from its base for miles.

Two long volcanic dikes radiate out from Shiprock (seen here above and to the right of the formation) and stretch for miles across the high desert of northwest New Mexico.

Throat of a volcano that erupted 3000 feet underground

Northwest New Mexico is an arid sea of desert, and rising from the waterless land is Shiprock: a 1500-foot-high monolith that dominates the landscape. From above, black horizontal dikes (formed when magma fills a rock fracture) radiate outward for miles from the central rock, which reaches a high point 7177 feet above sea level. The Navajo call Shiprock Tsé Bitàí, "rock with wings." Indeed, some say that from the north and south, the rock looks like a bird with its wings folded. In the 1870s, however, the U.S. Geological Survey officially named the rock for its likeness to a many-sailed clipper ship.

Shiprock is the eroded remains of a volcano. More specifically, the exposed rock we see today was once the throat—or central feeder pipe that ejects lava—of a volcano that erupted 3000 feet underground. Erosion of the surface layers has exposed a diatreme, a volcanic vent formed by a gaseous explosion. The diatreme is composed of dark volcanic rocks that contain fractured breccia (rock made of angular fragments) and vertical dikes of minette. Shiprock is the most prominent formation in the Navajo Volcanic Field, a series of intrusive eruptions that took place underground approximately 25 million years ago. Dating of Shiprock's dikes suggests that its eruption took place slightly earlier, around 27 million years ago.

Located deep in Navajo Nation land, Shiprock is off limits to outside visitors. Many native legends swirl around Shiprock. According to one, the rock was once a giant bird that carried the Navajo people from the cold north to the Four Corners region (where corners of Colorado, Utah, Arizona, and New Mexico meet). Other stories tell of a village that sat atop the rock until a lightning strike obliterated the access trail, trapping the people on top, where their ghosts still haunt the summit. Another story places Shiprock in a geographical context related to the Four Corners region, as part of a mythical figure known

as Goods of Value Mountain. The figure is made up of nearby land features: its body is the Chuska Mountains, the head is Chuska Peak, the legs are the Carrizo Mountains, and Beautiful Mountain is the feet. In this story, Shiprock represents the medicine pouch or weapon carried by the figure and the rock is celebrated as a source of wisdom and power.

At times in the past, Navajo warriors may have climbed Shiprock on vision quests, but today, climbing Shiprock is strictly forbidden. Determined (and some say disrespectful) non-Navajo rock climbers sometimes illegally poach the climb, however. In fact, the Navajo Nation forbids climbing throughout all its lands, citing traditional taboos surrounding death that may haunt accident sites for many years after a fatal fall. ■

Shiprock, a long-eroded volcanic remnant, is one of the most prominent features of the Four Corners region, where corners of Colorado, Utah, Arizona, and New Mexico come together.

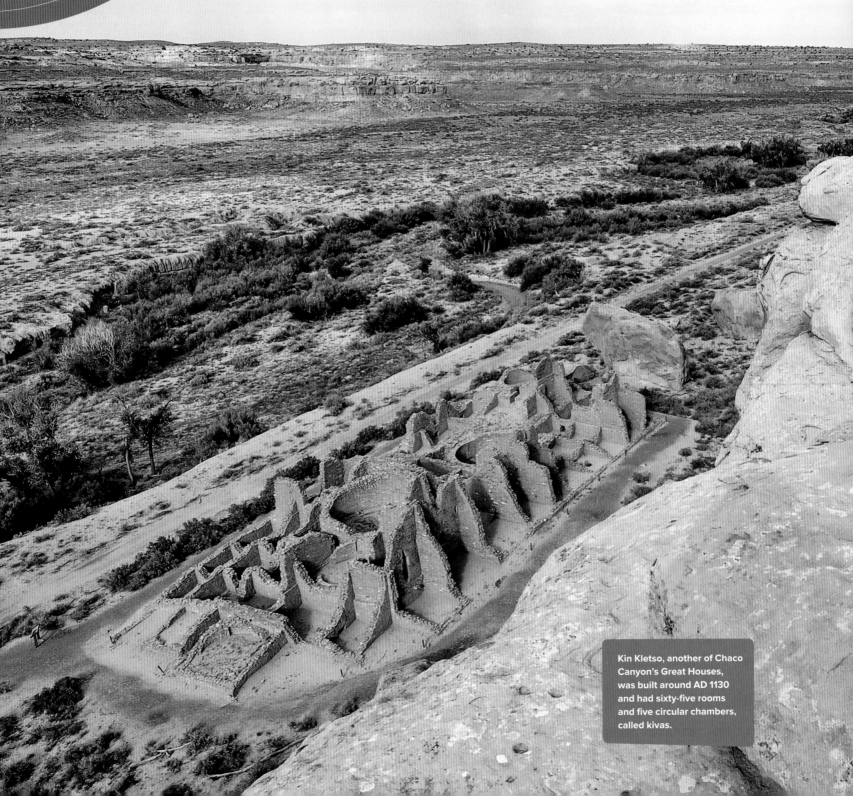

CHACO CANYON

Kin Kletso, another of Chaco Canyon's Great Houses, was built around AD 1130 and had sixty-five rooms and five circular chambers, called kivas.

Cut by flowing water over millions of years; gathering site of ancestral Puebloans

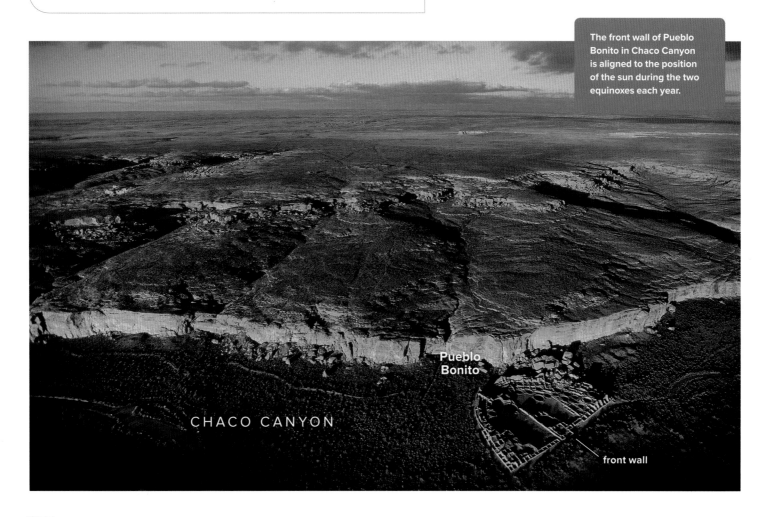

CHACO CANYON

Pueblo Bonito

front wall

The front wall of Pueblo Bonito in Chaco Canyon is aligned to the position of the sun during the two equinoxes each year.

Today, Chaco Canyon in northwest New Mexico is located in one of the most desolate landscapes in the country. But during the canyon's heyday, between AD 950 and 1150, this was the center of the Puebloan universe. Ancestral Puebloan people would journey for hundreds of miles—on foot—to visit this collection of Great Houses, widely considered to be the cultural hub of the Puebloan people. These journeys were so frequent and important that the Chacoan people built a network of thirty-foot-wide "roads" to connect Chaco with other Puebloan communities, such as Mesa Verde to the north and the site of Aztec Ruins National Monument to the northeast.

Looking down on Chaco Canyon, you can see the terrain of a broad, dry canyon, one of many in this arid region. From the air, however, it is the large, geometrically shaped buildings that are the most compelling features below.

Chaco Canyon was cut over millions of years by the Chaco Wash, an intermittent stream that very rarely runs with water. The sandstone cliffs lining the canyon date to the Cretaceous Period,

FLIGHT PATTERN

Look for Chaco Canyon on flights to Albuquerque, New Mexico.

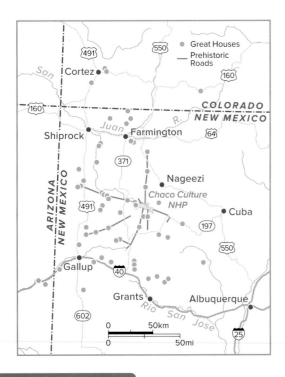

Chaco Canyon is connected to a number of other archaeological sites in the Four Corners region of the Southwest by a network of unusually wide, possibly ceremonial roads.

when dinosaurs lived, but the only fossils found in these rocks are shells left from an inland sea. Tucked into a nine-mile stretch of this canyon are the ruins of a dozen Great Houses: massive, multi-storied residential and ceremonial structures built out of uniformly shaped sandstone slabs. They remain some of the biggest building complexes in North America. The largest of the Great Houses, Pueblo Bonito, covers three acres and has 800 rooms. The complexes are large enough to house thousands of people, but the limited water resources in the canyon likely kept the permanent population low, with only a few hundred people living in the canyon at any time and others coming and going for ceremonies and trading. Chaco Canyon was abandoned during an

extreme fifty-year drought, which struck the region around AD 1130.

The Great Houses at Chaco were laid out very precisely, with at least twelve of the complexes aligned with various solar and lunar cycles. The Chacoan people must have been very advanced and dedicated astronomers, as some of the celestial cycles would have required decades of observations to chart. The front wall of the D-shaped Pueblo Bonito is sited along a precise east-west line that tracks the position of the sun during the spring and fall equinoxes. Other Great Houses are sited along lines running north and south. These patterns are best revealed from the tops of the sandstone cliffs on either side of the canyon—or from the air.

The ruins of Chaco Canyon have been partially restored and are protected within Chaco Culture National Historical Park.

Perhaps even more impressive than the Great Houses is the Chacoan road system, which radiates out from Chaco Canyon in all directions, connecting to other pueblos and important features in the landscape. The Great North Road, for example, starts just east of Pueblo Alto, one of the Great Houses, and runs due north for approximately thirty miles to Kutz Canyon. Nearly 200 miles of such roads have been mapped leading away from Chaco, though not all appear to be continuous. Archaeologists think many of the roads were ceremonial rather than practical, especially because most are wider than fifteen feet and some are wider than thirty feet—much broader than necessary, as this culture did not use wheeled carts or have draft animals. ∎

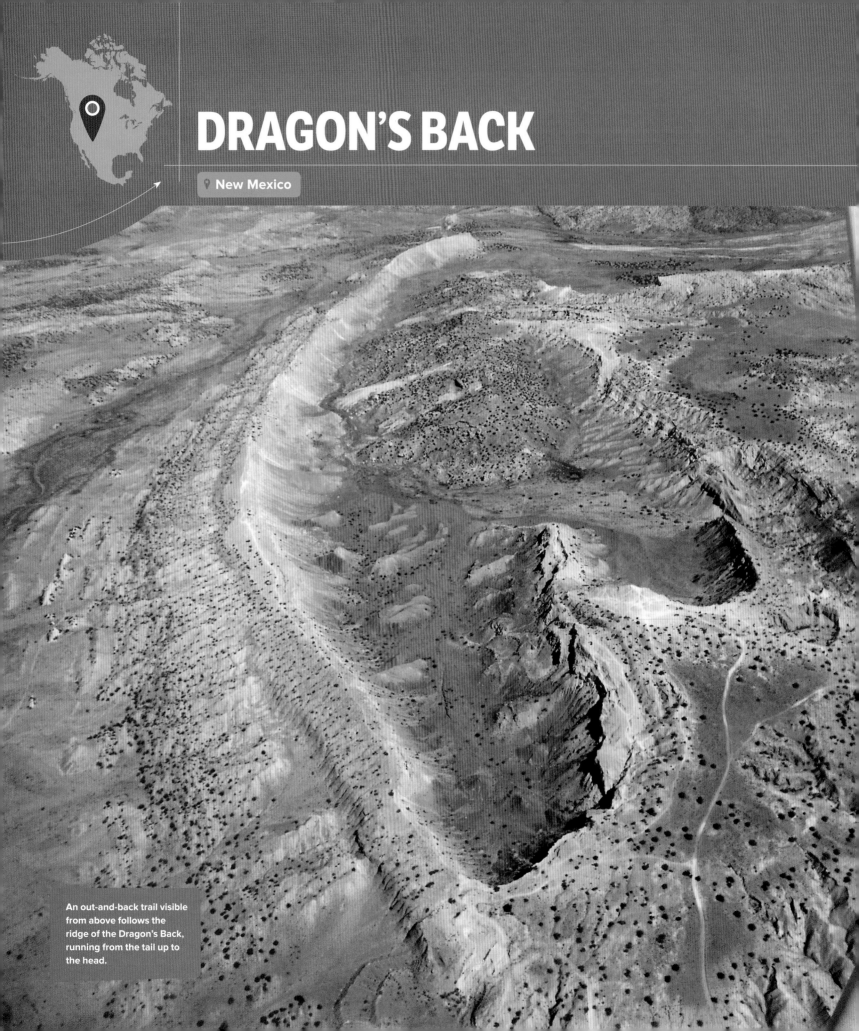

DRAGON'S BACK

📍 New Mexico

An out-and-back trail visible from above follows the ridge of the Dragon's Back, running from the tail up to the head.

Layers formed while dinosaurs roamed, then were chiseled by folding and erosion

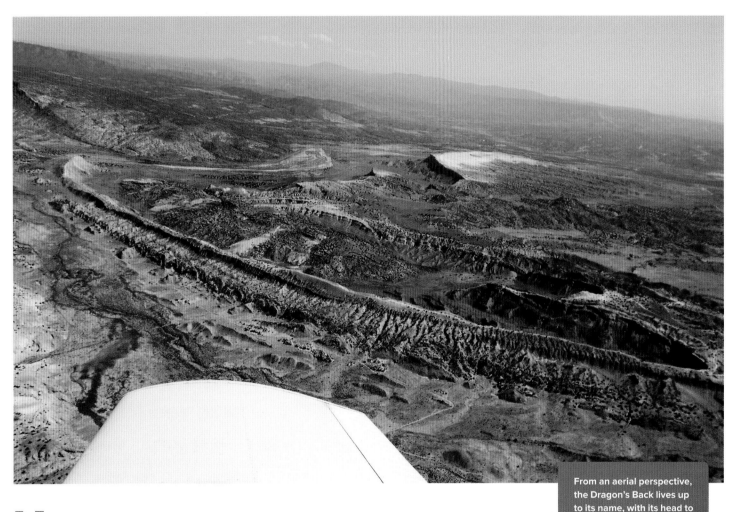

From an aerial perspective, the Dragon's Back lives up to its name, with its head to the east (left) and tail curving to the west (right).

Northwest New Mexico is one of the driest places in the United States—the region gets less than twelve inches of rain a year, most of it during the late-summer monsoon season. But despite the aridity, this desert is shaped by water. During the Mesozoic Era, starting around 160 million years ago, what is now New Mexico was flooded by a shallow inland sea that covered most of the southwestern United States. The sea was very salty and rich in minerals that left behind extensive deposits of limestone and gypsum.

These layers of gypsum, a white crumbly rock, have eroded away to sculpt the Dragon's Back: a striking ridgeline with a bulbous head and a tapering tail that, from the air, has the appearance of a great white serpent. Stretching two and a half miles, it stands out starkly against the contrasting red and orange landscape. Look closely and you may see tiny mountain bike riders or hikers making their way along the spine of the Dragon's Back. The top of the Dragon's Back is wide enough to bike or hike across without much danger of falling

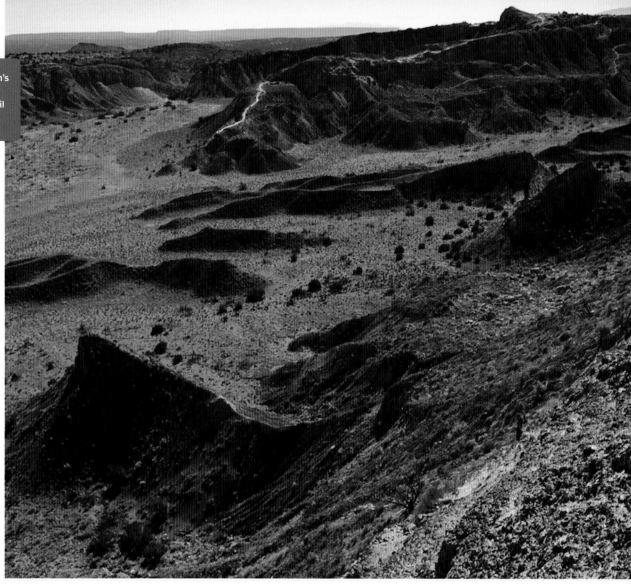

On the trail near the dragon's head, one can look across the anticline back at the tail (to the left).

off, but narrow enough in some sections to trigger vertigo. The trail is not for the faint of heart—gypsum is a water-soluble mineral and eons of rare rains have melted a few sinkholes into the top of the ridge, some big enough to swallow a bike and its rider whole.

The east side of the ridge drops steeply down into an enormous bowl, carved out by erosion over the past 150 million years. This bowl is actually an anticline: a fold in Earth's crust that creates a convex dome. The anticline here, however, is no longer a dome—the middle layers have been scooped out by erosion, leaving behind a bowl with upswept sides. The feature is so unique that geology classes from the University of New Mexico in Albuquerque journey here each year on field trips to see it in person.

The name Dragon's Back is fitting, and not just for the formation's distinctly reptilian shape. During the Mesozoic Era, when the layers that form the Dragon's Back were deposited, dinosaurs dominated the land and sea. New Mexico is home to some of the most productive dinosaur boneyards in the country, including the Ojito Wilderness, just ten miles south of the Dragon's Back, where remains of one of the longest dinosaurs found to date—the 110-foot-long Seismosaurus—were uncovered in 1985. Other fossils are common in the area, including whole petrified trees. ◼

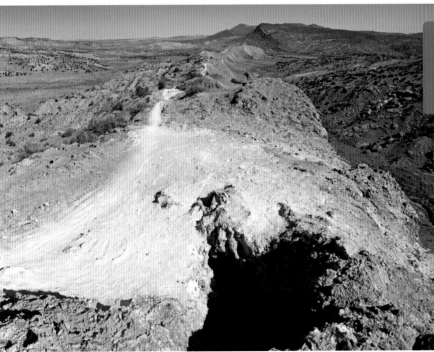

A few deep sinkholes have opened along the Dragon's Back ridge trail, which is made up of water-soluble gypsum.

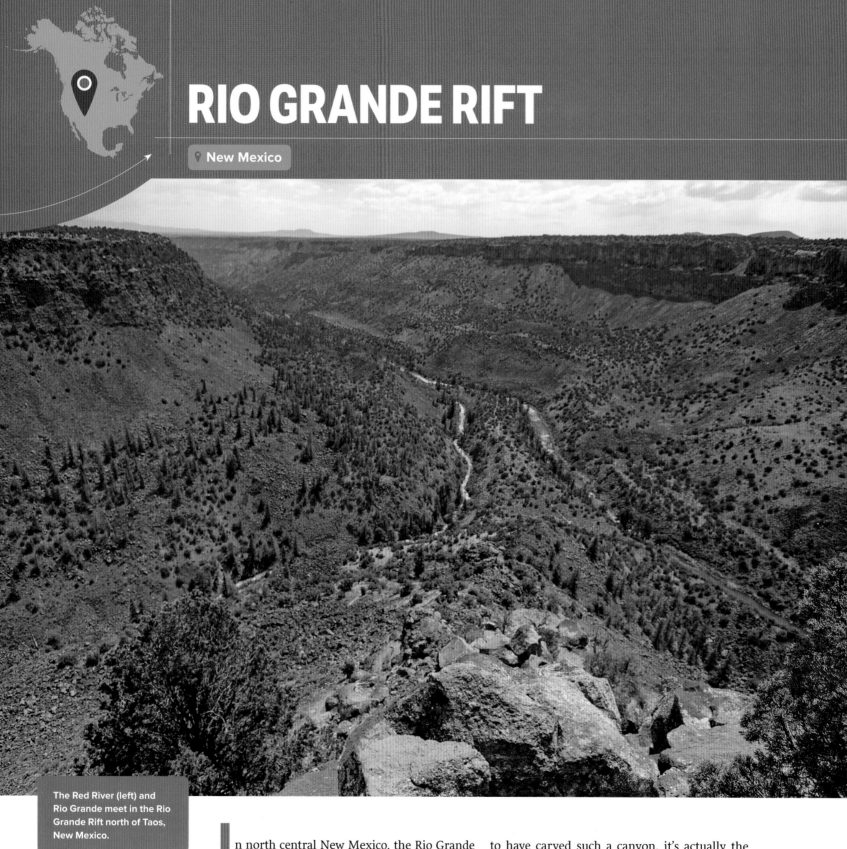

RIO GRANDE RIFT

New Mexico

The Red River (left) and Rio Grande meet in the Rio Grande Rift north of Taos, New Mexico.

In north central New Mexico, the Rio Grande cuts a deep gash in the surface of the landscape, exposing thick layers of dark volcanic rocks. The canyon is not difficult to spot from high above. But while the river looks big enough to have carved such a canyon, it's actually the canyon that created the river. The gorge was opened by a continental rift zone, where Earth's crust is pulling apart as a result of stretching, extensional forces.

Rip in the planet's crust that began 35 million years ago and widens a tenth of an inch a year

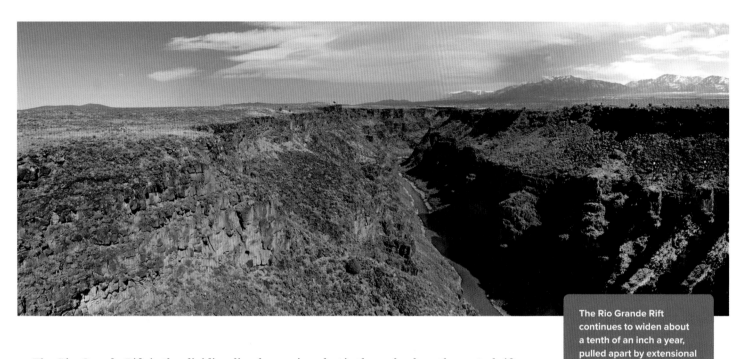

The Rio Grande Rift continues to widen about a tenth of an inch a year, pulled apart by extensional tectonic forces.

The Rio Grande Rift is the dividing line between the North American Craton (the ancient basement rock of the interior of the continent that became North America) and the Colorado Plateau (the uplifted high desert area centered over the Four Corners region, where corners of Colorado, Utah, Arizona, and New Mexico meet). This spreading zone runs from central Colorado to Chihuahua, Mexico. It started opening around 35 million years ago, when extensional forces began pulling the lithosphere apart to the east and west, triggering vigorous volcanism all along the rift. Thinning of the crust and faulting between large blocks of crust opened a series of north-south running basins. These topographic low points began capturing streams, which eventually evolved into the Rio Grande.

Tectonic forces are still at work, continuing to widen the Rio Grande Rift at a rate of about a tenth of an inch per year. This widening occurs not just in the narrow rift zone that's easily visible by the river, but in the rocks along the central rift zone, in a swath as wide as 180 miles in places.

It's no coincidence that many of New Mexico's major towns and cities were built along the rift. The Rio Grande runs from its headwaters in southern Colorado all the way through New Mexico, along the border between Texas and Mexico, to the Gulf of Mexico. On its way through New Mexico, the river cuts an almost straight course south, linking the state's major cities of Taos, Santa Fe, and Las Cruces. Archaeologists believe the rift was a major migration corridor for ancient people moving on foot north and south. The rift would have offered a foolproof landmark to follow, while the Rio Grande and its many side streams would have provided water in an otherwise arid country. In some places, such as near Taos, the rift would have likely presented a daunting barrier to east-west travel, forcing people to travel north or south to find a safe crossing. ▮

FLIGHT PATTERN

You might fly over the Rio Grande Rift en route to Santa Fe or Albuquerque, New Mexico.

VALLES CALDERA

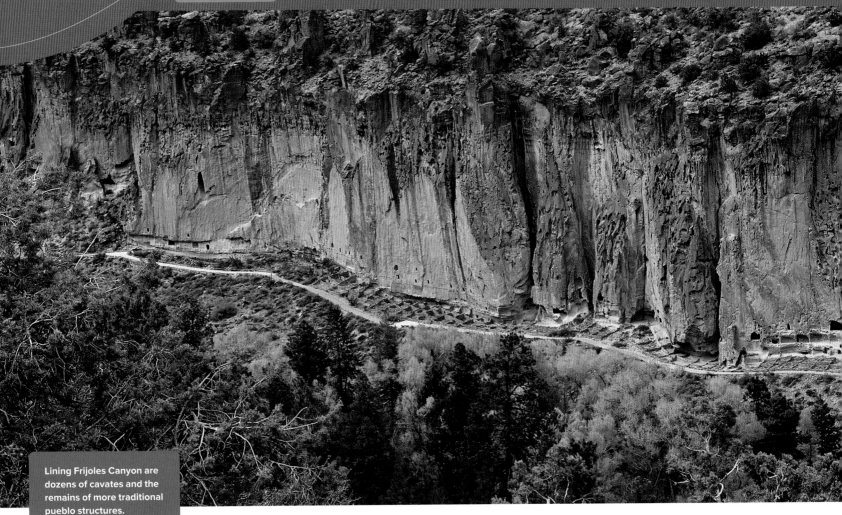

Lining Frijoles Canyon are dozens of cavates and the remains of more traditional pueblo structures.

FLIGHT PATTERN

You might fly over the Valles Caldera and Frijoles Canyon en route to Santa Fe or Albuquerque, New Mexico.

Supervolcano eruptions are infamously destructive—capable of smothering entire ecosystems under many feet of ash. But the eruption of the Valles Caldera supervolcano in what is now northern New Mexico actually created a unique habitat and way of life that sustained Ancestral Puebloans for hundreds of years. To see from altitude what is left of the volcano today, look for a circular depression in the Jemez Mountains just west of Los Alamos, and for white rocks blanketing the area to the north and east of the crater.

Valles Caldera is actually on the smaller side as far as supervolcanoes go, but the last eruption, around 1.25 million years ago, was still bigger than any eruption ever witnessed by man—over 1000 times bigger than the 1980 eruption of Mount Saint Helens. The rhyolitic magma produced by the Valles Caldera supervolcano was very high in water and other volatiles, making for a highly explosive eruption that spewed ash as far as Wyoming and Nebraska. The mixture of ash, pumice, and gases radiated outward from the caldera at speeds up to 200 miles per hour. At temperatures

Remains of supervolcano eruption 1000 times larger than Mount Saint Helens

over 1700 degrees Fahrenheit, the pyroclastic flow would have incinerated anything in its path.

After the bulk of the volcanic material was ejected from the magma chamber, the floor of the caldera collapsed into the chamber below, creating a broad depression fourteen miles in diameter. A number of active hot springs, fumaroles, and gas seeps on the floor of the caldera are evidence of ongoing volcanic activity, as is Redondo Peak, an 11,253-foot resurgent lava dome inside the caldera, formed sometime after the main eruption and collapse.

The ash and pumice produced in the eruption created extensive pyroclastic deposits throughout northern New Mexico; these hardened into a rock called tuff. Just south and east of the caldera lies the Pajarito Plateau, cut through by Frijoles Canyon, once home to a unique settlement of Ancestral Puebloans between AD 1150 and 1600. Here, the tuff is relatively soft and residents of the canyon created cliff dwellings by hollowing out caves known as *cavates* in the walls of the canyon. They also built more traditional pueblo homes out of harder blocks of tuff and dug circular underground kivas for shelter from the desert heat. This complex of cavates, pueblos, and kivas is now preserved as Bandelier National Monument.

The people of Frijoles Canyon occupied their dwellings for hundreds of years before moving on to other areas of New Mexico after a prolonged drought. Glassy obsidian from the Valles Caldera has been found throughout the Southwest and Mexico, traded far and wide for use in making arrowheads, spears, and other sharp tools. Distinct isotopes in the obsidian make it possible to trace such tools back to their original source in the Jemez Mountains. ▪

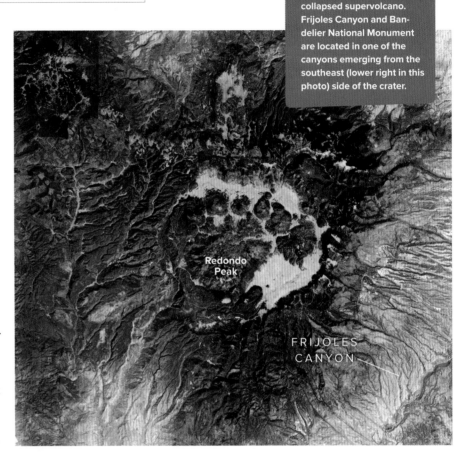

The Valles Caldera is a shallow crater left by a collapsed supervolcano. Frijoles Canyon and Bandelier National Monument are located in one of the canyons emerging from the southeast (lower right in this photo) side of the crater.

Redondo Peak

FRIJOLES CANYON

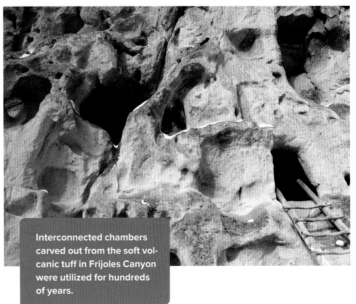

Interconnected chambers carved out from the soft volcanic tuff in Frijoles Canyon were utilized for hundreds of years.

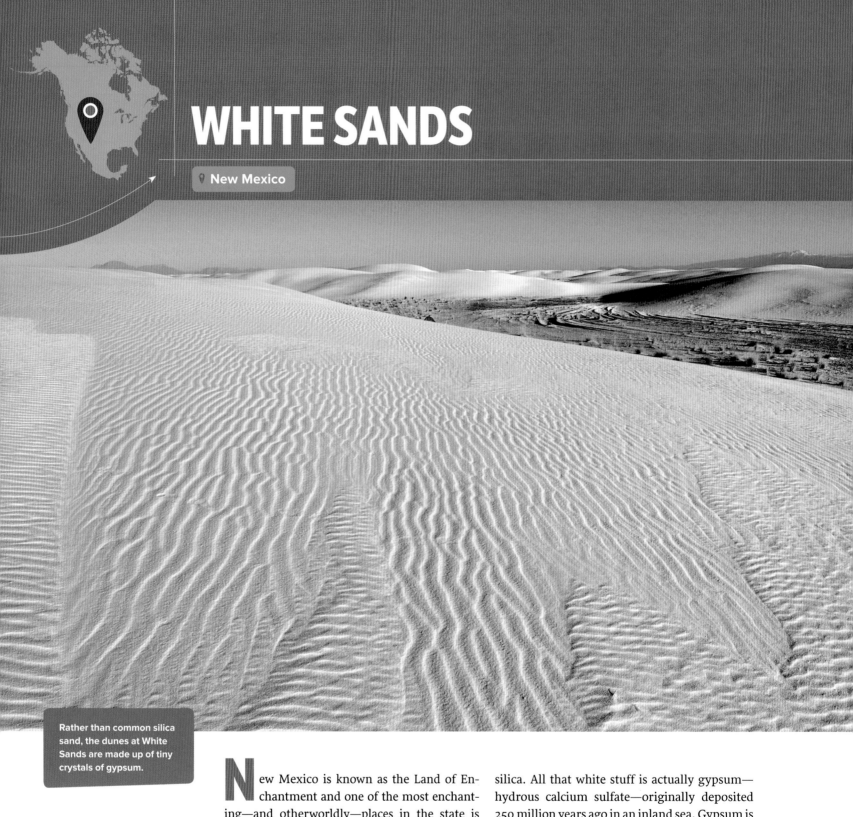

WHITE SANDS

New Mexico

Rather than common silica sand, the dunes at White Sands are made up of tiny crystals of gypsum.

New Mexico is known as the Land of Enchantment and one of the most enchanting—and otherworldly—places in the state is White Sands. This sea of stark white crystals is piled in ever-shifting dunes, seen from altitude as a barren, sandy expanse ringed by mountains, about fifteen miles southwest of Alamogordo, New Mexico.

The dunes here aren't made from typical sand, which is usually composed of minute grains of silica. All that white stuff is actually gypsum—hydrous calcium sulfate—originally deposited 250 million years ago in an inland sea. Gypsum is highly water soluble and easily dissolved by rainwater. White Sands exists in part because it's one of the driest deserts on Earth, receiving less than ten inches of rain a year. Gypsum crystals that do get dissolved by the occasional rainstorm are usually recrystallized and eventually eroded back into sand again, as the dune field is a closed basin—no

Largest gypsum sand field in the world, deposited 250 million years ago in an inland sea

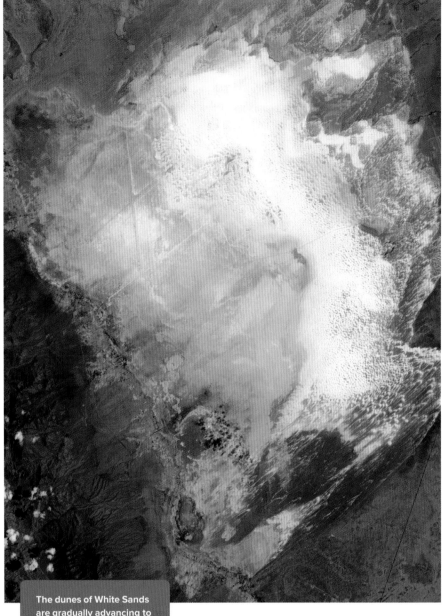

The dunes of White Sands are gradually advancing to the northeast. The missile range occupies the northern half of the dunes and White Sands National Monument is confined to the southern half.

streams exist to carry the dissolved gypsum away. White Sands boasts the largest gypsum field in the world, stretching more than 250 square miles.

This dune field is contained within the Tularosa Basin, a fault-block depression in the crust surrounded by mountains (the San Andres Mountains to the west and the Sacramento Mountains to the east). White Sands is trapped in the middle. The bulk of the gypsum sand comes from Lake Lucero, in the southwest corner of the dune field, which only rarely holds surface water. Here, selenite crystals, which are eroded by wind into gypsum crystals, are transported into the dune field in the northeast direction of the prevailing winds. A cycle of erosion, evaporation, and dune building dates back 6500 years, after Lake Lucero's predecessor, Lake Otero, dried up following the end of the last glacial period—relatively recently in geologic time.

Four types of dunes are found at White Sands—dome, crescent, parabolic, and transverse—each reflecting a different mechanism of formation. Dome dunes take shape along the margins of dune fields, in this case on the leeward shores of Lake Lucero. Crescent dunes form in windy areas and are the fastest-moving type. Parabolic dunes, the slowest-moving variety, are generally found along the perimeter of dune fields in areas with the least loose sand. Transverse dunes are created in areas with large amounts of loose sand stretching into long, wavy ridges.

This region in south central New Mexico is also home to exotic oryx—African antelopes imported for hunting in the 1960s—and the remote and inaccessible White Sands Missile Range, where the world's first atomic bomb was detonated in 1945. ▣

FLIGHT PATTERN

Look for White Sands en route to Alamogordo or Albuquerque, New Mexico. The area is divided into White Sands National Monument, in the southern part of the dune field, and the White Sands Missile Range to the north, which is closed to the public.

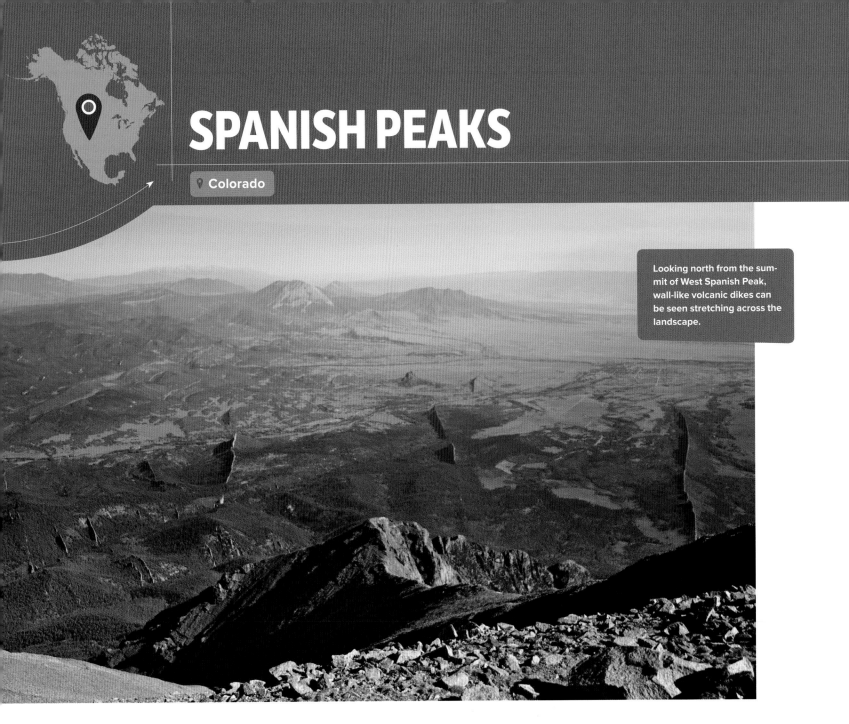

SPANISH PEAKS

Colorado

Looking north from the summit of West Spanish Peak, wall-like volcanic dikes can be seen stretching across the landscape.

FLIGHT PATTERN

A flight to Denver or Colorado Springs, Colorado, might offer views of the Spanish Peaks.

Geology students get to take the best field trips, and those lucky enough to study in Colorado may get to visit the Spanish Peaks—a textbook example of volcanic dikes. These formations are produced when magma intrudes into faults in surrounding layers of rock, partially melting the existing rocks and filling the cracks with molten rock that cools into crystalline dikes.

For a visual understanding, look no further than an aerial perspective of the Spanish Peaks, located in southern Colorado. You'll see two side-by-side summits, East Spanish Peak and West Spanish Peak, surrounded by lines radiating outward. These lines are radial volcanic dikes, and the Spanish Peaks have one of the world's most extensive and best-exposed systems of such dikes; the mountains were made a National Natural Landmark in 1976.

At the Spanish Peaks, dikes range from one to more than a hundred feet wide and stretch for almost fourteen miles. Because the igneous rock is generally more resistant to erosion than the surrounding sedimentary landscape, the dikes stand tall, some higher than a hundred feet, while the

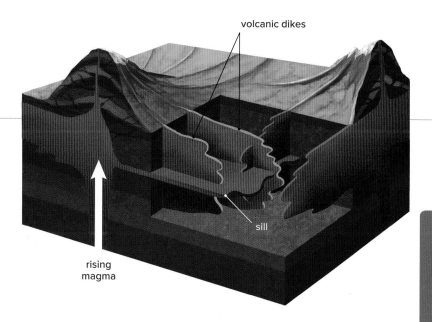

volcanic dikes

sill

rising magma

Volcanic dikes form when magma erupts underground along cracks or fissures. Over time, the many dikes emanating from the Spanish Peaks have been eroded to the surface, forming a network of impressive rock features.

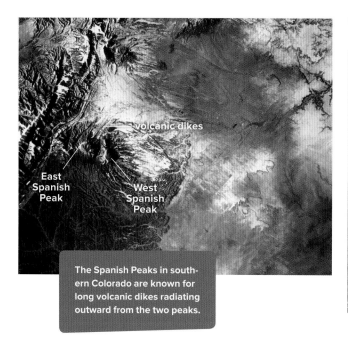

volcanic dikes

East Spanish Peak

West Spanish Peak

The Spanish Peaks in southern Colorado are known for long volcanic dikes radiating outward from the two peaks.

Softer surrounding rock has been eroded away over time, exposing volcanic dikes such as these.

surrounding sandstone is ground away by wind, rain, and ice.

The Spanish Peaks sit between the Sangre de Cristo Mountains in New Mexico and the Colorado Rockies. The two sister peaks were formed around 24 and 23 million years ago, respectively, by two separate volcanic intrusions deep underground. After millions of years of the surrounding rocks eroding, West Spanish Peak stands at 13,626 feet, while East Spanish Peak is slightly shorter, at 12,683 feet. Both peaks are primarily made up of granitic rock.

From the air, the dikes are so long and straight they can resemble massive manmade walls. Examples of other igneous formations can be seen in the area as well, including laccoliths, plugs, stocks, and sills—all types of intrusions that occur when volcanic eruptions take place underground, instead of at the surface. Erosion of the softer surrounding sedimentary rocks has left these once-buried volcanic features towering over the unique landscape, creating one of the best outdoor geology classrooms in North America. ∎

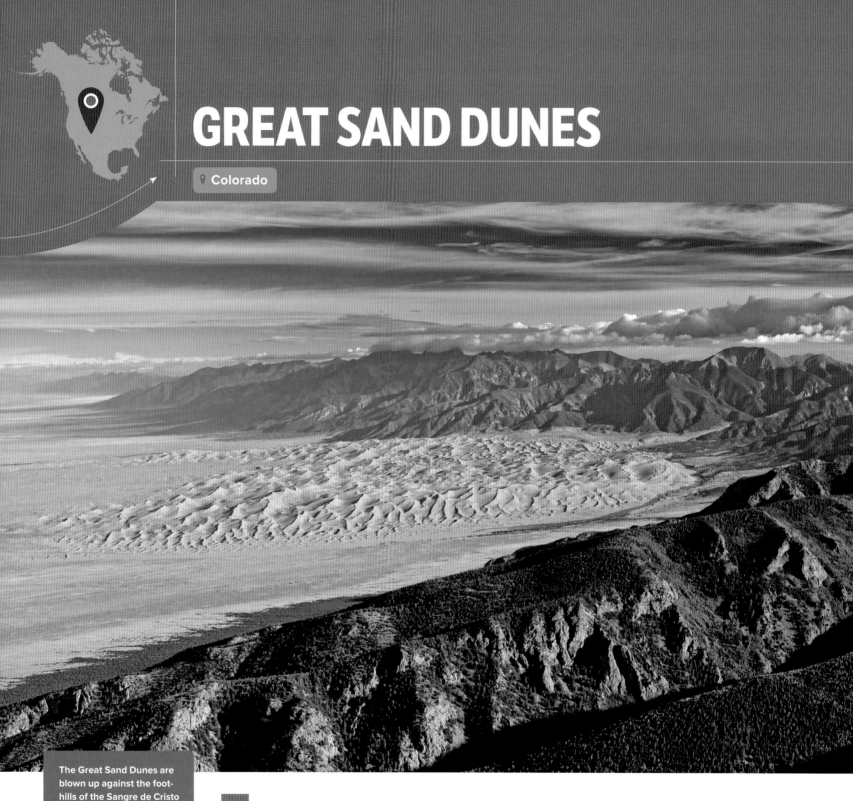

GREAT SAND DUNES

📍 Colorado

The Great Sand Dunes are blown up against the foothills of the Sangre de Cristo Mountains in southern Colorado.

The tallest sand dunes in North America are nowhere near an ocean, nor are they in a true desert. Instead, they are piled up against the edge of the Rocky Mountains in southern Colorado. Great Sand Dunes National Park and Preserve near Alamosa boasts sand dunes higher than 750 feet, blown against the west side of the Sangre de Cristo Mountains, a southern range of the Rockies.

From the air, the dune field stands out between the San Juan Mountains to the northwest and the Sangre de Cristos to the east, appearing as light-colored ripples in the shadow of the mountains. If you had flown over this area a hundred years ago, the dunes would have appeared very much the same. The effects of opposing winds and stream erosion are well balanced and the dune

Towering dunes of ancient lake sand, stacked against the Sangre de Cristo Mountains

star dunes

reversing dunes

barchan dunes

parabolic dunes

transverse dunes

nebkha or coppice dunes

system is quite stable. Ongoing dune-building activity occurs in only the top few inches of the main dune field; the deeper sand is well cemented by moisture.

The sand making up these eighty square miles of dunes was left behind by the once enormous ancient Lake Alamosa that filled what's now the San Luis Valley, before drying out around 440,000 years ago. Strong winds from the southwest blow the sediment out of the valley toward the mountains, where it piles up against the steep western slope. Occasional storm winds blow out of the northeast and the many streams that drain the mountains also carry sand back into the valley, which is then blown back into the dune field again, in a cycle that has persisted for millennia.

Six types of dunes form in Great Sand Dunes National Park and Preserve. The most common is the reversing dune, formed by the area's periodically reversing wind conditions. Star dunes are found in the northeast corner of the dune field, formed by more chaotic wind patterns that create branching arms in many directions—the highest dune in the park, 750-foot Star Dune, is, not surprisingly, a star dune. Parabolic dunes are found in the sand sheet on the edge of the dune field itself. Approximately 90 percent of valley's sand still resides in the sand sheet; only 10 percent makes up the dunes themselves. Barchan dunes and transverse dunes are rare in the park, but can be seen in areas where the wind blows only in one direction. Nebkha or coppice dunes are small sand hills that form around clumps of rooted vegetation. ∎

Six types of dunes are created in Great Sand Dunes National Park and Preserve; the formation of each type is dependent on the amount of sand available and the prevailing wind directions.

Medano Creek carries sediments blown into the mountains back to the dune field, playing an important role in continuing the cycle of dune building.

FLIGHT PATTERN

Great Sand Dunes National Park and Preserve is located in south central Colorado, on the west side of the Sangre de Cristo Mountains. You may fly over the dunes en route to Denver or Colorado Springs, Colorado.

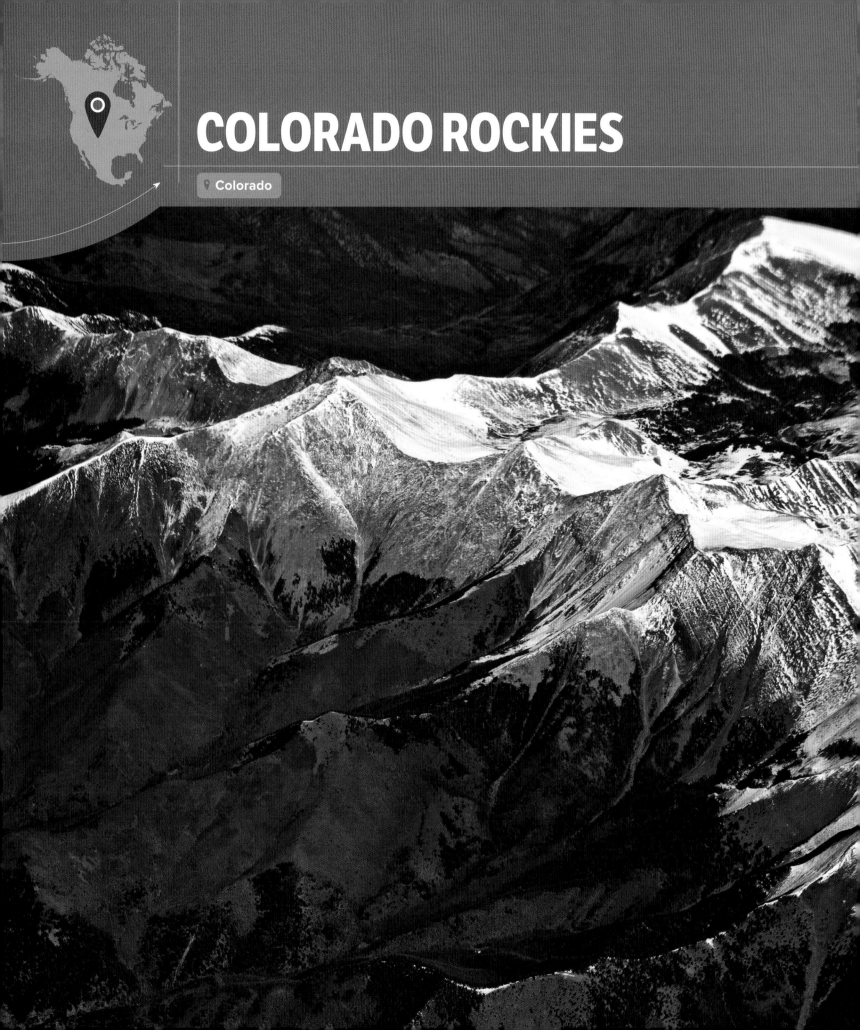

COLORADO ROCKIES

Fifty-eight peaks that top 14,000 feet, eroded from original heights exceeding 20,000 feet

Long before its legalization of marijuana, Colorado was the highest state in the lower forty-eight, boasting fifty-eight peaks exceeding 14,000 feet. The peaks, many of which hold snow year-round, are unmistakable from above, stretching across the state in a band that arcs from the Front Range north and west of Denver to the San Juan Mountains in the southwest part of the state.

The Colorado Rockies, the southern section of the U.S. Rockies, were uplifted between 70 and 40 million years ago, during a prolonged episode of mountain building (the Laramide orogeny), which raised the Rockies to heights over 20,000 feet. The driving forces of the uplift remain somewhat mysterious, however. Geologists know that 1000 miles to the west, at least one oceanic plate—the Farallon Plate—and possibly another, were being forced under the North American Plate during this time period. Subduction zones often form mountain ranges 200 to 400 miles inland, but the Rockies are twice as far away. So how could such a distant tectonic event create such huge mountains?

The answer may lie partly in an ancient mountain range known as the Ancestral Rocky Mountains, which existed around 300 million years ago, when amphibians ruled widespread swamps and dinosaurs had not yet evolved. During this time, what is now Colorado was home to two mountainous regions called Frontrangia and Uncompahgria, which were located where the Front Range and San Juan Mountains are today. Perhaps the hard roots of these mountains played some role in uplifting the region to Himalayan heights during the Laramide orogeny.

The Front Range, the eastern boundary of the Colorado Rockies, rises abruptly out of the eastern plains.

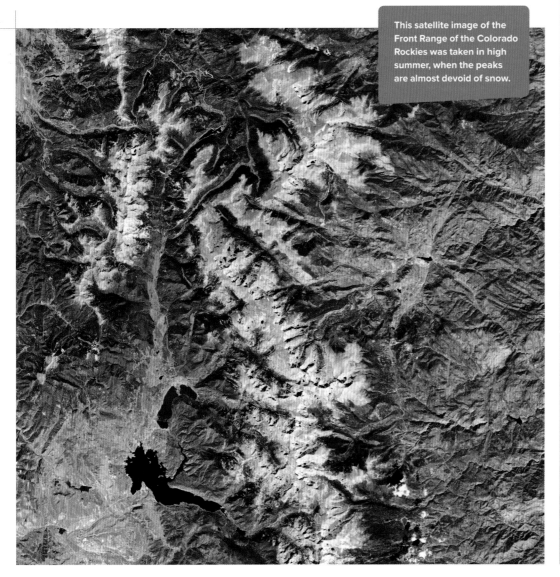

The Colorado Rockies today have been eroded down approximately 6000 feet from their maximum heights, exposing a mishmash of Precambrian metamorphic rock, fossil-rich rocks from the Permian Period, and conglomerates and sedimentary rock from the Mesozoic Era. Nearly sixty peaks still top 14,000 feet, however, and this variety of rock types gives many of Colorado's fourteeners unique profiles. The Maroon Bells, near Aspen, are composed of reddish, rotten, unstable mudstone that makes them some of the most difficult and treacherous fourteeners to climb. At the other end of the spectrum is Mount Elbert (the highest fourteener at 14,439), near Leadville, made up of very hard quartzite that lays the groundwork for an easy stroll to the summit.

Colorado has more fourteeners than any other state, followed by Alaska with twenty-nine, California with twelve, and Washington with two. None of the other states that host the U.S. Rockies—New Mexico, Wyoming, Montana, or Idaho—has any peaks reaching 14,000 feet. ▥

The state of Colorado is home to fifty-eight peaks higher than 14,000 feet (fourteeners), grouped into seven mountain ranges.

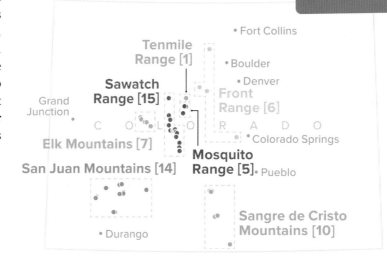

Tenmile Range [1]

Sawatch Range [15]

Front Range [6]

• Fort Collins

• Boulder

• Denver

Grand Junction

Elk Mountains [7]

San Juan Mountains [14]

Mosquito Range [5]

• Colorado Springs

• Pueblo

C O L O R A D O

• Durango

Sangre de Cristo Mountains [10]

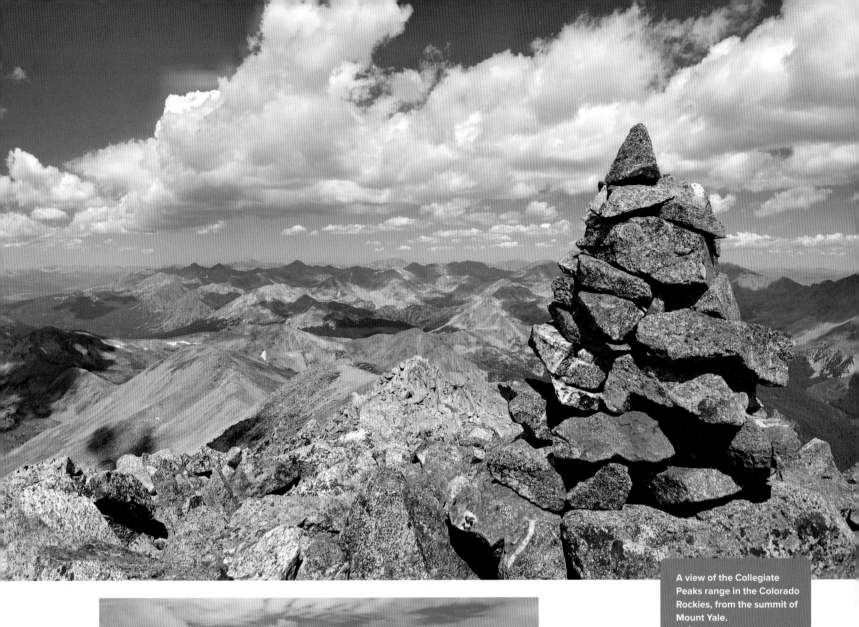

A view of the Collegiate Peaks range in the Colorado Rockies, from the summit of Mount Yale.

Hard quartzite juts out of the ground near the summit of Mount Elbert, the highest of the Colorado fourteeners.

FLIGHT PATTERN

You will fly over the Colorado Rockies en route to Denver, specifically, but also on many U.S. cross-continental trips.

BLACK CANYON OF THE GUNNISON

Colorado

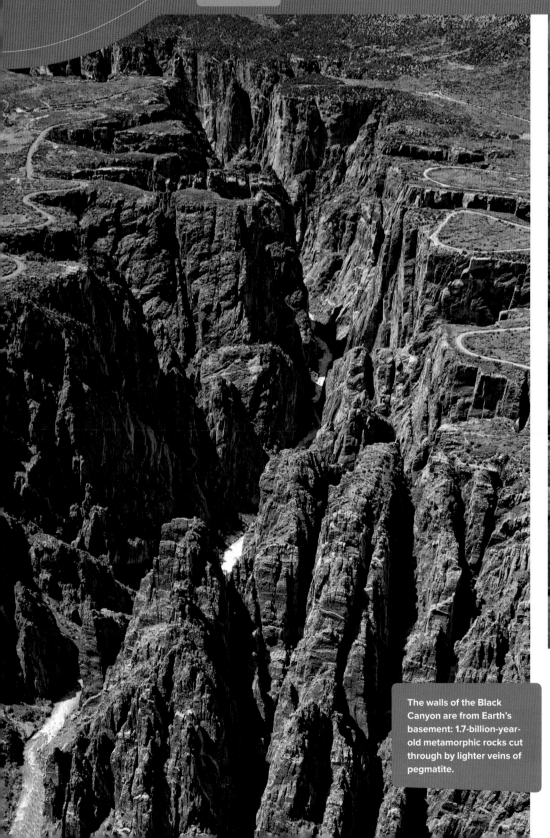

The walls of the Black Canyon are from Earth's basement: 1.7-billion-year-old metamorphic rocks cut through by lighter veins of pegmatite.

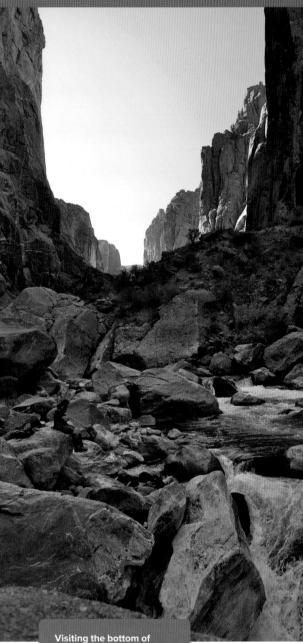

Visiting the bottom of the Black Canyon of the Gunnison is not for the timid, as the few poorly defined trails are steep and littered with large, unstable boulders that require careful scrambling.

The continent's darkest canyon sees only minutes of sunlight a day

No other major canyon system in North America equals the depth and darkness of the Black Canyon of the Gunnison. Depending on your altitude, it can be hard to appreciate from above just how deep and dark this precipitous gorge really is, but look for a series of manmade reservoirs that drop into a steep, narrow canyon.

The Gunnison River is a Colorado River tributary that drains parts of southwest Colorado and the Uncompahgre Plateau before joining the Colorado River in Grand Junction on its way into Utah. After flowing through a series of hydroelectric reservoirs near the town of Gunnison, the river enters the Black Canyon—so named because its high-walled depths only receive a few minutes of direct sunlight a day.

The sheer walls of the Black Canyon do indeed give it a foreboding appearance. Composed mainly of dark gneiss and schist dating back 1.7 billion years, during the Precambrian Period, these ancient rocks are crosscut by lighter-colored dikes of pegmatite that forced their way into the darker rocks around the same time period. The Gunnison River did not originally choose to carve its path through the very old, very hard rocks. It began its course around 15 million years ago, running through softer volcanic rocks that erupted during the Tertiary Period, between 35 and 26 million years ago.

Around 3 million years ago, a period of regional uplift raised parts of the Uncompahgre Plateau, causing the river to cut down deeper into the volcanic rocks, eventually reaching the harder Precambrian rocks below. At this point, many side-canyon rivers feeding into the Gunnison dried up, finding easier courses elsewhere, but the Gunnison River was trapped in its already deep gorge. Higher water levels during the last ice age are estimated to have carved the canyon at a geologically speedy rate of an inch every century, producing the canyon we see today in just a few million years.

As it thrashes its way through the canyon, the river drops an abrupt average of thirty-four feet per mile: the fifth-steepest river descent in North America. The Colorado River, in comparison, drops an average of seven and a half feet per mile through the Grand Canyon, considered one of the wildest white-water rides anywhere. In some places, the Black Canyon is only forty feet across, as it plunges more than 2000 feet into the bedrock. ▪

FLIGHT PATTERN

It's possible to spot the Black Canyon of the Gunnison on flights to Montrose, Grand Junction, or Colorado Springs, Colorado.

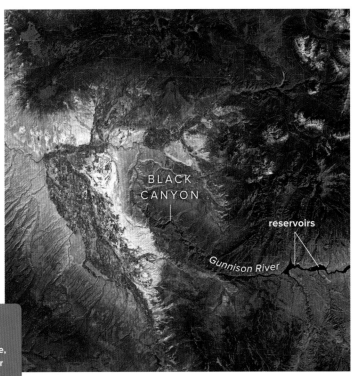

BLACK CANYON

reservoirs

Gunnison River

The Gunnison River flows through a series of three manmade reservoirs (large, lake-like areas in the lower right of this image) before plunging into the depths of the Black Canyon.

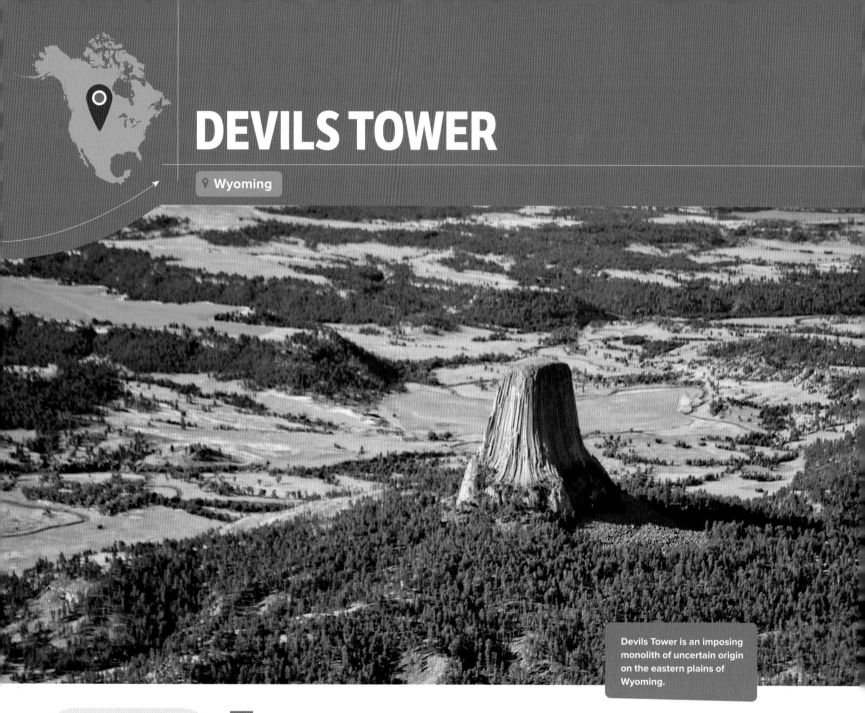

DEVILS TOWER

Wyoming

Devils Tower is an imposing monolith of uncertain origin on the eastern plains of Wyoming.

FLIGHT PATTERN

Devils Tower appears as a massive gray rock rising up from the landscape of rolling hills and patches of evergreen forests. You might fly over Devils Tower en route to Casper or Jackson, Wyoming, or Rapid City, South Dakota.

Eastern Wyoming is relatively flat, with one notable exception: Devils Tower, a sentinel of columnar basalt, rising 1200 feet above the nearby Belle Fourche River. Visible from miles away—including skyward—the tower has been a navigational and spiritual landmark for travelers and Native Americans for thousands of years.

The specific origin of Devils Tower is somewhat controversial. Geologists generally agree the stone that makes up the tower was born around 40 million years ago, when magma was forced up through layers of rock, but whether this rock reached the surface before it cooled is a matter of debate. Depending on whom you ask, Devils Tower could be classified as a stock, a laccolith, or a volcanic plug. A stock cools underground, a laccolith creates a dome at the surface, and a volcanic plug forms in the neck of an exposed volcano.

Whatever the tower's story of formation, outside layers of sedimentary rock eroded away over time, leaving the interior column of volcanic rock standing high above the surrounding landscape. Devils Tower is made up of hexagonal columns that formed when the rock cooled and fractured along regular joints, forming the geometrically shaped columns.

Stock, laccolith, or volcanic plug? Geologists argue over this 40-million-year-old lava tower.

Geologists aren't sure how Devils Tower formed. It could be classified as a volcanic plug, laccolith, or stock.

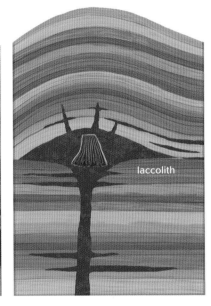

plug

magma chamber

laccolith

stock

batholith

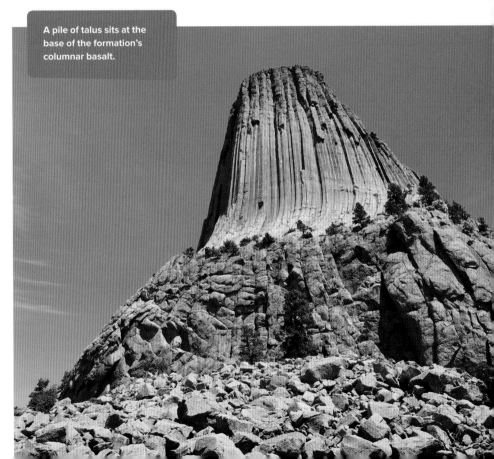

A pile of talus sits at the base of the formation's columnar basalt.

Native Americans tell different stories of how the tower formed. According to legends passed down by the Kiowa and Lakota Sioux, fearsome bears were chasing some young girls, who prayed to the Great Spirit for help. The tower rose up underneath the girls, lifting them out of reach. The angry bears clawed at the rock, leaving long vertical scratches said to result in the tower's cracks and columns.

Long before it was designated Devils Tower National Monument in 1906, the throne of rock was known by various tribes as the Bear's Lodge, the Bear's Tipi, Tree Rock, and Grizzly Bear Lodge. The name Devils Tower is considered an affront by many of the Native American tribes who revere the tower, including the Lakota Sioux, Crow, Arapaho, Cheyenne, Kiowa, and Shoshone, but the most recent proposal to rename the tower Bear Lodge National Historic Landmark was shot down in 2005. ∎

BIGHORN BASIN

📍 Wyoming

BEARTOOTH
MOUNTAINS

BIGHORN

BASIN

ABSAROKA
RANGE

Bighorn Basin appears
on the right side of this
NASA image, east of the
Beartooth Mountains and
the Absaroka Range.

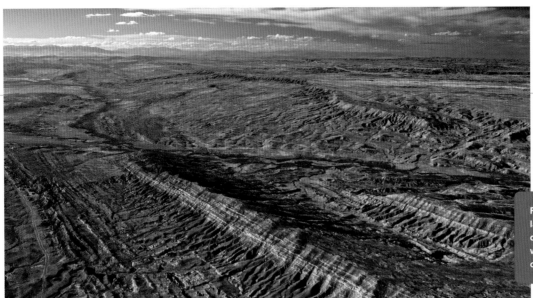

Folds in the sedimentary layers of the Bighorn Basin created traps and pockets where oil and natural gas collected over time.

Land depression created by warping crust—once a dense, plant-rich swamp

Gazing from an airplane window down on arid Wyoming, it's hard to believe the entire region was once covered in dense, swampy vegetation. Over geologic time, this plant matter decomposed into kerogen, a sticky substance that breaks down further into petroleum and natural gas products, which in turn have made Wyoming rich in fossil fuels. The sedimentary layers that store such reserves are widespread throughout the region.

One of the most productive places for petroleum is the Bighorn Basin in north central Wyoming. It is technically a structural basin—the opposite of a raised dome—where warping of the crust has produced a large-scale depression in the landscape. From the air, look for a large, dry swale enclosed by the Bighorn Mountains to the east, the Pryor Mountains to the north, the Beartooth Mountains and Absaroka Range to the west, and the Owl Creek and Bridger Mountains to the south. Over time, this depression has collected sediments that now measure more than 20,000 feet thick, dating from the Cambrian Period to the Miocene Epoch, between 500 and 5 million years ago.

The main reservoirs of oil are contained in porous layers of sandstone and limestone from the Mesozoic Era. The 500-foot-thick Tensleep Formation (sandstone), which dates to the Pennsylvanian Period, around 300 million years ago, is the most-tapped oil source in the region. More reserves are found within the Madison Formation (limestone), 330 million years old; the Phosphoria Formation (shale), 260 million years old; and the Frontier Formation (sandstone), 120 million years old.

Coal is also plentiful in the Bighorn Basin; over 50 million tons have been excavated since the early 1980s. As much as 18 million tons of coal is estimated to remain, but because much of this coal lies under 3000-plus feet of sediment, only a fraction of it is considered economically recoverable. These reserves date to the late Cretaceous Period (99 to 65 million years ago) and are mainly contained within the Fort Union Formation. Much of the coal found in the Bighorn Basin is bituminous, which is relatively soft and sooty and doesn't burn as hot as denser anthracite. Bituminous coal is a sedimentary rock, but the much rarer anthracite is metamorphic—produced when heat and pressure transform existing bituminous rock.

Where Mesozoic layers of sedimentary rocks are found, so are dinosaur bones. The Cloverly Formation in the Bighorn Basin has been an important source for Cretaceous Period fossils since the early 1900s. ∎

FLIGHT PATTERN

You might fly over the Bighorn Basin en route to Jackson, Wyoming, or Billings, Montana.

WIND RIVER RANGE

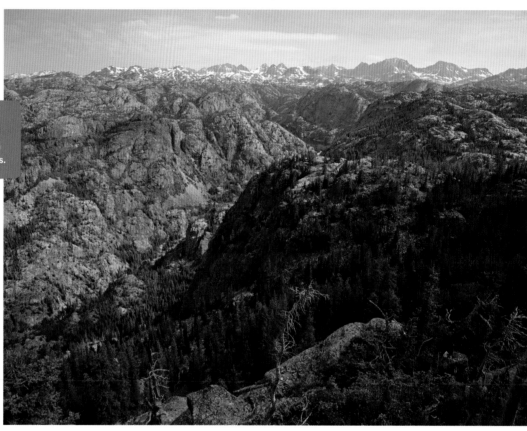

The granite wonderland of the Winds is one of the largest roadless regions in the lower forty-eight states.

Granite that formed underground, later carved by 2000-foot-thick ice sheets

With its smooth, silvery gray texture and tendency to erode into soaring walls and dramatic pinnacles, granite is one of the most beautiful rocks on Earth. The most famous granite is found in Yosemite National Park in California, but the remote and rugged Wind River Range in Wyoming gives Yosemite a run for its money. An extra enticement is that in contrast to the always-busy Yosemite, the Winds are far off the crowded tourist track.

The Wind River Range is located south and east of the Tetons—from the air, look for a silvery gray expanse of granite sprinkled with many blue lakes—but its geologic story is different from that of the Tetons. Over a billion years ago, an enormous volcanic intrusion formed deep underground, cooling slowly with time to form a granitic batholith. This batholith remained buried for millions of years, until the Laramide orogeny exposed the mass of granite at the surface starting around 70 million years ago.

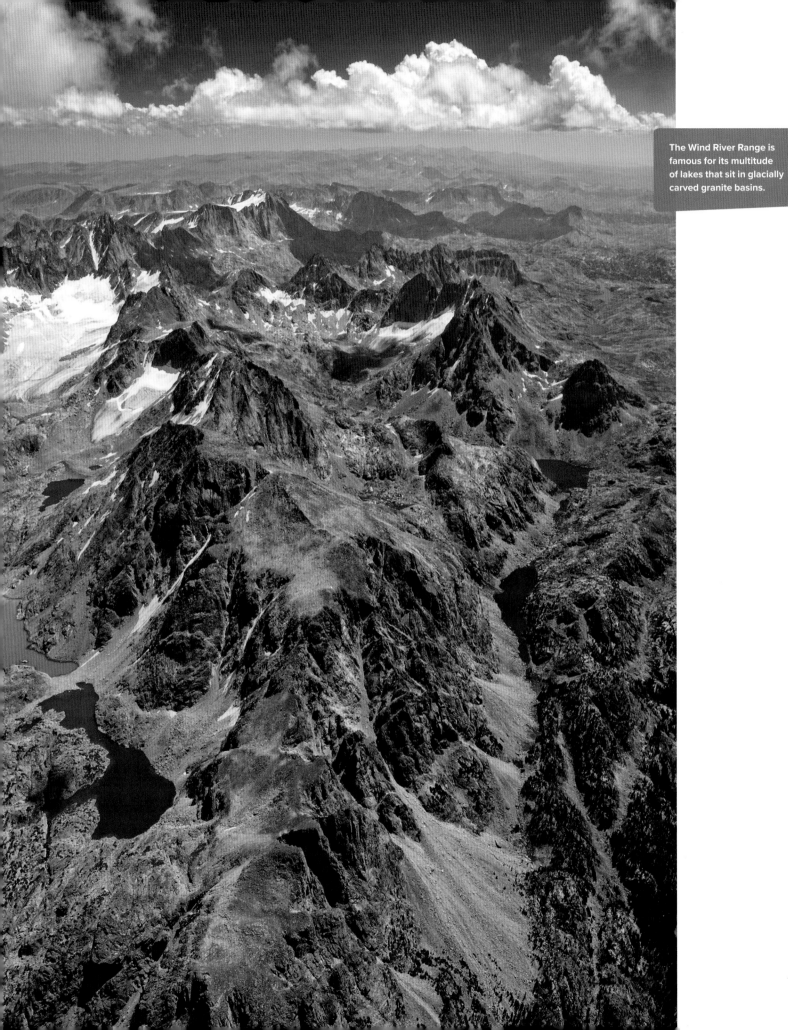

The Wind River Range is famous for its multitude of lakes that sit in glacially carved granite basins.

The planet's multiple ice ages had a profound impact on the Winds, which were covered in ice sheets over 2000 feet thick during much of the Pleistocene Epoch—a time from around 500,000 years ago until about 8000 years ago. The numerous lakes and cirques (amphitheater-shaped valleys) that characterize the Wind River Range today were carved by these highly erosive rivers of ice. The most famous of these is the Cirque of the Towers: a lush, lake-filled bowl surrounded by towering granite peaks.

At the foot of the Cirque of the Towers lies Lonesome Lake, the remaining vestiges of a once-powerful glacier that created the picturesque valley. Approximately 170 glaciers (both named and unnamed) remain in the Wind River Range today, including Gannett Glacier, which sits on the north slope of the highest mountain in Wyoming, 13,809-foot Gannett Peak. Gannett Glacier is currently the largest glacier in the U.S. Rockies, but like many glaciers it is shrinking. In 1950, Gannett Glacier covered nearly two square miles of Gannett Peak's slopes; by 1999, coverage had shrunk to just under a mile and a half, also thinning by more than sixty feet. ▪

FLIGHT PATTERN

The Winds are a beautiful sight on the way to Jackson or Casper, Wyoming. The range is located east of the Tetons.

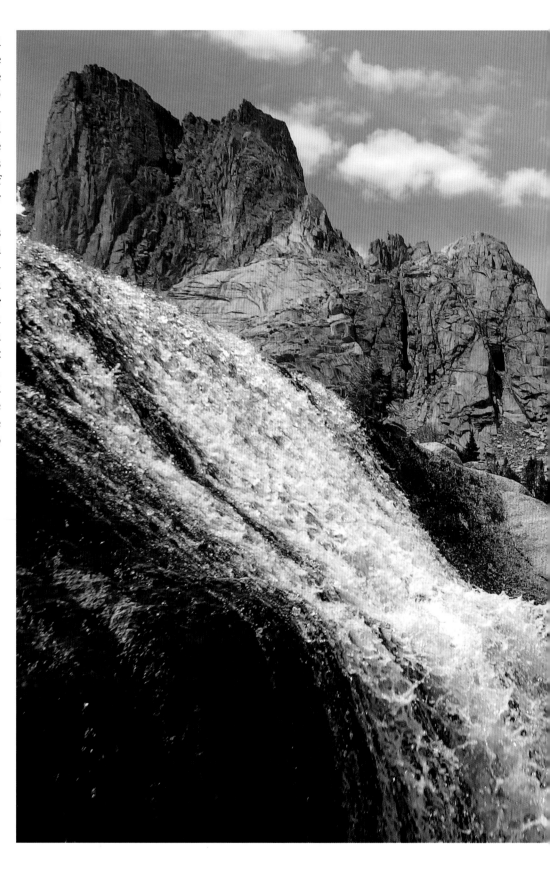

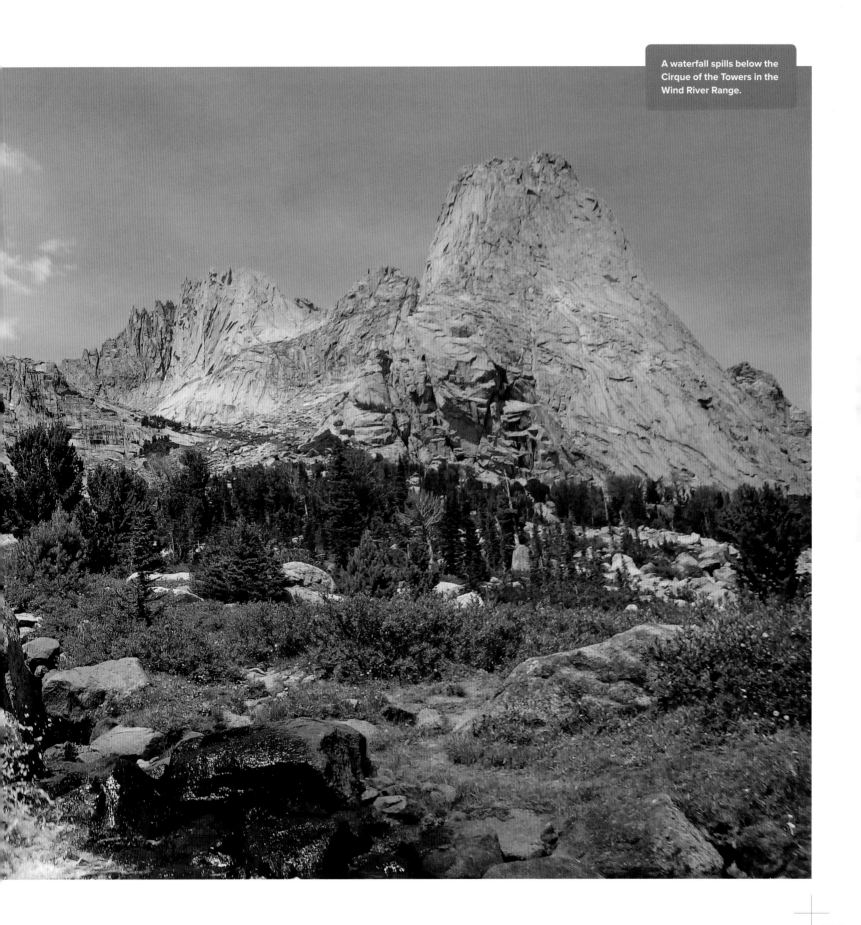

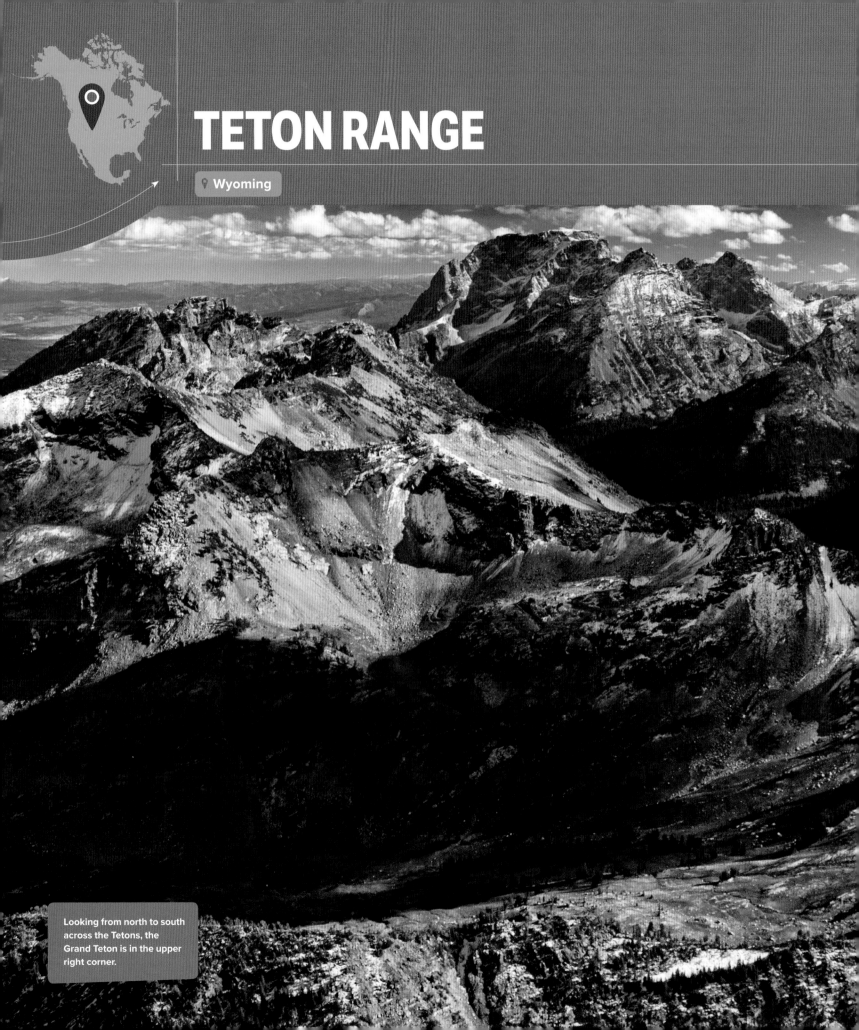

TETON RANGE

📍 Wyoming

Looking from north to south across the Tetons, the Grand Teton is in the upper right corner.

North America's youngest mountain range, made of some of the continent's oldest rocks

The Teton Range is one of the world's most visually stunning mountain ranges, shooting higher than 7000 feet above the adjacent valley floor—from the sky, it appears as a range of jagged peaks running north and south, bordered by the Jackson Hole valley to the east.

The Tetons have the distinction of being the youngest mountain range in North America, yet they were formed from some of the oldest rocks on the continent. The most famous summit is the Grand Teton. As the biggest tooth in a very toothy range, the Grand Teton soars to an elevation of 13,775 feet. The Grand is so extreme in part because it is so young. Both the Grand Teton and the nine spiky peaks that make up the range, including Teewinot Mountain and Mount Moran, are only about 9 million years old—toddler age in geologic time—and they're still growing taller.

The Tetons were thrust up as a result of extensional movement along the Teton Fault; both the mountain range and the Jackson Hole valley formed from tilted blocks of Earth's crust. As the block that forms the Tetons continues to be uplifted, the block that underlies Jackson Hole is sinking. In the past 9 million years, the vertical displacement along the Teton Fault has grown to as much as 23,000 feet as the mountains rise and the valley sinks. Movement along the fault is rushing along at geologic warp speed of a foot every 300 years.

In contrast to the Tetons' youthful age as mountains, the oldest rocks that make up the range began forming around 2.5 billion years ago, when this area of the world was covered by an ancient ocean. Extensive volcanism during this time

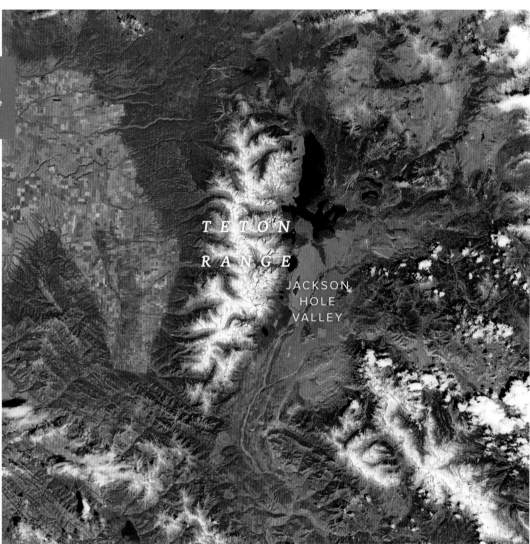

As the Teton Range keeps rising, the valley of Jackson Hole, on the east side of the range, keeps sinking.

TETON RANGE

JACKSON HOLE VALLEY

FLIGHT PATTERN

You will be treated to a view of the spectacular Teton Range flying into Jackson, Wyoming.

added to the deep piles of seafloor sediments, and the mix was later buried and metamorphosed under intense heat and pressure to produce gneiss.

Later episodes of volcanism forced magma up through cracks in the gneiss deep underground, creating granite intrusions, or dikes, that were exposed when the range was uplifted and eroded. This granite—harder than the gneiss—is as thin as a crack in some places and hundreds of feet thick in others. Dikes can be seen all over the Teton Range; the most famous is the black stripe on the east face of Mount Moran. Black Dike was formed

775 million years ago—long before the mountain was formed—when magma filled a vertical crack in existing rock that was 150 feet wide and more than seven miles thick. A portion of the dike remained when the uplift of the Tetons took place and can be seen today as a vertical streak on the summit spire. One of the classic technical climbing routes in the Tetons follows this dike to the summit of Mount Moran. ■

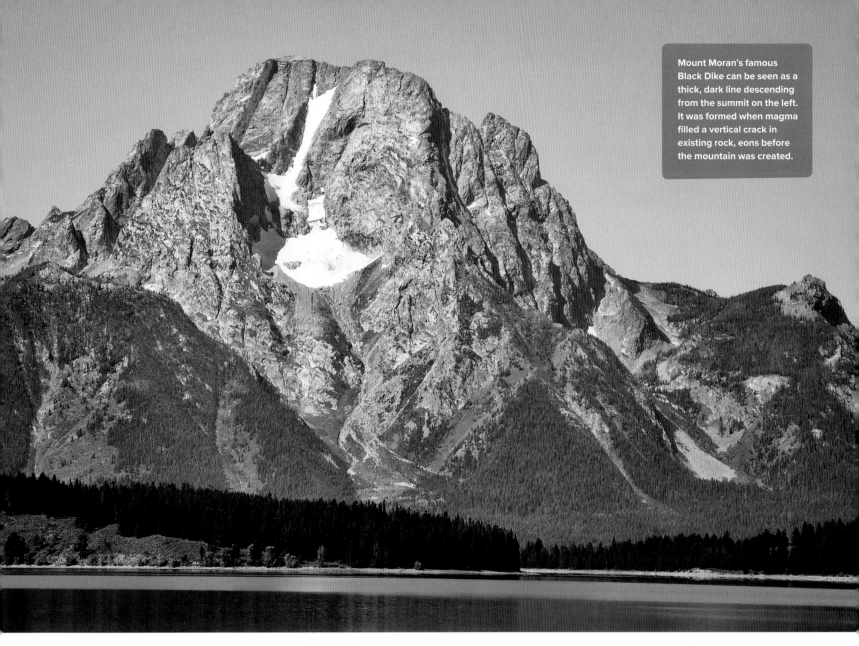

Mount Moran's famous Black Dike can be seen as a thick, dark line descending from the summit on the left. It was formed when magma filled a vertical crack in existing rock, eons before the mountain was created.

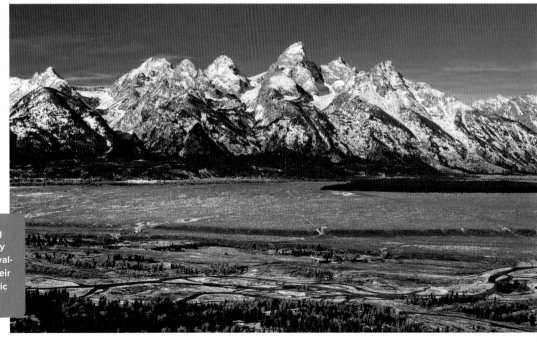

The Tetons are so striking in part because of the way they rise right out of the valley, with no foothills at their base, evidence of dramatic fault movement.

YELLOWSTONE NATIONAL PARK

Yellowstone National Park is one of the last intact wild ecosystems in the lower forty-eight states. Lucky visitors sometimes catch a glimpse of one of the park's apex predators: grizzly bears, wolves, and mountain lions. Most visitors, however, won't see the park's biggest, baddest resident—the infamous Yellowstone supervolcano. This supervolcano is one of the largest active volcanic systems on Earth today, but because of erosion, its outline is only apparent on the surface in a few places. From high above the region in northern Wyoming, though, one can trace the outline of the Yellowstone Caldera—the caldera created by the supervolcano's most recent super eruption—and the oddly outlined Yellowstone Lake, which sits inside. Heat from the supervolcano fuels the park's famous thermal features, including hot springs, geysers, and mud pots.

Yellowstone Caldera was created by the mammoth Lava Creek eruption approximately 640,000 years ago, an explosion that was over 2500 times larger than the Mount Saint Helens eruption in 1980. After the blast, the supervolcano collapsed in on itself, creating a caldera that covered 1500 square miles. Over time, this giant bowl was filled in by subsequent lava flows and erosion. Now only a few sections of the Yellowstone Caldera are visible in the park, such as from the Washburn Hot Springs Overlook (just south of Dunraven Pass) and the Flat Mountain Arm of Yellowstone Lake.

In the southeast section of the park, Yellowstone Lake has been a literal hotbed of volcanic activity since the Lava Creek eruption. Around 150,000 years ago, a short-lived but violent eruption created the West Thumb Geyser Basin, an extension of Yellowstone Lake. And about 13,800 years ago, a steam explosion opened a crater in Mary Bay, on the north shore of the lake.

All this activity is spawned by a magma chamber that lurks between twelve and twenty-eight miles beneath Yellowstone National Park. According to seismic surveys, the chamber is fifty miles long and twelve miles wide and holds enough molten rock to fill the Grand Canyon ten times over. In 2013, the chamber was discovered to

Geothermal hotbed spawned by underground magma chamber fifty miles long and twelve miles wide

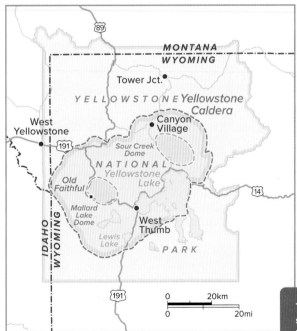

The Yellowstone Caldera is so large that it can only truly be appreciated from the air.

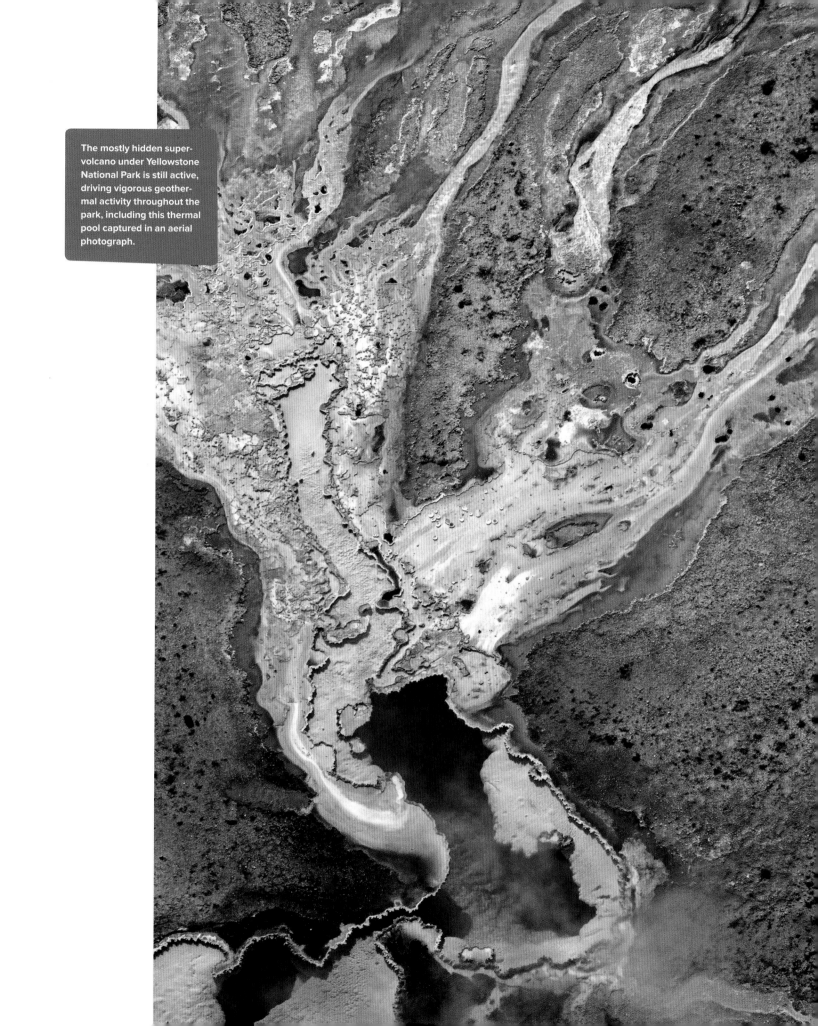

The mostly hidden super-volcano under Yellowstone National Park is still active, driving vigorous geothermal activity throughout the park, including this thermal pool captured in an aerial photograph.

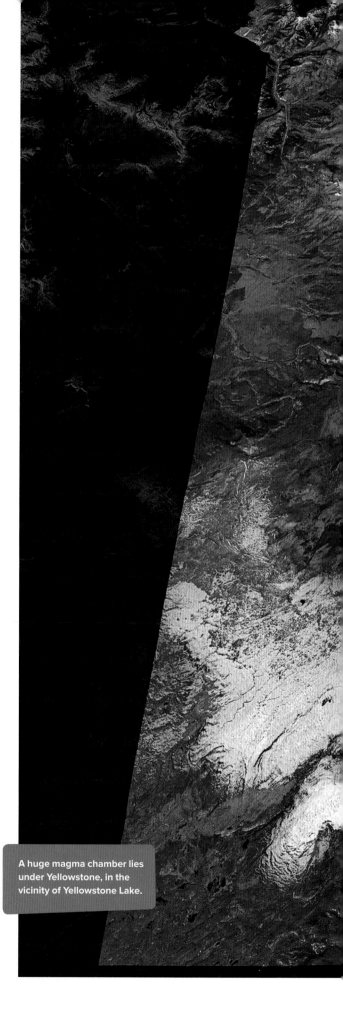

A huge magma chamber lies under Yellowstone, in the vicinity of Yellowstone Lake.

FLIGHT PATTERN

Flights to Jackson, Wyoming; Idaho Falls, Idaho; or Bozeman, Montana, can offer overhead views of the park and Yellowstone Lake, which sits inside the Yellowstone Caldera.

be two and a half times bigger than previously measured. These days, ongoing volcanism is expressed in the form of vigorous geothermal activity, minor earthquake swarms, and general geologic unrest. Another major eruption at Yellowstone the size of the Lava Creek event would devastate a large swath of North America, but careful monitoring of the underlying forces indicates that the volcano isn't likely to explode to life again anytime soon. ▣

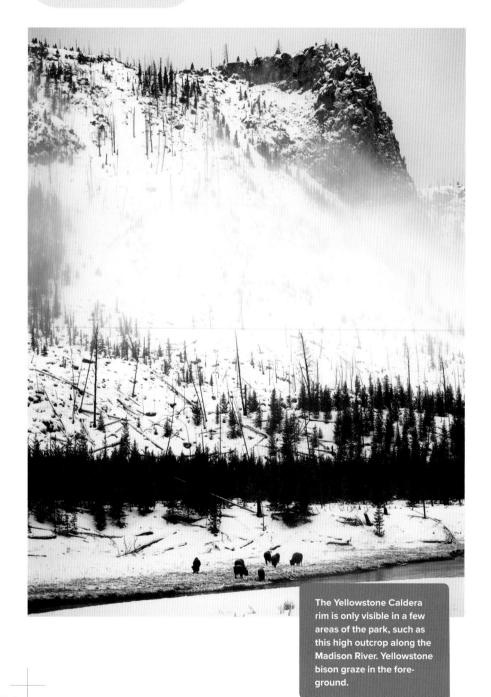

The Yellowstone Caldera rim is only visible in a few areas of the park, such as this high outcrop along the Madison River. Yellowstone bison graze in the foreground.

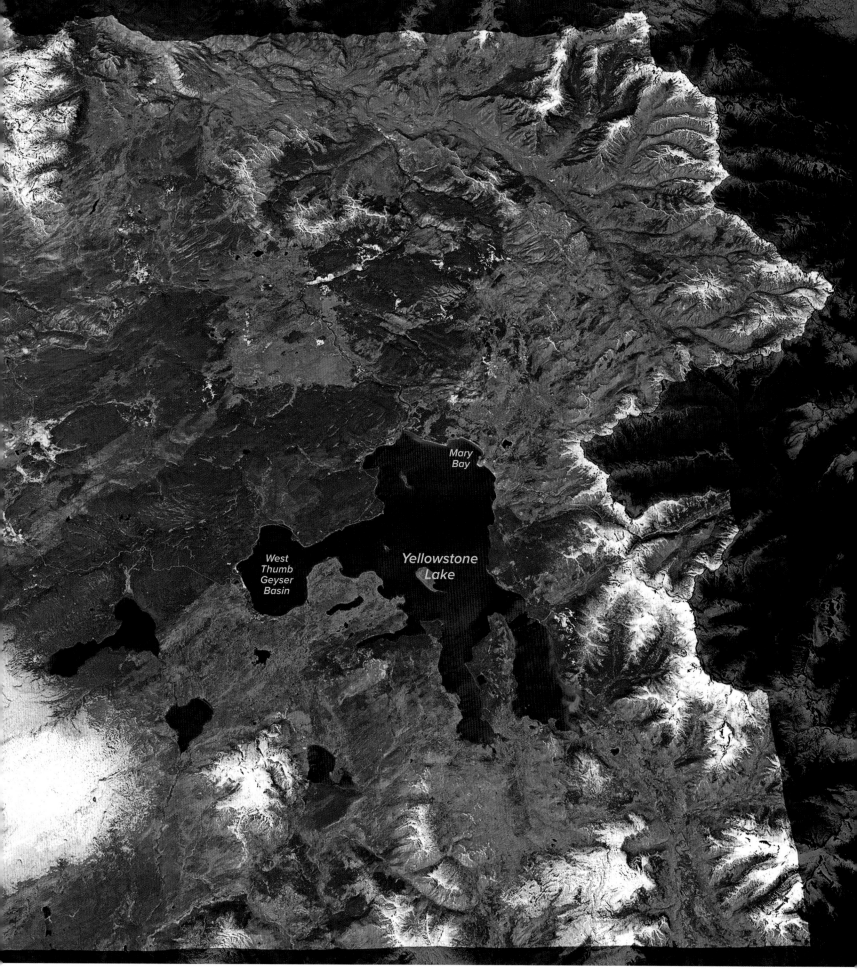

West
Thumb
Geyser
Basin

Mary
Bay

Yellowstone
Lake

LONE PEAK

📍 Montana

The Lone Peak Tram was designed to move with the rippled rock glacier underneath it. The tram base has moved more than ten feet since 1995–96.

A skier hikes along the Headwaters, one of several lateral arms that make up Lone Peak's Christmas tree laccolith.

If you were to design the ideal mountain for a world-class ski resort, you might come up with something like Lone Peak, the centerpiece of Big Sky Resort in Big Sky, Montana. Big Sky's tagline is "The Biggest Skiing in America," and even if that's no longer true in terms of acreage, the hair-raising double black diamond runs off Lone Peak's 11,166-foot summit certainly set the bar for sheer grandeur. From the air, look for a solitary conical peak in the midst of several mountain ranges, with the village of Big Sky on the east side.

Lone Peak dominates the Big Sky horizon but it isn't entirely alone. The pyramidal peak sits at the nexus of three mountain ranges: the Spanish Peaks, Gallatin Range, and Madison Range, which have very different formation stories. The Spanish Peaks to the north are composed of 2-billion-year-old metamorphic gneiss that was uplifted into mountains around 60 million years ago during the Laramide orogeny, which built the Rocky Mountains. The Gallatin Range, stretching northeast toward the Bozeman Valley, is made up

Failed volcano's subterranean eruption formed treelike trunk and arms

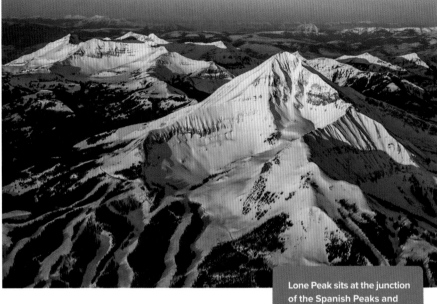

Lone Peak sits at the junction of the Spanish Peaks and the Gallatin and Madison Ranges. Cedar Mountain, behind Lone Peak to the left in this image, is part of the Madison Range.

of mostly volcanic rocks that erupted between 70 and 50 million years ago, related to the subduction of the Farallon Plate under the North American Plate. The Madison Range to the southwest is made up of fossil-rich sedimentary rocks that in some places were baked into metamorphic rock by underlying volcanism.

Lone Peak lies at the edge of the Madison Range and is actually a failed volcano that never erupted at the surface. Instead, magma rose up through a vertical conduit but then spread out sideways underground, flowing between layers of sedimentary rock, forming lateral arms of dacite and andesite. This type of eruption produces a Christmas tree laccolith: a structure with a central trunk and radiating lateral arms that intrude into existing sedimentary rock.

The underground eruption that built Lone Peak took place around 68 million years ago, but the pyramid we see today is the result of more recent carving by extensive glaciers during the Pleistocene Epoch. The bowl-shaped cirques on each side of the peak were scooped out by glaciers, some of which survive today.

The rocks in the bottom of these cirques are curiously rippled because they sit on top of moving rivers of ice hidden beneath the rocks. These rock glaciers move downhill over time; the base of the Lone Peak Tram, which whisks skiers up to the summit, was built on top of a mile-long rock glacier and designed to move to accommodate the slow downhill creep. Sliding at a rate of around seven inches per year, the tram base has moved backward more than ten feet since it was built in the winter of 1995–96. ∎

FLIGHT PATTERN

You might fly over Lone Peak en route to Bozeman, Montana.

TRIPLE DIVIDE PEAK

📍 Montana

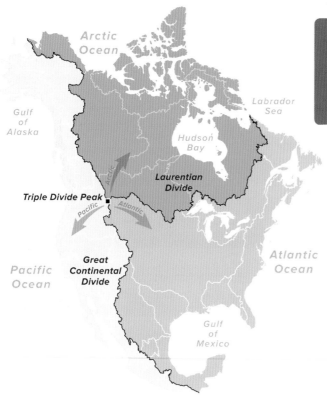

Arctic Ocean

Gulf of Alaska

Labrador Sea

Hudson Bay

Gulf of Mexico

Atlantic Ocean

Pacific Ocean

Triple Divide Peak

Laurentian Divide

Great Continental Divide

The hydrological divides of North America tend to follow major mountain ranges and drainages where rainwater makes its way down to various oceans.

Rain falling on this summit flows to three different oceans

FLIGHT PATTERN

Triple Divide Peak could be visible on trips to Kalispell, Montana, or Calgary, Alberta. The peak can also be viewed from Going-to-the-Sun Road in the Two Dog Flats area, on the east side of Glacier National Park.

Triple Divide Peak rises to its 8020-foot, prow-like summit in the heart of Glacier National Park. Flying over the area, look for a pyramid-shaped peak in the Lewis Range, in the southern half of the park. The Lewis Range is a subrange of the Canadian Rockies, formed around 170 million years ago, when an immense slab of ancient Precambrian rock slid over younger Cretaceous rocks, in a rare positioning of older rocks atop much younger rocks, adding to the peak's geologic interest.

The Continental Divide runs along the crest of the Rockies, directing rain that falls on the east side to the Atlantic Ocean and precipitation that falls on the west side to the Pacific Ocean. Rainwater that descends on Triple Divide Peak, however, is guided not just to two oceans, but three. The reason is the location: here, the Continental Divide meets the Laurentian Divide, which separates the Arctic and Atlantic watersheds. This means that water falling on this prominent peak flows to the Atlantic, the Pacific, *and* the Arctic Oceans. Only a handful of such continental hydrological apexes exist in the world.

Rainfall on Triple Divide Peak makes one of three impressive journeys: on the western side of the peak, water flows through streams to the Columbia River and out to the Pacific Ocean. On the northeastern side, rain makes its way to Hudson Bay, which is considered part of the Arctic Ocean. Rainwater on the southeastern slopes travels to the Mississippi River and out to the Gulf of Mexico, which is part of the Atlantic Ocean. ∎

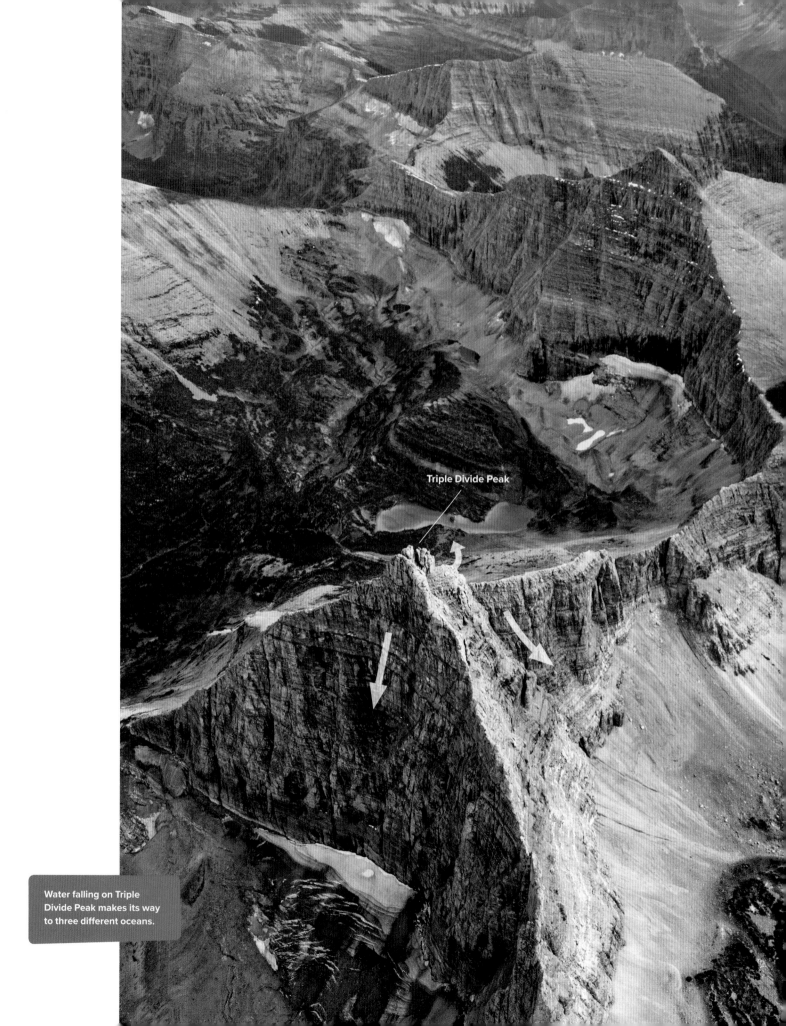

Triple Divide Peak

Water falling on Triple Divide Peak makes its way to three different oceans.

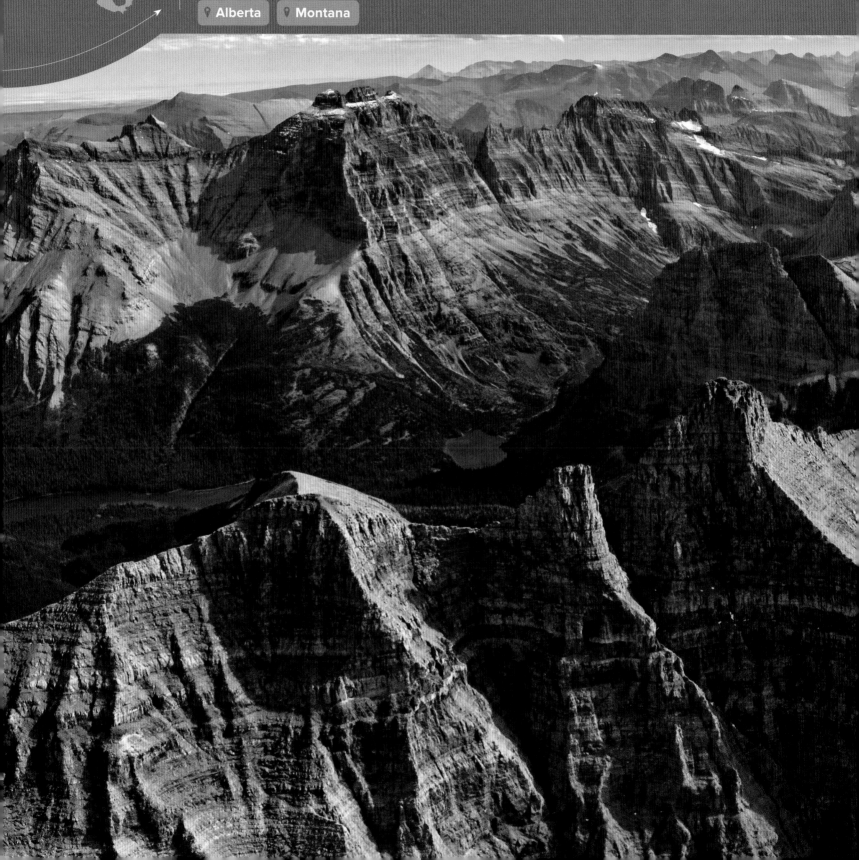

WATERTON-GLACIER
INTERNATIONAL PEACE PARK

Alberta Montana

Steep slopes and sedimentary rocks that predate plant and animal life

Glacier National Park in Montana and Waterton Lakes National Park in Canada are known jointly as the Waterton-Glacier International Peace Park. The international border running through them isn't the only boundary line here, though. The park boundaries also represent the dividing line between the U.S. Rockies and the Canadian Rockies.

Looking down on Waterton-Glacier, you will see steep-sided mountains with many horizontal layers. Rivers and lakes here tend to be bright blue because of the fine glacial rock flour in the water.

The rocks found here are more similar to those in the Canadian Rockies than the rocks found throughout the U.S. Rockies, which are primarily volcanic and metamorphic. In Waterton-Glacier, the layers are mostly sedimentary rocks deposited in shallow seas between 1.6 billion and 800 million years ago. Finding sedimentary rocks that old is unusual, as most get transformed into metamorphic rocks over long periods—a result of burial, heat, and pressure or mountain-building activity.

Sedimentary rocks are also known for containing fossils, created when organisms of creatures get preserved by burial in sediments and hardened over time. However, the rocks in Waterton-Glacier are too old to contain plant or animal fossils—they were laid down before complex life evolved on Earth. The only fossils found in these rocks are stromatolites: layered biomasses formed in shallow water by colonies of cyanobacteria. Such colonies—among the earliest life-forms to evolve on the planet—have been found in rocks dating back 3.5 billion years and can be found today thriving in similarly shallow water environments all over the world.

These tiny organisms had a big impact on the early days of Earth. Cyanobacteria use sunlight to convert carbon dioxide from seawater into oxygen.

FLIGHT PATTERN

You might spot this breathtaking area en route to Kalispell, Montana, or Calgary, Alberta.

The mountains in Glacier National Park in Montana are geologically part of the Canadian Rockies.

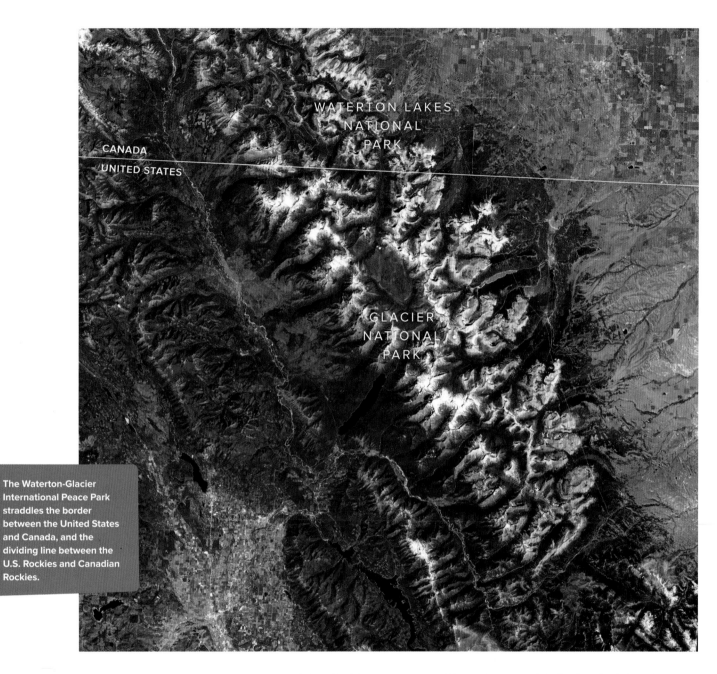

WATERTON LAKES
NATIONAL
PARK

CANADA

UNITED STATES

GLACIER
NATIONAL
PARK

The Waterton-Glacier
International Peace Park
straddles the border
between the United States
and Canada, and the
dividing line between the
U.S. Rockies and Canadian
Rockies.

This process creates particles of calcium carbonate, which help cement the stromatolite mats and build the massive deposits of carbonate-rich rocks found in the park. The production of oxygen by the cyanobacteria helped create the oxygen-rich atmosphere that gave rise to many early life-forms.

Not all the rocks in Waterton-Glacier are ancient. Some layers date to the more recent Cretaceous Period, but curiously, they underlie the older rocks. One of the basic principles of geology is that younger rocks sit on top of older rocks; the reversal here is evidence of a tremendous geologic upheaval. During the formation of the Rocky Mountains, a region of rock several miles thick and several hundred miles long, now known as the Lewis Overthrust, was shoved fifty miles eastward, coming to rest over the top of older rocks in what is now Glacier National Park. ▥

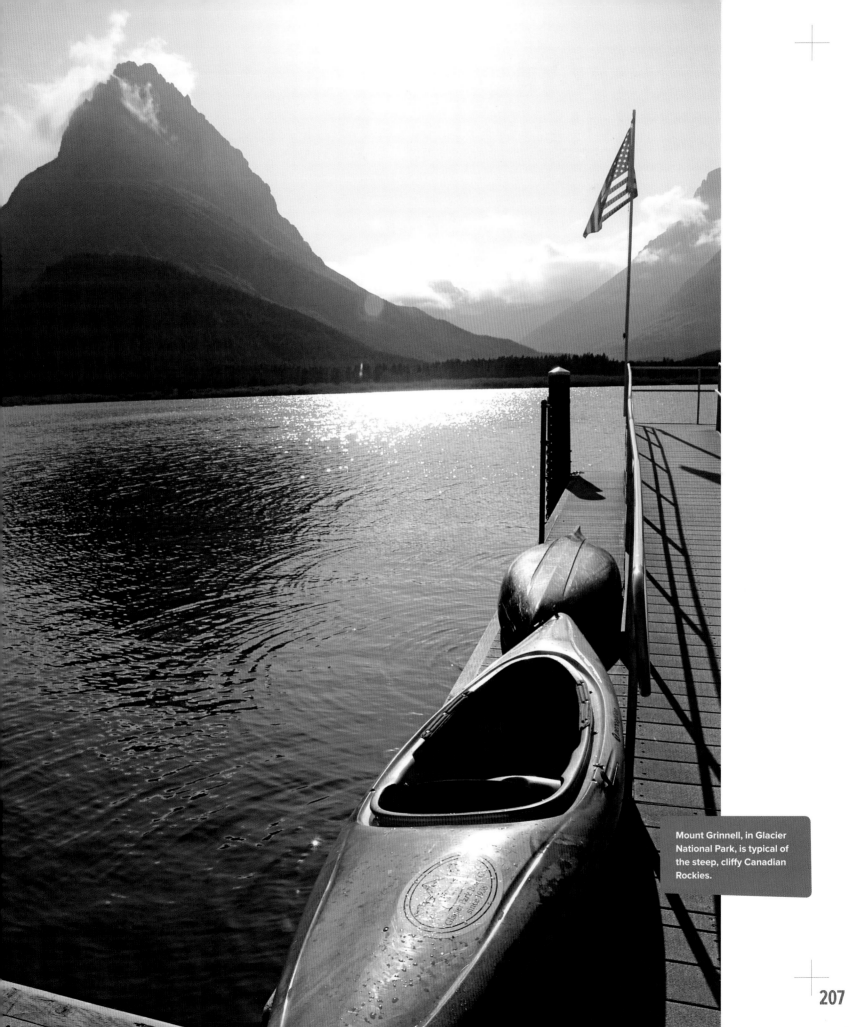

Mount Grinnell, in Glacier National Park, is typical of the steep, cliffy Canadian Rockies.

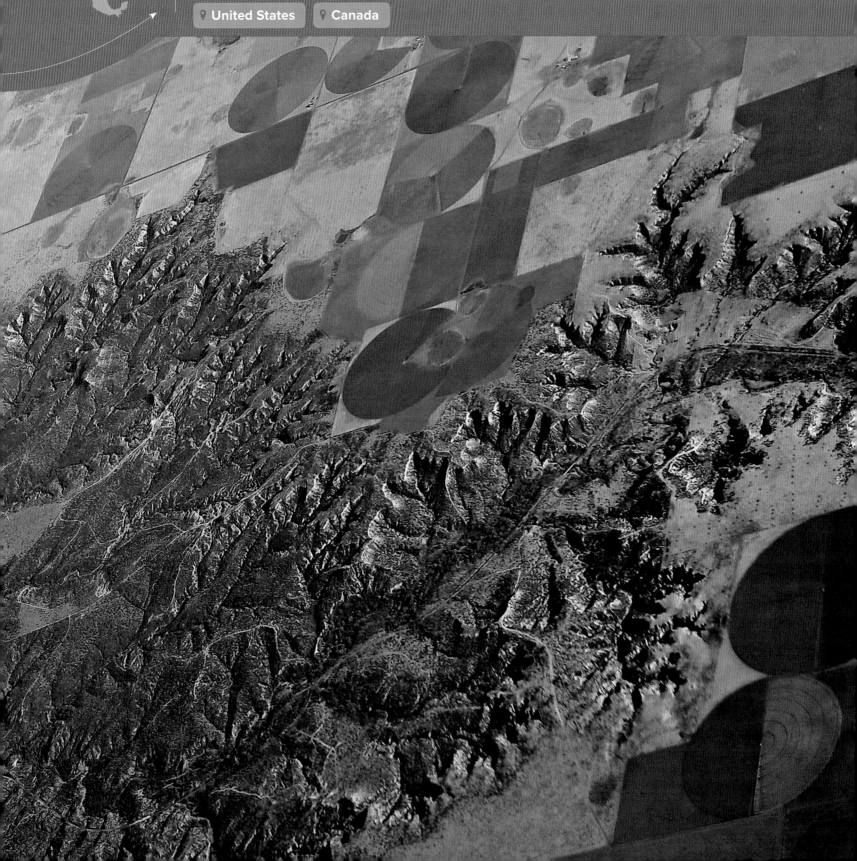

GREAT PLAINS & HIGH PLAINS

📍 United States 📍 Canada

Inland sea turned woolly mammoth grazing area turned agricultural mecca

A deep canyon system, etched by late summer flash floods, cuts across fields in the Great Plains area of northern Texas.

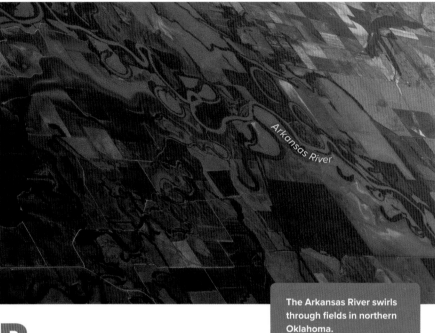

The Arkansas River swirls through fields in northern Oklahoma.

Between the Mississippi River and the Rocky Mountains lies the Great Plains: a broad expanse of grasslands that stretches across twelve states and three provinces. Within this 500,000-square-mile zone rises the High Plains, a 150,000-square-mile subregion of drier, elevated grasslands covering an area from southeast Wyoming to the Texas Panhandle. While some dismissively refer to the region as "flyover country," the Great Plains' geologic history is an important part of North America's story.

This broad swath of earth has been relatively flat since the Cretaceous Period, when dinosaurs ruled and this part of North America was covered by an inland sea called the Western Interior Seaway. The marine sediments that accumulated during this time created a smooth, deep-soil foundation for the Great Plains.

Starting around 25 million years ago, climatic changes toward hotter, drier weather began favoring the expansion of grasslands throughout

FLIGHT PATTERN

When crossing the country, it's nearly impossible to miss flying over the Great Plains. Look for telltale green irrigation circles across this former grasslands region.

this region, providing habitat for grazing animals, such as wooly mammoths, North American rhinos, and bison, as well as fearsome predators—saber-toothed cats, the American cheetah, and the American lion. Many of these megafaunal species went extinct around 13,000 years ago, as the result of cooler, wetter climates and pressures brought by the human invasion of North America. Fossils from these exotic species are found throughout the Great Plains region today.

Until the late 1800s, bison flooded the Great Plains in fantastic numbers and studies have shown that the droppings of millions of large grazing animals provided tremendous amounts of fertilizer to the grasslands, helping the plants to flourish in a relatively dry climate. Trees are rare in the grasslands because of the dry, sandy soil. Today, free-range cattle are raised in the Great Plains, and bison live only in a few isolated pockets, such as Theodore Roosevelt National Park in North Dakota and Wood Buffalo National Park in Alberta.

The High Plains subregion, rising to elevations exceeding 7000 feet, is even drier than the Great Plains—receiving less than twenty inches of rain a year. But the High Plains sit atop one of the largest groundwater aquifers in the world: the Ogallala Aquifer, which underlies more than 174,000 square miles of land. The deepest portion of this aquifer sits under western Nebraska, with shallower zones extending all the way south into the Texas Panhandle. About 30 percent of the groundwater used for irrigation in the United States comes from this aquifer, as well as over 80 percent of the drinking water supplied to 2.3 million people living in the High Plains.

Depletion of this aquifer has been accelerating at an alarming rate. Some estimates say the water table could be too low for irrigation use by 2030, a potentially fatal problem for the millions of acres of irrigated farmlands in the breadbasket of the United States—an area that produces a significant portion of the country's food and agricultural products. Center-pivot irrigation practices, which create green circle patterns when seen from the air, are partially to blame, as they apply huge quantities of water to crops that otherwise would not be able to grow in this dry grasslands climate. ∎

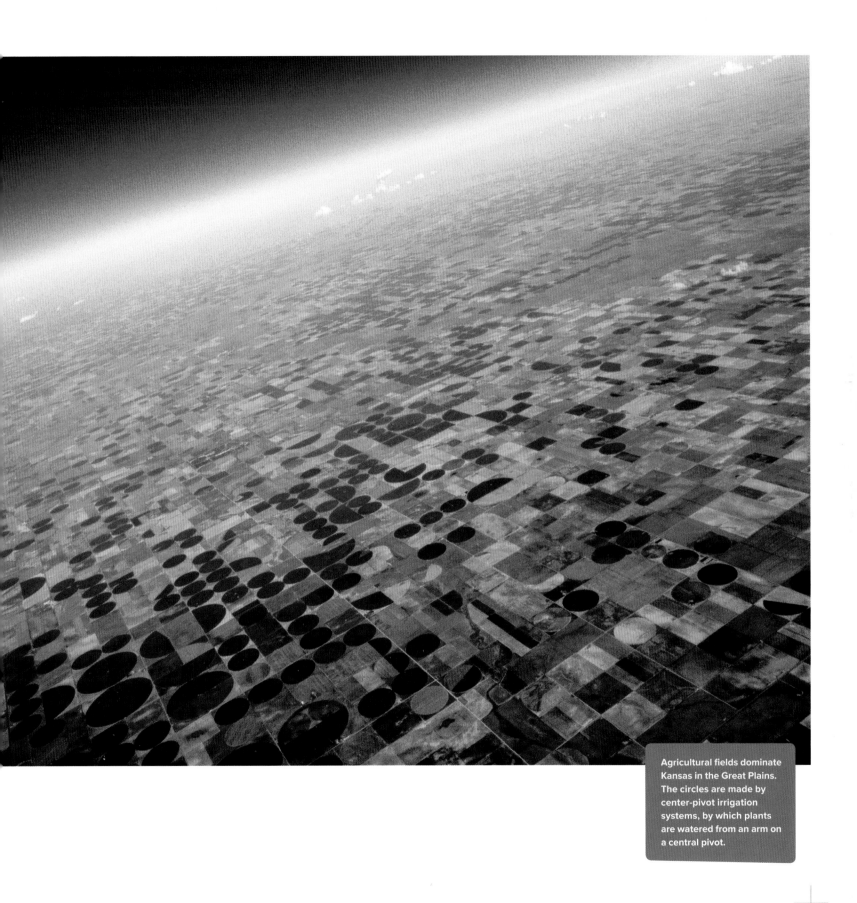

Agricultural fields dominate Kansas in the Great Plains. The circles are made by center-pivot irrigation systems, by which plants are watered from an arm on a central pivot.

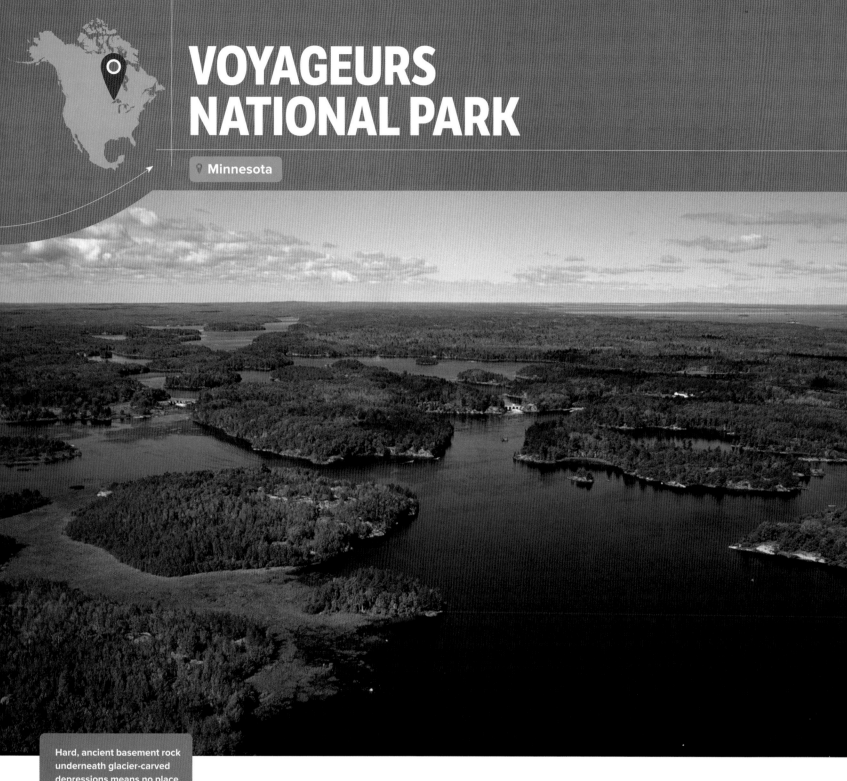

VOYAGEURS NATIONAL PARK

Minnesota

Hard, ancient basement rock underneath glacier-carved depressions means no place for water to go—creating a landscape of lakes and rivers in Voyageurs National Park.

In the eighteenth century, beaver-skin top hats were all the rage in Europe. The fashion trend fueled the fur industry in North America at a time when much of the continent was still uncharted, giving rise to legendary fur trappers—hardy mountain men who had more in common with the animals they pursued than the gentlemen they outfitted. One of the most productive regions of the New World for beaver furs was the lake-rich zone between northern Minnesota and Canada, now Voyageurs National Park.

From on high, the area appears as a mass of interconnected lakes and rivers. Visitors here can canoe or kayak for weeks at a time on 350 square miles of waterways. Almost a third of the park is water and most access through the park is by boat.

Lakes, rivers, and waterways sitting on some of the planet's oldest rocks

The foundation for this watery expanse was laid starting 3.96 billion years ago, when the Precambrian rocks of the Canadian Shield were among the first rocks to form on young, molten Earth. The Canadian Shield is the ancient geologic core of the North American continent that roughly encircles Hudson Bay and extends south into the northern Great Lakes region.

This foundation of very old, very hard, very eroded rock, in addition to the region's history of extensive glaciation, helps explain why central Canada has so many lakes. Water that collects on top of these basement rocks has nowhere to go. And the continental-wide glaciers that originated from Hudson Bay during the last ice age carved and scooped out countless depressions and bowls in the landscape, creating the extensive networks of lakes we see today.

Voyageurs National Park was established in 1975 and named for the French-Canadian fur trappers and canoeists who frequented the boundary waters between the United States and Canada two centuries earlier. Commemorated in folklore and song, the *voyageurs* (French for travelers) were once celebrities on par with Wild West cowboys, gold miners, and outlaws. Not only did these men trap beaver and other wild animals by the millions, they also transported the valuable pelts over hundreds of miles of wilderness by canoe, depositing their goods a few times a year at trading posts before lighting out again for unknown waters. ▥

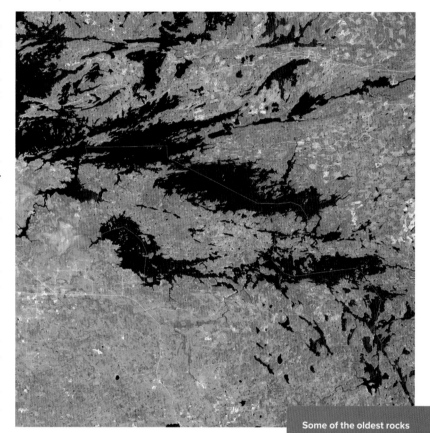

Some of the oldest rocks on the planet underlie Voyageurs National Park, seen here from space on the border between Minnesota and Ontario.

FLIGHT PATTERN

You might fly over Voyageurs National Park on your way to Thunder Bay, Ontario; Winnipeg, Manitoba; or Duluth, Minnesota.

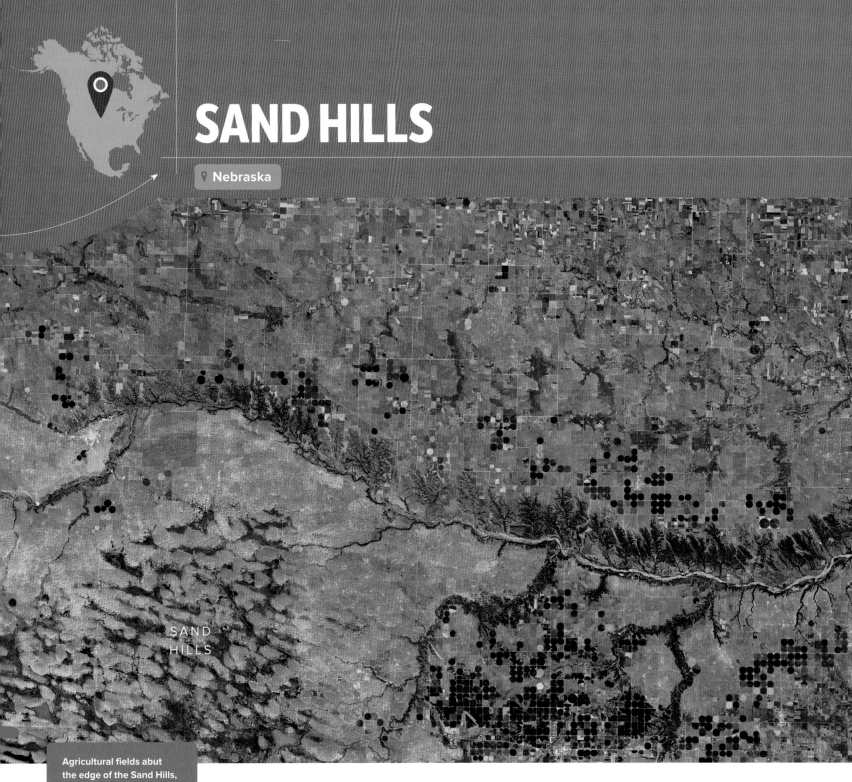

SAND HILLS

SAND
HILLS

Agricultural fields abut the edge of the Sand Hills, which can be seen in the lower left of this satellite photo. The dunes themselves are too sandy to be plowed and planted.

Middle America is known for widespread agriculture, but not all the Midwest is suitable for farming. The Sand Hills in northern Nebraska—appearing in satellite photographs as a huge expanse of undulating dunes blanketed by grasslands—is land that has never taken well to plowing and planting; the soil is too sandy to be productive.

The Sand Hills cover about a quarter of the state of Nebraska, spread out over twenty counties in the north central portion of the state. Here, the mixed-grass prairie that dominates so much of the Central Plains region is anchored on grass-stabilized sand dunes covering 13 million acres—more area than Vermont, New Hampshire, and Rhode Island combined. These grassy

Dunes covering 13 million acres, a product of long-melted glaciers

The many shallow lakes of the Sand Hills sit atop the Ogallala Aquifer, as seen in this false color NASA image.

dunes represent a unique ecoregion, distinct from other types of grasslands in the Midwest. Because the Sand Hills aren't suitable for planting, much of the region has never been plowed under (plowing is the death knell for mixed-grass prairies), and the ecoregion is one of the largest and most intact of its kind anywhere.

The dunes date back to the last ice age, around 20,000 years ago, when runoff from melting glaciers deposited large quantities of sand in the region. Several times in the Sand Hills' history, the region was much drier and desertlike, lacking the grassy vegetation that anchors the dunes in place. In the absence of grass, the dunes freely migrated across the plains, building into towers of sand taller than 400 feet and dozens of miles long. Today, the dunes are just as impressive—the tallest top 300 feet—but they are generally stationary, held in place by the tangled root systems that sustain the grasslands.

The Sand Hills sit atop the Ogallala Aquifer, the shallow reservoir of groundwater that underlies the Great Plains. One of the world's largest groundwater aquifers, the Ogallala Aquifer occupies more than 174,000 square miles in eight states, from Wyoming to Texas. This extensive water table means that the Sand Hills ecoregion is home to many lakes, particularly in low-lying valleys and depressions. These lakes play a role in replenishing the aquifer, which is estimated to recharge its water supply over 6000-year time spans. Tracking the health of the aquifer, which provides a third of the groundwater used for irrigation in the United States and over 80 percent of the Midwest's drinking water, has become a hot topic of environmental concern. Some estimates warn that the aquifer could be depleted by as soon as 2030 if current extraction rates continue.

These dunes can't be planted, but the area can support cattle, who follow in the footsteps of the bison that thrived in this region until they were nearly exterminated by overhunting in the late 1800s. Cattle ranchers must avoid overgrazing in the Sand Hills, however; the loss of the anchoring grass would return this thriving ecoregion to a migrating dune desert. ▣

FLIGHT PATTERN

Keep an eye out for the Sand Hills on flights to Lincoln or Omaha, Nebraska.

MOUNT RUSHMORE

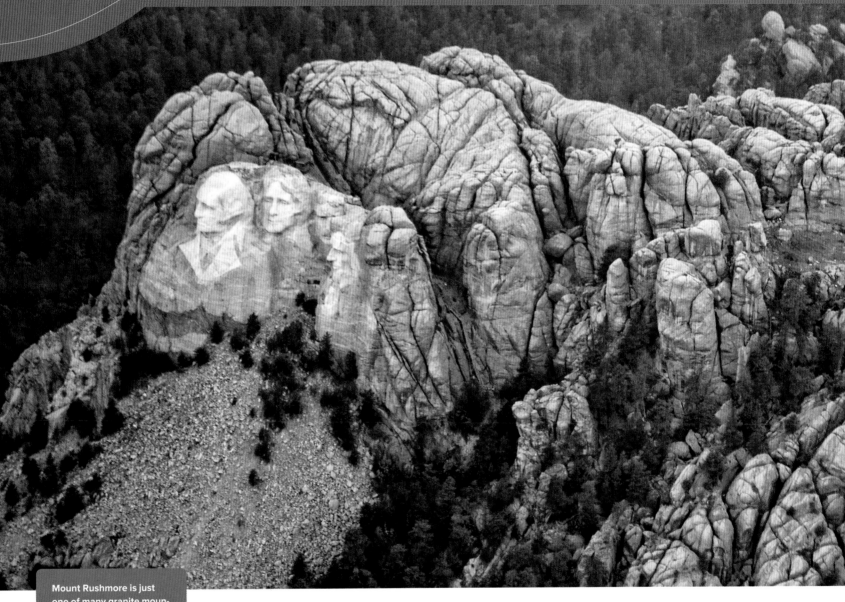

Mount Rushmore is just one of many granite mountains in the Black Hills of South Dakota.

Long before South Dakota's Mount Rushmore was carved into the now-familiar visages of four U.S. presidents, the mountain of granite was known as the Six Grandfathers by the Lakota Sioux, for whom it was a site of important spiritual quests. Now Mount Rushmore National Memorial is a popular stop on cross-country road trips, attracting more than 2 million visitors a year.

Mount Rushmore was partially inspired by the Confederate Memorial Carving on Stone Mountain in Georgia, another large-scale sculpture carved into the side of a granite mountain. Granite, an igneous rock that erupts underground,

A slow-eroding granite batholith formed around 1.6 billion years ago

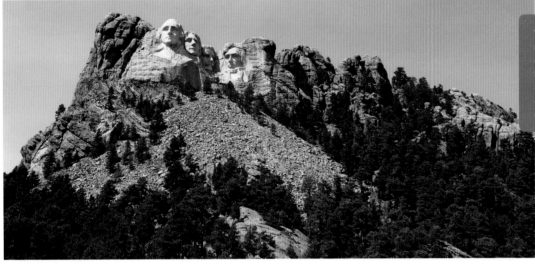

To create the sculpture, more than 450,000 tons of rock were blasted and hacked out of a granite batholith that was forced above ground between 70 and 40 million years ago.

cools slowly, allowing for the large crystals to form that give the rock its hard texture. The granite intrusion (batholith) that is Mount Rushmore formed around 1.6 billion years ago and was exposed at the surface between 70 and 40 million years ago, when the Laramide orogeny uplifted the Rocky Mountains.

Mount Rushmore, née Six Grandfathers, is only one of many granite formations in the Black Hills of South Dakota. An alternate site, the Needles in Custer State Park, was originally selected for the carving, but the sculptor, Gutzon Borglum (who also worked on Stone Mountain), thought the granite, which had eroded into spires, was too soft for large-scale carving. Instead, the current site was selected based on its smooth, fine-grained granite that erodes at a rate of an inch every 10,000 years—plus the fact that it faces southeast and is bathed in sunlight most of the day.

Between October 1927 and October 1941, Borglum, his son, Lincoln, and 400 workers blasted and sculpted the sixty-foot-high carvings of George Washington, Thomas Jefferson, Theodore Roosevelt, and Abraham Lincoln into the rock. The workers used dynamite to blast big chunks

out of the rock before drilling many side-by-side holes. These neighboring holes honeycombed the rock enough to allow small pieces to be removed with hand tools.

If Jefferson appears to be oddly placed, peering over Washington's left shoulder, it's because he was intended to appear on Washington's right, but the rock there turned out to be too soft. The incomplete figure was dynamited out and wedged between Washington and Roosevelt. Originally, the presidents were to be depicted down to their waists, but the project went far over budgets of time and money, and after Borglum died in 1941, the landmark was completed with just the leaders' faces.

A mere seventeen miles west of Mount Rushmore stands the Crazy Horse Memorial, another massive granite sculpture. Started in 1948 on the side of Thunderhead Mountain, the Crazy Horse Memorial currently depicts the Native American warrior's face and a partially chiseled outstretched arm. The carving has been mired in controversy and underfunding for decades, but if completed, it will be one of the largest sculptures in the world, topping 560 feet high. ▮

FLIGHT PATTERN

You might fly over Mount Rushmore en route to Rapid City, South Dakota.

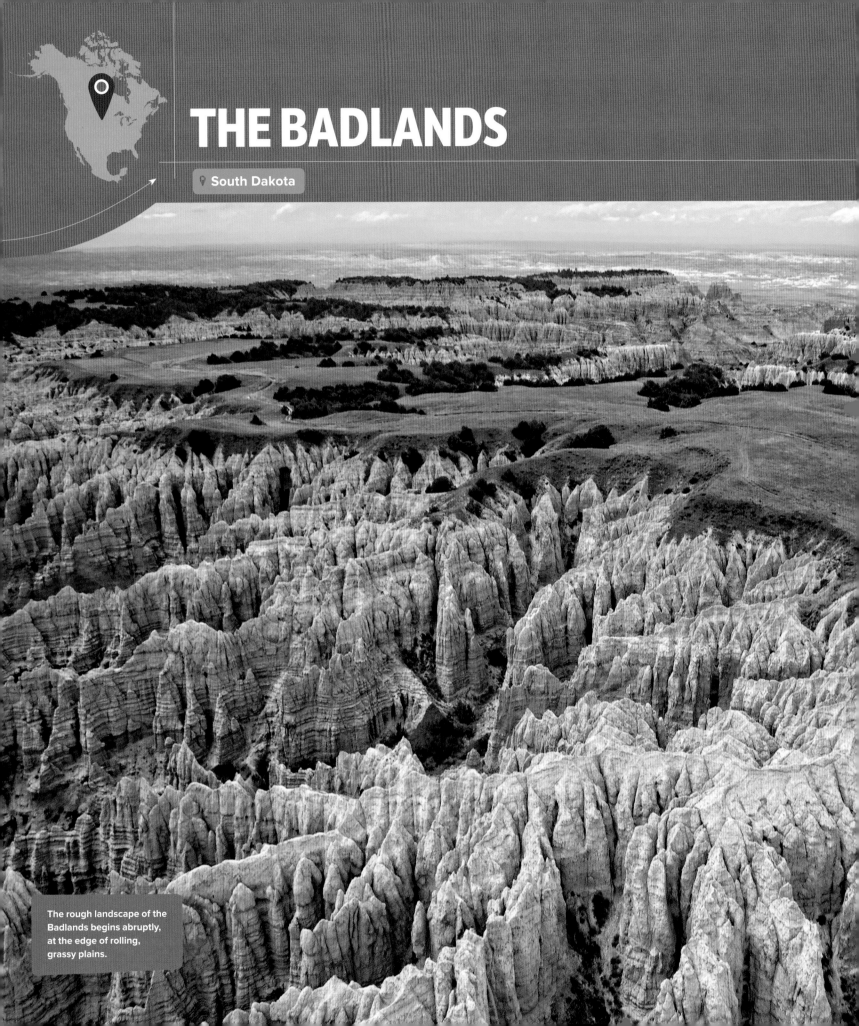

THE BADLANDS

South Dakota

The rough landscape of the Badlands begins abruptly, at the edge of rolling, grassy plains.

Jagged, unforgiving stonescape created first by deposition, then by erosion

The distinctive stripes of the Badlands represent layers of sediment deposited during different climatic and ecological conditions over a 50-million-year time span.

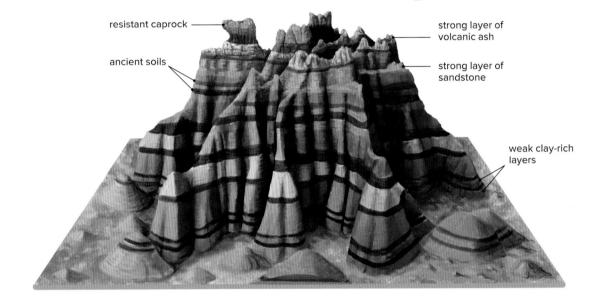

resistant caprock

ancient soils

strong layer of volcanic ash

strong layer of sandstone

weak clay-rich layers

The Badlands in southwest South Dakota were originally called *maco sica*, which means "land bad," by the Lakota people. Later the derogatory moniker was used by pioneers who didn't appreciate the challenges of the region's severe topography, which was a nightmare to navigate on foot and useless for farming. But for those who can appreciate the unique beauty of harsh terrain, the Badlands is one of the most striking landscapes in Middle America.

From altitude, the Badlands appear as a dramatic, bleak break in otherwise lush, rolling country. Green and yellow mixed-grass prairies flourish right up to the brink of the Badlands, where few plants can survive because of the constant erosion and nutrient-poor soil chemistry. On the ground, the place feels otherworldly, more like the surface of Venus than Earth. It's hard to believe any life-form would choose to reside here, but the prairies surrounding the Badlands are home to a vast array of wildlife, including bighorn sheep, bison, coyote, bobcats, rattlesnakes, and a healthy

population of black-footed ferrets—one of the most endangered mammals in North America. All of these animals are protected today within the 240,000 acres of Badlands National Park.

The rugged terrain tells a story of millions of years of deposition, followed by ongoing erosion. Composed of layers amassed between 75 million and 26 million years ago, the multi-hued bands of sediment—brown, yellow, red, white, and more—were laid down in a variety of ecosystems. These systems ranged over geologic time from a warm inland sea, to a tropical forest, to temperate woodlands, to a meandering river valley—with the younger layers supplemented by a generous helping of gray volcanic ash from eruptions in Nevada around 30 million years ago.

For nearly 25 million years, all these strata lay flat within a floodplain, where new sediment was continuously being deposited, until around 500,000 years ago. The Cheyenne River then captured many of the streams running out of the Black Hills and diverted their flow away from the

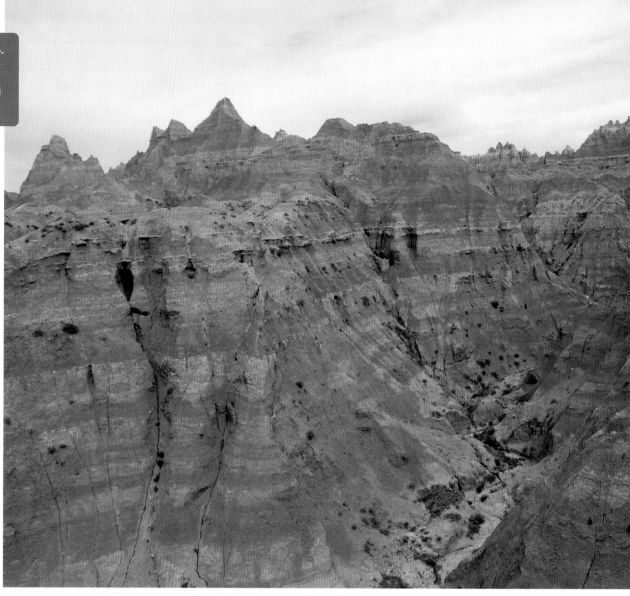

This beautiful but rocky territory holds more aesthetic appeal for modern visitors passing through than it did for the pioneers.

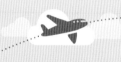

FLIGHT PATTERN

Look for the Badlands en route to Rapid City or Pierre, South Dakota. Keep an eye out for stark, earthy tones in a sea of green and yellow prairies.

Badlands, ending the supply of new sediment. Once the balance was tipped, the Badlands went from an environment of deposition to one of erosion: small intermittent streams cut the once-flat floodplain into a jagged maze of columns, hoodoos (totem pole–like spires of rock), and towers of sediment. Currently, the Badlands are eroding at a rate of an inch a year. In another 500,000 years, the Badlands will be gone.

This region is perhaps even more famous for its long-dead residents; specimens from the late Eocene Epoch to early Oligocene Epoch make it one of the most prolific fossil beds in North America, in part thanks to the excellent environment of preservation within the Badlands' sedimentary layers. During the Oligocene Epoch, between 33.9 and 23 million years ago, this part of North America was populated by exotic mammals, including relatives of the rhinoceros, hippopotamus, and camel, as well as early wolves, deer, and horses. ▥

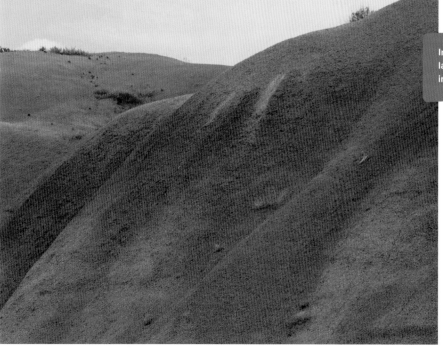

Iron oxides stain the Badlands' sedimentary layers in hues of red and orange.

PALO DURO CANYON

📍 Texas

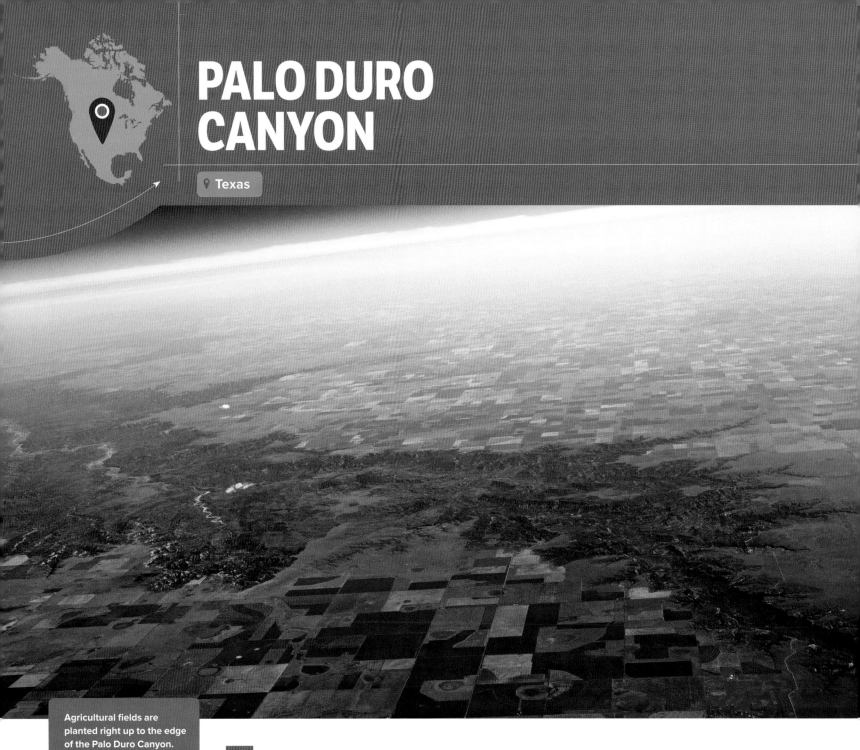

Agricultural fields are planted right up to the edge of the Palo Duro Canyon.

Texas is known for its rambling, flat expanses, but in the northern part of the state, in the middle of the panhandle, the ground falls away abruptly into a spectacularly colorful gorge system called Palo Duro Canyon. Nicknamed the Grand Canyon of Texas, Palo Duro Canyon is seventy miles long, eight hundred feet deep, and as wide as twenty miles across—the second-largest canyon system by area in North America.

From the air, the deep surface cracks and colorful layers appear in dramatic contrast to the flat patchwork of fields and farms across northern Texas. Palo Duro Canyon sits at the edge of the Caprock Escarpment, a line of cliffs that marks the geographical transition from the High Plains to the more rolling terrain of the lower Tablelands. In Texas, this escarpment—a tough layer of calcium carbonate that resists erosion—runs from the Oklahoma border for 200 miles south-southwest across the Texas Panhandle. In some places, the cliffs rise more than 1000 feet above the flat plains.

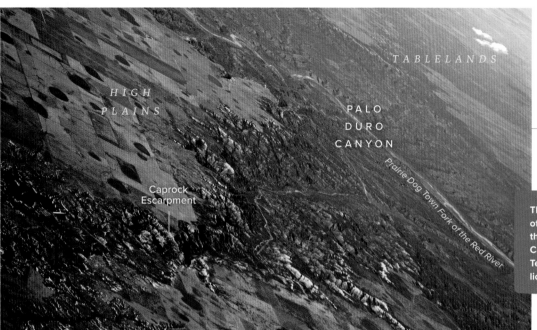

HIGH PLAINS

TABLELANDS

PALO DURO CANYON

Caprock Escarpment

Prairie Dog Town Fork of the Red River

The Prairie Dog Town Fork of the Red River has carved the extensive Palo Duro Canyon system in northern Texas within the past million years.

Deep canyon system reveals fossils from early amphibians to saber-toothed cats

Southeast of Amarillo, the Prairie Dog Town Fork of the Red River plunges over the edge of the Caprock Escarpment, into the Palo Duro Canyon. Powerful erosive forces generated by the falling river have carved the canyon within the last million years, producing dramatic geologic formations such as caves, towers, and bizarrely chiseled pillars.

The canyon itself may be only a million years old, but the rocks exposed there date back as far as 250 million years. These oldest layers accumulated in a shallow inland sea and the rocks preserve ripple marks (created in mud that turned to rock) and gypsum deposits known as Cloud Chief Gypsum. The rocks from the Triassic Period consist of bright, colorful layers of shale, siltstone, and sandstone deposited in swamps and streams during the early days of the dinosaurs. Fish and amphibian fossils are found in this band. The youngest layers, which form the cliffs and ledges at the top of the canyon, contain fossils of saber-toothed cats and North American rhinos collected between 20 and 2 million years ago, when grand pre–ice age mammals still roamed the continent.

With its steep walls and limited access points, Palo Duro Canyon is a natural fortress and evidence of human occupation dates as far back as 12,000 years, when North America's first people were spreading across the continent. Archaeologists believe that ancient cultures gave way to the Apache, who were later displaced by the Comanche and Kiowa Tribes, who warred over the territory for centuries until they were both removed by the U.S. military in 1874. ◼

OKLAHOMA

TEXAS PANHANDLE

Amarillo

Palo Duro Canyon

NEW MEXICO

HIGH PLAINS

CAPROCK ESCARPMENT

Lubbock

SOUTHWESTERN TABLELANDS

CENTRAL GREAT PLAINS

Abilene

0 50km
0 50mi

The Palo Duro Canyon cuts into the edge of the ecological and geological boundary between the High Plains and lower Tablelands of the Texas Panhandle.

FLIGHT PATTERN

Palo Duro Canyon lies southeast of Amarillo, in the middle of the Texas Panhandle. You might fly over it on your way to Amarillo, Texas.

BIG BEND

📍 Texas

The winding Rio Grande marks the southern border of Big Bend National Park and the dividing line between the United States and Mexico.

TEXAS

CHISOS MOUNTAINS

BIG BEND NATIONAL PARK

MEXICO

Rio Grande

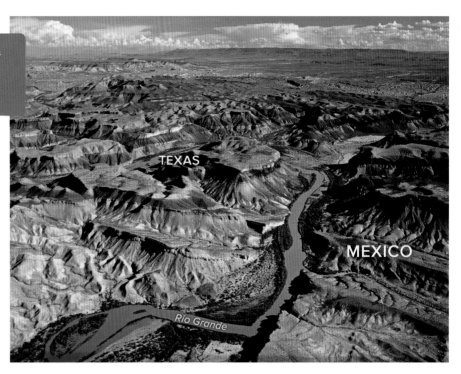

Eons' worth of sediments make for complicated geology in Big Bend National Park.

TEXAS

MEXICO

Rio Grande

Everything is bigger in Texas. So it should come as no surprise that Texas's biggest national park—Big Bend, on the southern border with Mexico—is home to some of the most complicated geology in North America. The park includes both the Chisos Mountains and a portion of the Chihuahuan Desert, as well as a significant stretch of the Rio Grande. From space, the Rio Grande provides a convenient visual marker of the park's southern boundary. The river also forms the international line between the United States and Mexico.

Between 500 and 300 million years ago, a deep ocean trough extended from what is now Oklahoma and Arkansas southward into Texas and Mexico. For longer than 200 million years, sediments collected in this trough, piling thousands of feet thick. Around 300 million years ago, these layers of shale and sandstone were compressed and uplifted into the ancestral Ouachita Mountains, the highly eroded roots of which are still present today in Big Bend National Park.

That story may seem simple enough, but 200 million years of sedimentation makes for some thick layers of rock. Several later episodes of uplift, volcanism, and erosion have resulted in an impressively convoluted and colorful geologic map. The sparse vegetation of the Chihuahuan Desert ecosystem makes a perfect backdrop for studying the many complex layers of strata displayed throughout the Big Bend region.

One of the most prominent features of Big Bend is the Rio Grande, which flows for 2000 miles from the southern Rocky Mountains in south central Colorado through New Mexico, into Texas, where it forms the boundary with Mexico for more than 1000 miles before emptying into the Gulf of Mexico. About a quarter of this international boundary flows through Big Bend National Park, including the sharp turn from the southeast to the northeast that gives the park its name.

The rocks of Big Bend may date back 500 million years, but the Rio Grande is much younger. In fact, it's the youngest major river system in North

Volcanism, uplift, erosion— and the continent's youngest major river system

America, having achieved its path to the Gulf of Mexico only within the past 2 million years. Once its route was established, the river served as a conduit for transporting sediments out of the highly eroded basins in Big Bend; it continues to carry one of the highest sediment loads of any major river.

The Rio Grande is still working out its winding route to the sea. Occasionally, the upstream water demands on the river for municipal, irrigation, and industrial uses combine with seasonal drought conditions to slow the flow of water to the point that the Rio Grande begins dumping its sediment load just shy of the Gulf of Mexico. The sediments then form a large sandbar at the mouth of the river and dam the water's flow into the Gulf. Dredging can help restore movement, but more sustainable water use practices on both the U.S. and Mexican sides of the Rio Grande will be needed to reestablish a robust flow of the river to the Gulf. ▪

FLIGHT PATTERN

Try to spot Big Bend on flights to San Antonio or El Paso, Texas.

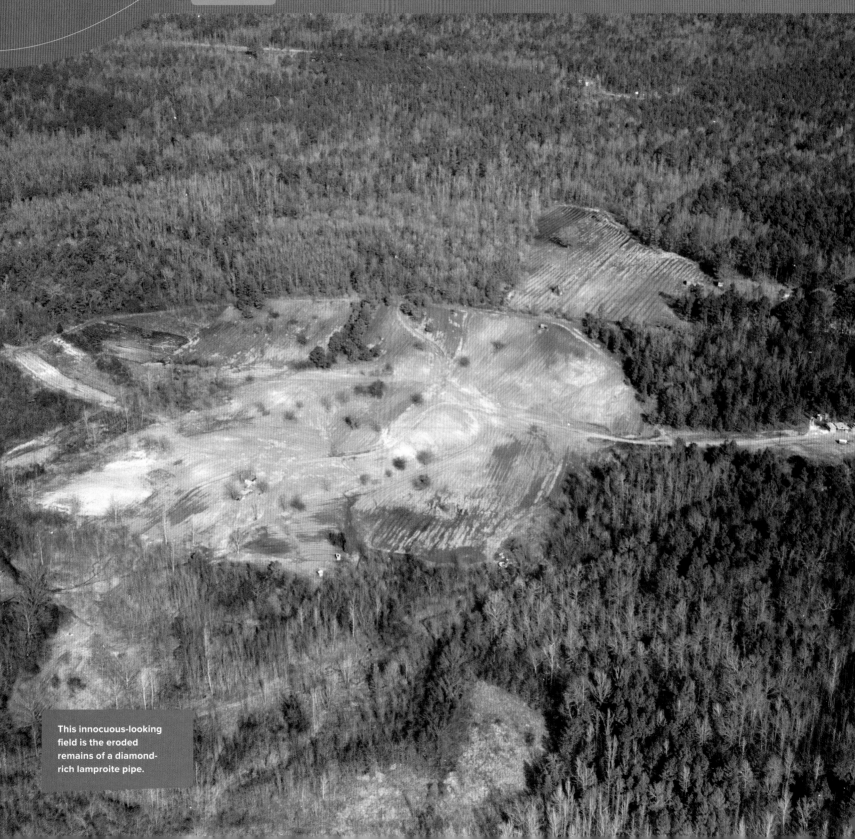

This innocuous-looking field is the eroded remains of a diamond-rich lamproite pipe.

3-billion-year-old diamonds brought to the surface by volcanic conduit

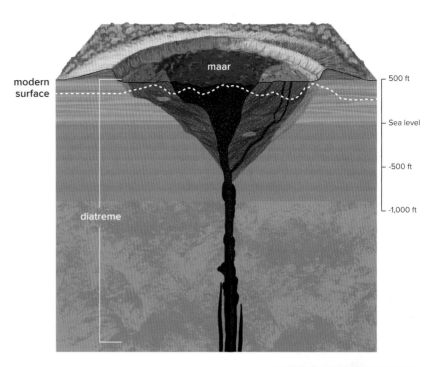

modern surface

maar

diatreme

500 ft

Sea level

-500 ft

-1,000 ft

Diamond mining is intensive and hazardous, with most of the world's diamonds coming from large-scale, privately owned operations in Canada, Russia, Africa, and Australia. In contrast is Crater of Diamonds State Park in southwest Arkansas—the world's only public diamond mine, where anyone can mine diamonds for a mere $10 entry fee, and keep everything they find.

Unfortunately, you'll never spot one of Crater of Diamonds' tantalizing attractions through an airplane window—from above, the state park appears as a large dirt field surrounded by forest. However, what the gems at Crater of Diamonds lack in size, they make up for in history. Diamonds found here are more than 3 billion years old, formed by intense heat and pressure in the planet's mantle, at depths in excess of a hundred miles. Around 100 million years ago, volcanic rock called lamproite rose from the deep mantle through a conduit, or diatreme, bringing diamonds and other mantle materials to the surface. This conduit became known as the Prairie Creek Pipe. As it neared the surface, the pipe exploded, creating an eighty-three-acre, funnel-shaped crater, or maar. Today, the state park occupies part of this maar. The volcanic pipe still exists below the surface and is shaped like a martini glass, with the stem extending deep into Earth's mantle.

People have been searching for diamonds here since the early 1900s, when the first precious stones were found sitting on the surface of a freshly plowed field. In the years that followed, several companies tried to commercially mine diamonds here, but none made much of a profit; the diamonds were too small and too scattered.

In 1972, the field was turned into a state park and since then, visitors have turned up more than 29,000 diamonds. Most stones found at the park average a modest 25 points—100 points equal a carat—but a few lucky hunters have found some real whoppers: the 40.23-carat Uncle Sam Diamond, the largest ever found in North America, was turned up here in 1924 and in 1990, a 3.03-carat stone found at the park was certified Triple Zero® for perfect cut, color, and clarity, and declared "the most perfect diamond ever certified by the American Gem Society." Most stones are somewhat rounded by chemical weathering and appear clear, yellow, or brown in color.

The park plows the field about once a month to bring more diamonds to the surface. On average, two diamonds a day are found by park visitors using the most basic tools. At that rate, diamonds should be plentiful in the park for another 500 years. ▮

Lamproite pipes such as the one that gave rise to Crater of Diamonds State Park bring materials—including diamonds—from deep in Earth's mantle up to the surface.

A 7.44-carat diamond—the seventh-largest diamond found to date at the site—was discovered in the park's plowed fields by a fourteen-year-old boy in 2017.

OUACHITA MOUNTAINS

Arkansas **Oklahoma**

The middle of the North American continent is notoriously flat, but a beautiful exception is the Ouachita Mountain range. From the air, the complicated east-west trending folds of the range stand out crossing between Arkansas and Oklahoma, to the north of Lake Ouachita. These folds form the Interior Highlands, an uplifted mountainous region that also includes the Ozark Mountains.

Rising to 2753 feet at Mount Magazine, the Ouachita Mountains are the highest mountain range east of the Rockies and west of the Appalachians. The range has very deep roots, which extend all the way to southern Texas and date back 500 million years, when this region existed as a great ocean trough. Sediments collected in this trough until they were piled thousands of feet thick and compressed into layers of shale and sandstone.

During the Pennsylvanian Period, 300 million years ago, the coastline of the Gulf of Mexico was located in central Arkansas. A tectonic plate that had previously been attached to South America and Africa broke off and collided with the North American Plate from the south, buckling the overriding plate. In an episode known as the Ouachita orogeny, the layers of shale and sandstone from the area's ancient ocean trough were uplifted in this buckling, and the ancestral Ouachita Mountains were created. The plate collision from the south accounts for the unusual orientation of the Ouachita Mountains, which run east and west—most mountain ranges in North America are oriented north and south.

These peaks once rose to Rocky Mountain heights, but 300 million years of erosion have worn them down to their roots—even lower than the Appalachians, parts of which formed around the same time. This is likely due, at least in part, to the dominance of erosion-prone sedimentary rock in the Ouachitas. The Appalachians are made up of a sturdier mixture that includes harder sedimentary, volcanic, and metamorphic rocks.

In a color-enhanced satellite image, the swirling folds of central Arkansas's Ouachita Mountains tell the story of an ancient tectonic collision.

Mountain range produced by tectonic plates crashing and buckling

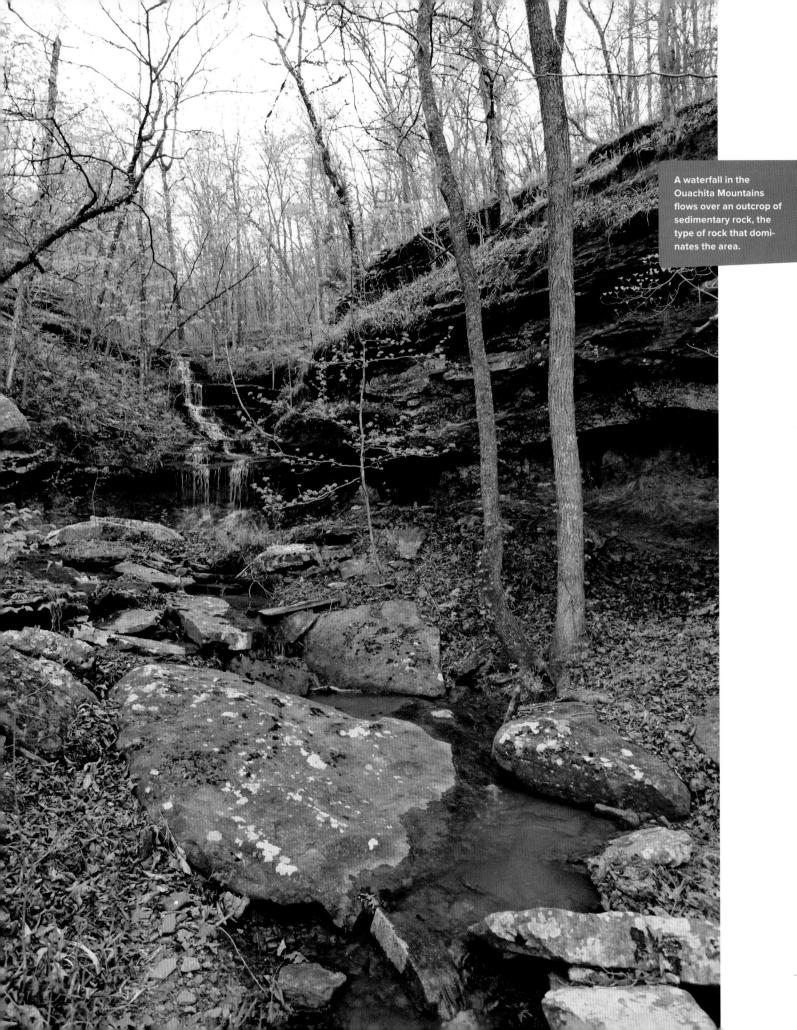

A waterfall in the Ouachita Mountains flows over an outcrop of sedimentary rock, the type of rock that dominates the area.

MISSISSIPPI RIVER DELTA

Louisiana

The mighty Mississippi is now captured and channelized along its entire downstream length, all the way to the Gulf of Mexico.

From high overhead, the Mississippi River Delta resembles a branching set of lungs reaching out into the Gulf of Mexico. The mighty Mississippi is North America's largest watershed, draining over 40 percent of the continent's waterways into the Gulf of Mexico. The river's unusual name comes from the Ojibwa word *misiziibi*, meaning a river spread over a large area. For at least the past 10,000 years, since the retreat of the last ice age, the Mississippi has emerged from Lake Itasca in northern Minnesota. However, the mouth of the river, where it empties into the

230

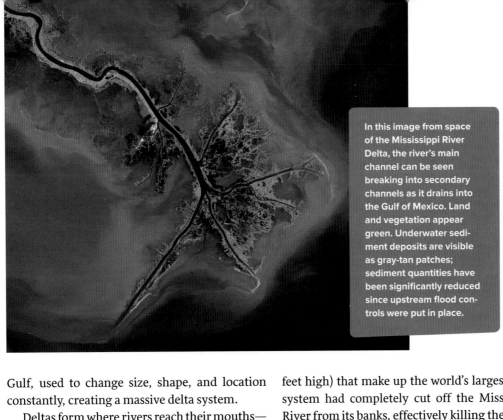

In this image from space of the Mississippi River Delta, the river's main channel can be seen breaking into secondary channels as it drains into the Gulf of Mexico. Land and vegetation appear green. Underwater sediment deposits are visible as gray-tan patches; sediment quantities have been significantly reduced since upstream flood controls were put in place.

10,000-year-old natural balance threatened by flood controls

Gulf, used to change size, shape, and location constantly, creating a massive delta system.

Deltas form where rivers reach their mouths—at a much larger, slower-moving body of water—and the river drops its load of sediment. Over time, this sediment builds up, creating new landmasses called lobes. These lengthen the river's path to open water and eventually force the river to change course as it seeks the quickest route to the larger body of water. With its historically high sediment loads, the muddy Mississippi once boasted the seventh-largest delta in the world, but flood control efforts over the past few decades are threatening to destroy the river's 10,000-year-old balance.

Today the Mississippi is one of the most tightly controlled rivers in the world, with more than 3000 miles of levees—flood control walls—enclosing the river and its tributaries, from southern Illinois to the mouth in Louisiana. But all that flood control is backfiring into an ecological disaster for the Mississippi River Delta.

Before the levee system was installed along the Mississippi's banks by the Army Corps of Engineers, the river flooded seasonally, redistributing nutrient-rich sediments along the length of the river and revitalizing the floodplains and delta. But these floods also caused death and destruction to people living along the river, and in 1928 Congress passed the Flood Control Act, authorizing construction of a system that would ensure the river never overflowed its banks again.

By the 1980s, the walls (twenty-five to fifty feet high) that make up the world's largest levee system had completely cut off the Mississippi River from its banks, effectively killing the riparian ecosystem that had flourished for thousands of years. All the sediment that once served as the restorative lifeblood of the "muddy Mississippi" was trapped by dams and levees, starving the river for nutrients downstream.

At the delta, the price of upstream flood control has proved to be astronomically high—since the 1930s, Louisiana has lost nearly 2000 square miles of land, an area about the size of Delaware. Every hour, a football field–sized expanse of wetlands is flooded by open water, caused by the combined effects of reduced downstream sediment, natural subsidence of the delta, and climate-influenced rising sea levels. The environmental consequences are alarming. Many plants and animals struggle to maintain their brackish way of life against the encroaching salt water, and the once-thriving fishing and seafood industries along the coast battle to survive. By some estimates, the Mississippi River Delta could be drowned completely by 2100.

If the Army Corps of Engineers had never exerted their control over the river, the delta would look very different from what it does today. It would be much larger, with many more branches. The additional acreage could have buffered much of the destruction wrought by Hurricane Katrina in 2005, when flood waters topped the levees in New Orleans, killing more than 1200 people and causing more than $100 billion in damage to the city. ■

FLIGHT PATTERN

You might fly over the Mississippi River Delta en route to New Orleans, Louisiana.

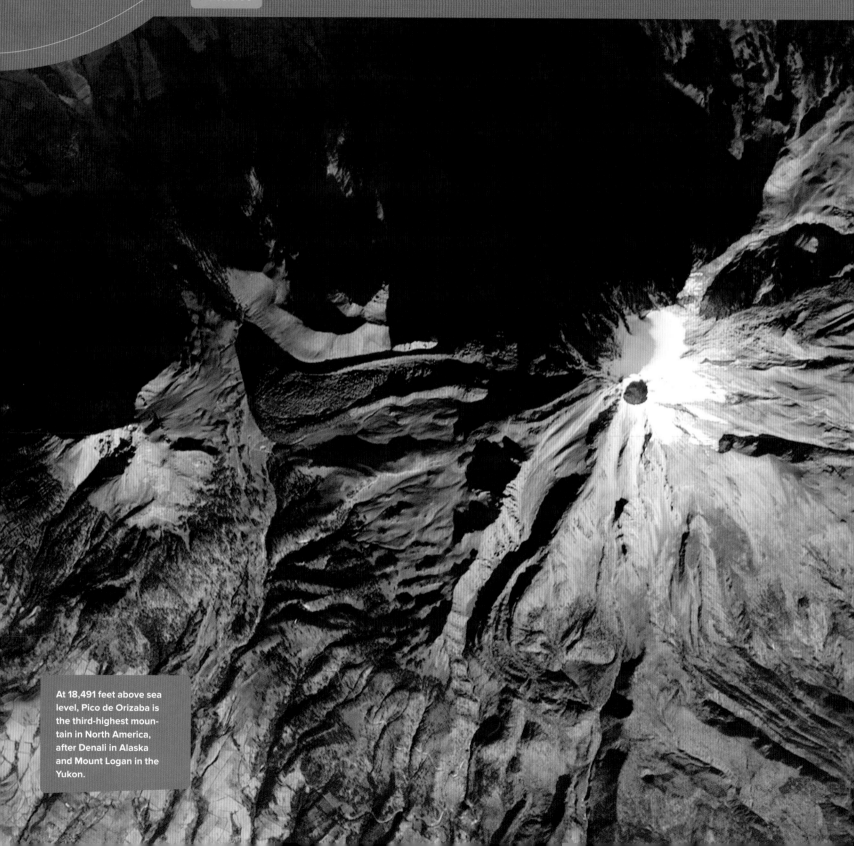

PICO DE ORIZABA

📍 Mexico

At 18,491 feet above sea level, Pico de Orizaba is the third-highest mountain in North America, after Denali in Alaska and Mount Logan in the Yukon.

Tallest stratovolcano on the continent

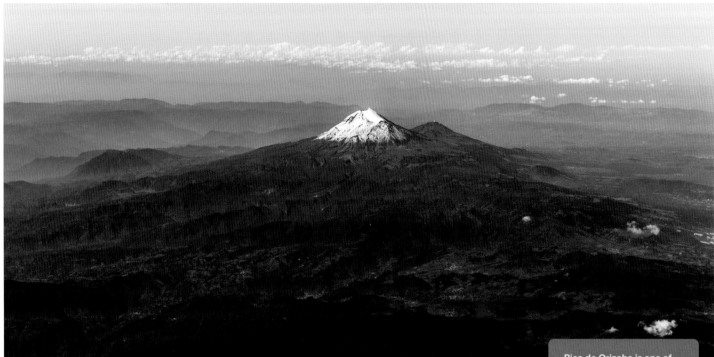

Mexico is known more for its beaches than its mountains, but the southernmost arm of North America is home to some very big stratovolcanoes (conical domes built up by layers of volcanic deposits), including Pico de Orizaba, the tallest volcano on the continent. Rising from the Trans-Mexican Volcanic Belt, which runs roughly east and west across Mexico, Pico de Orizaba soars to 18,491 feet above sea level. From the air, you can see the lone, snowcapped peak between Mexico City and the Gulf of Mexico; the summit crater stands out amidst the glaciers. Notice there are no glaciers on the volcano's sunny, south-facing slope: they are long gone.

Pico de Orizaba, also known as Citlaltépetl, is actually made up of three successive volcanoes in the same spot, created in three eruptive stages, each superimposed on top of the other. Volcanism began around 20 million years ago, after the Farallon Plate broke into the smaller Cocos and Rivera Plates, which began subducting under the Middle America Trench off the west coast of Mexico, fueling volcanism several hundred miles inland.

The most recent eruptive stage began around 16,000 years ago and culminated in the last eruption in 1846, which had a relatively mild magnitude of 2 on the Volcanic Explosivity Index. The largest known eruption occurred in 6710 BC—a magnitude 5 blast that was on par with the 1980 eruption of Mount Saint Helens. Today the volcano is considered dormant, but not extinct, and is carefully monitored for signs of reawakening.

Pico de Orizaba stands out not just for its height, but for its snowy summit—a very rare sight in Mexico. In point of fact, the snow is actually an ice cap made up of nine overlapping glaciers, including Gran Glaciar Norte, the largest glacier in Mexico. These glaciers are fast retreating, as a result of climate change. ■

Pico de Orizaba is one of the few places in Mexico that holds snow year-round. On its southwest flank, behind and to the right of the snowcapped summit in this image, stands the 15,225-foot Sierra Negra volcano, now considered extinct.

FLIGHT PATTERN

Try to catch a glimpse of Pico de Orizaba en route to Mexico City, 120 miles west of the volcano.

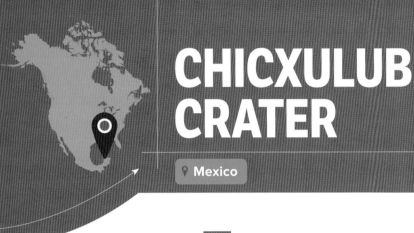

CHICXULUB CRATER

📍 **Mexico**

The resort town of Cancún on the Yucatán Peninsula is famous for tropical vacations, but 66 million years ago, this peninsula between the Caribbean Sea and the Gulf of Mexico was ground zero for one of the most violent and devastating impacts in Earth's history.

In an event marking the end of the Cretaceous Period and the 165-million-year reign of the dinosaurs, an asteroid at least six miles wide slammed into the planet, blasting out a crater wider than a hundred miles in diameter and twelve miles deep, creating Earth's third-largest confirmed impact crater. From the air, using computer enhancements, the semicircular edge of what is known as the Chicxulub Crater can be traced across the northern edge of the Yucatán Peninsula; a little more than half the ring is underwater in the Gulf of Mexico.

The blast produced by the impact scorched Earth with over 2 million times the energy produced by the biggest atomic bomb ever detonated, and kicked up a mega-tsunami that swamped the Gulf Coast. A shockwave containing 48,000-plus cubic miles of super-heated dust, ash, and sediment flew high into the atmosphere, blocking out the sun's radiation for months or possibly years.

One of the most devastating asteroid impacts in Earth's history

A thin layer of carbon preserved in soils from this time period suggests that the blast set off widespread wildfires that generated a tremendous amount of soot. This resulting cloud of airborne debris blocked the sun, cooled the planet, and dampened plant photosynthesis, devastating the planet's food chain.

The effect on life-forms was catastrophic. As many as three-quarters of all plants and animals went extinct within a short period of time, including the non-avian dinosaurs. Avian dinosaurs would go on to evolve into birds. With the exception of a few aquatic species like turtles and crocodiles, no species of animal weighing fifty pounds or more survived. After the dust cleared, perhaps decades later, life found a way to reoccupy the ecological niches vacated by the extinct species, and a rapid evolutionary radiation (organisms diversifying into new forms) produced an array of new species, including birds and the first primate-like mammals.

This impact extinction theory, named the Alvarez hypothesis for the father-and-son team who first proposed it in 1980, was introduced a decade before the Chicxulub Crater was identified as an impact crater. On the ground, erosion has filled in much of the depression. The trough around the edge of the ring is only about ten feet deep and often obscured by jungle vegetation and erosion; a digitally enhanced aerial perspective is the best way to make out the crater rim. ▪

A digitally enhanced image reveals the edge of the Chicxulub Crater, which was more than a hundred miles in diameter and twelve miles deep upon impact—Earth's third-largest known impact crater. The remainder of the crater's perimeter is submerged off the coast of the Yucatán Peninsula.

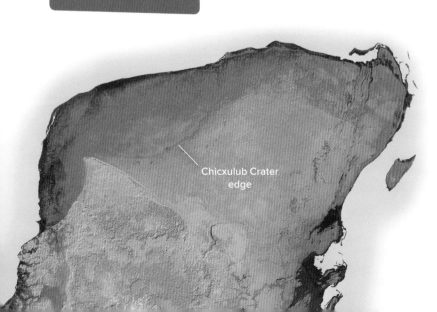

Chicxulub Crater edge

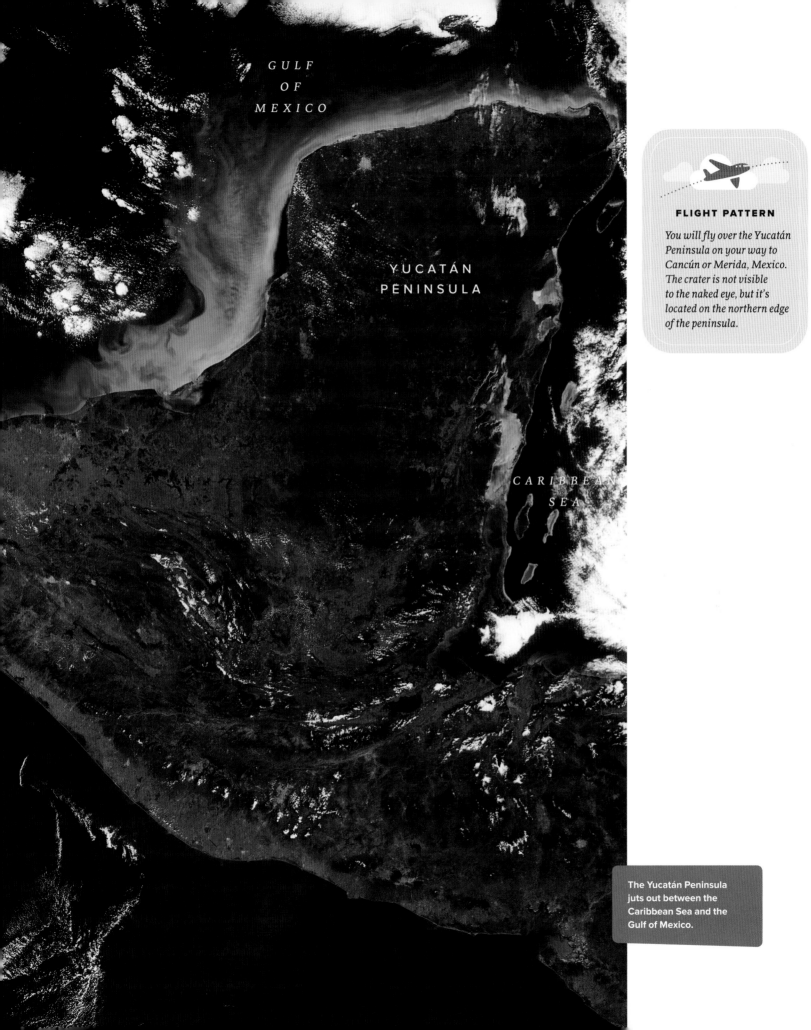

GULF
OF
MEXICO

YUCATÁN
PENINSULA

CARIBBEAN
SEA

FLIGHT PATTERN

You will fly over the Yucatán Peninsula on your way to Cancún or Merida, Mexico. The crater is not visible to the naked eye, but it's located on the northern edge of the peninsula.

The Yucatán Peninsula juts out between the Caribbean Sea and the Gulf of Mexico.

FLORIDA KEYS

📍 Florida

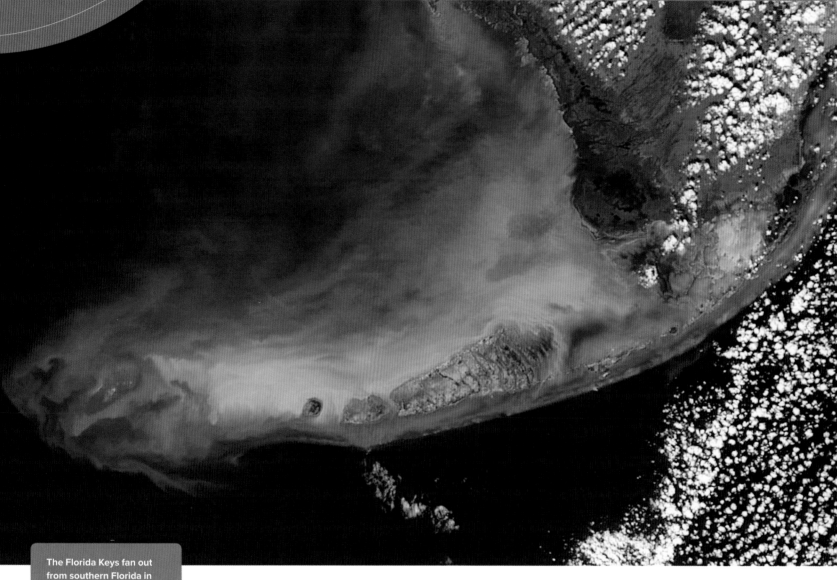

The Florida Keys fan out from southern Florida in an arc built on top of coral reefs.

While most of the world's landmasses are millions, if not billions of years old, the ephemeral Florida Keys emerged from the waves only a few thousand years ago. If projections of rising sea levels are borne out, the island chain could disappear again within the next century.

In aerial views, the Keys are distinctive, swinging in a gentle arc for 120 miles south and west of the southern tip of Florida. Today there are 882 charted islands in the chain, but only a few dozen are inhabited, connected by the wave top–skimming Overseas Highway that runs from Key Largo in the northeast to Key West in the southwest.

The story of the Florida Keys begins in the Pleistocene Epoch, after enough marine sediment

Reefs created by sunlight, exposed when ice caps expanded and sea level fell

The Florida Keys are connected by the 113-mile-long Overseas Highway.

A multitude of small islands make up the Keys island chain, including more than 850 that are uninhabited.

had accumulated on the seafloor south of Florida to result in a platform sufficiently high for sunlight to reach. Sunlight was the main ingredient needed for corals to colonize the underwater platform and create a reef out of their calcium carbonate skeletons. The Keys' coral reefs were built up by elkhorn, staghorn, and star corals until around 100,000 years ago, when the planet's ice caps began expanding, taking up seawater and lowering sea levels by as much as 300 feet. The Keys have remained above the waves ever since, gradually accumulating soil, plants, and animals, such as the diminutive Key deer, which lives only in this unique island setting.

Nearly 80,000 people live in the Keys (the Conch Republic to locals). About a third of the population lives in Key West, the largest town and last inhabited island in the chain. The Conch Republic may not be around for much longer, though. Sea levels have been rising since the Last Glacial Maximum (when glacial ice sheets were at their greatest extension) around 10,000 years ago, by an average of about twenty-four inches every 1000 years. Largely as a result of climate change, rates have been accelerating in the last century; some tide gauges in the Keys have recorded an alarming rise of just over a tenth of an inch per year.

In 2013, the Intergovernmental Panel on Climate Change projected that sea levels would rise between ten and thirty-two inches by 2100. Other studies have projected an even more dramatic rise. According to the Nature Conservancy, even a conservative sea level rise estimate of seven inches by 2100 would mean the loss of about ninety of the Keys' 240 square miles of land, while the more extreme projections of sea level rise would put all the Florida Keys underwater in the next century. ◾

FLIGHT PATTERN

You might fly over the Florida Keys en route to Miami or Fort Lauderdale, Florida. Look for an island chain arcing off the southern tip of Florida.

THE EVERGLADES

📍 Florida

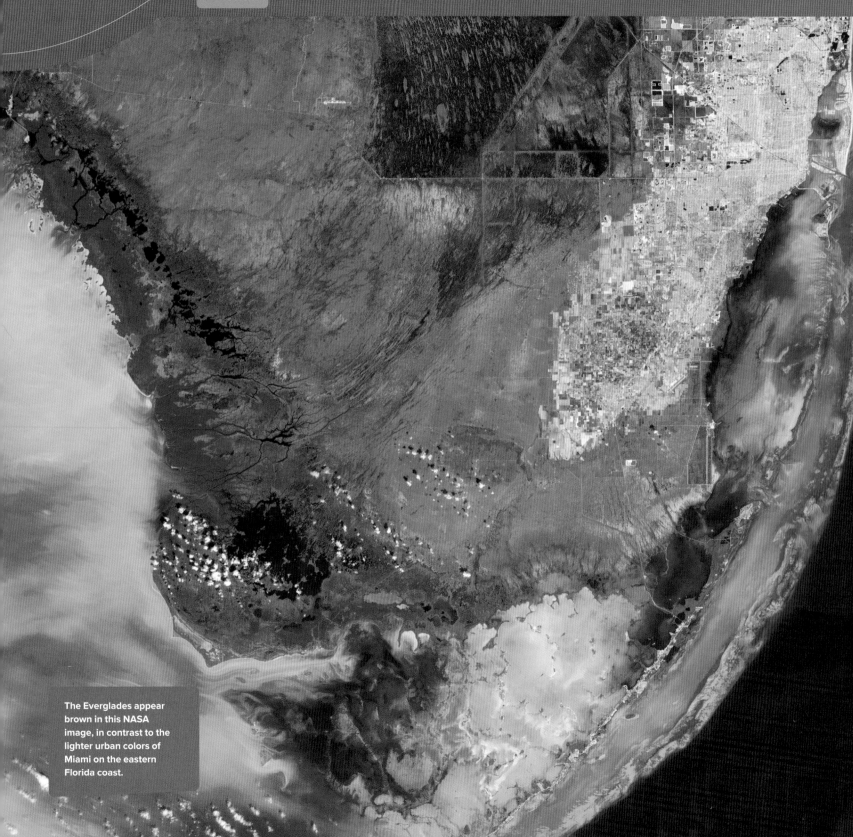

The Everglades appear brown in this **NASA** image, in contrast to the lighter urban colors of Miami on the eastern Florida coast.

Sixty-mile-wide River of Grass

More than 200,000 American alligators live in the Everglades.

The Florida Everglades are nicknamed the River of Grass. But this is no ordinary river, running in a channel between defined banks. Rather, it's an entire region of slow-moving water wider than sixty miles, extending a hundred miles south from the Kissimmee River near Orlando to the Florida Bay. To identify the Everglades from the air, look for extensive wetlands (which can appear green to brownish green) west of Miami and south of the large, round Lake Okeechobee.

Southern Florida is dominated by a limestone shelf that was laid down between 70 and 25 million years ago, when this region was covered by a shallow sea. Over the last 50,000 years, changing sea levels have exposed and inundated this low-lying shelf numerous times. Limestone is formed when marine creatures with shells made of calcium carbonate pile up on the seafloor, mix with sand, and get compressed over time. At least five kinds of limestone are found in southern Florida, including Miami Limestone and limestone from the Fort Thompson Formation, which have the greatest influence on the Everglades.

Miami Limestone is made up of ooids: concentric shells of calcium carbonate that form around single grains of sand. Even after ooids are compressed into limestone, the rock is very porous and stores large quantities of groundwater, which sustain the Everglades during droughts and dry seasons. In contrast, the limestone of the Fort Thompson Formation is made of dense, hard layers that are much more compacted—to the point of impermeability in places. This encourages water to keep flowing.

FLIGHT PATTERN

You might fly over the Florida Everglades en route to Miami or Key West, Florida. Look for extensive wetlands extending south from Lake Okeechobee.

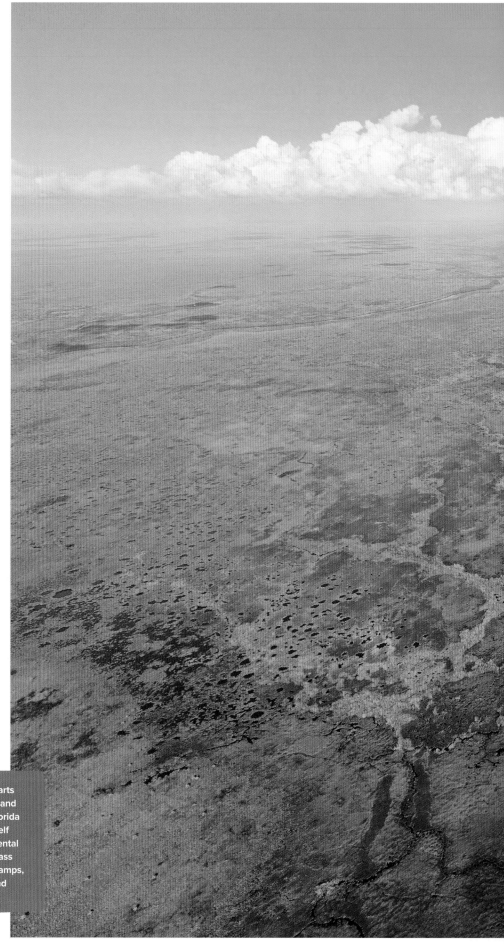

Around 6000 years ago, the climate of south Florida started getting wetter, laying the foundation for the extensive marshes and wetlands we see today. As the River of Grass runs along this shelf of limestone, it drops only a few feet in elevation—about two inches per mile. Flowing south at an average rate of a half-mile per day, water may take months or even years to flow through the system from the Kissimmee River, through Lake Okeechobee, to the Florida Bay. Along the way, incremental drops in elevation give way to a variety of ecosystems, including sawgrass marshes, cypress swamps, hardwood hammocks, pinelands, mangrove islands and the marine habitats of Florida Bay. Such diversity of ecosystems is directly tied to the underlying geology of the region, which controls the flow of water along with the mineral and nutrient content of the soils.

The landform that we know today as south Florida has existed for about 17,000 years, with evidence of human habitation dating back to around 14,000 years ago, when the landscape was much drier and occupied by giant ground sloths and saber-toothed cats. ▣

The River of Grass starts at Lake Okeechobee and runs south toward Florida Bay, along a giant shelf of limestone. Incremental drops support sawgrass marshes, cypress swamps, mangrove islands, and other ecosystems.

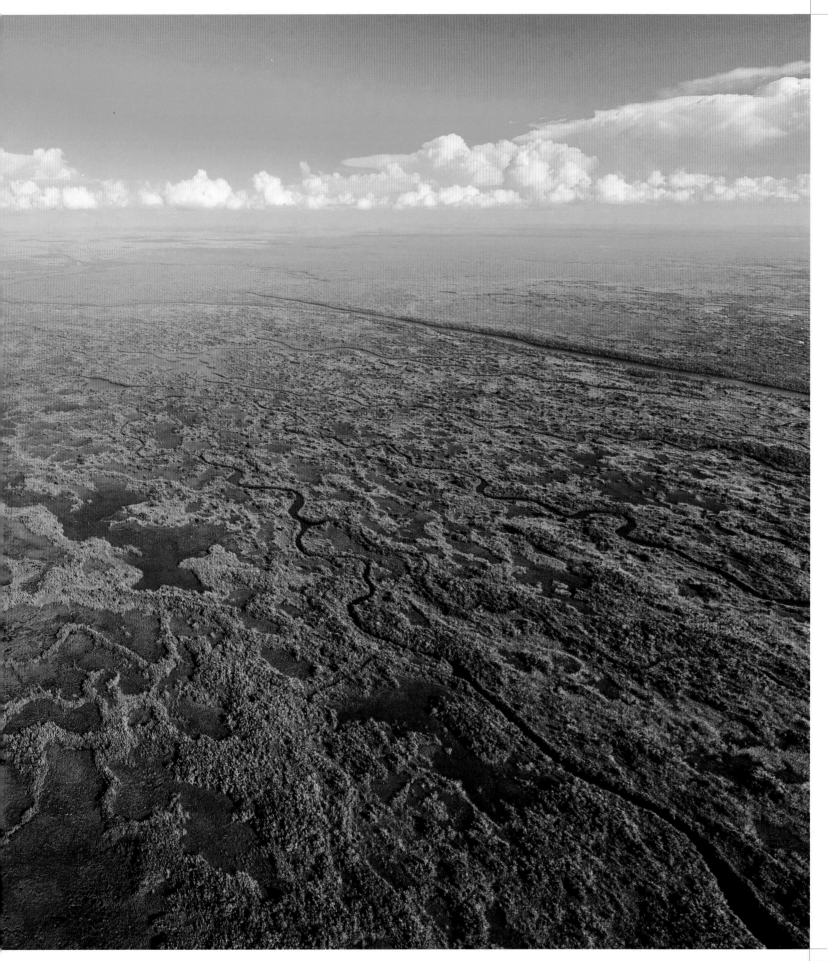

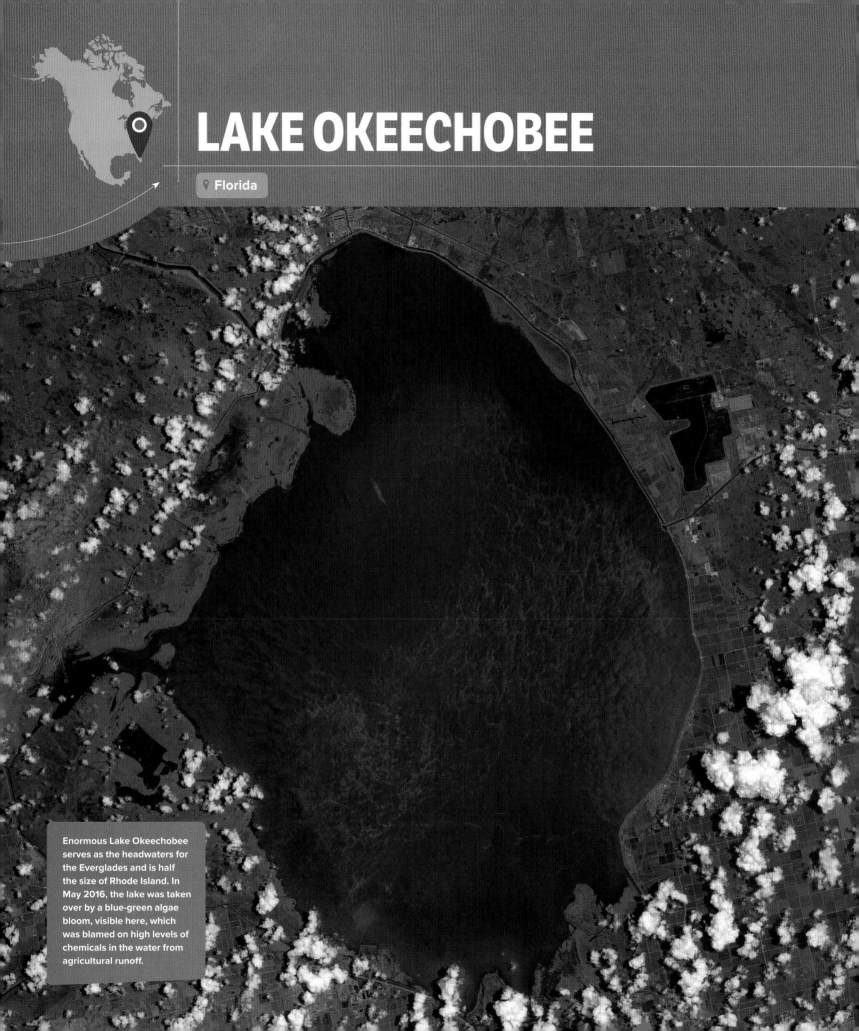

LAKE OKEECHOBEE

Florida

Enormous Lake Okeechobee serves as the headwaters for the Everglades and is half the size of Rhode Island. In May 2016, the lake was taken over by a blue-green algae bloom, visible here, which was blamed on high levels of chemicals in the water from agricultural runoff.

More than 1 trillion gallons of freshwater

As the headwaters for the Everglades, Lake Okeechobee is immense—it holds more than a trillion gallons of water when full—but its average depth is only nine feet. From the air, it appears as a huge, roundish lake northwest of Miami, easily visible in satellite photographs.

Prior to about 6000 years ago, the area that is now the lake was a dry basin, sitting atop a region of compacted clay impermeable to water. Then the climate of south Florida started getting wetter, eventually giving rise to the vast wetlands that dominate southern Florida today. As the groundwater table became saturated, Lake Okeechobee took form, eventually filling an area half the size of Rhode Island.

From above, it's sometimes possible to see that both Lake Okeechobee and the Everglades are in trouble. Development along the shores of the lake is obvious, with land divided up into both residential and agricultural sectors. Agriculture here is dominated by the sugarcane industry, which thrives in the dark, black muck of the Everglades Agricultural Area. But soil in south Florida is nutrient-poor and the fertilizer required to keep centuries-old fields productive has found its way into Lake Okeechobee.

In May 2016, a bloom of blue-green algae grew to cover thirty-plus square miles of Lake Okeechobee. The bloom was blamed on high levels of nitrogen and phosphorus in the lake, a result of fertilizer-permeated runoff from the sugarcane fields. The algae in turn produces toxins that can poison fish, destroy entire ecosystems, and negatively impact human health. High levels of arsenic, pesticides, and other pollutants have also been detected at alarming levels in the lake in recent years. In the absence of significant efforts to correct the degradation of southern Florida's waters, Lake Okeechobee and the entire Everglades are quickly becoming one of the most endangered ecosystems in North America. ◗

FLIGHT PATTERN

Trips by air to Miami, Tampa, or Key West, Florida, often offer an overhead view of Lake Okeechobee.

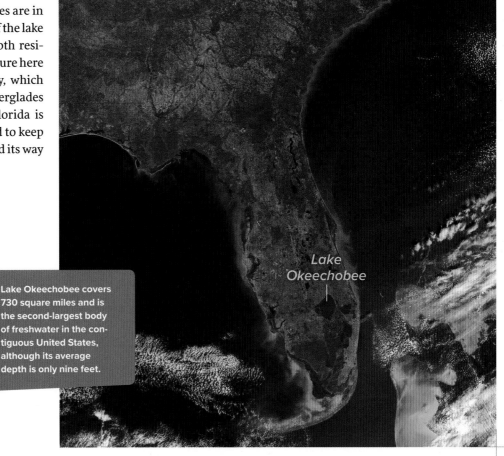

Lake Okeechobee

Lake Okeechobee covers 730 square miles and is the second-largest body of freshwater in the contiguous United States, although its average depth is only nine feet.

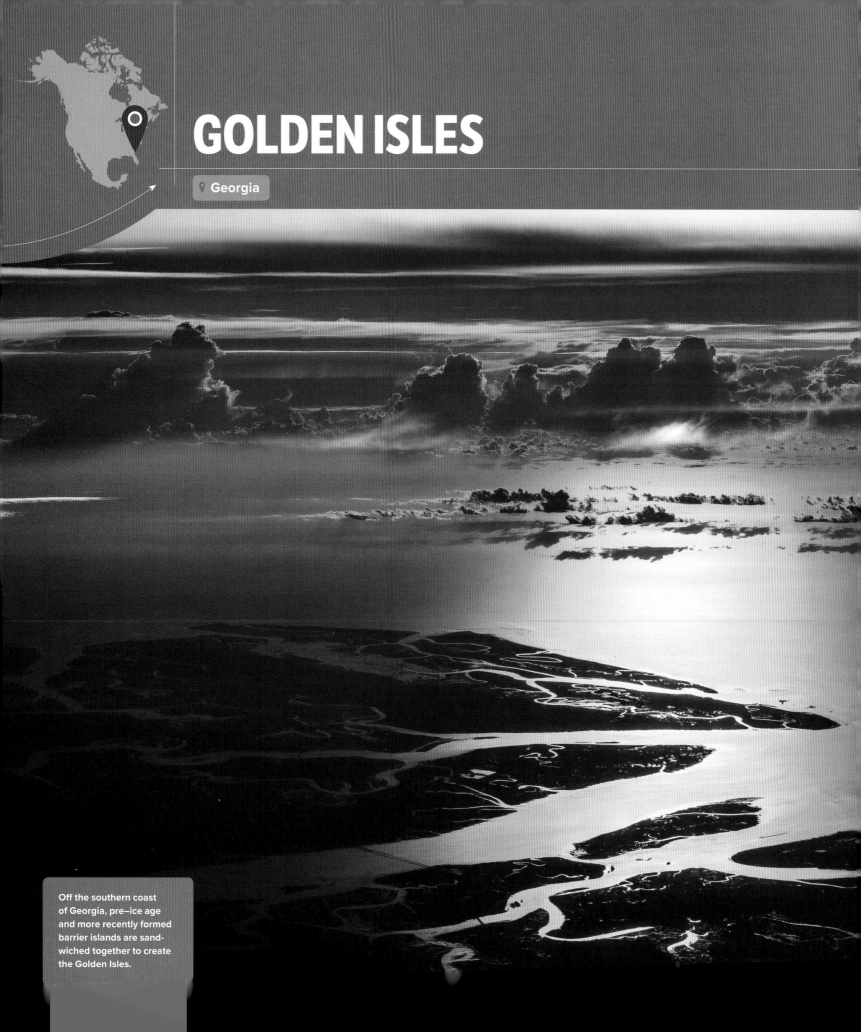

GOLDEN ISLES

📍 Georgia

Off the southern coast of Georgia, pre–ice age and more recently formed barrier islands are sandwiched together to create the Golden Isles.

Eight barrier islands, two geological epochs

Georgia boasts about a hundred miles of coastline between Savannah and the St. Marys River, interwoven with eight major offshore islands and island groups known collectively as the Golden Isles. These formations are easily seen from on high, in a pattern of islands and inlets along the southern Georgia coast.

The geological histories of these barrier islands reveal two parallel sets of formations, created during two distinct time periods—one dating back to before the last ice age and one formed more recently.

Barrier islands form along coasts in places where sand is plentiful. Waves pile and carve sand into long, narrow spits, often forming chains of islands that parallel the coast, protecting the mainland from wave action. In the Golden Isles, six of the eight large islands closest to the mainland date back to the Pleistocene Epoch, around 40,000 years ago, during an interglacial period before the last great continental ice sheet began spreading south from Canada across North America. During this period, sea levels were about six feet higher than today and the elevation of the older islands represents the higher sea levels of that period.

Around 25,000 years ago, as the last ice age was in full force, sea levels were 300 to 500 feet lower than today, and the coast of Georgia was eighty miles out from the current shoreline, stranding the islands far inland. Around 18,000 years ago, as the ice sheets began melting, sea levels began to rise again, inundating forests that had flourished along the ice age coast. As sea levels rose, around 5000 years ago, the Holocene barrier islands began to form offshore, gradually migrating westward with the rising waters until they met the older Pleistocene-era islands. Today, the older Pleistocene and younger Holocene landforms can be found sandwiched together along the length of the Georgia coast.

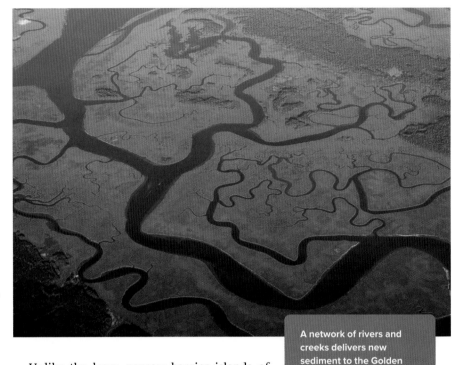

A network of rivers and creeks delivers new sediment to the Golden Isles, helping sustain them against the ravages of wave action.

Unlike the long, narrow barrier islands of North Carolina's Outer Banks, Georgia's Golden Isles are short and wide. This difference in shape is a result of the positioning of the continental shelf, which is closer to shore in North Carolina, creating intense wave action that erodes the barrier islands and keeps them from growing wider. In Georgia, the continental shelf is farther offshore and the shallower, calmer water action allows for more sand to build up, producing wider barrier islands.

Complex interactions between wind, waves, currents, tides, sand supply, and slowly rising sea levels are constantly reshaping the Golden Isles. Sediment-laden rivers deliver new supplies of sand through the inlets between the islands, seasonally changing the shape of the isles. But as sea levels continue to rise (around twelve to fourteen inches per century), the barrier islands will eventually disappear. ▄

FLIGHT PATTERN

You might fly over Georgia's Golden Isles en route to Jacksonville, Florida; Savannah, Georgia; or Charleston, South Carolina.

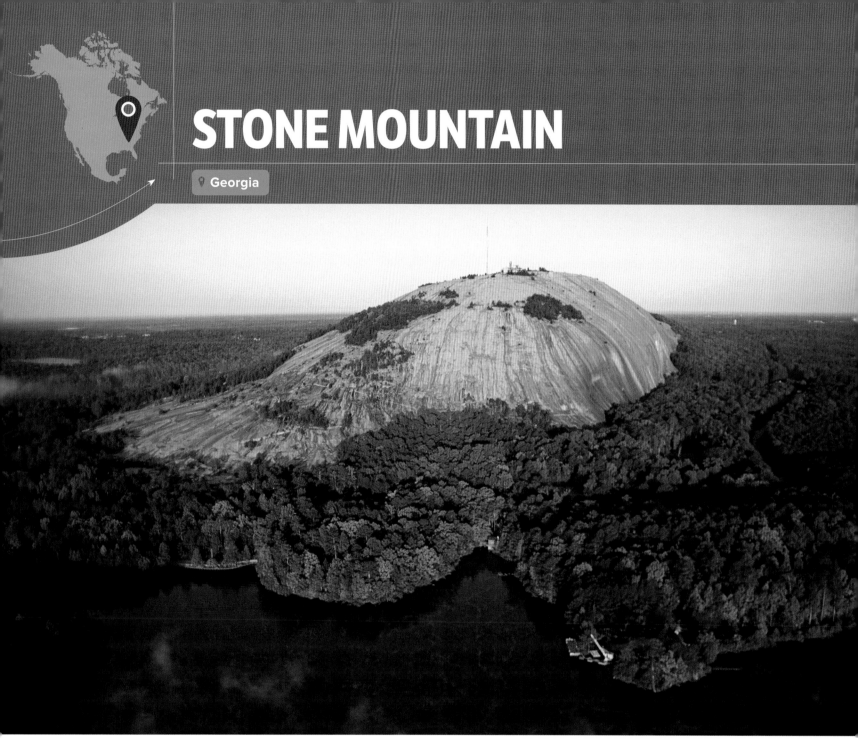

STONE MOUNTAIN

FLIGHT PATTERN

You could fly over Stone Mountain en route to Atlanta, Georgia.

If the presidential carvings on South Dakota's Mount Rushmore are masterpieces on a grand scale, it may be because the sculptor got to practice on Georgia's Stone Mountain. This granite dome in north central Georgia is home to the world's largest bas-relief sculpture, immortalizing three Confederate war heroes: Stonewall Jackson, Robert E. Lee, and Jefferson Davis, on their favorite horses, Little Sorrel, Traveller, and Blackjack, respectively.

At an elevation of 1688 feet, Stone Mountain looms 825 feet above the ground, with a circumference of five miles at its base. The landmark is easy to spot from the air just east of Atlanta.

Stone Mountain and Mount Rushmore are both made of granite, igneous rock that erupts underground, where it cools slowly and forms large crystals that make the rock exceptionally hard. Stone Mountain is a granite formation known as a quartz monzonite dome monadnock; the quartz

Granite mass that continues underground for nine miles north and east

monzonite refers to the high mineral quantities of orthoclase and plagioclase feldspars that give the rock a smooth, light gray texture. A monadnock is an isolated mountain that rises abruptly from the surrounding landscape.

The rock was formed five to ten miles underground between 300 and 350 million years ago, during one of the uplift stages of the Appalachian Mountain chain. It was likely exposed to the surface by erosion sometime in the last 15 million years. The mountain that appears at the surface is only the tip of the iceberg; a mass of granite continues underground for nine miles to the north and east, extending into the next county.

Depicted in relief on the side of Stone Mountain, the Confederate Memorial Carving is slightly smaller than two football fields, reaching four hundred feet above ground and measuring ninety feet high and nearly two hundred feet wide. At its deepest point, the bas-relief is carved forty-two feet into the mountain. The carving was commissioned by the United Daughters of the Confederacy in 1916 and started by Gutzon Borglum, who would abandon the project in 1925 to move his talents to Mount Rushmore. Originally, Borglum conceived of the carving as a parade of gigantic figures encircling the mountain, but the three figures on horseback alone took more than fifty years to complete and the project was never expanded.

Stone Mountain has been owned by the state of Georgia since 1958 and is operated today as a visitor attraction. Guests can ride to the top of the mountain on the Summit Skyride (a high-speed cable car that passes the carving on the way up) or hike to the top on a steep path just over a mile long that ascends 786 feet to the summit. From the top, the city skyline of Atlanta is visible to the west. ▪

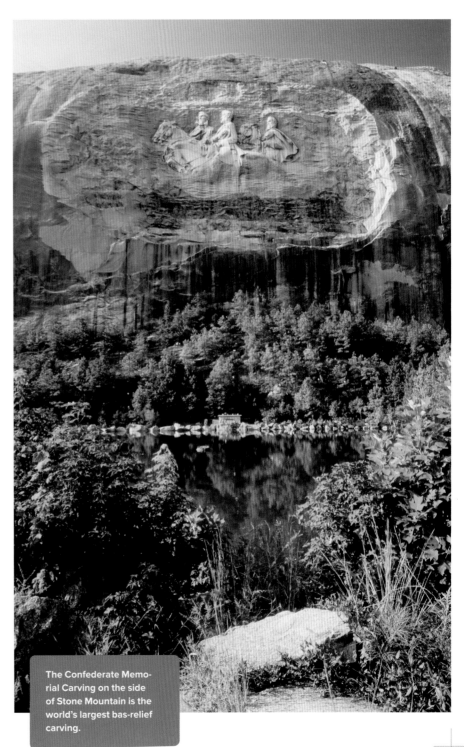

The Confederate Memorial Carving on the side of Stone Mountain is the world's largest bas-relief carving.

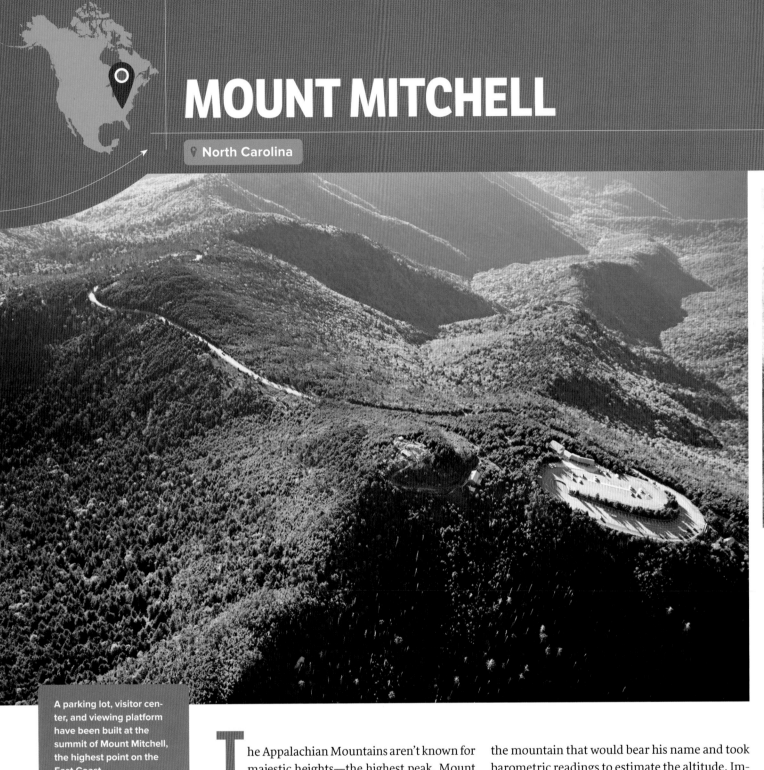

MOUNT MITCHELL

A parking lot, visitor center, and viewing platform have been built at the summit of Mount Mitchell, the highest point on the East Coast.

The Appalachian Mountains aren't known for majestic heights—the highest peak, Mount Mitchell, in western North Carolina, tops out at 6684 feet. It is the highest summit east of the Mississippi River, but it hasn't always worn the eastern high-point crown. In the early 1800s, Mount Washington in New Hampshire was thought to be the East's highest point. In 1835, Elijah Mitchell, a professor from the University of North Carolina, bushwhacked to the top of the mountain that would bear his name and took barometric readings to estimate the altitude. Impressively, his primitive calculations fell short by only twelve feet; his efforts were enough to dethrone Mount Washington, which is actually the eighth highest in the East, at 6289 feet.

From the air, Mount Mitchell is noticeable as part of the Black Mountains, a region of the Appalachians named for the thick swaths of spruce and fir trees that darken the range. North Carolina

Mount Mitchell and the Black Mountains appear in the reddish cluster of mountains.

Mount Mitchell

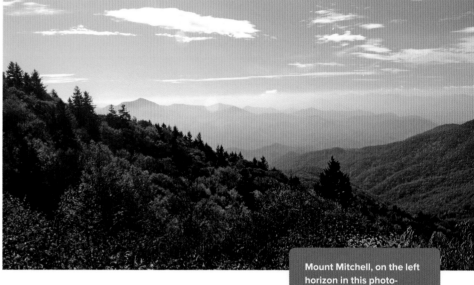

Mount Mitchell, on the left horizon in this photograph, looms over the rest of the Black Mountains. The perspective is from the Blue Ridge Parkway, which winds through the Appalachians.

Highway 128 can be seen running up to a parking lot near the summit.

Mount Mitchell stands tall thanks to its geologic history. The rocks making up the mountain were laid down as marine deposits during the late Precambrian Era, more than 500 million years ago. After they were buried, heat and pressure metamorphosed the rocks into gneiss and schist, very hard rocks that tend to erode slowly. During a later episode of Appalachian mountain building, between 325 and 260 million years ago, what is now Africa collided with North America in the process of forming the supercontinent Pangaea, and these ancient metamorphic rocks were uplifted to Rocky Mountain heights. Geologists think the Appalachians may have once been one of the most impressive mountain ranges on Earth, but hundreds of millions of years of erosion have reduced them to majestic hills.

Today, Mount Mitchell is protected by Mount Mitchell State Park within Pisgah National Forest. Here, the Black Mountains are home to six of the ten highest peaks in the eastern United States, including Mount Mitchell and Mount Craig, the second-highest Appalachian pinnacle at 6647 feet. The Black Mountains are notorious for some of the most rugged hiking in the Appalachians, including the Mount Mitchell Trail, which runs from the Black Mountain campground to the Mount Mitchell summit, for a strenuous round-trip hike of about eleven and a half miles. Less hardy folk can drive to the summit, where a large parking area and observation deck are open year-round, weather permitting.

The relatively high elevation of the Black Mountains makes them a biological island, an isolated environment home to species otherwise found only much farther north. Many of the ninety-some bird species here are northern species, more common to New England and Canada. Each winter, when the upper reaches of the range see more than sixty inches of snow, bird species like Carolina chickadees and slate-colored juncos, which normally migrate long distances, simply travel down the mountain to seek milder temperatures. ▪

FLIGHT PATTERN

Mount Mitchell can sometimes be seen on flights to Asheville, North Carolina, or Knoxville, Tennessee.

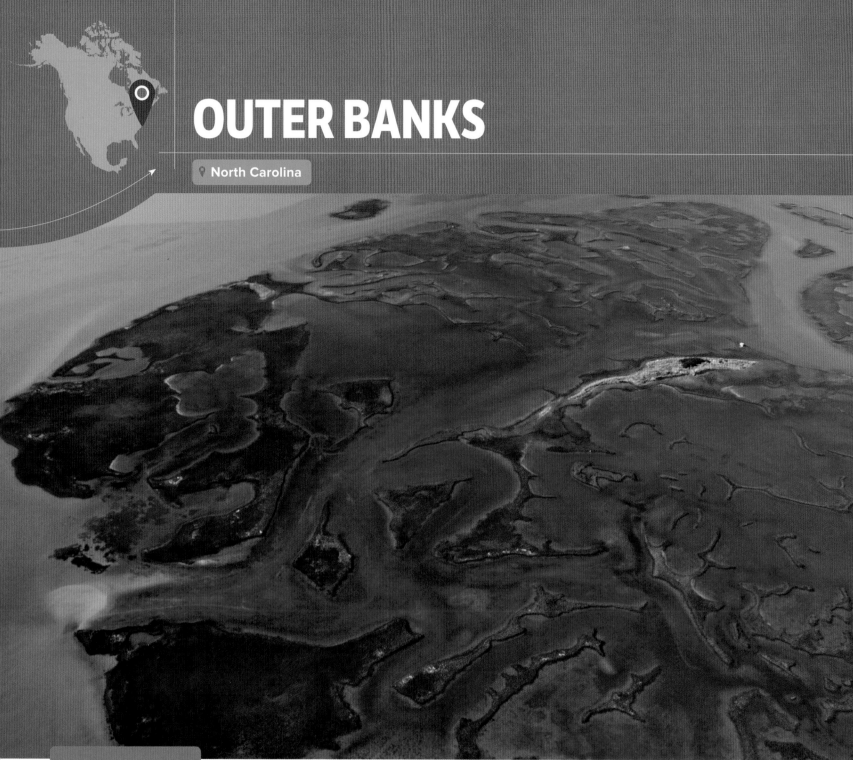

OUTER BANKS

Landforms are constantly changing in the Outer Banks as storms, wind, and waves pummel the sandy islands and sandbars.

The Atlantic and Gulf Coasts of the United States are ringed by more than 300 barrier islands. These long, narrow, sandy islands, seen from the air running parallel to the mainland, are among the most dynamic landforms in the world, constantly changing in the face of wind, waves, and weather. North Carolina's Outer Banks are textbook examples of barrier islands, appearing from the air as a line of narrow islands and peninsulas just off the state's coastline. Their fraught history of storms and shipwrecks highlights the dangers of living on and boating near these ever-changing landforms.

Barrier islands are formed by dynamic interactions between gradually rising sea levels, a surplus of sand along the coast, and the erosive forces of

4000-year-old islands at the constant mercy of wind and waves

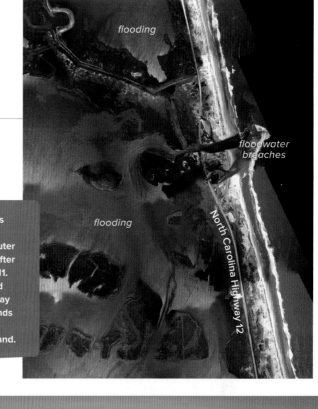

flooding

floodwater breaches

flooding

North Carolina Highway 12

Hurricanes and storms often cause overflow and flooding of the Outer Banks, as seen here after Hurricane Irene in 2011. Floodwaters breached North Carolina Highway 12, cutting off thousands of people on Hatteras Island from the mainland.

wind and waves. The variability of such factors makes these islands inherently unstable; indeed, the number of islands and inlets often changes after storms. The barrier islands of the Outer Banks are typically one to three miles wide and ten to twenty miles long, located between two and twenty miles offshore. These islands lack any rock base; instead they are built from piled-up sand, on average no higher than ten to twenty feet above sea level, although some dunes pile taller than a hundred feet. When storms hit such islands, erosion can be devastating to people, structures, and infrastructure. Hurricanes and tropical storms make landfall in the Outer Banks every few years, often with destructive and expensive results.

Despite this instability, the Outer Banks have existed for about 4000 years and have been settled and developed for centuries, with some of the more populated islands, such as Bodie Island, home to several thousand people. Other islands have been preserved in their natural, undeveloped states; nine of the most scenic islands are designated by the National Park Service as national seashores and wildlife refuges. The estuaries tucked between the barrier islands and the mainland are some of the richest and most productive coastal ecosystems in the United States, providing nurseries, shelter, and food for many species of fish, shellfish, birds, and other wildlife.

Offshore the Outer Banks is the Graveyard of the Atlantic, where 5000-odd ships have wrecked on the shifting, sandy shoals hidden just beneath the waves. A number of lighthouses have been erected along this stretch of coast, in hopes of

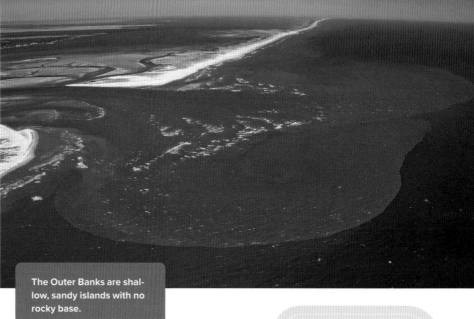

The Outer Banks are shallow, sandy islands with no rocky base.

warning disoriented ships away from deceptively shallow depths. The waters off Cape Hatteras, Cape Lookout, and Cape Fear, North Carolina, have all claimed more than their fair share of ships and lives. A high-profile tragedy occurred in October 2012, when the HMS *Bounty* sank off Cape Hatteras in the high waves of Hurricane Sandy, killing the captain and a crew member. ▪

FLIGHT PATTERN

Look for the narrow islands and peninsulas of the Outer Banks en route to Norfolk, Virginia, or Raleigh, North Carolina.

CHESAPEAKE BAY CRATER

DELMARVA
PENINSULA

CHESAPEAKE
BAY

location of
impact crater

The Chesapeake Bay Crater is hidden beneath the waters of the bay. Notice that rivers running into the southern end of the bay converge around the depression created by the impact crater.

Meteor impact hole originally fifty-three miles wide and a mile deep

Even in a low-flying plane, it does no good to strain your eyes trying to catch a glimpse of the Chesapeake Bay Crater, on the Mid-Atlantic Coast between Maryland and Virginia. Millions of years of sedimentation have filled in the crater, which today lies under the waters of Chesapeake Bay. In fact, the crater is so well hidden by erosion that it was only discovered by geologists in the 1990s. However, while the crater itself may not be visible to the naked eye, its effects on surrounding landforms are still apparent.

What is the invisible crater's story? Early in Earth's childhood, our planet was constantly bombarded by objects from space that were let loose during the chaotic formation of our solar system. These comets and asteroids helped shape the young planet, delivering some of the first water molecules and, some scientists believe, even the first life-forms. Once Earth developed its own atmosphere around 500 million years ago, the majority of these objects burned up in the atmosphere before they could strike the planet. But over millennia, a few large comets and asteroids have survived entry to collide with the surface—becoming meteorites and scarring the crust with giant craters. These events have triggered at least one major extinction: the end of the dinosaurs, some 65 million years ago.

Around 35 million years ago, a large meteor five miles in diameter streaked through the atmosphere and impacted the planet in what is now Chesapeake Bay. At the time, sea level was much higher and the region was already underwater. The impactor, termed a bolide, was traveling many miles per second and punched a deep hole through the planet's crust, into the granite basement rock below. The impact was so violent that the bolide was completely vaporized, leaving a hole fifty-three miles in diameter and a mile deep.

The aftermath of the collision devastated much of the East Coast—shattered rock from the impact has been found hundreds of miles from ground zero, possibly carried by a monstrous tsunami. Some evidence suggests that this tsunami may have traveled a hundred miles inland and flowed over the Appalachian Mountains in Virginia and Maryland. Eons of geologic activity have transformed the area's landscape since then, but the crater played an important role in the evolution of the shape of Chesapeake Bay: the depression created in Earth's crust captured several major rivers. From above, it's clear that these rivers running into the bay come together near the crater's depression, in the southern end of the bay. ◼

The highly eroded inner and outer rims of Chesapeake Bay's impact crater are completely hidden underwater and beneath many layers of sediment.

FLIGHT PATTERN

From above, the location of the Chesapeake Bay Crater is centered around the tip of the Delmarva Peninsula, which juts down from the coastal tip of Maryland, forming a barrier between Chesapeake Bay and the Atlantic Ocean.

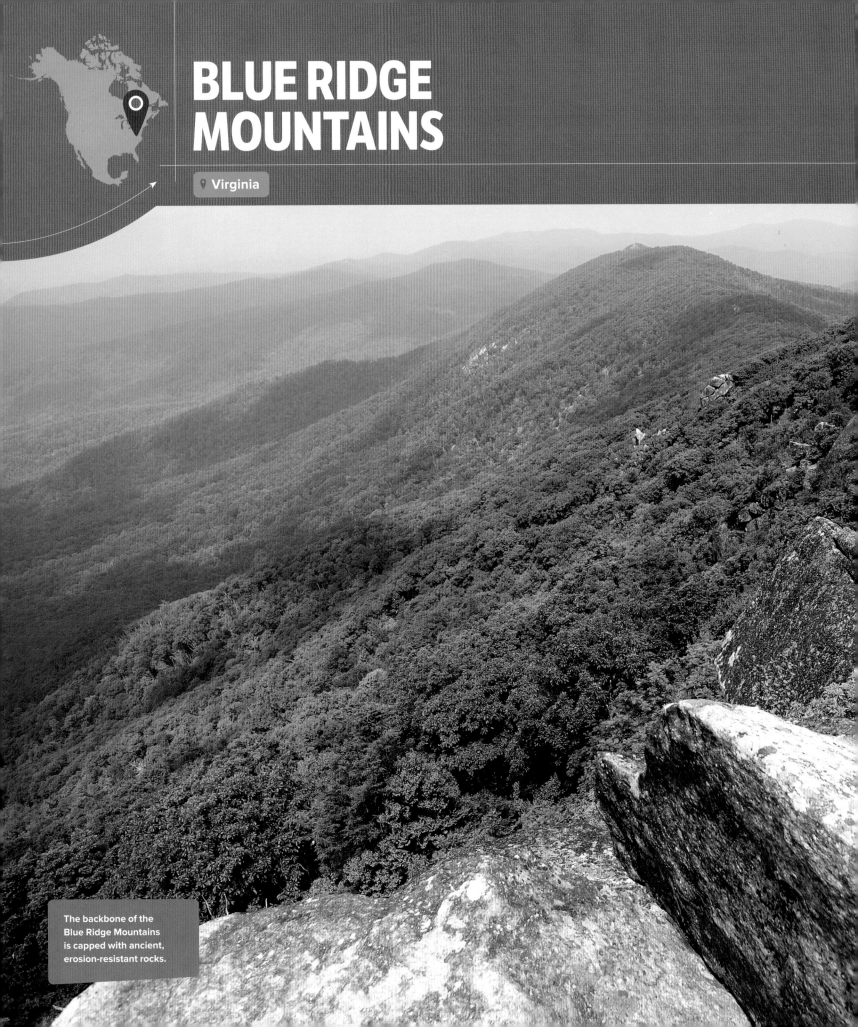

BLUE RIDGE MOUNTAINS

📍 Virginia

The backbone of the Blue Ridge Mountains is capped with ancient, erosion-resistant rocks.

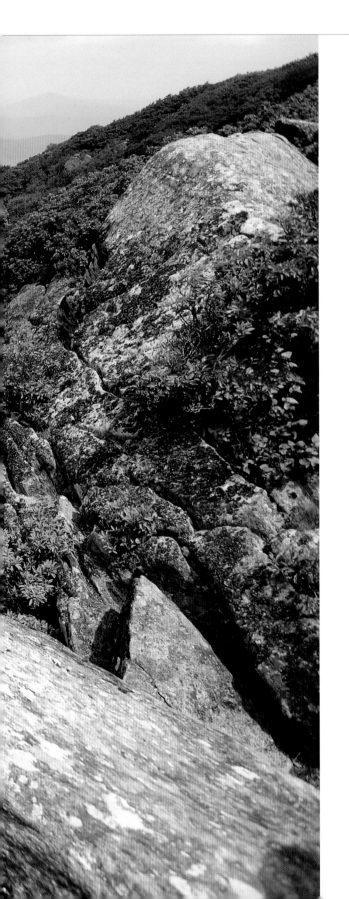

300-million-year-old seafloor fossils brought to surface by uplift and erosion

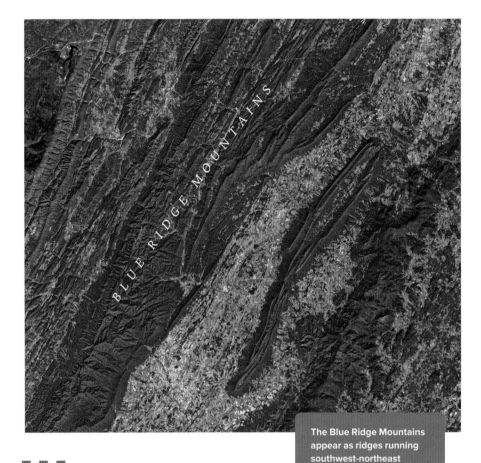

Within the Appalachian Mountains is a subrange, the Blue Ridge Mountains, running from Alabama to southern Pennsylvania. Their name comes from the bluish haze that appears over the range most mornings, a cloud produced by the organic exhalations of oak, poplar, and other broadleaf trees as they make energy through photosynthesis. From the air, the Blue Ridge Mountains can be seen running diagonally from southwest to northeast—they are most prominent in western Virginia.

The granite rocks that make up the Blue Ridge Mountains are especially old—the most ancient date back more than a billion years, before life

evolved on the planet. These rocks were originally erupted underground, where they cooled slowly, forming the large crystals that compose granite.

The first mountain-building episodes began around 480 million years ago, when the super-continent Pangaea was coming together, eventually combining all the world's landmasses into one gigantic continent around 300 million years ago. The Appalachians and what are now the Blue Ridge Mountains were near the center of Pangaea. At that time, North America and Africa were connected (the Little Atlas Mountains in Morocco are made up of the same rocks as the Appalachians). After Pangaea split up around 175 million years ago, separating North and South America from Europe and Africa, mountain building in the Appalachian region continued. As the east coast of North America evolved, a new offshore subduction zone sparked episodes of onshore volcanism, and the suturing of continents, microplates, islands, and seafloors onto North America's eastern shore helped form the continent we know today.

All the topography produced by these episodes of mountain building was almost wiped clean by erosion during the Mesozoic Era. In the Cenozoic Era, however, a new episode of global uplift raised many of the world's mountains to greater heights, producing much of the familiar topography seen along the Appalachians today. Some of the billion-year-old granite created underground is now exposed at the summit of the lumpy mountain Old Rag, on the eastern side of the Blue Ridge range, in Shenandoah National Park, near Sperryville, Virginia. Limestone layers now above the surface contain fossils from organisms that once lived on ancient seafloors during the late Carboniferous Period, around 300 million years ago. ■

Hard basement rocks make for scenic waterfalls throughout the Blue Ridge Mountains.

Granite boulders—some of which date back more than a billion years—sit near the summit of Old Rag in the Blue Ridge Mountains.

FLIGHT PATTERN

You will fly over the Blue Ridge Mountains on your way to Washington, DC, or Richmond, Virginia. Look for bluish parallel ridges running southwest and northeast.

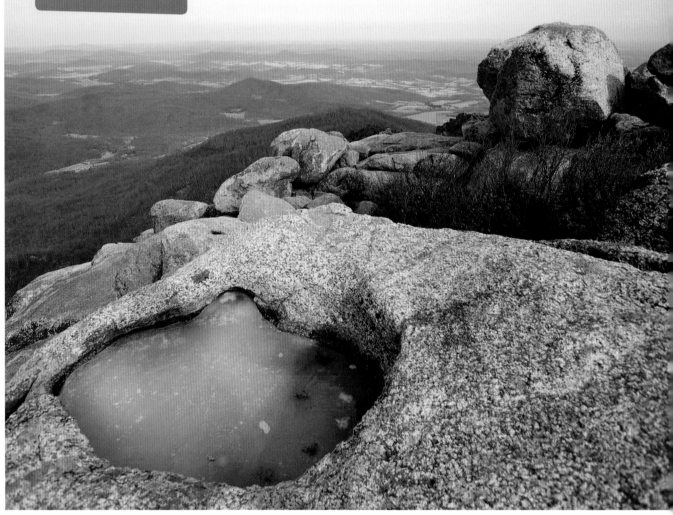

NEW RIVER GORGE

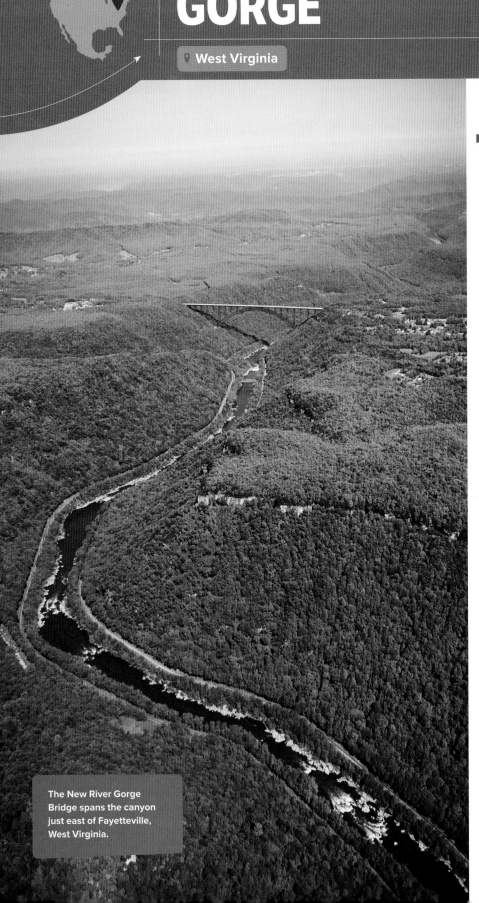

The New River Gorge Bridge spans the canyon just east of Fayetteville, West Virginia.

The New River's name is misleading—it is actually one of the oldest rivers on the globe. The New River began forming around 350 million years ago, back when Africa and North America were colliding to form the supercontinent Pangaea. As continents slammed into continents, a river system known as the Teays formed in what is now North Carolina, to drain the Appalachian Mountains' western slopes. This laid the foundation for the New River and its spectacular gorge. Coming or going from Yeager Airport in Charleston, West Virginia, look for the gorge running north and south near the town of Fayetteville, West Virginia.

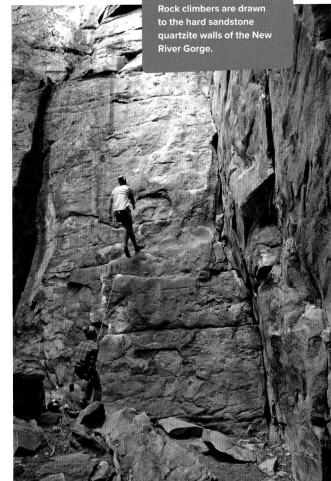

Rock climbers are drawn to the hard sandstone quartzite walls of the New River Gorge.

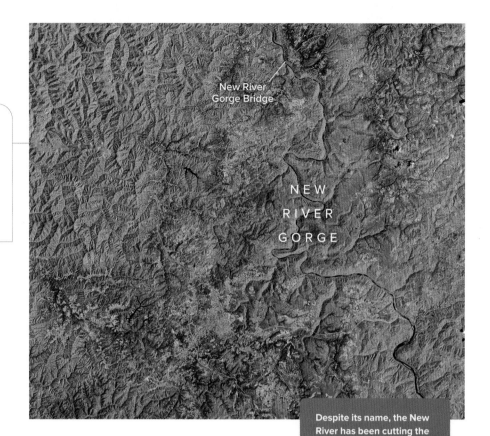

One of the few north-flowing waterways in North America

New River
Gorge Bridge

NEW
RIVER
GORGE

Despite its name, the New River has been cutting the 1500-foot-deep New River Gorge over millions of years. It is one of the few rivers in North America that flows north, and can be seen as the winding blue line in this false-color satellite image.

Around 60 million years ago, during the Cenozoic Era, the Appalachians went through one of several periods of gradual uplift. A slower-running river might have changed course, but the powerful, fast-flowing Teays cut down into the bedrock faster than the rate of uplift, maintaining its ancient course and creating the deep, V-shaped New River Gorge.

Today, the New River flows from North Carolina, through the Virginias, to Ohio, then turns west to drain into the Mississippi River Basin, once a vast inland sea. It is one of the only north-flowing rivers on the continent. Rivers flow in the direction of the most direct downhill route to drainage, and in North America, most times that means east to the Atlantic Ocean, west to the Pacific, or south to the Gulf of Mexico. However, for the New River, north to the Mississippi River Basin is the most direct path.

The New River Gorge cuts a 1500-foot-deep trench through southern West Virginia, exposing 350 million years of geologic activity. The most sought-after layers of the gorge are seams of bituminous coal, wedged between sandstone layers, formed from dead plant and organic matter deposited in deep basins around 200 million years ago. Between 1900 and 1962, miners hacked 16 million tons of coal from the walls of the gorge.

The miners and their families lived in sixty ramshackle towns along the banks of the New River, many reachable only by railroad. Today, virtually all the settlements are abandoned, marked by overgrown foundations and rusting metal machinery. From the air, look for the railroad tracks bordering the banks of the river—you may see signs of these ghost towns.

The most recognizable manmade feature of the New River Gorge is the New River Gorge Bridge, a 3030-foot-long steel span. When it was finished in 1977, it was the longest single-span arch bridge in the world, an impressive feat of engineering. These days, it's the third longest and second highest, suspended a dizzying 876 feet above the river. Before the bridge was built, cars had to travel from one side to the other on steep, winding roads, then cross a bridge at the bottom, just above the river. Now cars zip across the gorge in a matter of seconds.

Crossing the precipitous New River Gorge Bridge in a car is exciting, but many visitors prefer more adventurous thrills in the gorge. World-class mountain biking, rock climbing, and white-water rafting are all popular pursuits. Each fall, Fayetteville hosts Bridge Day, when hundreds of daredevils leap from the New River Gorge Bridge and deploy parachutes, aiming for the riverbanks. ▣

FLIGHT PATTERN

Look for the New River Gorge Bridge on the outskirts of Fayetteville, West Virginia, en route to Charleston, West Virginia.

SENECA ROCKS

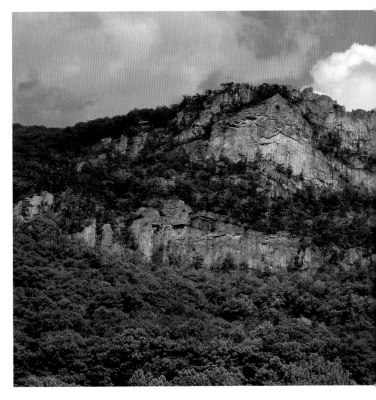

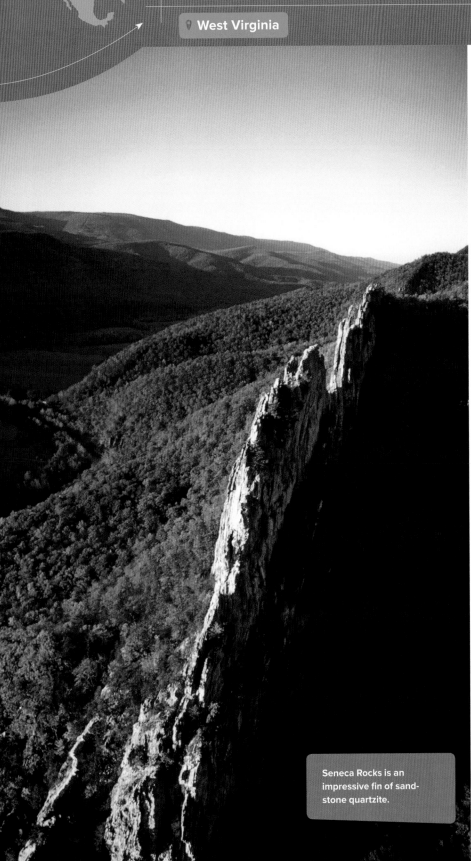

Seneca Rocks is an impressive fin of sandstone quartzite.

Occasionally, formations defy the basic rule of geology that says rock layers are laid down horizontally, with younger layers sitting on top of older layers. Sometimes the rule is broken in spectacular fashion, as at Seneca Rocks in eastern West Virginia. Here, horizontal layers of rock have been turned on end, in a dramatic dorsal fin of sandstone quartzite that rises nearly 900 feet above the North Fork River. From above—the likeliest way to catch an aerial view is from a chartered flight—the light-colored rock emerges from a wooded ridgeline in a series of skyward-jutting stone blades.

Seneca Rocks is one of several vertical outcroppings, including Judy Rocks, Nelson Rocks, and Champe Rocks, that crown the razorback ridges of North Fork Mountain. The fins are composed of Tuscarora Quartzite, a type of very hard sand-

Horizontal rock layers turned on end like dorsal fins

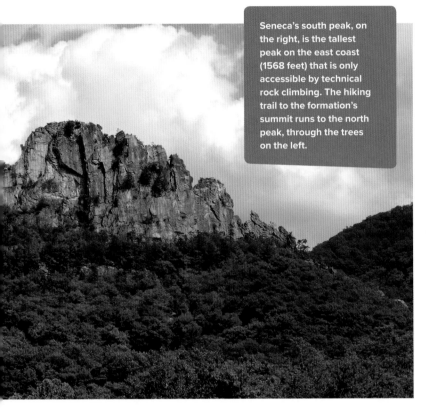

Seneca's south peak, on the right, is the tallest peak on the east coast (1568 feet) that is only accessible by technical rock climbing. The hiking trail to the formation's summit runs to the north peak, through the trees on the left.

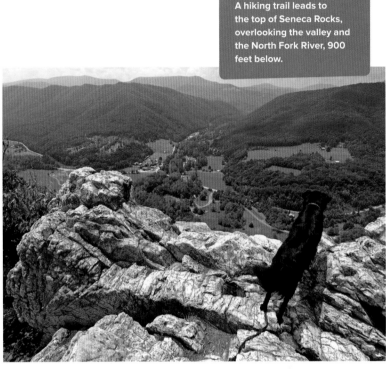

A hiking trail leads to the top of Seneca Rocks, overlooking the valley and the North Fork River, 900 feet below.

stone quartzite made up of fine grains of sand that amassed in horizontal layers during the Silurian Period, 440 million years ago. At that time, this region lay on the edge of the ancient Iapetus Ocean, which straddled the Southern Hemisphere between the paleocontinents of Laurentia, Baltica, and Avalonia. The ocean disappeared when these three continents joined into the supercontinent Euramerica, which became part of Pangaea, around 300 million years ago.

The quartzite that makes up Seneca Rocks is around 250 feet thick. Geologists aren't exactly sure when this layer was uplifted to reach skyward, but it has likely been exposed in its current position only for a few tens of millions of years. The rock is extremely hard and its vertically oriented cracks make for excellent rock climbing. In the 1940s, the 10th Mountain Division of the U.S. Army used Seneca, Nelson, and Champe Rocks as training grounds for fighting in the Italian Alps. The soldiers' pitons—steel spikes hammered into the rocks to create anchors—can still be found by the thousands rusting in cracks in the rocks. One wall has so many of these relics, it's nicknamed The Face of a Thousand Pitons. Today, there are nearly 400 mapped climbing routes up both the west and east faces of Seneca Rocks, some up to 300 feet long.

Seneca's sandstone quartzite is famously hard, but it is still eroding. On October 22, 1987, around 3:27 p.m., a famous pillar between the north and south peaks of Seneca Rocks known as the Gendarme fell to the ground. The first ascent of the Gendarme was recorded in 1908 and hundreds of climbers had stood on the spire in the years since. ■

FLIGHT PATTERN

This part of West Virginia is several hundred miles from any major airport. Your best bet for seeing Seneca Rocks from the air is on a chartered flight.

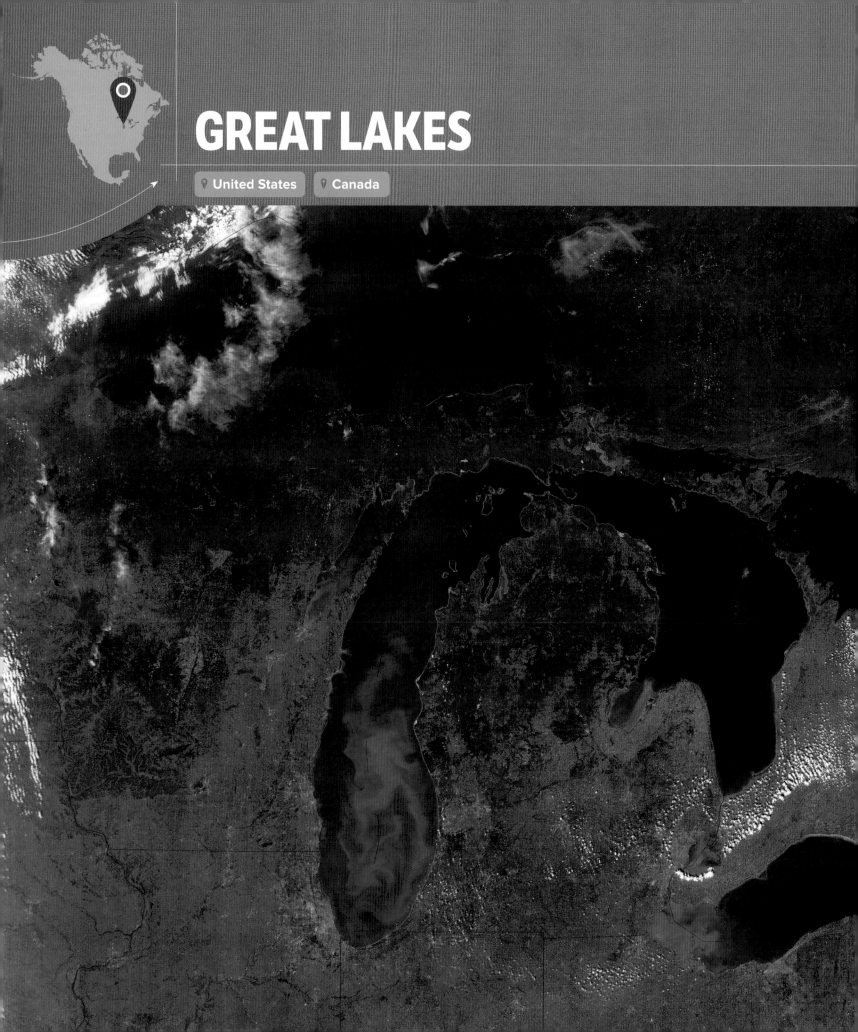

GREAT LAKES

United States Canada

Glacial meltwater–filled rifts that hold more than a fifth of Earth's freshwater

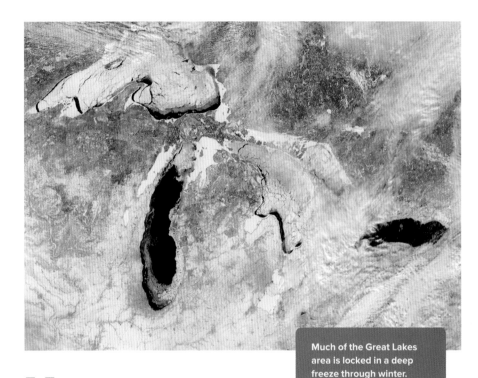

Much of the Great Lakes area is locked in a deep freeze through winter. The scene brings to mind the period when the lakes started forming, as the last ice age was ending.

Holding more than a fifth of the world's freshwater, the five Great Lakes—Superior, Michigan, Huron, Ontario, and Erie—are more like inland seas than lakes. From numerous vantage points on the ground, these broad expanses of water are too vast to see land on the other side. Many commercial flights offer excellent views of the five iconic, interconnected lakes along the border between the United States and Canada.

The Great Lakes began forming around 14,000 years ago, as the last ice age was winding down, after the Laurentide Ice Sheet retreated north of the Great Lakes region, filling it with glacial meltwater. However, the foundation for these enormous lakes was set over a billion years ago, when the core of the ancient continent Laurentia began splitting in half. This breach, the Midcontinent Rift, is a 1200-mile-long geological cleft now

FLIGHT PATTERN

You could fly over the Great Lakes en route to Chicago, Illinois; Detroit, Michigan; Toronto, Ontario; or a number of other North American destinations. The well-known shape of the five-lake system is hard to miss.

The name Pictured Rocks was inspired by the streaks of mineral stains that paint the rocks on Lake Superior. Red and orange come from iron, blue and green from copper, and brown and black from manganese.

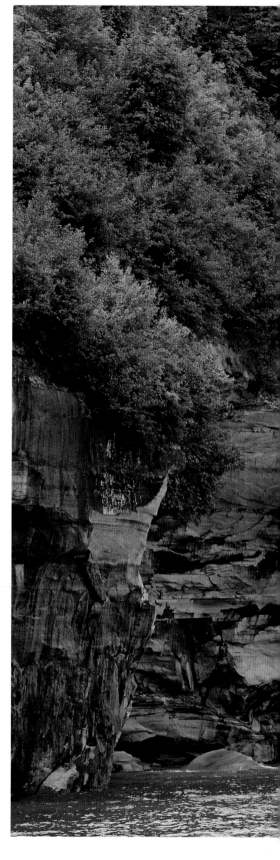

located in the center of North America. The root of the rift is in what is now Lake Superior, with the two arms of the split reaching down into Alabama and Oklahoma.

Around 10 million years after it began separating, the Midcontinent Rift stopped spreading, eventually filling with flood basalts from volcanic eruptions fueled by a plume of molten rock rising from deep in Earth's mantle. In some places, basalt filled the rift to depths twelve miles beneath the surface. Then around 570 million years ago, a second split, the Saint Lawrence rift system, began opening, laying the foundation for Lake Ontario, Lake Erie, and the Saint Lawrence River.

The first Great Lakes to form were ancestral lakes known as Early Lake Chicago and Early Lake Maumee. Early Lake Chicago formed in the basin where Lake Michigan is located today, while Early Lake Maumee formed in what is now the Lake Erie Basin. At that time, a large sheet of glacial ice still persisted north of the Great Lakes region and the ancestral lakes drained to the south, through what is now the Mississippi River Basin. As the ice sheet melted, the weight of the ice lifted, allowing the land to rise at a rate of about a foot per century—a phenomenon known as post-glacial isostatic rebound. As the land rose, the drainage patterns of the rapidly filling Great Lakes region shifted to the northeast, to its modern-day path through the Saint Lawrence River and Seaway to the North Atlantic Ocean. ▪

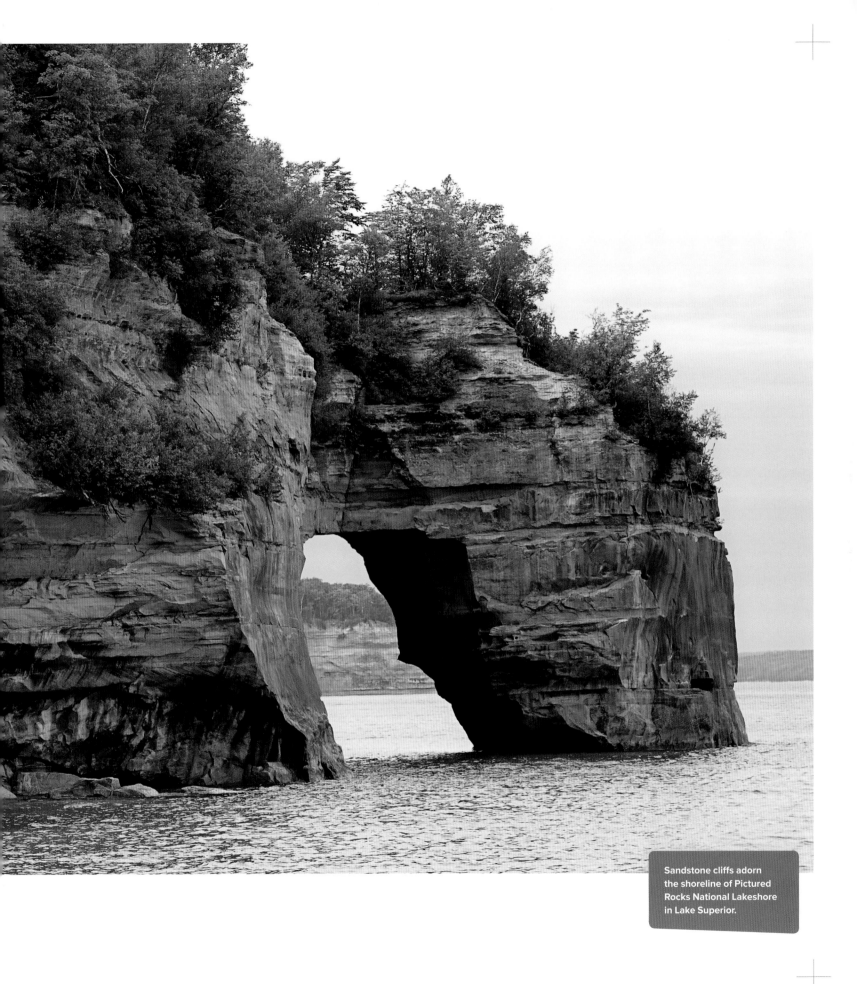

Sandstone cliffs adorn the shoreline of Pictured Rocks National Lakeshore in Lake Superior.

SLEEPING BEAR DUNES

📍 Michigan

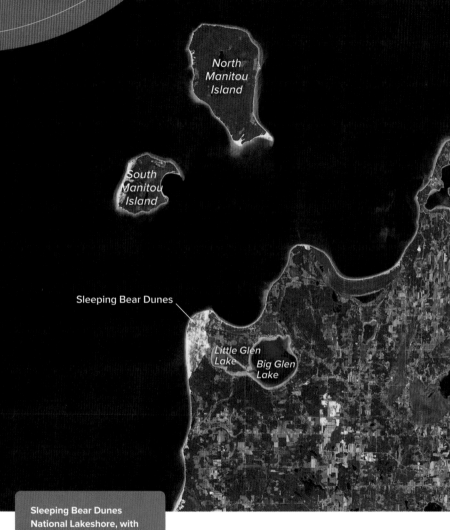

North
Manitou
Island

South
Manitou
Island

Sleeping Bear Dunes

Little Glen
Lake Big Glen
Lake

Sleeping Bear Dunes
National Lakeshore, with
its two inland lakes and
two offshore islands, is
located on the northeast
shore of Lake Michigan.

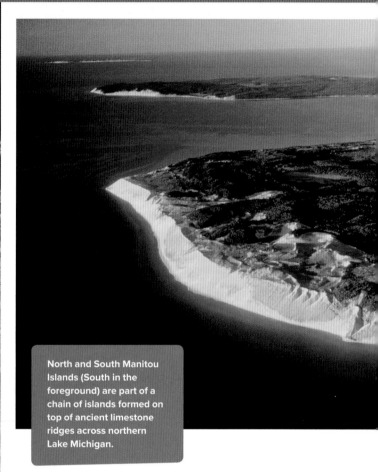

North and South Manitou
Islands (South in the
foreground) are part of a
chain of islands formed on
top of ancient limestone
ridges across northern
Lake Michigan.

The middle of the North American continent is far from landlocked. The Great Lakes region exceeds 10,000 miles of coastline—more than the Atlantic and Pacific coasts combined. Between Lake Michigan and Lake Huron, the state of Michigan alone has 3288 miles of water-front; only the state of Alaska has more. One of the most striking places on Lake Michigan is Sleeping Bear Dunes National Lakeshore, which, from an aerial perspective, appears as a tan, dune-covered stretch of lakeshore with two inland lakes.

At Sleeping Bear Dunes, 450-foot-high sandy bluffs tower over the lakeshore, providing views of the park's thirty-five miles of dunes as well as North and South Manitou Islands, just offshore. This dramatic scene was born of ice. During the last ice age, glaciers advancing south from Canada ground over the bedrock of the region, producing copious quantities of sand. After the ice retreated from the area around 12,000 years ago, huge piles of sand were left behind. Despite thousands of years of water and wind erosion, enough sand remains to create what are known as perched dunes on the cliffs above the waterline.

Just inland, separated from Lake Michigan by a sandbar, is bright blue Glen Lake, named one of

Sand left by the rock-crushing advance of ice age glaciers

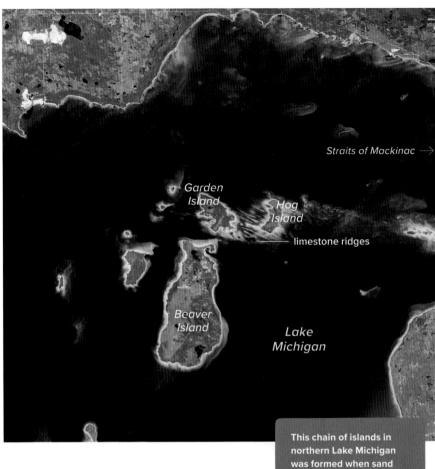

Straits of Mackinac →

Garden Island

Hog Island

limestone ridges

Beaver Island

Lake Michigan

This chain of islands in northern Lake Michigan was formed when sand and glacial debris were piled on top of ancient limestone bedrock. Sleeping Bear Dunes and the Manitou Islands are just south of this image.

the most beautiful lakes in the world by National Geographic. Glen Lake is actually two bodies of water, Big Glen and Little Glen, which are joined by a narrow channel. At one time, Glen Lake was connected to Lake Michigan, until shifting sands created a barrier between them. The constant movement of sands continues to reshape the lakes today: Little Glen is filling in with sand blown from the Sleeping Bear Dunes and measures only thirteen feet deep. It used to be about the same depth as Big Glen, which is deeper than a hundred feet.

Just offshore of Sleeping Bear Dunes lie the Manitou Islands, two dots in a chain of islands extending across northern Lake Michigan,

formed along tilted ridges of limestone bedrock that jut out from the depths of the lake. This limestone was laid down 500 million years ago, when the area was covered by a shallow sea. When the glaciers retreated, they left a blanket of sand and glacial debris piled on top of these limestone ridges, forming the island chain, which also includes Beaver, Hog, and Garden Islands.

The series of submerged limestone ridges create freshwater reefs that are ideal spawning grounds for fish, including endangered lake trout. The reefs also make for tricky navigation into and out of the Straits of Mackinac—the narrow waterway that connects Lake Michigan and Lake Huron and divides the upper and lower peninsulas of Michigan. This is one of the busiest shipping lanes on the Great Lakes and the Manitou Islands are surrounded by more than fifty shipwrecks, caused by vessels running aground on the limestone—or on other submerged wrecks. The South Manitou Island Lighthouse was built in 1858 to warn vessels away from the hidden rocky ridges. ■

FLIGHT PATTERN

You might fly over Sleeping Bear Dunes and the Lake Michigan islands en route to Green Bay, Wisconsin, on the west shore of Lake Michigan. The tall tan dunes stand out on the lakeshore, as do the two inland lakes. The island chain starts just offshore, stretching north and west.

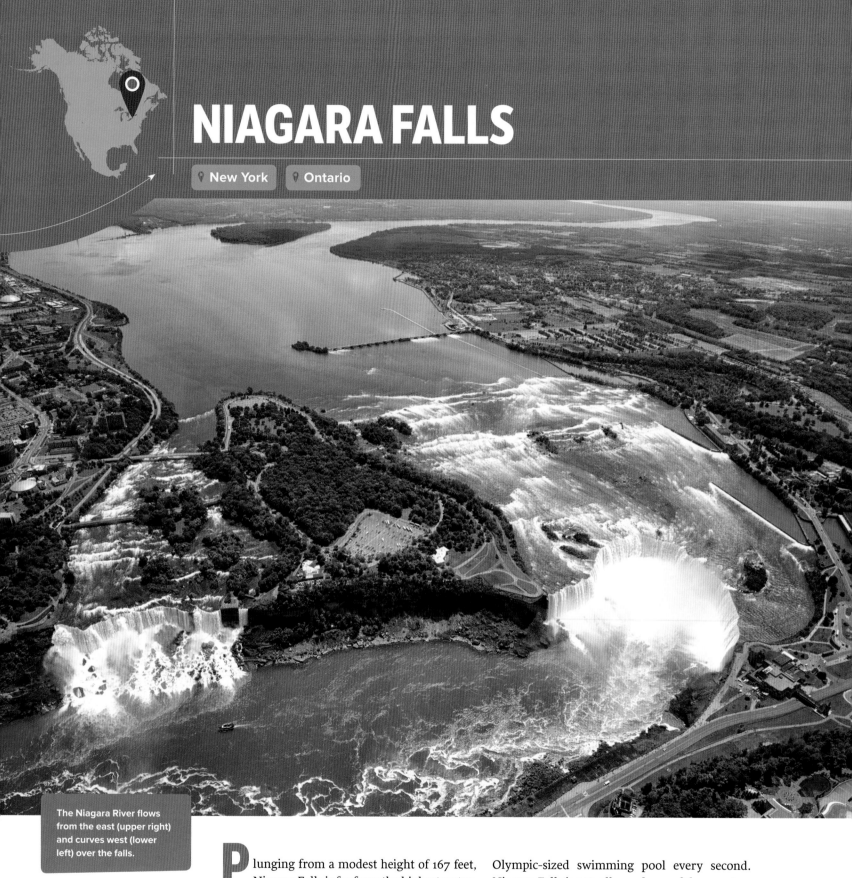

NIAGARA FALLS

📍 New York 📍 Ontario

The Niagara River flows from the east (upper right) and curves west (lower left) over the falls.

Plunging from a modest height of 167 feet, Niagara Falls is far from the highest waterfall in North America. But it is the most powerful—more than 4 million cubic feet of water a minute flow over the brink, enough to fill an Olympic-sized swimming pool every second. Niagara Falls is actually made up of three waterfalls: Horseshoe, American, and Bridal Veil, each separated by small islands. Horseshoe is the widest, at over 2500 feet, followed by American

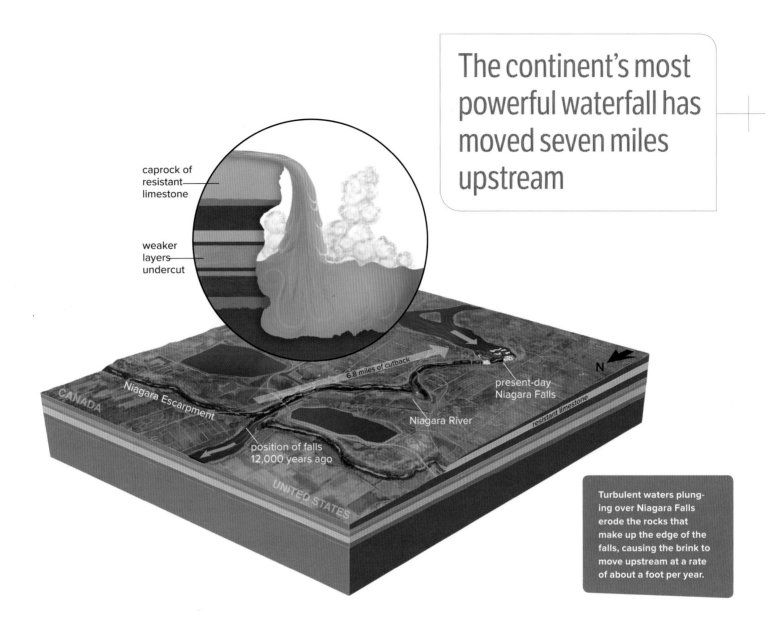

The continent's most powerful waterfall has moved seven miles upstream

caprock of resistant limestone

weaker layers undercut

6.8 miles of cutback

CANADA

Niagara Escarpment

position of falls 12,000 years ago

UNITED STATES

Niagara River

present-day Niagara Falls

resistant limestone

N

Turbulent waters plunging over Niagara Falls erode the rocks that make up the edge of the falls, causing the brink to move upstream at a rate of about a foot per year.

Falls (just over a thousand feet), and Bridal Veil (less than a hundred feet). The distance across all three falls is nearly three quarters of a mile.

From above, Niagara Falls is centered in the land bridge between Lakes Erie and Ontario, on the Niagara River just downstream from where the river reconverges after splitting around Grand Island. The United States–Canadian border actually runs through the west passage of the split river (the Chippawa Channel). At Niagara Falls, the international border is drawn somewhere under Horseshoe Falls; Horseshoe is on the Canadian side and American and Bridal Veil are on the U.S. side, although erosion blurs the exact line.

The Niagara River drains Lake Erie into Lake Ontario, and Niagara Falls, on the Niagara River, is a product of the last ice age. Around 14,000 years ago, at the end of the Wisconsin Glacial Episode (the last major glaciation in North America), the Great Lakes were just beginning to take shape as the ice sheets receded, leaving behind massive quantities of meltwater that filled up the basins we now know as the Great Lakes.

As freshwater from the lakes makes its way to the Atlantic Ocean, it plunges over the Niagara Escarpment, a caprock of dolomitic limestone running in an arc through the Great Lakes from Lake Michigan to Lake Ontario. This limestone

FLIGHT PATTERN

Niagara Falls may be visible en route to Rochester, New York, or Toronto, Ontario.

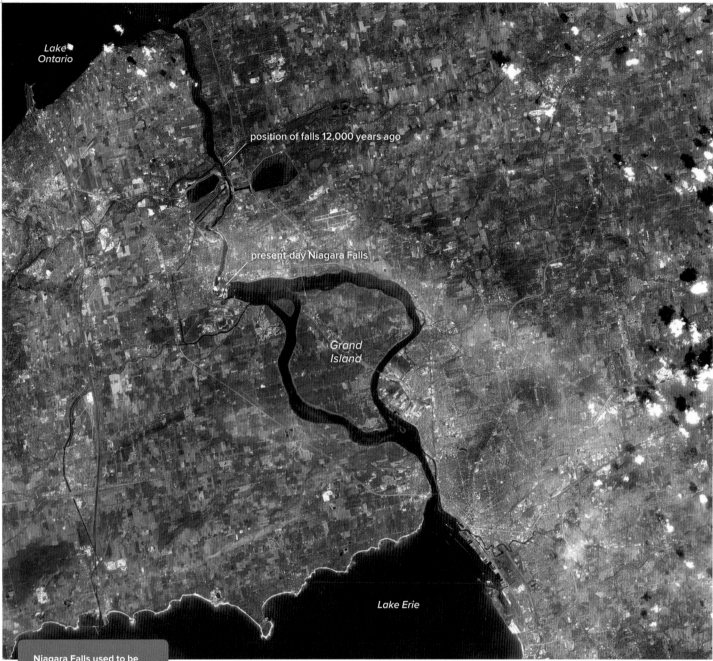

Lake Ontario

position of falls 12,000 years ago

present-day Niagara Falls

Grand Island

Lake Erie

Niagara Falls used to be nearly seven miles closer to Lake Ontario. Over the past 12,000 years, it has retreated upstream to its current position as a result of water erosion.

was deposited in the Ordovician and Silurian Periods, starting around 480 million years ago, when much of the globe was dominated by tropical seas. Several waterfalls drop over the north-facing Niagara Escarpment along its 450-mile length, but Niagara Falls is the largest and most famous.

From the air, it may be possible to see where Niagara Falls was originally located. It first formed nearly seven miles downstream from its current site, between present-day Queenstown, Ontario, and Lewiston, New York. Because of the falls' tremendous erosive power, the brink has retreated upstream as the force of the cascading water erodes the rock of the escarpment. The shape of the falls has also changed dramatically, evolving from a small arch, to a horseshoe shape, to the large V seen today.

Erosion continues to define Niagara Falls, cutting the ledge back at a rate of a foot per year. The falls' greenish hue is caused by very finely ground rock flour, produced at a rate of sixty tons per minute by the Niagara River. Over the next 50,000 years, the falls will continue to migrate upstream, eroding Grand Island, and whatever is left of a brink will eventually fall into Lake Erie. ■

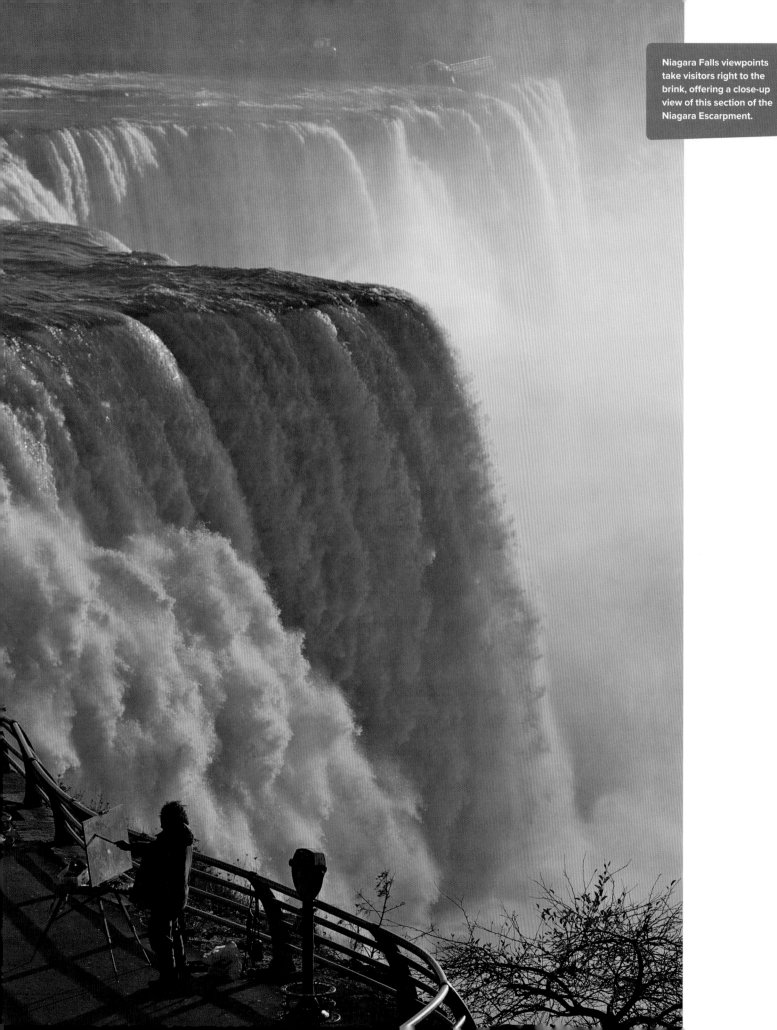

Niagara Falls viewpoints take visitors right to the brink, offering a close-up view of this section of the Niagara Escarpment.

FINGER LAKES

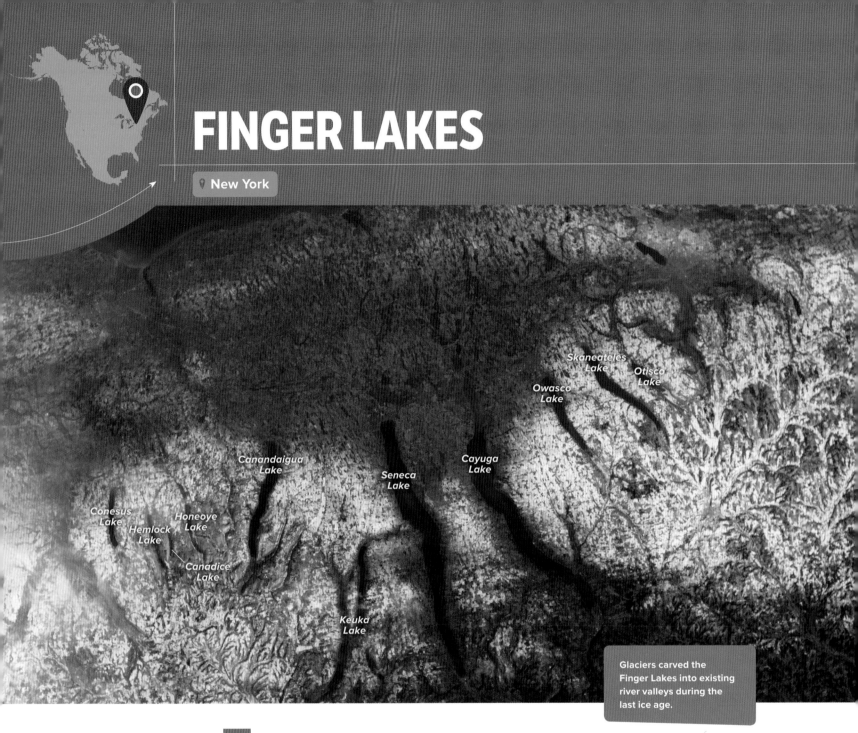

Skaneateles Lake

Otisco Lake

Owasco Lake

Canandaigua Lake

Cayuga Lake

Seneca Lake

Conesus Lake

Hemlock Lake

Honeoye Lake

Canadice Lake

Keuka Lake

Glaciers carved the Finger Lakes into existing river valleys during the last ice age.

FLIGHT PATTERN

Look for eleven elongated lakes oriented north and south on some flights to Rochester, Syracuse, or Albany, New York.

The Finger Lakes in western New York State are aptly named relics from the last ice age—a set of eleven long, glacially carved lakes running parallel to each other, like the fingers on a polydactyl hand. The lakes—from west to east, Conesus, Hemlock, Canadice, Honeoye, Canandaigua, Keuka, Seneca, Cayuga, Owasco, Skaneateles, and Otisco—can be seen just south of Lake Ontario from an aerial viewpoint.

These elongated lakes began as north-flowing rivers. Then, around 2 million years ago, massive glaciers began moving southward from the Hudson Bay area, engulfing the region in ice. As the glaciers moved south, they followed existing river valleys, carving them much deeper. Glaciation peaked around 20,000 years ago, when all of New York state was under ice, before the glaciers started retreating around 19,000 years ago, finally disappearing from this area around 11,500 years ago.

Today the Finger Lakes are among the deepest lakes in North America. The largest, Seneca Lake, is thirty-eight miles long with a maximum depth over 600 feet—so deep, it sits in bedrock below sea level. The Finger Lakes are fed mainly

Eleven glacially carved lakes that never freeze

During the last ice age, glacial ice covered much of Canada and New England, dipping in a curve south of the Great Lakes region and helping form the Finger Lakes.

by underground springs, which replenish the lakes at incredible rates: 328,000 gallons flow into Seneca per minute. The constant influx circulates the water and keeps it from freezing over, even in the harshest winters. These large bodies of water create a milder surrounding microclimate, and the region is famous for its wineries; several dozen line lakeshores along three Finger Lakes wine trails.

The geology of the Finger Lakes has recently led to local ecological concerns. The region sits atop the Marcellus and Utica Shales, both of which harbor significant reserves of natural gas. These rocks were laid down 400 million years ago, during the Devonian Period, when the area was covered by a warm, shallow sea. Such layers are rich in natural gas, thanks to the marine fossils that decomposed here. However, gas is extracted through hydraulic fracturing, or fracking, which involves injecting highly pressured fluids deep underground to liberate the natural gas. Fracking's large footprint and potential for contaminating groundwater aquifers—such as the many underground springs that feed the Finger Lakes—make it highly controversial. Several local anti-fracking organizations are working to keep the practice out of the Finger Lakes region. ▥

Seneca Lake is the largest of the eleven Finger Lakes.

ADIRONDACK MOUNTAINS

📍 New York

The view from the top of Panther Peak, in the High Peaks Wilderness, near the center of the Adirondack Mountains dome.

Most of North America's mountain ranges run north and south, with a few oriented east and west. But the Adirondack Mountains in upstate New York have a unique geometry. Seen from the air, the range is shaped like a circular dome, 160 miles in diameter and about a mile high. Mountain ranges usually form along plate boundaries, as the result of collisions, extensional stresses, or volcanic activity. But the Adirondacks were uplifted by entirely different forces working deep in Earth's mantle.

The rocks that make up the Adirondacks are among the oldest on the planet. Dating back as many as 2 billion years, to the Precambrian Era,

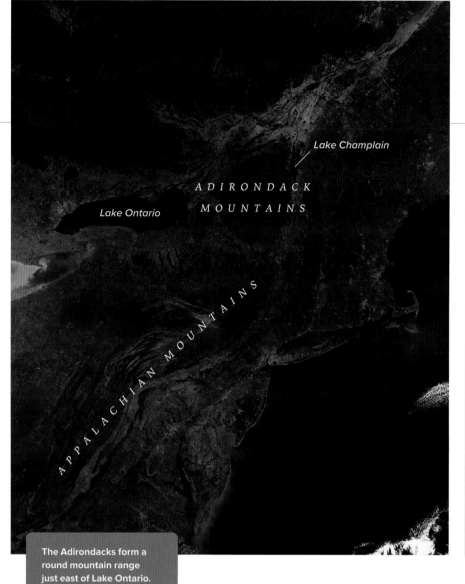

Lake Champlain

ADIRONDACK MOUNTAINS

Lake Ontario

APPALACHIAN MOUNTAINS

The Adirondacks form a round mountain range just east of Lake Ontario. Lake Champlain is visible on the northeast corner of the range.

Rare dome-shaped mountain range harbors some of the planet's oldest rocks

Canoeing is popular on the many lakes of the Adirondack Mountains.

these rocks were originally laid down as fine sediments at the bottom of an ancient sea. At the time, this sea was located near the equator and the sedimentary rocks were likely once rich in fossils from the earliest life-forms.

As the first continents began to form and move into new positions via plate tectonics, the precursor continent to North America (Laurentia) collided with the oceanic plate underlying the seafloor sediments. The heat and pressure generated by this collision changed the sedimentary rocks into metamorphic rocks, erasing most of the ancient fossils in the process. Around 10 million years ago, hundreds of millions of years after the Appalachian

Mountains had formed, the seafloor rocks that make up the Adirondacks began to be uplifted into a dome shape. The driving force of this uplift is not well understood, but some geologists think it's the result of a hot spot deep in Earth's mantle.

So far, the dome has been uplifted nearly 7000 feet and continues to rise about two millimeters per year. Earthquake swarms up to magnitude 5 tend to strike around Blue Mountain Lake—one of the region's many lakes—located near the center of the dome, suggesting these uplifting forces are centrally located and still active. This unique source of uplift means the Adirondack Mountains are wholly separate from the Appalachian Mountains geologically, even though the two are close neighbors. ▪

FLIGHT PATTERN

You might fly over the Adirondacks on your way to Portland, Maine; Boston, Massachusetts; or New York City. Look for a circular mountain range to the north and west of the elongated Appalachian range.

CAPE COD

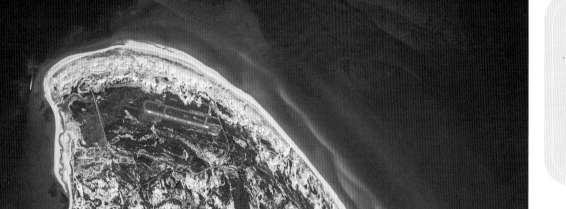

FLIGHT PATTERN

On flights to Boston, Massachusetts, or New York City, look for a long spit of land shaped like a bent arm with a flexed fist.

Primitive shacks can be found throughout the shifting sand dunes of Cape Cod National Seashore. Many of these historic structures were originally used as warming stations for Coast Guard members on patrol.

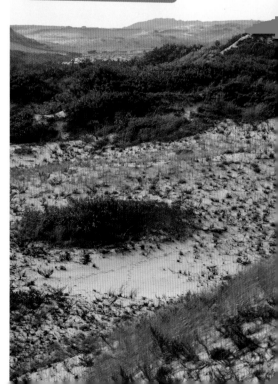

Provincetown, Massachusetts, is located at the tip of Cape Cod, which is constantly being swept west and south by wave action, forming the hook shape.

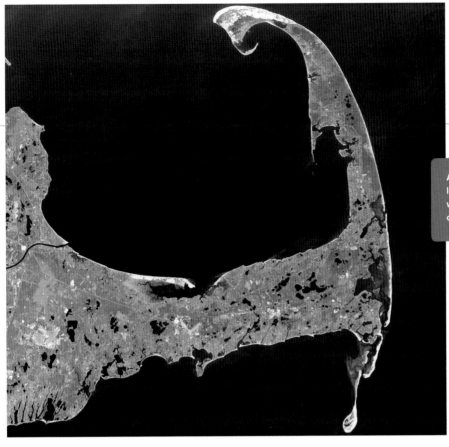

At sixty-five miles in length, Cape Cod is the world's longest glacially carved peninsula.

Built by an ice sheet's repeated advances and retreats

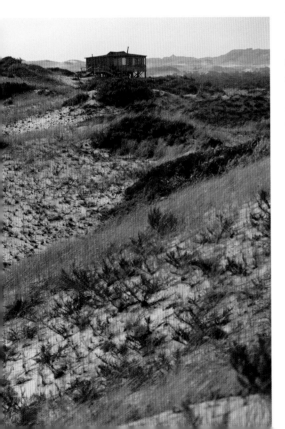

Jutting out into the Atlantic Ocean like a boxer's arm flexed for a blow, Cape Cod is among the most distinctive landforms on the East Coast. This sandy peninsula, a famous summer beach retreat, was built by ice. During the last ice age, the Laurentide Ice Sheet advanced and retreated across New England numerous times, leaving a legacy of huge boulders, shallow ponds, rocky moraines—and Cape Cod.

Around 23,000 years ago, the Laurentide Ice Sheet reached its maximum southward extent, dipping down from Canada across the eastern United States in a frozen arc that stretched from New York City to Chicago. As the climate began warming, the ice sheet retreated north and by 18,000 years ago, the landform that would become Cape Cod was revealed. At the time, sea levels were much lower than they are today and the peninsula was much larger, without its distinctive shape. Over time, rising sea levels and erosion have produced the familiar upraised fist we see today.

Clues to the cape's glacial past can be found all over the peninsula. The entire landform follows the outline of a terminal moraine, a collection of rocks and debris carried to the end of a glacier and deposited as the glacier melts and retreats. House-sized boulders called glacial erratics can be found throughout the cape, carried by moving ice and dropped in place when the ice melted.

The peninsula is also riddled with shallow pools or kettle ponds, created when chunks of ice left behind by the retreating glacier were buried by sediments, which insulated the blocks and kept them intact for hundreds or thousands of years. After the chunks of ice finally melted, the sediments slumped into the holes, which filled with water to become kettle ponds. Wild cranberries and many of the cranberry farms found on Cape Cod and throughout Massachusetts thrive in these kettle ponds, also known as bogs.

Cape Cod is famous for its summer crowds, which descend upon Provincetown (at the tip of the peninsula) by the millions. But while developed parts of the cape are densely packed on summer weekends, quiet spots can still be found in the rolling sand dunes of Cape Cod National Seashore. Visitors should enjoy this area while they can. Geologists estimate that the peninsula will disappear altogether in a few thousand years, as sea levels continue to rise. ∎

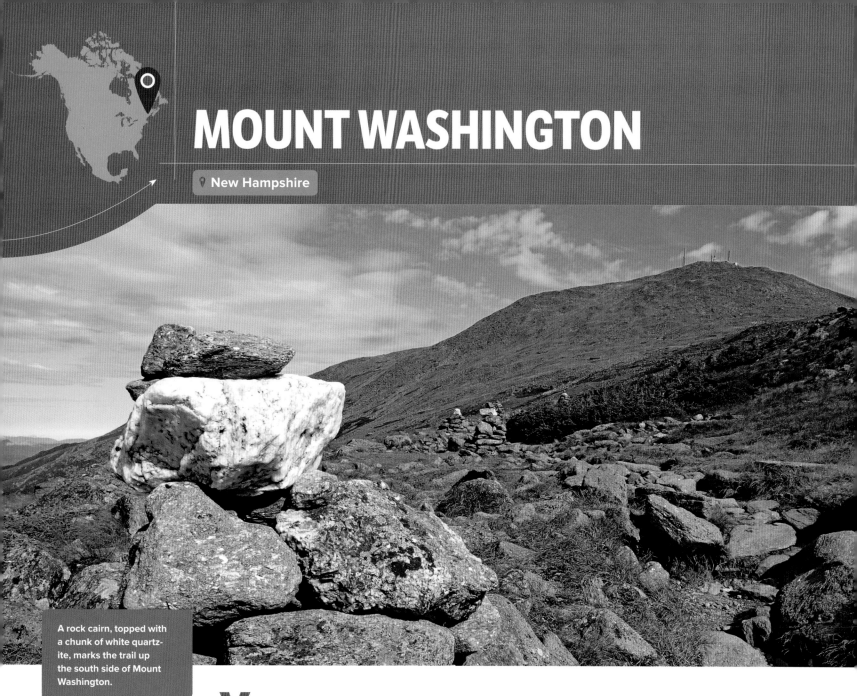

MOUNT WASHINGTON

A rock cairn, topped with a chunk of white quartzite, marks the trail up the south side of Mount Washington.

FLIGHT PATTERN

You might catch a glimpse of Mount Washington on a flight to Montpelier, Vermont, or Portland, Maine. Look for the auto road running to the summit.

You might think the worst weather on Earth would be found at one of the two poles, or on top of a towering Himalayan peak. But some of the most brutal wind speeds ever recorded were measured on a peak in New Hampshire's Presidential Range—Mount Washington, the highest point in New England.

From above, Mount Washington is most easily identified by the weather station on the summit. Howling winds and arctic temperatures recorded at this station are a result of geographical quirks, as several storm tracks converge on the mountain. The north-south orientation of the Presidential Range serves as a barrier to winds blowing in from the west, while the coastline of Maine, located less than a hundred miles to the east, tends to generate low-pressure zones that suck storm systems from west to east, creating severe turbulence over the peak. The result: hurricane-force wind gusts, often accompanied by low temperatures, recorded on the summit more than a hundred days each year.

Mount Washington hasn't always been so frigid. Around 600 million years ago, the rocks that make up the mountain were laid down in tropical seas, near the equator. These sedimentary rocks, mostly sandstone and shale, were later compressed by mountain-building events into quartzite and schist—the rocks found on the summit

New England's highest peak attracts some of the planet's most extreme weather

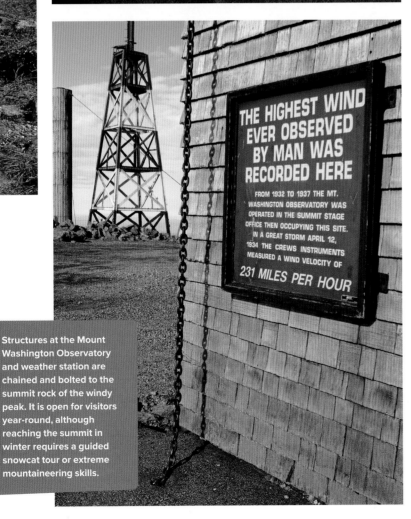

Mount Washington, the highest peak in New Hampshire's Presidential Range, attracts some of the most extreme weather on the planet due to converging weather patterns.

THE HIGHEST WIND EVER OBSERVED BY MAN WAS RECORDED HERE

FROM 1932 TO 1937 THE MT. WASHINGTON OBSERVATORY WAS OPERATED IN THE SUMMIT STAGE OFFICE THEN OCCUPYING THIS SITE. IN A GREAT STORM APRIL 12, 1934 THE CREWS INSTRUMENTS MEASURED A WIND VELOCITY OF

231 MILES PER HOUR

Structures at the Mount Washington Observatory and weather station are chained and bolted to the summit rock of the windy peak. It is open for visitors year-round, although reaching the summit in winter requires a guided snowcat tour or extreme mountaineering skills.

today. These exceptionally hard rocks don't erode easily and their stubbornness has helped shape Mount Washington into the fierce heart of the Presidential Range, at 6289 feet.

Mount Washington's wicked weather has been notorious since 1870, when the first primitive instruments were installed on the summit. In 1932, the world's first mountain weather observatory, the Mount Washington Observatory, was built here to house more sophisticated instruments for weather and storm research. The building was designed to withstand 300-mile-per-hour winds, and everything that couldn't be directly anchored to the bedrock was chained to the mountain.

On April 12, 1934, the world record wind speed was recorded on the summit: 231 miles per hour. This still stands as the world record for the Northern and Western Hemispheres, but in 1996 Tropical Cyclone Olivia produced wind gusts up to 253 miles per hour off the coast of Western Australia. Mount Washington also receives around a hundred inches of precipitation a year, with around 300 inches of snow falling in the winter. Temperatures regularly fall well below zero; the wind chill value sometimes reaches a hundred degrees below zero.

The Mount Washington Auto Road is usually open to passenger cars from late May into October, before being closed to the public because of snow. In the winter, the weather station is manned by an extremely hardy team of scientists, who must stay inside the building or risk being blown off the mountain by high winds. Numerous hiking trails, including the Appalachian Trail, run over the summit. Ski mountaineers and ice climbers sometimes scale the mountain in winter via the steep and icy Tuckerman Ravine. Since 1849, more than 150 people have died on trails and slopes around Mount Washington, most from falls and exposure in severe weather. ■

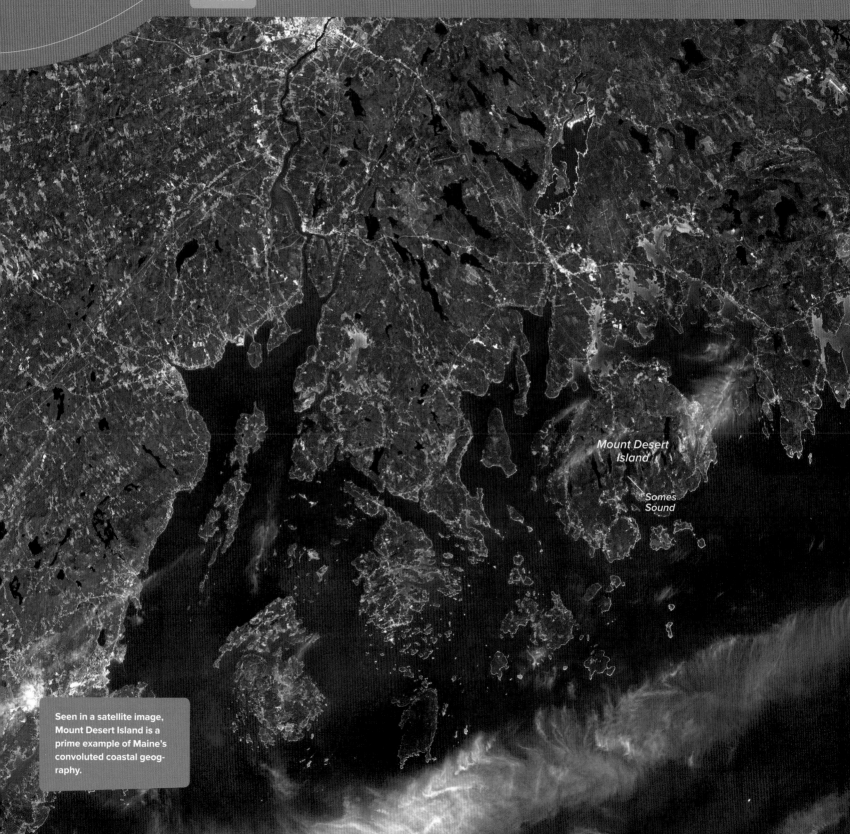

COAST OF MAINE

📍 Maine

Mount Desert
Island

Somes
Sound

Seen in a satellite image,
Mount Desert Island is a
prime example of Maine's
convoluted coastal geog-
raphy.

3478 twisting miles shaped by erosion over billions of years

Quick! Which state has a longer coastline: California or Maine? If you measure just oceanfront and exclude tidal inlets, the answer is California, with 840 miles to Maine's 228. But if you include inlets, Maine rockets to the lead with 3478 miles of coast. That's a lot of inlets.

Aerial photographs of Maine show how convoluted the coast really is. The mainland swoops in and out of deeply carved tidal waterways, separated by high, rocky bluffs, with a bevy of offshore islands sprinkled along the North Atlantic Ocean. This complicated seascape required billions of years of erosion to shape the coastline into the jagged puzzle of peninsulas and islands we see today.

A scenic and spectacular part of Maine's coast is Acadia National Park, the state's only national park, on Mount Desert Island, a rocky bulge of land divided into two lobes by a deep fjord-like inlet called Somes Sound. With its tall granite cliffs, thriving tide pools, and still-wild landscapes, Acadia was a prime choice to become the first national park east of the Mississippi, in 1919. The park covers about half of Mount Desert Island.

The rock underlying Mount Desert Island dates back 550 million years, when mud and volcanic layers accumulated on an ancient seafloor around the time the first complex life was evolving on Earth. Soon afterward, during the Silurian Period, the Acadian orogeny uplifted these sediments and metamorphosed them into schist. During the Devonian Period, around 400 million years ago, mountain-building activity gave rise to three types of granite on Mount Desert Island: Cadillac Mountain granite, fine-grained Somesville granite, and medium-grained Somesville granite, which have long been quarried throughout the region.

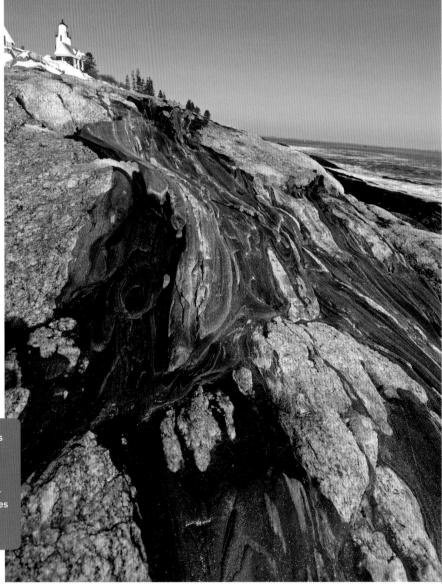

More than fifty lighthouses cover rugged coastal Maine, including this one at Pemaquid Point, where swirls of ancient metamorphic rocks and granite dikes have been sculpted and polished by wave action.

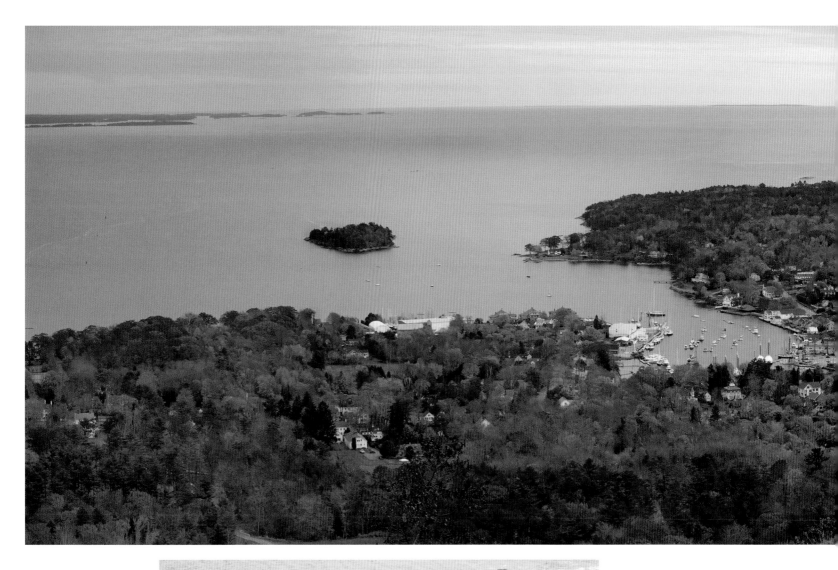

A vertical dike of 200-million-year-old black basalt intrudes between jagged blocks of 500-million-year-old metamorphic rocks at the Giant's Stairway, near Harpswell, Maine.

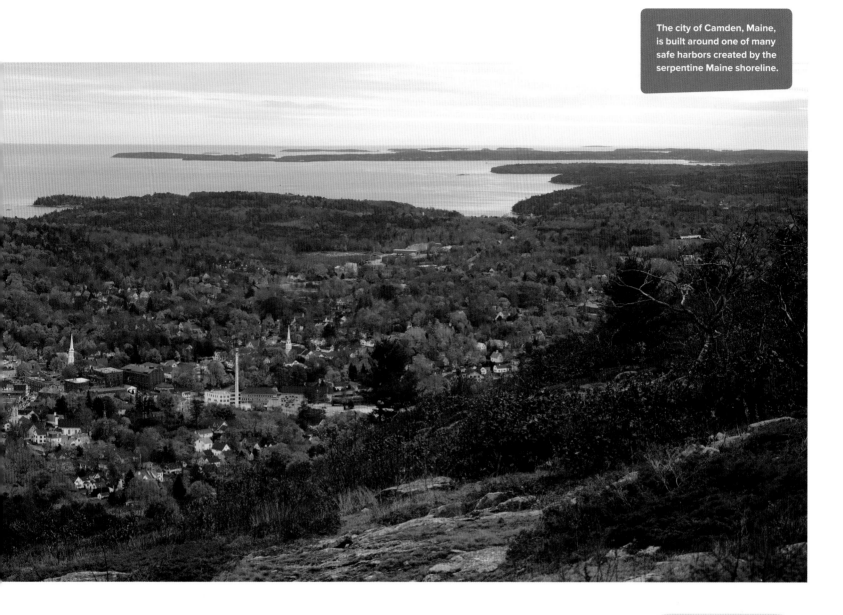

Then, during the last ice age, the Laurentide Ice Sheet buried the coast of Maine under many feet of ice. The weight of all that ice scraped and gouged the coast into myriad inlets and islands. Evidence of the area's glacial past can be seen most dramatically at Bubble Rock, a giant boulder carried by a glacier and deposited precariously on the side of South Bubble Mountain on Mount Desert Island.

After the ice melted, the weight of all that ice lifting off the land led to significant post-glacial rebound, or rising, of the North American continent, including the coast of Maine. At times in the past, the rate of land rebound was faster than the rate of sea level rise, effectively mitigating the effects of rising sea levels that changed coastlines all over the world after the last ice age. This isostatic rebound is ongoing, uplifting the sea cliffs, headwalls, peninsulas, and islands, though the rate today is minuscule compared to the rate of sea level rise. ▮

FLIGHT PATTERN

You could fly over the coast of Maine en route to Portland, Maine, or Saint John, New Brunswick. Look for a complicated coastline of inlets, peninsulas, and islands stretching from Casco Bay near Portland, Maine, north into Canada.

BAY OF FUNDY

📍 New Brunswick 📍 Nova Scotia

NEW BRUNSWICK

see
tide
insets

Bay of Fundy

NOVA SCOTIA

ATLANTIC

OCEAN

The Bay of Fundy sits inside
a failed rift between the
mainland and Nova Scotia.

Extreme tides rise and drop nearly fifty feet every six hours

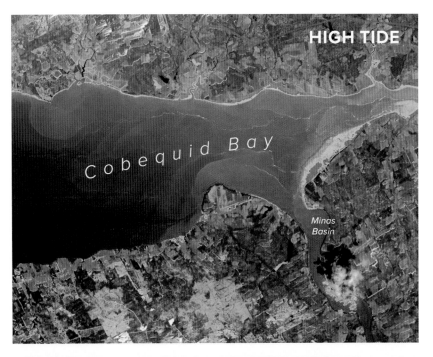

HIGH TIDE

Cobequid Bay

Minas Basin

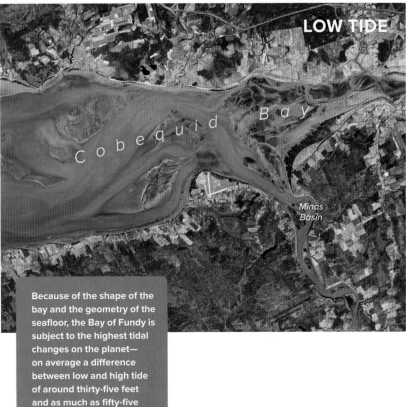

LOW TIDE

Cobequid Bay

Minas Basin

Because of the shape of the bay and the geometry of the seafloor, the Bay of Fundy is subject to the highest tidal changes on the planet— on average a difference between low and high tide of around thirty-five feet and as much as fifty-five feet in Minas Basin.

The greatest tides in the world occur in the Bay of Fundy, the strip of water between New Brunswick and Nova Scotia on the east coast of Canada. From the air, look for a rectangular body of water between the mainland and the lower lobe of Nova Scotia, with the Canadian Maritimes to the north.

The bay sits inside a failed rift, where a spreading ridge was once attempting to open a new ocean basin between mainland North America and Nova Scotia. The result was more of a depression than an ocean: the Fundy Basin, formed around 220 million years ago, as the supercontinent Pangaea was beginning to break up. Rifting produced volcanic activity and an outpouring of flood basalts, which formed the North Mountain volcanic ridge, still visible along the eastern side of the bay. At some point after North Mountain formed, volcanic activity ceased and the rift is now considered inactive.

From above, you'll be able to see two smaller basins within the Fundy Basin, toward the northern end of the bay. Here the Bay of Fundy splits into Chignecto Bay to the northeast and the Minas Basin to the east. The highest tides ever recorded in the Bay of Fundy occurred at the head of Minas Basin in October 1869 during the Saxby Gale, a tropical cyclone. The record high-water level of seventy-one feet—taller than a seven-story building—was the result of a perfect storm combination of high winds, low atmospheric pressure, and high spring tides.

As the planet spins, its oceans slosh in clockwork with the gravitational pull of the moon, generating tides. Tides are a powerful force involving global-scale movements of water. They are generally stronger toward the North Pole because of the tight configuration of continents. The extreme tides in the Bay of Fundy—which rise and lower by nearly fifty feet every six hours—are

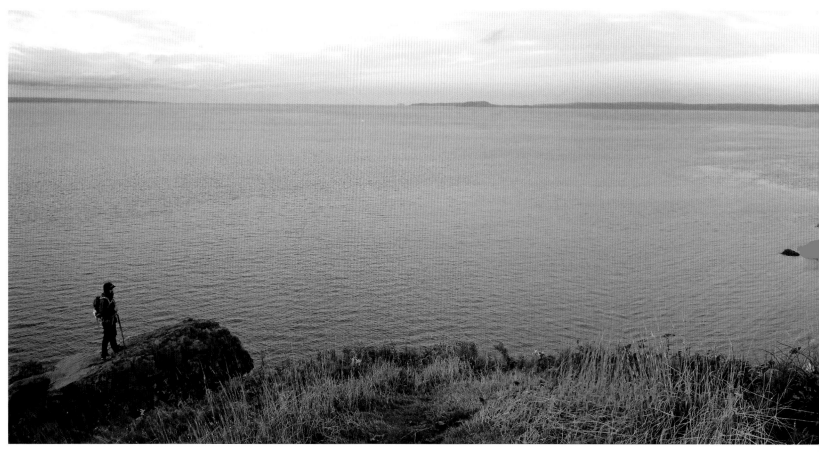

During low tide, ships sit in the mud at the docks in Alma, New Brunswick (left), which borders the Bay of Fundy. At high tide in the same spot (right), fishermen have a window of time to come and go.

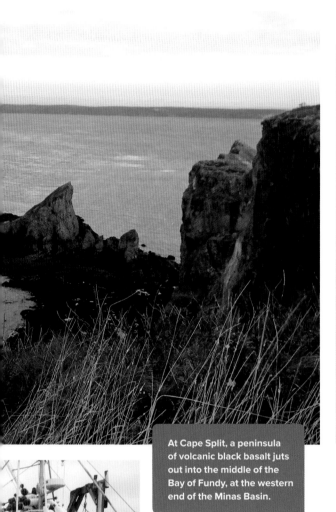

At Cape Split, a peninsula of volcanic black basalt juts out into the middle of the Bay of Fundy, at the western end of the Minas Basin.

The Bay of Fundy boasts the most extreme tidal changes in the world. Storms can make such changes more than seventy feet.

NEW BRUNSWICK

Moncton

Fredericton

Northumberland Strait

Chignecto Bay

FUNDY NAT'L PARK

Amherst

42ft

39ft

see tide inset

48ft

Truro

Passamaquoddy Bay

Saint John

39ft

42ft

45ft

Cobequid Bay

Calais

36ft

MAINE (U.S.)

33ft

Windsor

30ft

27ft

NOVA SCOTIA

Halifax

24ft

Digby

Grand Manan Island

21ft

KEJIMKUJIK NAT'L PARK

Atlantic Ocean

18ft

St. Mary's Bay

0 20km
0 20mi

Liverpool

Yarmouth

amplified by the shape and bathymetry of the bay and a unique quirk of timing: the time it takes for a wave to travel from the mouth of the bay to the inner shore and back out again is nearly equal to the time from one high tide to the next. This coincidence greatly amplifies tidal changes in the bay. Fundy's extreme tides are semidiurnal, with two high tides and two low tides each day; around six hours and thirteen minutes elapse between each high and low tide. During the twelve-hour tidal period, 115 billion tons of water flow in and out of the bay. ■

FLIGHT PATTERN

Flights to Saint John, New Brunswick, or Portland, Maine, could fly over the Bay of Fundy.

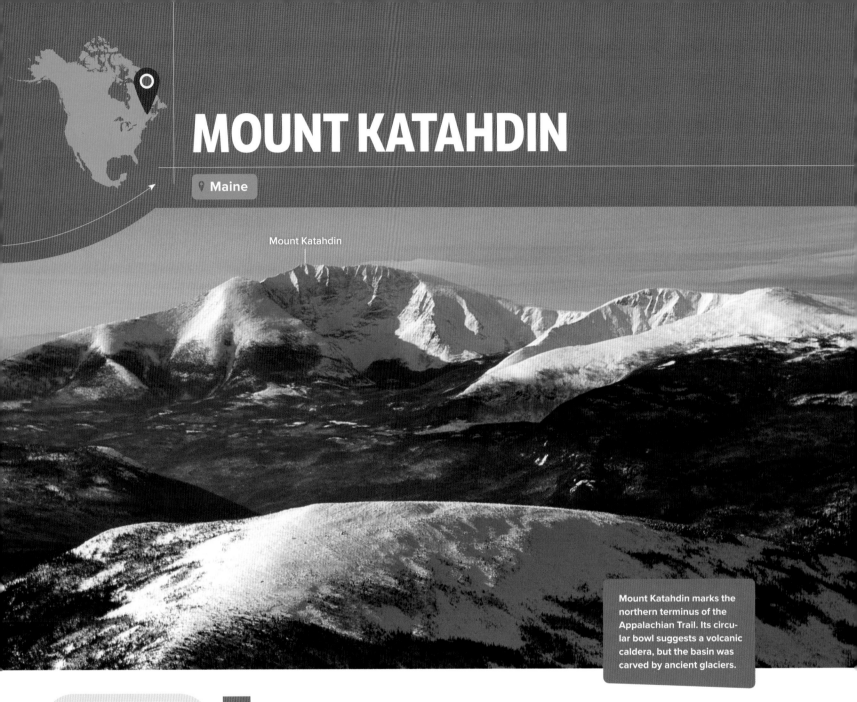

MOUNT KATAHDIN

📍 Maine

Mount Katahdin

Mount Katahdin marks the northern terminus of the Appalachian Trail. Its circular bowl suggests a volcanic caldera, but the basin was carved by ancient glaciers.

FLIGHT PATTERN

You might fly over Katahdin on a trip to Portland or Bangor, Maine; Quebec City, Quebec; or Saint John, New Brunswick. Look for a bright gray horseshoe-shaped mountain with a knife-edge ridge running east and west to the high point.

The Appalachian Trail runs for 2180 miles, from the rolling foothills of Georgia to its craggy finish in north central Maine, where the much-heralded northern terminus of the trail, Mount Katahdin, serves as a fitting bookend for North America's oldest footpath.

From an aerial perspective, Katahdin appears as a horseshoe, with the open end facing to the northeast. It has five main subpeaks: Baxter (the highest point), Hamlin, Howe (two summits), Pamola, and South Peaks. Mount Katahdin's most famously hair-raising feature is the Knife Edge, a narrow trail that follows the ridge between Pamola and Baxter Peaks. For about a quarter

mile, the trail is only three feet wide, with deadly drop-offs on both sides. Falls and exposure on this part of the Appalachian Trail have claimed most of the nineteen lives lost here since the 1960s. Officials at Baxter State Park, who manage Mount Katahdin's trails, frequently close this section in high winds and wet weather.

Geologically speaking, Mount Katahdin is decidedly different from most other eastern mountains of the continent. The Appalachians are a mishmash of sedimentary and metamorphic rocks that were uplifted into mountains in three separate mountain-building events between 480 and 250 million years ago. Mount Katahdin,

Shaped like a caldera but not volcanic, a mountain basin carved by glaciation

however, is a granite intrusion. Granite is volcanic rock that erupts underground, where it cools slowly, allowing time for large crystals to form. This crystalline matrix makes for a very hard rock that is highly resistant to erosion. Over time, the granite of Mount Katahdin was exposed above the surface.

Katahdin's circular bowl resembles a caldera, leading many to surmise it was once a volcano. But the bowl shape was carved by glacial action during the Pleistocene Epoch, when extensive glaciers covered northern North America. The granite formation of Mount Katahdin is surrounded by softer sedimentary rock that was easily eroded by episodes of glaciation, leaving the formation standing alone in the landscape. Rising to 5267 feet, it is the tallest mountain in Maine.

The name Katahdin means "the greatest mountain" in the language of the Penobscot Nation, who revere the mountain but also fear it, believing it to be the home of the cold-weather storm god Pamola (namesake of Pamola Peak). Pamola has the head of a moose, the body of a man, and the wings and feet of an eagle. Hiking to the summit of Katahdin has long been considered taboo by the Penobscot people, but each year, thousands of visitors make the trek, including some 1000 hikers who either start or end their successful Appalachian Trail hike on the summit of this greatest mountain. ▪

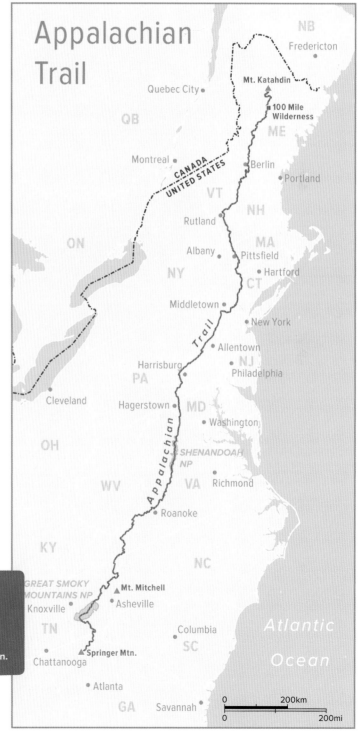

The Appalachian Trail follows the crest of the Appalachian Mountains through fourteen states from Georgia to Maine, ending at Mount Katahdin.

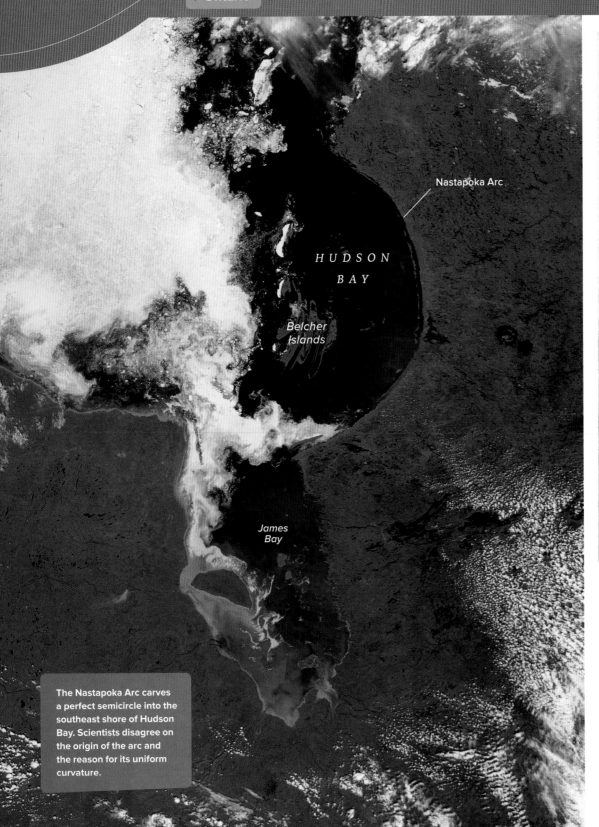

HUDSON BAY & NASTAPOKA ARC

📍 Ontario

Nastapoka Arc

HUDSON BAY

Belcher Islands

James Bay

The Nastapoka Arc carves a perfect semicircle into the southeast shore of Hudson Bay. Scientists disagree on the origin of the arc and the reason for its uniform curvature.

Winter holds Hudson Bay in an icy grip for much of the year.

Earth's second-largest bay harbors a mystery

The final days of Henry Hudson are a Hudson Bay mystery, as is the odd shape of the Nastapoka Arc, a stunningly visible arc forming a portion of the bay's shore. Seen from above, Hudson Bay is a vast inland waterway in northeastern Canada; the Nastapoka Arc is a uniformly curving coastline in the bay's southeastern corner. Nastapoka's nearly perfect semicircle covers 160 degrees of a 280-mile-wide circle about the size of Wisconsin.

Hudson Bay is the world's second-largest bay (after the Bay of Bengal in the Indian Ocean), draining the watersheds of much of central Canada and parts of the northern United States. With its high northern latitude, the bay is iced over for about half the year—from mid-December to mid-June—and the huge expanse of ice is prime seal-hunting grounds for a large population of polar bears. But from a geological standpoint, the Nastapoka Arc is perhaps Hudson Bay's most compelling element. Because of its smooth shape, the arc was long thought to be the remnants of an impact crater from a meteorite strike. The Belcher Islands seen in the middle of the arc were considered the remains of the raised, central high point of the crater. However, a 1972 study found no evidence of the shocked rocks, radial fractures, or other melted rocks that would back up the impact theory.

Instead, many scientists today ascribe the unusual geometry of the Nastapoka Arc to plate tectonics, with the curved boundary possibly having been created during a mountain-building episode that took place around 2 billion years ago. This time of mountain building also gave rise to the basement rocks known as the North American Craton, the precursor of what would become the North American continent. Some scientists still doubt the theory, however, as this would be the only known example of a perfectly curved tectonic boundary on Earth.

Hudson Bay is named for Sir Henry Hudson, who explored the bay in 1610 on his ship *Discovery*, in search of the mythical Northwest Passage from Europe to Asia. Hudson did not know that while the bay is salt water, it is significantly less salty than ocean water and therefore ices over earlier in the year than the Atlantic Ocean. Much to its crew's dismay, the *Discovery* became trapped in ice and was forced to spend the miserably cold winter of 1611 on the shore of James Bay, the southern arm of Hudson Bay. When the ice melted in late June, a determined Hudson proposed continuing the mission west to find a route to China. The exhausted crew mutinied and put Hudson, his son, and seven supporters adrift on a small boat, then set sail back to England. Hudson was never seen again; he presumably died not long after being abandoned. ∎

FLIGHT PATTERN

Some flights from the eastern United States to Europe fly over northern Canada and the Arctic, offering views of Hudson Bay, but there are no commercial airports near the bay itself.

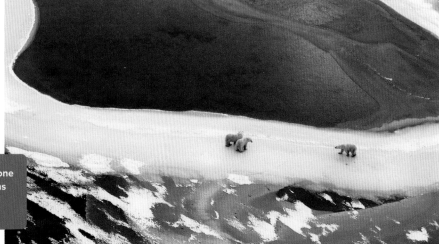

Hudson Bay is home to one of the largest populations of polar bears on the planet.

LAKE MANICOUAGAN

Lake Manicouagan, nick-named the Eye of Quebec, is classified as an annular lake: a circular lake created by meteorite impact.

FLIGHT PATTERN

You might fly over Lake Manicouagan en route to Quebec City, Quebec, but the reservoir is more than 300 miles north of the closest major airport.

Quebec seems to be a target for extraterrestrial objects, as the lake-studded landscape is home to at least two craters created by meteorite impacts. But viewed from above, Lake Manicouagan in central Quebec is ring-shaped, with an outer circle of water enclosing a raised central island, while the Pingualuit Crater, far to the north, is almost perfectly round. The different shapes of the lakes are a factor of age: Lake Manicouagan is 214 million years old, while the Pingualuit Crater is around 1.4 million years old. Two hundred million additional years of erosion have shaped the Manicouagan impact crater into a very different kind of scar, exposing the deepest structures of the impact ring.

The meteorite that created the Lake Manicouagan crater is estimated to have had a diameter of around three miles, originally punching a hole in the planet's surface more than sixty miles across, accompanied by a shock wave that roared outward at 600 miles per hour. Erosion has smudged the edges of this original ring down to the forty-mile-wide crater we can see today from altitude—a ring-shaped lake fed and drained by tendrils of rivers to the north and south. Still, this is the sixth-largest visible impact crater on Earth, and even larger rings from the event may have been erased altogether by erosion. Lake Manicouagan is classified as an annular lake: a circular lake created by a meteorite impact. Its distinctive shape inspired its nickname, the Eye of Quebec.

Because the Lake Manicouagan crater dates to the early Triassic Period, scientists had long wondered whether the impact could have played a role in the extinction event between the Triassic and the Jurassic Periods, when nearly half of all life-forms on Earth disappeared from the fossil record. More accurate dating methods, however, have shown the impact took place about 12 million years before the major waves of extinctions, making it unlikely that this impact was the smoking gun.

The creation of the Manicouagan Reservoir in the 1960s, involving the flooding of Lake Manicouagan and building of a dam and a series of hydroelectric plants, further altered the lake. With a volume of thirty-three cubic miles, Manicouagan Reservoir is the fifth-largest manmade reservoir in the world by volume. Hydroelectric power produced here is used to power whole regions of Quebec and New England. ■

The planet's sixth-biggest impact crater: a coffee ring–shaped lake

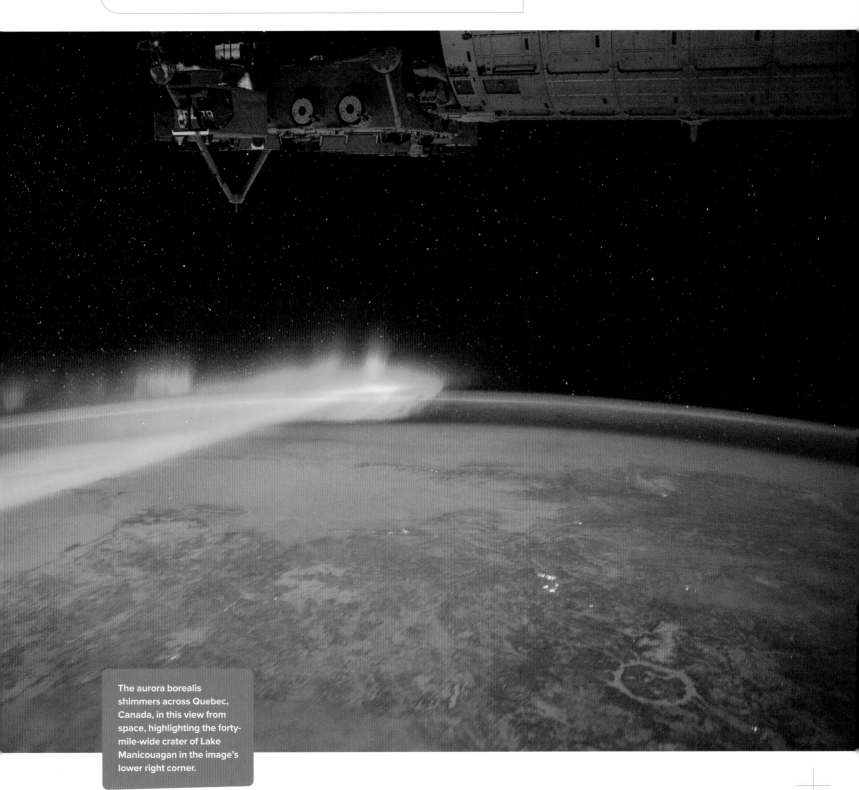

The aurora borealis shimmers across Quebec, Canada, in this view from space, highlighting the forty-mile-wide crater of Lake Manicouagan in the image's lower right corner.

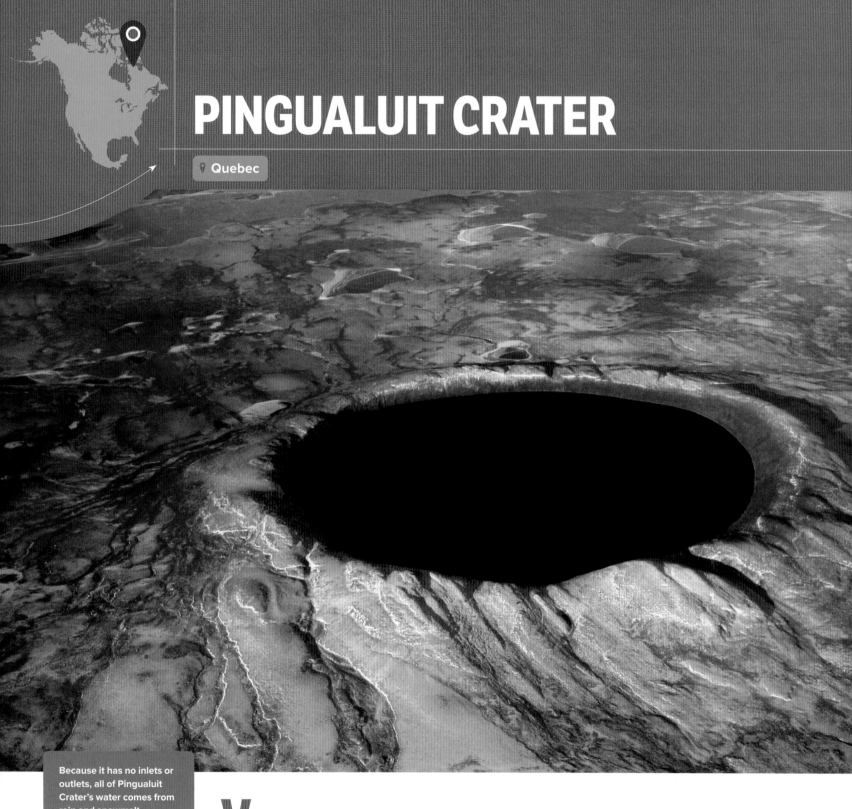

PINGUALUIT CRATER

Because it has no inlets or outlets, all of Pingualuit Crater's water comes from rain and snowmelt.

Viewed from the air, the deep, pure water in Pingualuit Crater appears electric blue and the lake's contours seem perfectly round. Located on the Ungava Peninsula in northern Quebec, this circular lake sits inside the scar left in the planet's crust by a meteorite impact 1.4 million years ago.

Pingualuit translates from the Inuit language as "place where the land rises." From the ground, the crater does appear as nothing more than a sharp rise; the rim looms 500 feet taller than the surrounding landscape. When the meteorite hit the hard rock of the Canadian Shield, it exploded, melting thousands of tons of rock and incinerat-

1300-foot-deep meteorite crater with sediments pre-dating the last ice age

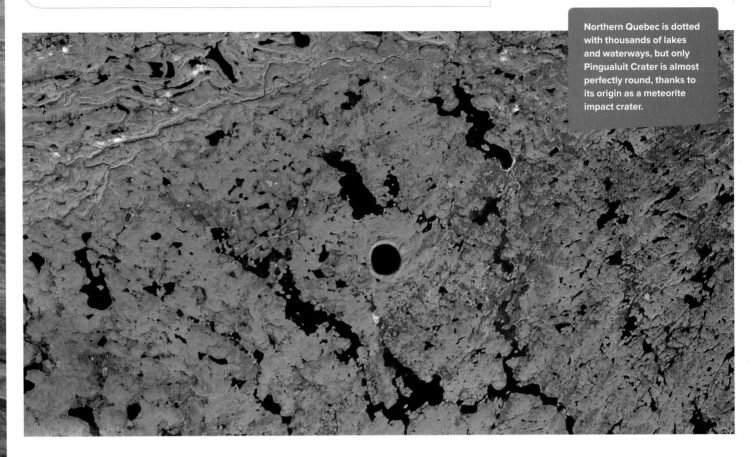

Northern Quebec is dotted with thousands of lakes and waterways, but only Pingualuit Crater is almost perfectly round, thanks to its origin as a meteorite impact crater.

ing itself in the process. Today, few traces of the extraterrestrial rock have been detected near the impact zone. The force of the crash shattered and shocked the rocks that now make up the crater rim, causing them to expand out and up, forming a raised ring in an otherwise flat landscape.

The crater the meteorite left behind is wider than two miles in diameter and filled with water nearly to the brim. At 1300 feet deep, the giant pool qualifies as one of the world's deepest lakes. There are no inlets or outlets, but the lake does host a population of Arctic char fish, whose isolation from other char populations has made the species genetically unique. All the lake's water comes from accumulations of rain and snowmelt, making for exceptionally clear freshwater.

For thousands of years, the Inuit considered Pingualuit Crater a sacred place of healing. During World War II, pilots used its nearly perfect round shape to navigate across the often-confusing, lake-covered landscape of northern Quebec. Today the crater is protected within the boundaries of Pingualuit National Park.

This impact crater lake is also considered a valuable resource for climate scientists. Northern Canada has been thoroughly scoured by glaciers over the last two ice ages, removing all traces of dirt, dust, and pollen that might offer clues about the ecological and climate history of this region before the Pleistocene Epoch. But the depths of Pingualuit Crater hold about thirty feet of sediments that date back to before the last ice age. Several expeditions have drilled cores out of these sediments and used the fossilized insects, pollen, and algae preserved within to study the area's climate over the past 120,000 years. ▪

FLIGHT PATTERN

The isolated Pingualuit Crater is more than sixty miles from the closest settlement and difficult to view except by air via a chartered flight. Look for a bright blue circle that stands out in the lake-covered landscape.

METRIC CONVERSIONS

Inches	Centimeters
¼	0.6
⅓	0.8
½	1.3
¾	1.9
1	2.5
2	5.1
3	7.6
4	10
5	13
6	15
7	18
8	20
9	23
10	25

Feet	Meters
1	0.3
2	0.6
3	0.9
4	1.2
5	1.5
6	1.8
7	2.1
8	2.4
9	2.7
10	3

Miles	Kilometers
¼	0.4
½	0.8
1	1.6
10	16
50	80
100	160
500	800
1,000	1,600

Square miles	Square kilometers
100	260
500	1,300
1,000	2,600
5,000	13,000
10,000	26,000
50,000	130,000
100,000	260,000
500,000	1,300,000

Temperatures

degrees Celsius = 0.55 × (degrees Fahrenheit – 32)

degrees Fahrenheit = (1.8 × degrees Celsius) + 32

To convert length:	Multiply by:
Yards to meters	0.9
Inches to centimeters	2.54
Inches to millimeters	25.4
Feet to centimeters	30.5
Miles to kilometers	1.6

SUGGESTIONS FOR FURTHER READING

Baars, Donald L. 2002. *A Traveler's Guide to the Geology of the Colorado Plateau*. Salt Lake City, UT: University of Utah Press.

Childs, Craig. 2001. *The Secret Knowledge of Water*. New York, NY: Back Bay Books.

Gadd, Ben. 1996. *Handbook of the Canadian Rockies*. 2nd ed. Canmore, Alberta: Corax Press.

Hopkins, Ralph Lee. 2002. *Hiking the Southwest's Geology: Four Corners Region*. Seattle, WA: Mountaineers Books.

McPhee, John. 2000. *Annals of the Former World*. New York, NY: Farrar, Straus and Giroux.

Nance, Damien and Brendan Murphy. 2015. *Physical Geology Today*. Oxford, UK: Oxford University Press.

Weidensaul, Scott. 2000. *Mountains of the Heart: A Natural History of the Appalachians*. Golden, CO: Fulcrum Publishing.

Zalasiewicz, Jan. 2012. *The Planet in a Pebble*. Oxford, UK: Oxford University Press.

ACKNOWLEDGMENTS

This project was a collaborative effort between myself, two pilots, an illustrator, a cartographer, and the team at Timber Press. Garrett Fisher and Malcolm Andrews are two ace pilot/photographers who somehow manage to fly their airplanes while also composing beautiful photographs of the world far below.

Science illustrator Kathleen Cantner and I have worked together on many a story for *EARTH* magazine, my bread-and-butter as a freelance science writer for the last eight years. Much gratitude to my long-time editor at *EARTH*, Megan Sever, for always encouraging my roving lifestyle and thinking of me when she heard about this enticing aerial geology project. Master map maker David Deis has proved—much to my delight and relief—that plenty of Earth remains uncharted. Many thanks to the team at Timber Press—especially Julie, Sarah, and Juree—who have always believed in my vision for this book.

Most of all, thank you to my parents, who raised me to hike up mountains and overturn rocks and to believe in both science and the arts. And to my much beloved mountain family in Big Sky, Montana, who gave me the home and the space to write this book: I'll see you all up top.

PHOTO AND ILLUSTRATION CREDITS

Getty Images

James L. Amos, pages 266–267
James P. Blair, pages 51, 260
Ira Block, page 161
Matthias Breiter, page 31
John Delapp/Design Pics, page 21
Michele Falzone, page 76
Kevin Fleming/Corbis/VCG, page 246
Marka/Contributor, page 247
Steve Ogle, page 42, 43
Charles O'Rear, page 46
Planet Observer/UIG, page 54
Space Imaging, page 128
Brian Stablyk, page 135
James L. Stanfield/Contributor, page 225
Jim Wark, page 119
Wild Horizon/Contributor, page 138, 159

(courtesy) Squire Haskins Photography Collection, Special Collections, The University of Texas at Arlington Libraries, Arlington, Texas, page 226

NASA (no specific credits), pages 15, 18, 30, 34, 37, 52, 91, 106, 121, 175, 215, 232, 234, 249, 251, 252, 270, 272, 276, 277, 284, 285, 293

NASA

Jesse Allen, pages 2–3, 15, 20, 28, 38, 50, 63, 83, 89, 145, 173, 180, 183, 194, 213, 214, 231, 280, 295
Jesse Allen/Robert Simmon, pages 15, 71, 102, 132, 139, 150, 171, 224, 228, 263, 267
Jacques Descloitres, pages 22, 25, 33, 48, 235, 243, 290, 291
Sally King/NPS, page 170
Norman Kuring, page 90
Matt Radcliff, page 238
Laura Rocchio, pages 15, 154, 259
Jeff Schmaltz, pages 19, 45, 236, 262, 275
Robert Simmon, pages 47, 77, 86, 99, 110, 127, 186
Joshua Stevens, page 199, 242, 266
Michael Taylor/Adam Voiland, page 255
Bob Wick, page 88

NASA/Earth Observatory, page 206

Keith Owens, page 68

Ryan Turner, pages 16–17, 201

Dan Winn Whitaker, pages 140, 142, 143

Wikimedia

Used under a GNU Free Documentation 1.2 license
©Ralf Roletschek, page 233
Used under a Creative Commons Attribution-Share Alike 2.0 Generic license
Abhinaba Basu from Redmond, United States, page 64
Graham from Rickmansworth, England, page 59
Used under a Creative Commons Attribution-Share Alike 3.0 Unported license
Paul Hermans, page 195
Public Domain on Wikimedia Commons
Federal Emergency Management Agency, NOAA News, page 54
NASA, courtesy of Denis Sarrazin, page 294
National Park Service Digital Image Archives, pages 148, 212
United States Geological Survey, pages 12–13
United States Geological Survey, Harry Glicken, USGS/CVO, and Gripso_banana_prune, page 53
United States Geological Survey, Bruce Molnia, pages 26, 27, 29
United States Geological Survey, Lyn Topinka, pages 49, 54

Illustrations

K. Canter/AGI, pages 27, 37, 44, 48, 84, 100, 117, 123, 132, 146, 175, 177, 219, 227, 269. Kat Cantner is the science illustrator for the American Geosciences Institute. She illustrates for magazines, textbooks, and picture books and also creates sculpture and jewelry. You can find more of her work at kcantner.com.

David Deis/Dreamline Cartography, pages 9, 11, 23, 31, 58, 66, 73, 82, 108, 162, 180, 202, 223, 253, 273, 287, 289. David Deis is the staff cartographer in the Department of Geography at California State University, Northridge. He has been designing custom maps and graphics for nearly two decades. His portfolio is located online at dreamlinecartography.com.

Kenneth Townsend, page 9 (terrain)

INDEX

MARY CAPERTON MORTON is a freelance science and travel writer with undergraduate degrees in biology and geology and a master's degree in science writing. A regular contributor to *EARTH* magazine, where her favorite beat is the Travels in Geology column, Mary also inspires people to see more of the world with her blog *Travels with the Blonde Coyote*. In her ten years as a road-warrior nomad, Mary hiked in all fifty states and evolved from a girl who looks up at the mountains to a woman who climbs to the summits. She now lives at 8000 feet in Big Sky, Montana. When she's not at the keyboard, you can find her outside, hiking, skiing, and mountaineering. For more, visit theblondecoyote.com.